NO LONGER PROPERTY OF
SEATTLE PUBLIC LIBRARY

NO LONGER PROPERTY OF
SEATTLE PUBLIC LIBRARY

VOTES FOR WOMEN!

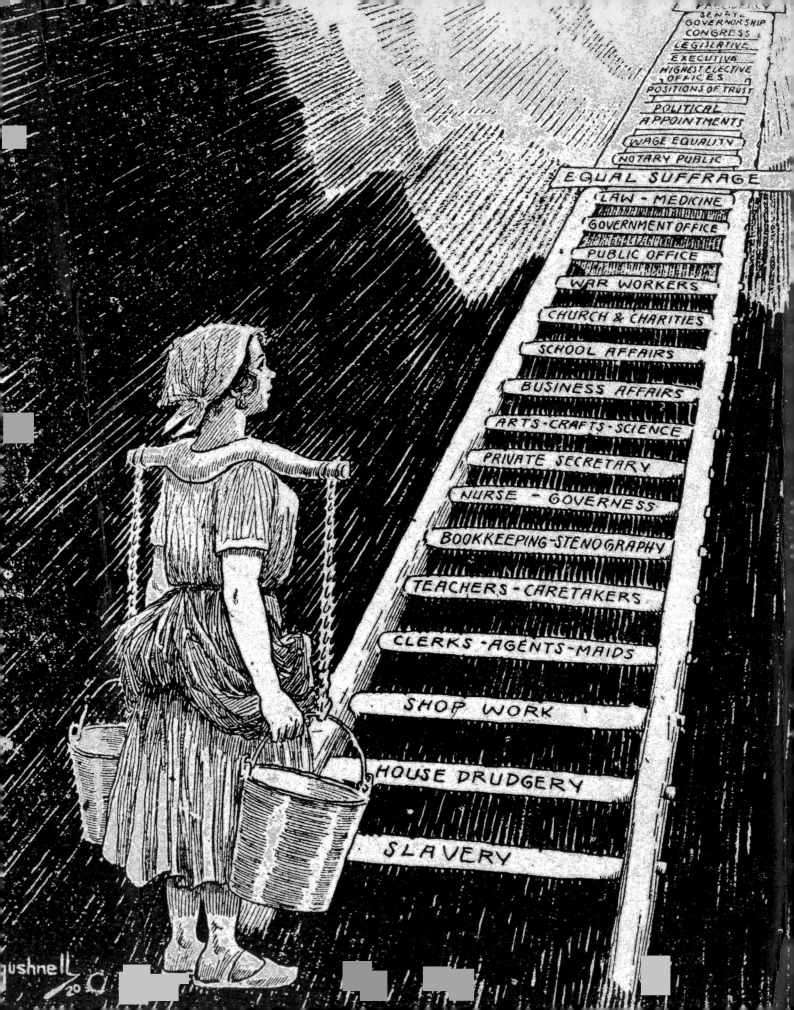

VOTES FOR WOMEN!

A PORTRAIT OF PERSISTENCE

———

Kate Clarke Lemay

———

With Susan Goodier,
Martha S. Jones, and
Lisa Tetrault

National Portrait Gallery
Smithsonian Institution
Washington, D.C.

In association with
Princeton University Press
Princeton and Oxford

DONORS

Votes for Women: A Portrait of Persistence has been made possible through the generous support of:

The Honorable Richard Blumenthal and Cynthia M. Blumenthal

Karla Scherer

Embassy of the State of Qatar

Purvi and Bill Albers

Dr. Elena Allbritton

Tina Alster, M.D.

Grace Bender

Dr. and Mrs. Paul Carter

Mr. and Mrs. Glen S. Fukushima

Ronnyjane Goldsmith

Dr. Sachiko Kuno

Barbara Lee Family Foundation Fund at the Boston Foundation

Mr. and Mrs. Michael H. Podell

Helen Hilton Raiser

Mr. and Mrs. John Daniel Reaves

Dr. Ann E. Roulet

Ronnie Lapinsky Sax

Ms. Alyssa J. Taubman and Mr. Robert J. Rothman

Alan and Irene Wurtzel

Additional support has been provided by the American Portrait Gala endowment.

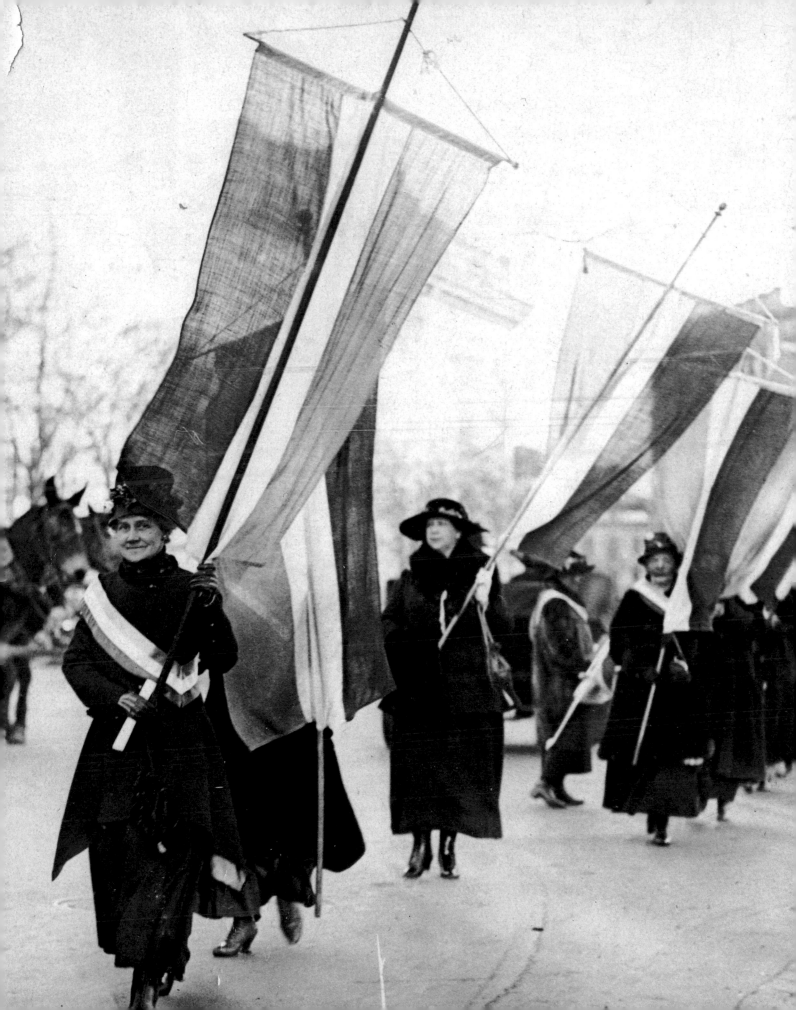

CONTENTS

DIRECTOR'S FOREWORD

With the advantage of hindsight, the early histories of women who engaged in voting rights are becoming increasingly important to understand, not simply for the tactics they used but for the central belief that women have an important role to play in the future of this nation. Their struggle, however, was never smooth—nor finished.

In October 1968, when the National Portrait Gallery opened its doors to the public, only twelve women—six Democrats and six Republicans—were members of Congress. The sole woman senator, Margaret Chase Smith from Maine, was nearing the end of her long political career, while Shirley Anita Chisholm was about to become the first African American woman elected to the House of Representatives. Chisholm, who had run on the platform "Unbought and Unbossed," reportedly told other women, "If they don't give you a seat at the table, bring a folding chair." Both Smith and Chisholm, who were uncompromising and independent leaders, embodied what the suffragists at the turn of the twentieth century were striving to achieve: a vote, a voice, and a vocation.

Votes for Women: A Portrait of Persistence is not a feel-good story about hard-fought, victorious battles for female equality. Rather, it is an unvarnished look at the past with all its biases and complexities. Those complexities are well communicated through portraiture, a powerful form of visual biography that serves as both a window into the past and a mirror reflecting the present. This is the first major exhibition and publication to document how material culture and portraiture helped the national suffrage movement achieve success. Gathering images for the exhibition has not been easy, a fact reflected in our own collection: even now, in 2018, only 18 percent of the National Portrait Gallery's collection depicts women.

This catalogue and its essays uncover suffragists who were written out of the main narrative, paying particularly close attention to the history of African American women activists, who didn't have the privilege of a single-issue focus. For women of color, especially, this exhibition hopes to shed more light onto a dark period of historical exclusion. In the face of the #BlackLivesMatter movement and #MeToo,

Mary Church Terrell's statement and the motto of the National Association of Colored Women's Clubs "lifting as we climb" is still as salient today as it was in the 1890s.

Given the importance of marking the hundredth anniversary of the passing of the Nineteenth Amendment, I therefore wish to extend enormous thanks to those individuals and organizations who have lent us their rare objects at such a singular time; their generosity has made it possible for the museum to lead the way in reconsidering the country's suffragist "heroines" and re-remember those who have fallen from our collective memories.

This publication has the potential to become one of the most definitive resources on the radical women who fought for equality between 1832 and 1965. This is in no small measure thanks to the scholarship of National Portrait Gallery historian Kate Clarke Lemay, who, along with Lisa Tetrault, Martha S. Jones, and Susan Goodier, contributed groundbreaking essays on the movement. Whether debunking some of the mythologies surrounding the first national women's convention at Seneca Falls that took place without Susan B. Anthony; uncovering the stories of African American suffragists; noting Philadelphia, alongside New York, as a hotbed of activism; or recognizing how the movement began at the "grass-roots" level—in church congregations, wartime hospitals, colleges, and statehouses—this history of women's enfranchisement in the United States is a riveting read.

Kim Sajet
Director, National Portrait Gallery

INTRODUCTION

—

Kate Clarke Lemay

Votes for Women: A Portrait of Persistence is the first book to offer a richly illustrated history of the national suffrage movement. Its unique presentation of portraiture, art, and material culture promises to captivate readers, and the essays provide a rare opportunity to learn about the complexity of one of the longest reform movements in American history.

The volume uncovers many lesser-known stories of extraordinary women, recognizing the flaws as well as the myriad accomplishments of this diverse group of individuals. Marking the centenary of the ratification of the Nineteenth Amendment in 1920, Votes for Women celebrates past efforts while looking toward what actions we might take in the future to further support women's equality.

In writing this book to help commemorate the enfranchisement of American women, it has been important to think about whom we remember and why. Today, more than ever, it is critical to consider whose stories have been forgotten or overlooked, and whose have not been deemed worthy to record. In addressing these questions, Lisa Tetrault, a scholar of American women's history, writes about the "myth" of Seneca Falls, outlining how the architects of the first wave of the suffrage reform movement—Susan B. Anthony and Elizabeth Cady Stanton—helped position the record in ways that worked in their favor.

Martha S. Jones, who is an expert in American law, presents research addressing the foundational concerns that African American women had with regard to their citizenship rights—beyond suffrage. She describes how black women, excluded from white organizations, made a united effort to remain in step with white organizations to ensure that their voices would be heard. She also outlines just how long it took to safeguard the African American women's vote, as the Nineteenth Amendment did not resolve discriminatory state laws. For this reason, Jones's essay extends well beyond the date of the ratification of the Nineteenth Amendment on August 18, 1920.

Susan Goodier, who is an authority on the anti-suffrage movement, furthers the scholarship on a topic that is often misunderstood. Through delving into the biographies of individuals who worked in opposition to the suffragists, her essay reveals the complex ideology of the women and men who stood against granting women the vote.

With my background in military history, I was curious to know more about American women's involvement in World War I. Some suffragists were pacifists, but the majority supported the war and wanted to do "their part." My essay therefore explores the relationship between World War I and suffrage by examining the all-woman team of doctors, nurses, electricians, carpenters, and others who created mobile hospitals in France. By introducing a long roster of women previously unaffiliated with this reform movement, I hope to offer an innovative approach—one that is completely outside the traditional purview of American women's suffrage history.

Despite the accomplishments and endeavors of the suffragists presented in this catalogue, American history—specifically its framework and its featured biographies—is punctuated and defined by men. Only fifteen women were named in more than ten current state standards for public education in grades six through twelve.[1] It is clear that women have not yet been recognized as significant contributors to American history. There is work to do, and I hope readers consider this a call to action. If women constitute more than 50 percent of the American population, why do milestones dominated by men frame American history? We must change the way we write history and consider not only the pioneers and the firsts but also the countless seconds and thirds who work together to create a movement.

The catalogue section of this volume offers detailed descriptions that illustrate the key suffragist communities in the United States, beginning circa 1832 and continuing through the present moment. By combining scholarship with beautiful illustrations and delving into the history—not only of suffrage but also of the material culture accompanying the movement—we hope *Votes for Women* provides an invaluable resource for anyone wishing to learn about change-makers in American history.

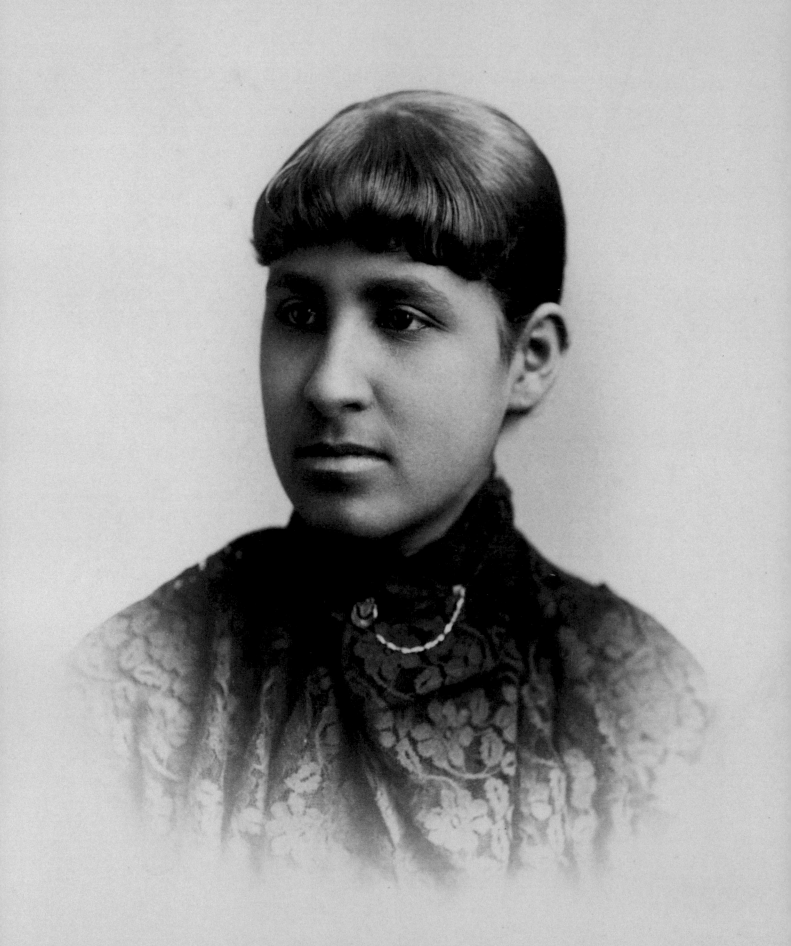

VOTES FOR WOMEN!

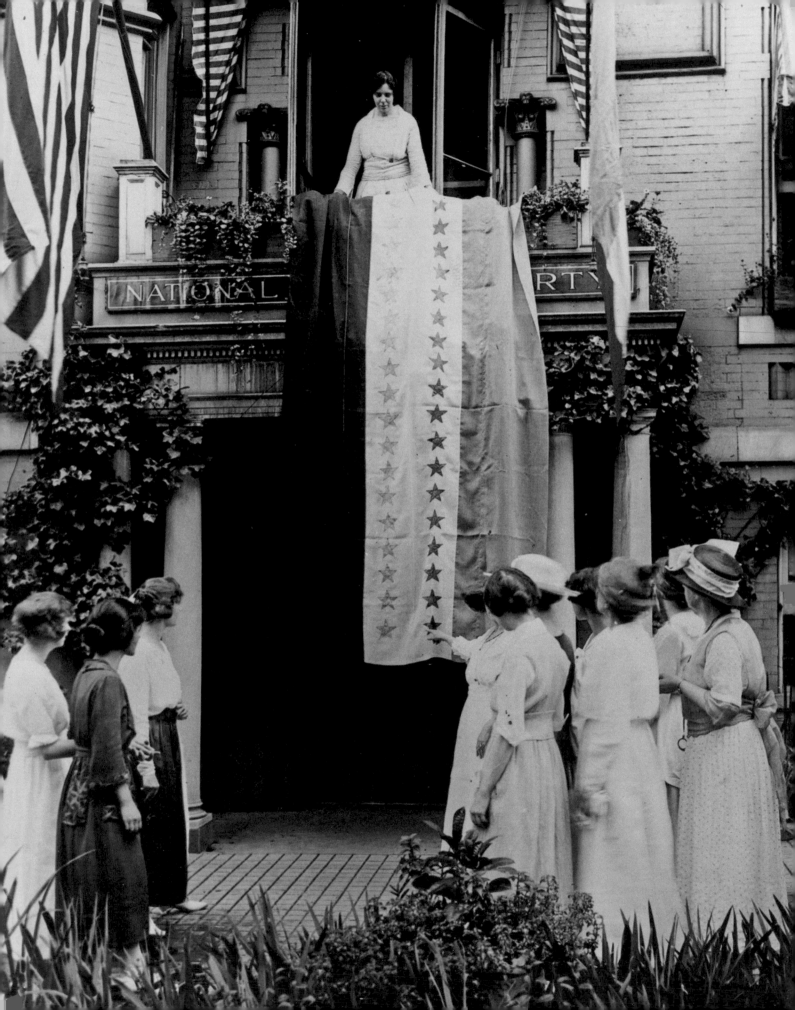

TO FIGHT BY REMEMBERING, OR THE MAKING OF SENECA FALLS

Lisa Tetrault

FIG. I

Alice Paul, the National Chairman of the Woman's Party, unfurls the ratification flag from the organization's headquarters in Washington, DC.
National Photo Company, 1920
Gelatin silver print
16.5 × 21.6 cm (6½ × 8½ in.)
Library of Congress, Prints and Photographs Division, Washington, DC

As the last state ratified the Nineteenth Amendment, celebrations erupted across the country. Movement leader Alice Paul stitched the final yellow star onto her National Woman's Party flag, three bold stripes of purple, cream, and gold. For every state that ratified, Paul had added a star. States had quickly fallen in line, slowed, and then stopped—short of the thirty-six states needed. The long battle came down to one man in Tennessee, a southern state known for its fierce opposition to women's rights. Like many, Harry T. Burn, the Tennessee legislature's youngest member, only twenty-four years of age, declared his objection. It seemed clear the amendment would not pass. But on receiving a letter from his mother urging his support—in which she instructed him "to be a good boy"—Burn changed his vote. Surprising everyone, the Tennessee legislature approved the amendment by a one-vote margin. The Nineteenth Amendment to the US Constitution was finally ratified on August 18, 1920. Hastily affixing the last star, Paul rushed outside of her headquarters and triumphantly unfurled the flag (fig. 1).[1]

Emphasizing the long struggle that had culminated in this moment, newspapers heralded the so-called Anthony Amendment "as a living monument to its dead framer, Susan B. Anthony." History was invoked again and again. The United Press syndicate headlined its wire story the "Outline Story of Suffrage in the United States." Sent to hundreds of subscriber newspapers, the piece recounted a story that many knew by heart: that the now triumphant movement took shape when "in 1848 at Seneca Falls, N.Y., Miss Anthony called to order the first national woman's [rights] convention." There, Anthony had spearheaded women's demand for the vote. "She knew her cause was right," the story continued, and "she assumed national control of

suffrage matters on the occasion of Seneca Falls."[2] Women in the United States, it was said, had finally won the vote.

Errors abounded. The Anthony Amendment (as it remains known today) was actually written by another activist, Anthony's close friend Elizabeth Cady Stanton. Anthony had not even been at the famed 1848 meeting in Seneca Falls. Yet newspapers and celebrants alike constantly placed her there. Anthony had not joined the cause of suffrage until a full three years later, in 1851, when she met Stanton, who recruited her. Women had not even won the right to vote on that historic day in August 1920. The amendment stipulated in full that "the right of citizens of the United States to vote shall not be denied or abridged by the United States or by any State on account of sex."[3] Those twenty-eight words failed to prohibit other forms of discriminatory practices, such as poll taxes and literacy tests, which were then law in several states across the country. Together, with outright violent intimidation and targeted administration, those legal prohibitions continued to bar from the polls many women of color. When these women came to the leading suffrage organizations asking for help in securing voting rights, white women turned them away.[4] The vote, a fight begun by Anthony in 1848, it was said, had been won.

As we ponder how to commemorate this 2020 centennial moment, it behooves us to attend to the memories that suffragists themselves handed down. This essay interrogates how and why celebrants in 1920 so assuredly placed Anthony at Seneca Falls, even though she had not been there, and why they so confidently used Seneca Falls as the movement's beginning, when the movement actually had no singular point of departure. When we pull at that thread and ask how this story came to be—not the facts of the 1848 convention itself, but the *story* about that convention, along with the lessons that inhered within it—we unravel something that we were not meant to see: history-telling as an important form of activism.

The reporters were absolutely right—history mattered—but not in ways that they fully grasped. They missed how, in the aftermath of the American Civil War, Elizabeth Cady Stanton and Susan B. Anthony had invented this Seneca Falls origin story in an effort to shape a postwar suffrage campaign. They missed how memory itself had played a critical role in the long fight for the vote. When Stanton and Anthony first argued that the suffrage movement had begun in July 1848, when Stanton called a women's rights convention in the small hamlet of Seneca Falls, New York, where Stanton then lived, they were not reciting merely objective, agreed-on facts. They, along with others in the movement, did not tell this origins tale until some thirty to forty years after the convention. The story was a post–Civil War creation. Yet, as in 1920, people today tell the story of Seneca Falls as if it has always been true, and they forget to attend to *its* history. That oversight has resulted in a misunderstanding of the multiple facets of this long campaign.

Beginning in the 1870s, Stanton and Anthony first turned Seneca Falls into a story they could use to combat post–Civil War challenges. This fabricated memory helped them: (1) consolidate their own deeply contested postwar leadership; (2) set an agenda for a sprawling, and to their mind, undisciplined postwar women's movement; (3) make a pointed and controversial public argument for the necessity of

women's suffrage; and (4) sustain the movement in the face of repeated, often devastating, setbacks.[5]

They carefully adapted and honed the story to address postwar fights while gently persuading more and more suffragists to adopt it. In doing so, people espoused, however unconsciously, the lessons Stanton and Anthony meant to impart. This origin story was not neutral. In fact, its appeal and its potential derived from its underlying political motives. The pair recognized that history-telling is, and could be, a decisive form of power. This was not unique to the story of Seneca Falls. All remembering, all history-telling, comes with fraught interpretative choices and implicitly coded lessons.[6]

The post–Civil War origins and purposes of this story would later be forgotten, however. Instead, it would seem to have been miraculously and unassailably true from 1848 forward. But stories don't write themselves. People make stories.[7] And people made this story, well after the event. They made it as a tool in their postwar fight for the vote. And it became a tool that served them well. Attending to that history, that process, tells us a great deal about how the movement restarted, defined, and sustained itself after the bloodiest war in American history, and how this social movement endured over roughly seventy-five years. It shows us how remembering was an essential piece of the long fight for the vote and how remembering is always loaded with significant political consequences.[8]

An Antebellum Movement Takes Shape

So, let us go back to the ostensible beginning to sort out how this tangle of fact and falsehood got intertwined, and why it ultimately mattered. Elizabeth Cady, the supposed moving influence at Seneca Falls, had, in 1840, defied her father's wishes and, at the age of twenty-five, married a scruffy abolitionist named Henry Stanton. The newlyweds soon departed for a European honeymoon. While in England, Henry suggested they stop by the World's Anti-Slavery Convention in London. The controversy that unfolded there, far across the Atlantic Ocean, would forever change Stanton's life and—it would be said—the course of US history.[9]

Stanton watched as the 1840 World's Anti-Slavery Convention spiraled into chaos (fig. 2). The United States had sent a delegation to London, made up of both men and women. But the British delegation, comprised entirely of men, objected to the women's presence, deeming their participation offensive. The US abolition movement supported and sanctioned women's involvement, however, and many of the US men leaped to the women's defense. Instead of focusing on the issue at hand, how to abolish slavery, the convention's first day veered wildly off topic and devolved into a lengthy, acrimonious dispute about the rights of women to participate. Arguments ended in a ridiculous compromise: women could listen, seated behind a bar, but they could take no active part. The young Stanton was suitably furious. Meeting Lucretia Coffin Mott (fig. 3), however, transformed her rage into purpose. Mott was twenty-two years Stanton's senior and, unlike Stanton, already a

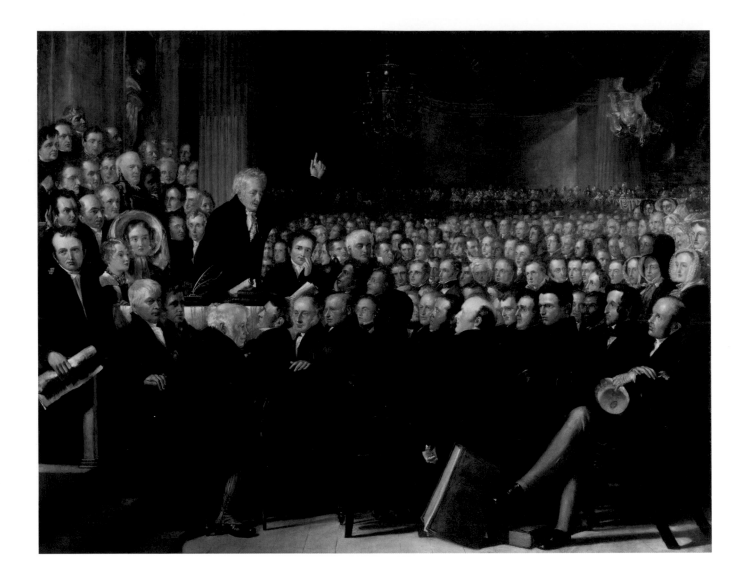

seasoned activist. Sent as a US delegate, Mott enjoyed universal respect within the US abolition movement. A penurious Quaker, she lived by her principles, and Stanton instantly revered her. Supposedly, the pair walked the streets of London spewing outrage over women's treatment by the British delegation, and they vowed to hold a women's rights convention on their return to the United States—an assembly dedicated solely to women's advancement.[10]

Then an eight-year gap in the story ensues. The idea gets rekindled, according to lore, when Mott joined Stanton for tea in July 1848. Following the Stantons' honeymoon, Henry had settled his new and growing family in the small town of Seneca Falls, New York—situated on the state's western edge and nestled among the Finger Lakes. There, he opened a small law practice. The town's provincial nature was no match for Elizabeth's prodigious intellect. And her increased boredom with the confinements of domestic life compounded her growing dissatisfaction. Although they had seen each other infrequently since London, Mott called on Stanton when she passed through Seneca Falls, inviting her to tea with three other area

FIG. 2

Portrait of the 1840 Convention of the Anti-Slavery Society
Benjamin Robert Haydon
(1786–1846)
ca. 1841
Oil on canvas
297.2 × 383.6 cm (117 × 151 in.)
National Portrait Gallery, London; given by British and Foreign Anti-Slavery Society, 1880

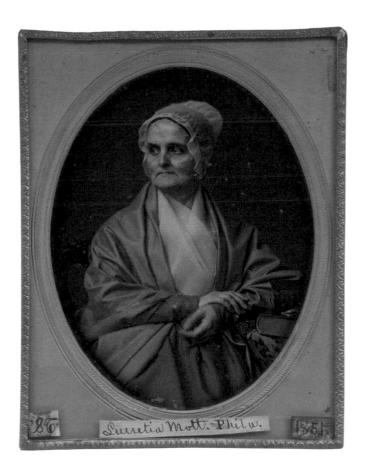

FIG. 3

Lucretia Coffin Mott (1793–1880)
Marcus Aurelius Root
(1808–1888)
1851
Daguerreotype
11.6 × 8.9 cm (4 9/16 × 3 1/4 in.)
National Portrait Gallery,
Smithsonian Institution

reformers. Around Jane Hunt's parlor table, as the story goes, Stanton poured out her domestic woes. Together, the five women—Mott, Stanton, Hunt, Martha Coffin Wright (Mott's pregnant sister), and Mary Ann M'Clintock—decided, then and there, to hold a convention to discuss women's grievances. They had only a few days to organize. Hastily, they put an advertisement into the local newspaper, the *Seneca County Courier*, announcing: "A Convention to discuss the social, civil, and religious condition and rights of women will be held in the Wesleyan Chapel, at Seneca Falls, N.Y., on Wednesday and Thursday, the 19th and 20th of July current; commencing at 10 o'clock A.M."[11] The five women worried that no one would show.[12]

In the interim, they got to work preparing an agenda for the proceedings. They decided that the convention should have a guiding document, to focus discussion. That document would contain their complaints and their demands. As they struggled to compose something befitting, they struck on a brilliant idea: to model their document on the Declaration of Independence. "We hold these truths to be self-evident," they revised, "that all men *and women* are created equal." Where that founding document listed colonists' grievances against the king, they substituted women's grievances against "man," detailing how the masculine sex deprived the feminine persuasion of their inherent rights. They then listed a series of twelve demands, called "resolutions." They agreed that these resolutions would be taken up, one by one, in the convention, thoroughly debated and then voted on.[13]

On the morning of the convention, to their utter amazement, nearly three hundred people arrived, women and men alike.[14] While this was a women's rights convention, organizers worried that appointing a woman to chair the proceedings would be too scandalous, so they appointed Mott's husband, James. They worked their way through what they now called their "Declaration of Sentiments," thoroughly debating each of its twelve resolutions. These included the right of married women to own property, the right to leave the confinements of the home and participate equally in the public sphere, women's access to the professions, equal pay, equal education, and women's right to vote. All passed unanimously, except for the ninth, women's "sacred right to the elective franchise." That demand, often credited to Stanton, met with considerable opposition. Only after the abolitionist and escaped slave Frederick Douglass, who lived in nearby Rochester, stood and vehemently defended women's suffrage, did it finally pass (fig. 4). In the end, nearly one hundred convention goers signed the declaration and its accompanying demands.[15]

News of this impromptu local convention and its accompanying declaration circulated far and wide. Across the country, newspapers reported on the 1848 proceedings and its demands. Coverage varied, from comically disdainful to surprisingly respectful—even at times, supportive. Douglass, meanwhile, pulled together the proceedings and the declaration into a short pamphlet, published by the offices of his *North Star* newspaper.[16]

At the time, no one believed that this local convention had started a woman's (as it was known at the time, in the singular) suffrage movement, as is now often claimed. That story did not yet exist because it was not yet needed. And although Seneca Falls was absolutely the first women's rights convention in the United States—and certainly significant for this reason—it did not offer a novel definition of women's rights. Nor was this the first demand for the franchise, as would later be claimed. Women's rights ideas had been percolating for some time. Far from conceiving of women's suffrage and the other demands, the women at Seneca Falls simultaneously drew on a rich heritage and advanced that ongoing project.[17]

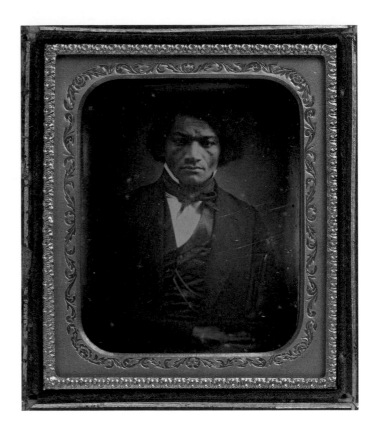

FIG. 4

Frederick Douglass (1818–1895)
Unidentified photographer
ca. 1847–1850
Daguerreotype
6.8 × 5.4 cm (2 11/16 × 2 1/8 in.)
National Portrait Gallery,
Smithsonian Institution

Before 1848, various women, in various ways, had called for many of the early women's rights demands outlined at Seneca Falls already, including the vote. In 1776, Abigail Adams had warned her husband John, a representative to the Continental Congress, who was busy drafting laws for the new nation, that women "threatened fomenting a Rebellion." She assured him that women "would not hold ourselves bound by any Laws in which we had neither a voice, nor representation."[18] From its very beginning, the American Revolution unleashed aspirations of equality among the downtrodden, including white women.[19] In New Jersey, propertied white women even voted, casting ballots legally until 1807.[20] In 1845, Massachusetts-born Margaret Fuller, steeped in American transcendentalism, published *Woman in the Nineteenth Century*, one of the first major feminist works produced in the United States, in which she too called for the ballot.[21] And in 1846—two years before the convention at Seneca Falls—six women from Jefferson County, New York, petitioned their state legislature for their right to the elective franchise.[22]

The other women's rights demands made at Seneca Falls had important precursors, too. As women joined the abolitionist movement, ministers and other men attacked them for forcefully exercising their political opinions in public. Abolitionist women defended themselves by articulating some of the earliest women's rights stances. The most famous of these women were the Grimké sisters, Sarah and Angelina, who were castigated in the 1830s for speaking against slavery before so-called promiscuous (or mixed-sex) audiences, violating the biblical Pauline dictate

FIG. 5

Sarah Moore Grimké (1792–1873)
Unidentified artist
ca. 1850
Wood engraving
9 × 11.5 cm (3 ½ × 4 ½ in.)
Library of Congress, Prints
and Photographs Division,
Washington, DC

FIG. 6

Angelina Emily Grimké Weld
(1805–1879)
Unidentified artist
ca. 1850
Wood engraving
9 × 11.5 cm (3 ½ × 4 ½ in.)
Library of Congress, Prints
and Photographs Division,
Washington, DC

that women should remain silent (figs. 5–6).[23] The Grimkés retorted that God meant for women to leave the domestic sphere and advocate their political and moral minds. And in 1838, Sarah authored her widely read *Letters on the Equality of the Sexes,* an important early women's rights treatise. The Grimkés were part of a mass movement of black and white women within abolition who began blending their anti-slavery work with women's rights activism.[24] For instance, in 1847, Lucy Stone, the first Massachusetts woman to earn a college degree, took a lecturing job with the American Anti-Slavery Society, in which she spoke about abolition during one part of the week and women's rights during the other (fig. 7).[25] Immigrant women, too, helped build an early women's rights analysis, arriving in the United States steeped in very different traditions of European radicalism.[26]

This ongoing national discussion about women's rights, variously defined, and over several decades, was precisely what generated an audience of three hundred at the Wesleyan Chapel on a hot day in July 1848. Some were merely curious onlookers. The women's rights discussion was emergent, rather than fully fledged. But some of these convention goers were surely midstream in their thinking about these issues when they took their seats at the meeting.

After the 1848 convention in Seneca Falls, the conversation continued and intensified. A central difference was that it now began to be articulated in women's rights conventions (although it continued in other venues as well). A month after Seneca Falls, a follow up meeting was held in nearby Rochester, New York—this time chaired by a woman. Activists in other states, such as Ohio, Indiana, and Massachusetts, also began holding local and state women's rights conventions. Adherents started forming women's rights organizations, which pursued the agendas spelled out in conventions. By 1850, these meetings and organizations were

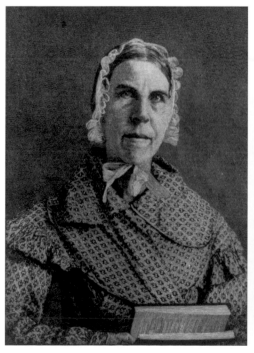 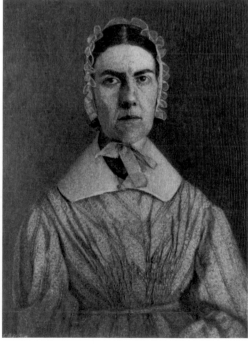

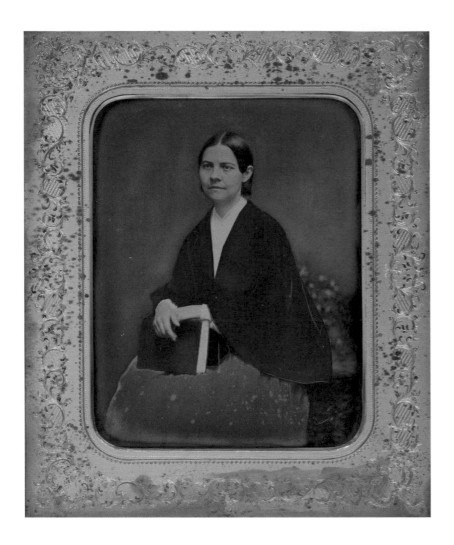

FIG. 7

Lucy Stone (1818–1893)
Unidentified photographer
ca. 1855
Daguerreotype
13.9 × 10.7 cm (5 ½ × 4 ³/₁₆ in.)
National Portrait Gallery,
Smithsonian Institution

numerous enough that activists held the first *national* women's rights convention, in Worcester, Massachusetts. After this, women held national conventions, which gathered activists from around the country, every year (save for 1857), until the outbreak of the American Civil War in 1861.[27] Although all this would later be pegged as the beginning of a women's *suffrage* movement, antebellum activists never centered the vote as the pinnacle of their work. They called themselves woman's rights activists, not suffragists, as the vote was only one of many demands. That switch came after the war.

During all this ferment, Stanton met Anthony, a meeting that irrevocably changed both their lives—and some would argue, the landscape of American feminism. Stanton had remained engaged in women's rights activity after her first foray in 1848, but she was limited by domestic and maternal duty, including new pregnancies (ultimately having seven children). Much of this growing women's rights activity proceeded without her. Notably, she would not attend a national convention, for example, until 1860. Meanwhile, as women's rights activity picked up around the country in the early 1850s, Anthony was living in Rochester, New York, where she worked as a schoolteacher, while also participating in area abolition and temperance

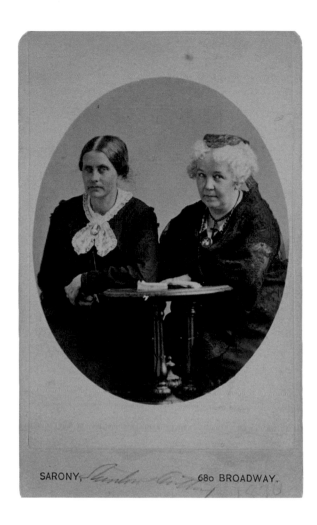

reform. Their 1851 meeting would transform their respective reform careers.[28]

The two quickly developed an astonishingly productive friendship, their respective skills being exceedingly well matched. Stanton persuaded Anthony to abandon temperance and focus on women's rights, and it soon became their joint life's work. It became hard to talk about one without talking about the other. Where Stanton was the intellect and philosopher, Anthony was the organizer. Soon, Anthony left teaching and became a full-time organizer. Never marrying, she dedicated her life to the cause. Needing content for meetings—calls, speeches, and the like—and not being a particularly good writer, Anthony would travel to Seneca Falls, lock the domestically preoccupied Stanton into a room with pointed directives to write, and babysit Stanton's growing brood. As Anthony would later say of their close, lifelong collaboration, Stanton "forged the thunderbolts, and I fired them" (fig. 8).[29]

Although increasingly prominent and active over the 1850s, the two were by no means the center of an antebellum women's rights movement. That mistaken impression—so prominently on display in the newspaper coverage of ratification in 1920, where reporters confidently declared that Anthony "assumed national control of suffrage matters" after 1848—would be forged through the Seneca Falls origin story. In the wake of the American Civil War, which brought an entirely new set of political challenges, Stanton and Anthony leveraged and reinvented the past.[30]

The World the War Made

In April 1861, cannon fire engulfed Fort Sumter, a US military fort in a South Carolina harbor. Thus began the American Civil War. Women's rights activists immediately suspended their work on behalf of the "fairer sex" and threw themselves into supporting the Northern war effort. At first, Lincoln remained committed to restoring the Union, with slavery intact. But as the war dragged on and the North suffered repeated military defeats, Lincoln realized what many had already concluded: that slavery had to end. Two years into the war, in January 1863, Lincoln ended slavery in the Confederacy (where he technically had no jurisdiction) with the Emancipation Proclamation, causing chaos in the South, just as he had hoped. Freed people and abolitionists rejoiced. In 1865, Lincoln accepted the South's surrender. Then began the hard work of what came next.[31]

The divisive national postwar battles about how to rebuild the war-torn nation engulfed the abolitionist and women's rights movements, as they

FIG. 8

Susan B. Anthony (1820–1906) and Elizabeth Cady Stanton (1815–1902)
Napoleon Sarony (1821–1896)
ca. 1870
Albumen silver print
6.1 × 9.7 cm (2 ⅜ × 3 ¹³/₁₆ in.)
Susan B. Anthony Papers, 1815–1961, Schlesinger Library, Radcliffe Institute, Harvard University

SARONY, 680 BROADWAY.

struggled to navigate a new political climate. Although freed people were now nominally "free," they had no clear legal status. Were they equal citizens, subject to the same laws as whites? Were they entitled to compensation for their long history of enslavement? These and so many other questions swirled around in postwar political culture.[32]

Antebellum reformers from the abolition-and-women's-rights coalition reorganized into the American Equal Rights Association (AERA). Formed in 1866 to intervene in this larger national debate about postwar political rights, the AERA lobbied for two inextricable demands—the vote for both blacks and women. Membership included many prominent activists, notably Frederick Douglass (now the nation's leading African American statesman), Lucy Stone, Elizabeth Cady Stanton, Susan B. Anthony, Lucretia Coffin Mott, and a number of Northern black women, such as Sojourner Truth (fig. 9), Frances Ellen Watkins Harper, and Harriet Purvis. Bitter internal disputes split the AERA, however, when the national political scene put their twin demands into conflict.[33]

In 1869, the US Congress precipitated a debate that would destroy the AERA. Unwilling to grant most of the rights freed people demanded—such as land, bodily protection, and education—Congress decided to grant their appeals for political representation. That February, they passed the Fifteenth Amendment to the US Constitution. The amendment barred the states from discrimination in voting on the basis of "race, color, or previous condition of servitude." In effect, it granted black male suffrage. The AERA had fought to have "sex" included in the wording of the provision, which would have granted women's suffrage too, but that had failed. Nevertheless, the AERA considered supporting the amendment as it headed to the states for ratification. Most considered it a vitally important step forward, but Stanton and Anthony balked. At the AERA's May 1869 convention, they staunchly opposed the amendment for its exclusion of women. Although it is often said today that the two took the high road, refusing to compromise and insisting on equal voting for all ("universal suffrage"), the reality is considerably less savory.[34]

As the convention began, Stanton delivered the opening salvo. "'Manhood suffrage' is national suicide and women's destruction," she railed. "Remember, the fifteenth amendment takes in a larger population than the 3,000,000 black men on the Southern plantations. It takes in all the foreigners daily landing in our Eastern cities, [and] the Chinese crowding our western shores," she continued. "Think of Patrick and Sambo and Hans and Yung Tung, who do not know the

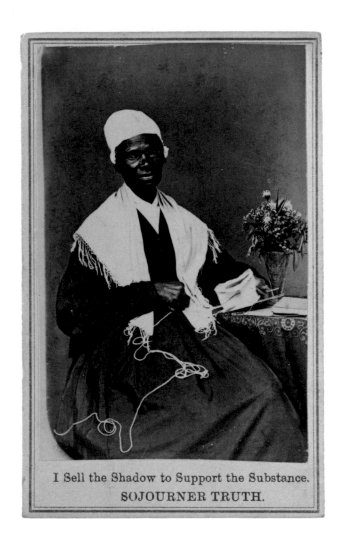

I Sell the Shadow to Support the Substance.
SOJOURNER TRUTH.

FIG. 9

Sojourner Truth (1797–1883), *"I Sell the Shadow to Support the Substance"*
Unidentified photographer
1864
Albumen silver print
8.5 × 5.4 cm (3 ⅜ × 2 ⅛ in.)
Metropolitan Museum of Art; purchase, Alfred Stieglitz Society Gifts, 2013

difference between a monarchy and a republic, who cannot read the Declaration of Independence or Webster's spelling book, making laws for Lucretia Mott . . . [or] Susan B. Anthony." The amendment, she charged, "creates an antagonism everywhere between educated, refined women and the lower orders of men, especially at the South." Many fought back against the blanket racism in Stanton's remarks, her elitism on naked display.[35]

As the tumult quelled, Douglass spoke. He attacked the use of such disparaging language and spoke in favor of the Fifteenth Amendment. "I must say," he shouted, referencing the uncontrolled, vigilante violence inflicted on freed people across the South, "I do not see how any one can pretend that there is the same urgency in giving the ballot to the woman as to the negro. . . . With us, the matter is a question of life and death. . . . When women, because they are women, are hunted down through the cities of New York or New Orleans; when they are dragged from their houses and hung upon lamp-posts; when their children are torn from their arms, and their brains dashed out upon the pavement; when she is an object of insult and outrage at every turn; when they are in danger of having their homes bur[n]t down over their heads; when their children are not allowed to enter schools, then she will have an urgency to obtain the ballot equal to our own." Whereupon a newspaper indicated "Great applause." A voice from the audience shouted: "Is that not true about black women?" "Yes, yes, yes," Douglass rejoined, "but not because she is a woman but because she is black."[36]

The convention declined into chaos. Arguments flew on all sides. Like Stanton, Anthony shouted, "If you will not give the whole loaf of justice to the entire people, if you are determined to give it, piece by piece, then give it first to women, to the most intelligent & capable of the women at least," clearly meaning native-born, white women. Stone, by contrast, praised the Fifteenth Amendment and despaired over the introduction of questions of priority in the debate. She closed by asking that someone get them "out of this terrible pit." Harper, one of the black female activists, declared that "the question of color was far more to her than the question of sex." Like Harper, the other black women there also ardently supported the amendment. In the end, the convention could not even restore enough order to call a vote.[37]

The dispute effectively ended the AERA and began Stanton and Anthony's alienation from their former allies—a state of affairs they would omit when offering their own interpretation of the past. Refusing to sanction black men voting before white women, the pair pulled out of the AERA and in a small, unadvertised reception, they formed a brand-new organization, the National Woman Suffrage Association (National Association). Stone and the many other women's suffrage allies in the AERA charged that they had been deliberately excluded, that Stanton and Anthony had colluded to form a national organization without them. Stone gathered with reformers from across the country and formed an alternative national women's suffrage organization: the much larger American Woman Suffrage Association (American Association). By the end of 1869, the antebellum women's rights movement had reorganized into a bitterly divided postwar women's suffrage movement.[38]

As personal animosities grew, reformers also split over what a post-war women's suffrage movement *could* and *should* do. In Stanton and Anthony's mind, the Fifteenth Amendment had one redeeming feature: it set a new constitutional precedent by affirming federal regulation of voting, a right that had historically been regulated by individual states. States had determined who could vote within their boundaries. But with the ratification of the Fifteenth Amendment, the federal government had, for the first time in US history, imposed stipulations on *who* the states permitted to vote. According to Stanton and Anthony, this had changed the terms of the fight. Women no longer needed to demand voting rights from each individual state legislature, which had been the antebellum method. They could concentrate their efforts on a single point, demanding that the US Congress pass a Sixteenth Amendment prohibiting the states from using "male" as a voting qualification.

By contrast, Stone and the American Association staunchly disagreed that the Fifteenth Amendment changed constitutional prerogatives around voting. They argued that those still rested with the states and any winning strategy should focus there. So, while Stone and her allies threw themselves into organizing and coordinating activism in the individual states, Stanton, Anthony, and the National Association attacked the congressional citadel with demands for a Sixteenth Amendment (figs. 10–11).[39]

FIG. 10

Flocking for Freedom
Udo J. Keppler (1872–1956) for
Puck, January 23, 1878
Lithograph
46.5 × 31 cm (18 5/16 × 12 1/4 in.)
Library of Congress, Prints
and Photographs Division,
Washington, DC

FIG. 11

Appeal for a Sixteenth Amendment
National Woman Suffrage
Association, November 10, 1876
Printed paper, with inscription
25.5 × 20.3 cm (10 × 8 in.)
Center for Legislative
Archives, National Archives,
Washington, DC

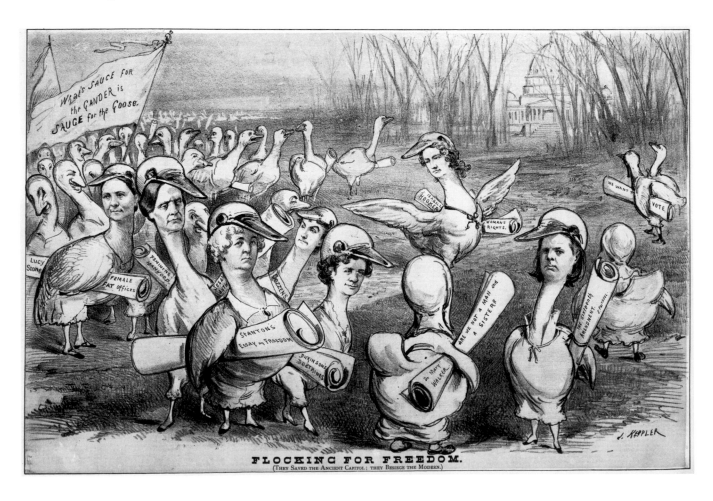

FLOCKING FOR FREEDOM.
(They Saved the Ancient Capitol; they Besiege the Modern.)

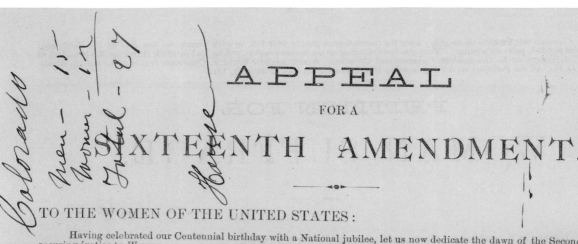

APPEAL

FOR A

SIXTEENTH AMENDMENT.

Colorado
Men –
Women – in
Futul – 27
House

TO THE WOMEN OF THE UNITED STATES:

Having celebrated our Centennial birthday with a National jubilee, let us now dedicate the dawn of the Second Century to securing justice to Woman.

For this purpose we ask you to circulate a petition to Congress, just issued by the "*National Woman Suffrage Association,*" asking an amendment to the United States Constitution, that shall prohibit the several States from disfranchising any of their citizens on account of Sex. We have already sent this petition throughout the country for the signatures of those men and women who believe in the citizen's right to vote.

To see how large a petition each State rolls up, and to do the work as expeditiously as possible, it is necessary that some person, or society in each State and District should take the matter in charge, print, and send out petitions to reliable friends in every county, urging upon all thoroughness and haste. When the petitions are returned, they should be pasted together, neatly rolled up, the number of signatures marked on the outside, with the name of the State, and forwarded to Sarah Andrews Spencer, Chairman of our Congressional Committee, corner of L. and 7th street, Washington, D. C. On the 16th and 17th of January, 1877, we shall hold our 8th Annual Convention at the Capitol and ask a hearing on our petition before Congress.

Having petitioned to our law-makers, State and National, for years, many from weariness and despair have vowed to appeal no more; for our petitious, say they, by the tens of thousands, are piled up mid the National archives unheeded and ignored. Yet, it is possible to roll up such a mammoth petition, borne into Congress on the shoulders of stalwart men, that we can no longer be neglected or forgotten. Statesmen and politicians, alike, are conquered by majorities. We urge the women of this country to make now the same united effort for their own rights, that they did for the slaves at the south, when the 13th amendment was pending. Then a petition of over 300,000 was rolled up by the leaders of the suffrage movement, and presented in the Senate by the Hon. Charles Sumner. But the leading statesmen who welcomed woman's untiring efforts to secure the black man's freedom, frowned down the same demands when made for herself. Is not liberty as sweet to her as to him? Are not the political disabilities of Sex as grievous as those of color? Is not a civil rights bill that shall open to woman the college doors, the trades and professions—that shall secure her personal and property rights, as necessary for her protection, as for that of the colored man?

And yet the highest judicial authorities have decided that the spirit and letter of our National Constitution are not broad enough to protect Woman in her political rights; and for the redress of her wrongs they remand her to the State. If this Magna Charta of Human Rights can be thus narrowed by judicial interpretations in favor of class legislation, then must we demand an amendment that in clear, unmistakable language, shall declare the equality of all citizens before the law.

Women are citizens, first of the United States, and second of the State wherein they reside: hence, if robbed by State authorities of any right founded in nature or secured by law, they have the same right to national protection against the State, as against the infringements of any foreign power. If the United States government can punish a woman for voting in one State, why has it not the same power to protect her in the exercise of that right in every State? The Constitution declares it the duty of Congress to guarantee to every State a republican form of government, to every citizen equality of rights. This is not done in States where women, thoroughly qualified, are denied admission into colleges, which their property is taxed to build and endow; where they are denied the right to practice law and are thus debarred from one of the most lucrative professions; where they are denied a voice in the government, and thus while suffering all the ills that grow out of the giant evils of intemperance, prostitution, war, heavy taxation and political corruption, stand powerless to effect any reform. Prayers, tears, psalm-singing and expostulation are light in the balance, compared with that power at the ballot box that converts opinions into law. If Women who are laboring for peace, temperance, social purity and the rights of labor, would take the speediest way to accomplish what they propose, let them demand the ballot in their own hands, that they may have a direct power in the government. Thus only can they improve the conditions of the outside world and purify the home. As political equality is the door to civil, religious and social liberty, here must our work begin.

Constituting as we do one-half the people, bearing the burdens of one-half the National debt, equally responsible with man for the education, religion and morals of the rising generation, let us with united voice send forth a protest against the present political status of Woman, that shall echo and re-echo through the land. In view of the numbers and character of those making the demand, this should be the largest petition ever yet rolled up in the old world or the new;—a petition that shall settle forever the popular objection that "Women do not want to vote."

ON BEHALF OF THE NATIONAL WOMAN SUFFRAGE ASSOCIATION.

ELIZABETH CADY STANTON, Pres.
MATILDA JOSLYN GAGE, Chairman Ex. Com.
SUSAN B. ANTHONY, Cor. Sec.

Tenafly, N. J., Nov. 10, 1876.

Over the late 1860s and early 1870s, there arose incredible optimism that the female franchise might be won. Women's suffrage now rolled off the tongues of most Americans—with plenty of talk in favor. One prominent activist, Mary Livermore, noted that after the war, "the whole country was seething with interest in the questions that relate to women."[40] In 1869, the territory of Wyoming even granted women full voting rights. The next year, Utah did the same. In two territories, women now voted on the same terms as men.[41] Suffragists felt keenly that this historic opportunity should not be squandered with misdirected energy for fear that the cause be lost forever. As such, they believed that how the battle was fought and who led it urgently mattered.

By the early 1870s, when yet another dramatic controversy flowed in their wake, Stanton and Anthony had become a liability in the eyes of many suffragists. The pair received a rain of bad press because of their alliance with the controversial Victoria Woodhull, who seemingly burst onto the national scene out of nowhere (fig. 12).

The insanely rich railroad magnate Cornelius Vanderbilt called on Woodhull's services as a clairvoyant—someone who could talk to the dead, an ability many nineteenth-century people believed in. Grateful for her assistance with all things psychic, Vanderbilt showered Woodhull and her sister, Tennessee Claflin (who scandalized the public by wearing men's attire and smoking cigars), with gifts. He set them up with the first female-run Wall Street brokerage firm, which gripped national attention, and he financed their reform-minded newspaper, *Woodhull and Claflin's Weekly*, which drew additional focus to the sisters' rising fame. Woodhull, meanwhile, espoused sex radicalism, being a so-called free lover. All of this made her a deeply controversial figure. Even though she was an outspoken proponent of the cause, some wanted her nowhere near the suffrage movement, for fear she would bring ill repute on the reform.[42]

When Woodhull, of all people, was invited to address the House Judiciary Committee in January 1871, on the topic of women suffrage, Stanton and Anthony felt determined to be present (fig. 13). The House Judiciary Committee, after all, was not in the habit of inviting females to address it. Neither did it routinely take up the topic of women's suffrage. Stanton and Anthony delayed the start of their association's annual convention in Washington, DC, in order to bear witness. Taken with Woodhull's meteoric public prominence and her eloquent defense of women's right to vote, the pair invited her to speak before their convention, which took place that same day. There, she delivered her address for a second time to a packed and enthusiastic hall.[43]

Woodhull promoted yet another new strategy for pursuing the vote, the "New Departure," for which women creatively probed and interpreted existing

FIG. 12

Victoria Claflin Woodhull
(1838–1927)
Unidentified photographer
ca. 1870
Albumen silver print
10 × 6 cm (4 × 2 ½ in.)
The Library Company of
Philadelphia

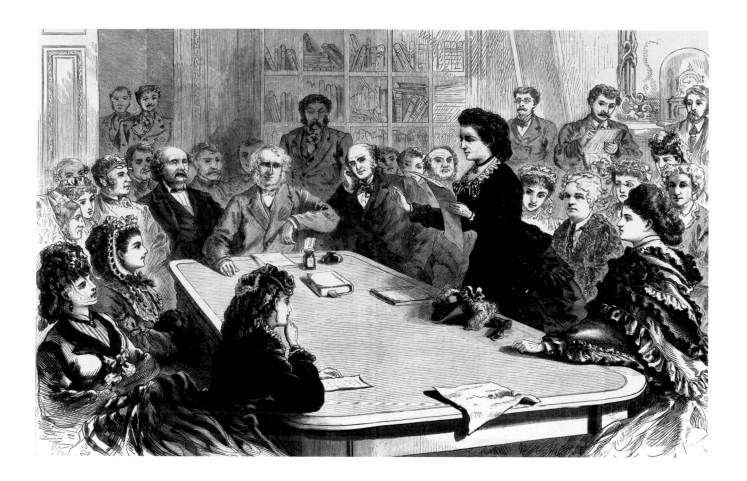

FIG. 13

*Lady Delegates Speaking to the
Judiciary Committee of the House
of Representatives
Standing:* Victoria Woodhull
(1838–1927), *seated:* Lillie
Devereux Blake (1833–1913),
Isabella Beecher Hooker
(1822–1907), Rev. Olympia
Brown (1835–1926), Paulina
Wright Davis (1813–1876), Kate
Stanton (life dates unknown),
Josephine Sophia White
Griffing (1814–1872), Belva Ann
Lockwood (1830–1917), and
Susan B. Anthony (1820–1906)
Unidentified artist for *Frank
Leslie's Illustrated Newspaper,*
February 4, 1871
Wood engraving
23 × 36 cm (9 15/16 × 14 1/4 in.)
Library of Congress, Prints
and Photographs Division,
Washington, DC

constitutional amendments as a way of claiming that they *already* possessed the ballot. All they had to do was go vote, get arrested, and then argue this theory in court. If the courts could be persuaded to accept it, then suffragists would win their fight. In essence, the New Departure was an end run around the legislative process, one that relied on the judicial branch of government. Eagerly, the National Association jettisoned its Sixteenth Amendment work and began recruiting women to vote. The American Association was appalled. The idea seemed preposterous to them, a total distraction from the hard work they needed to do. It was yet more indication that the National Association had gone completely off the rails. Determined to pursue Woodhull's strategy, Anthony famously cast her vote in the 1872 presidential election, and was—as she hoped—arrested for it. But this short-lived strategy quickly failed, as the courts rebuffed women's claims.[44]

Meanwhile, that same fall, Woodhull frequented the headlines, bringing more bad press to the movement. Some blamed Stanton and Anthony for having invited Woodhull into the movement. The fall of 1872 was momentous. Not only did hundreds of women go out and vote, but Woodhull also boldly declared herself a third-party candidate in the 1872 presidential race.[45] She was the first woman to ever run for US president.[46] Rather than rejoice over her candidacy (itself a women's rights victory), the American Association continually rebuffed Woodhull for her supposed "free-love" immorality. Woodhull seethed with anger over their hypocrisy; everyone

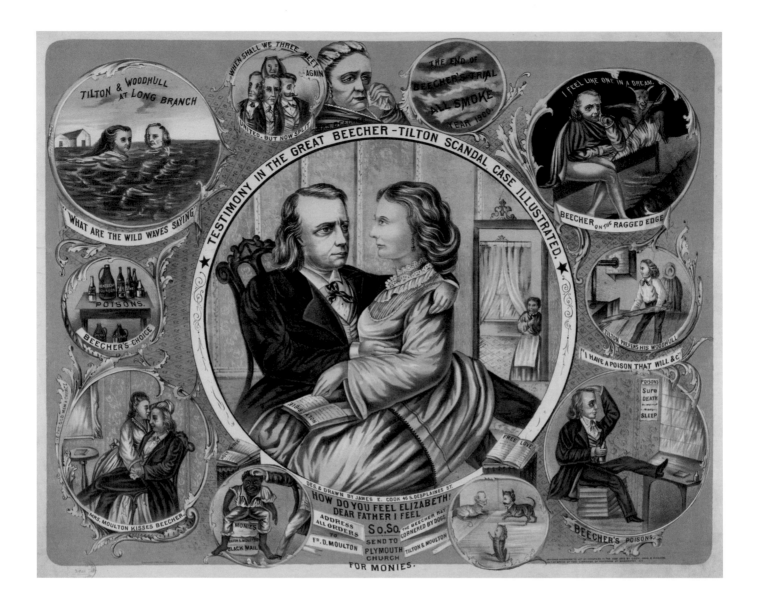

knew, even if no one dared speak about it, that the American Association's one-time president, the nation's leading minister, Henry Ward Beecher, was having an illicit affair with his best friend's wife. Having had enough of the attacks on her morals, Woodhull charged Beecher with adultery, on the front page of her newspaper, setting off the most famous sex scandal of the nineteenth century. It was a national sensation (fig. 14).[47] To compound matters, Woodhull named Stanton as her source, something Stanton (having no tolerance for the sexual double standard) happily corroborated. Anthony furiously tried to smooth the waters, but it was a public relations disaster. Branded "Mrs. Satan" by a leading political cartoonist (see cat. 31), Woodhull took the brunt of public criticism and was soon chased out of the country. The suffrage movement took a heavy blow as well, as it was now being branded in the press as no more than a conspiracy to promote "free love."

FIG. 14

*Testimony in the Great Beecher–
Tilton Scandal Case Illustrated*
James E. Cook (active 1870s)
ca. 1875
Lithograph
56.1 × 70.8 cm (22 1/16 × 27 7/8 in.)
Library of Congress, Prints
and Photographs Division,
Washington, DC

To Fight by Remembering

In response to this swirling catastrophe, Stanton and Anthony began honing a new political strategy: history telling. With no viable strategy for achieving the vote, now that the New Departure had failed, and facing the fallout of the Woodhull public relations disaster, Stanton and Anthony struggled with how to focus the National Association's 1873 annual convention. Finding little good news in the present, they looked backward to the 1848 convention. They began to use it as a political tool—tentatively, and perhaps even unconsciously at first, but then more overtly and deliberately. With very little to celebrate, they turned their National Association annual meeting into a Seneca Falls anniversary convention, something activists had never before publicly commemorated. It was perhaps no more than coincidence that the 1848 Seneca Falls convention was exactly twenty-five years old and ripe for an anniversary party at the dawn of 1873.

At this point, Seneca Falls, as a key memory of the movement, was almost nonexistent. Some of the older veterans still remembered the event as the first convention, but they attached no special significance to it. Almost no one considered Seneca Falls the beginning of the movement—not even Mott.[48] Many of the new recruits, on the other hand, who poured into the suffrage fight after the Civil War, knew nothing about a local 1848 meeting, or about the antebellum movement in general.[49] That antebellum past, now twenty to thirty years distant, was a relatively blank slate, and thus provided a prime political opportunity.

If antebellum activists had not been especially concerned with where and when the movement began, pinpointing a beginning served a very useful political purpose after the Civil War—namely, adjudicating authority within a bitterly divided national suffrage movement. Should suffragists disregard the work of the National Association and follow the path of the American Association? Should they jettison Stanton and Anthony's guidance? Was the pair the dangerous liability that Stone and others believed them to be? How were suffragists to know? Seneca Falls as an origin point offered clear—seemingly nonpartisan—answers.

If the movement began in 1848 at Seneca Falls, then surely Stanton and Anthony were on the right side of history in 1873. If they *originated* the movement, then it stood to reason that they *were* the movement. Amid all the chaos and confusion that now plagued the campaign, the correct path forward could be intuited by looking backward. Stanton and Anthony could not be the dangerous renegades that other suffragists charged them with being after the Civil War. On the contrary, having started it, they were, by definition, the movement's continuation, and their rivals were the deviants. Moreover, the event's exclusivity now served as a highly useful historical sieve. Being a small, hastily planned, local convention, many who were already active in the antebellum women's rights movement, like Stone herself, didn't attend the Seneca Falls gathering. Without having to resort to seemingly partisan exclusion, an 1848 story could focus on Stanton alone, and by proxy, owing to their close friendship and near inseparability, Anthony, even though she had not been there. But for this argument to work, Stanton and Anthony had to first

mark 1848 as the beginning of the movement and persuade other suffragists to adopt this claim (fig. 15).

FIG. 15

Susan B. Anthony (1820–1906)
Napoleon Sarony (1821–1896)
ca. 1870
Albumen silver print
16.5 × 11 cm (6 ½ × 4 ⁵⁄₁₆ in.)
The New York Public Library;
the Miriam and Ira D. Wallach
Division of Art, Prints and
Photographs: Photography
Collection

As commemorative events go, the twenty-fifth anniversary convention was meager in its ceremonial display, perhaps underscoring just how tentative this new point of origin was. Aside from a "wreath of laurels, interwoven with a silver thread," no other trappings or relics graced the stage, save for three of the original organizers: Mott, her sister Martha Coffin Wright, and Stanton. Because she had not been there in 1848, Anthony presided over the convention. Taking on the role of onstage historian, she narrated events she had not witnessed and imbued them with retrospective significance.[50]

Anthony opened by announcing their intent to celebrate "the twenty-fifth anniversary of the movement"—an entirely new claim. She then read from the printed report of the 1848 convention since most of those in attendance would not have been familiar with what had happened or what had been discussed. The retelling of the basic 1848 convention details underscores just how novel and inventive this nascent memory was. In what amounted to its first public telling, the account was not yet the codified, widely known tale that it would eventually become.[51]

Getting one's hands on a printed report of the 1848 convention would have been nearly impossible only a few years earlier. Copies of the 1848 pamphlet that Douglass printed from his newspaper offices that same year were now relics and had become, in the words of one suffragist just after the war, exceedingly "rare."[52] (Today, fewer than twenty-five copies survive.[53]) Those "rare" proceedings began to circulate more widely, however, after Stanton had them reprinted in 1870. This helped establish a documentary basis for this emergent origins account, making news of the meeting widely available for all who cared to learn.[54]

It was surely one of these reprints that Isabella Beecher Hooker—the half sister of the adulterous Henry Ward Beecher and National Association partisan—had in her hands when she enthusiastically read a letter to those assembled: "First, let me beg you . . . one and all, to read the report of the first convention at Seneca Falls twenty-five years ago . . . that you may join me in heartfelt admiration." Hooker rejoiced that she had just finished reading the report "for the third time," adding that "had I the means, the printed reports to this convention should be placed in the hands of every woman in the United States." She exhorted women to learn their history, now available in convenient and plentiful form, and positioned this new origin as true and uncontested. Hooker's enthusiasm helped begin the long process of turning this report—and more specifically, the Declaration of Sentiments—into a sacred text.[55]

By imploring activists to turn their attention to 1848, the celebration argued that much could be learned from the event. The proper lines of succession formed the first lesson. A convention resolution made this abundantly clear: "Resolved, that Lucretia Mott and Elizabeth Cady Stanton will evermore be held in grateful remembrance as the pioneers in this grandest reform of the age," it presaged; "that as the wrongs they attacked were broader and deeper than any other, so as time passes they will be revered as foremost among the benefactors of the race,

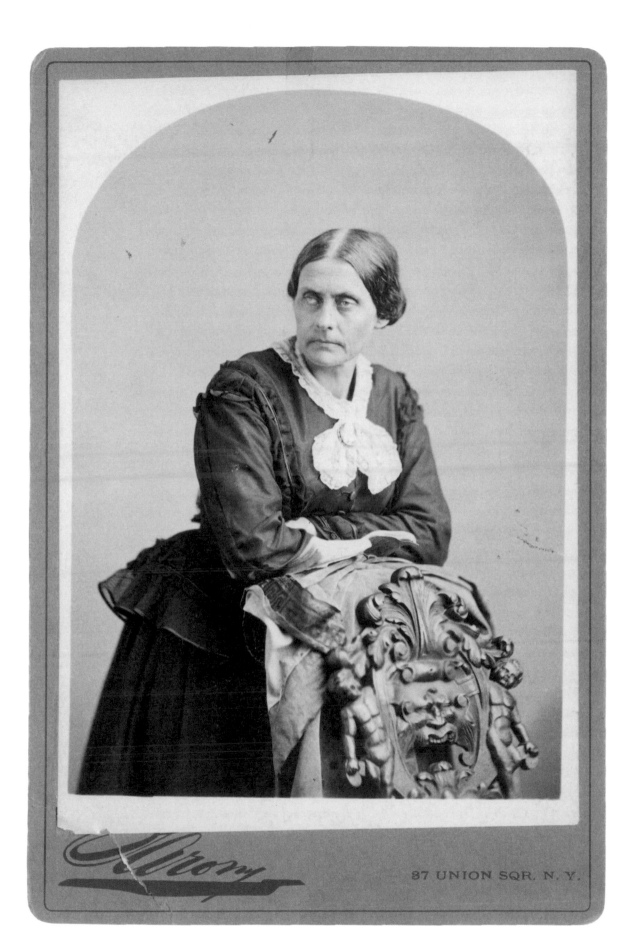

Bron

37 UNION SQR. N. Y.

legions of other beginnings that could have been picked. In fact, it could easily be argued that seeking a single origin point for an antebellum (and postbellum) women's rights movement is nonsensical, given the many antecedents and contributing factors.[63] Yet Stanton, never short on ambition or self-confidence, always conflated *her* story with the *movement*'s story. For her, and for Anthony, 1848 was simple truth.

Lucy Stone hated all this remembering. She thought it detracted from the work. But Stanton and Anthony were only getting started. They would continue to recall the Seneca Falls convention—however imperfectly—in new and inventive ways. They held another, more-robust anniversary convention in 1878. They wrote encyclopedia entries, pegging Seneca Falls as the suffrage movement's beginning. They also began writing a history of the movement itself, centered on Seneca Falls and their National Association. As each new memory project unfolded, Stone vehemently distrusted that Stanton and Anthony would tell the story properly. When they wrote her for material, she refused cooperation, signing her letter, "Yours with ceaseless regret that any 'wing' of suffragists should attempt to write the history of the other."[64] Stone remained continually blind to how remembering could serve as an effective form of activism for the movement—something she ignored to her peril. But over the 1880s, as the Seneca Falls narrative took an increasingly strong hold on the movement, she began to realize how dangerous this memory was to her own standing in, and vision for, the campaign.

A Movement Memory Made

The 1880s witnessed two of Stanton and Anthony's seminal historical works, both of which firmly cemented their increasingly familiar postwar version of the antebellum past. The first was the publication of their enormous, multivolume *History of Woman Suffrage*, a three-thousand-page history of the movement; and the second historical act involved the elaborate staging of the now codified 1848 memory, during the historic 1888 International Council of Women (ICW), the largest international women's rights convention the nation had yet seen. After 1888, this story had no serious rivals. While Stone and the American Association held several small, local anniversary celebrations for the 1850 Worcester National Women's Rights Convention, during which they pointedly labeled the 1850 event as the beginning of the movement—one that Stone had attended, and which Stanton and Anthony had not—their commemorations never gained much traction.

In response to the *History of Woman Suffrage*, which completely marginalized Stone and the American Association, Stone wrote a few, very short, rival historical accounts, but she never published them.[65] By the time the 1888 ICW rolled around, now positioned by Stanton and Anthony as the fortieth anniversary not just of the US suffrage movement, but of a *global* women's rights movement (a claim buttressed by three massive, seemingly authoritative volumes of movement history), Stone felt hemmed in. She wrote privately of her fervent desire "to puncture the bubble that the Seneca Falls meeting . . . was the *first* public demand for suffrage," but



there was little she could do.[66] Since its first public iteration in 1873, this now domi-nant tale of a miraculous 1848 origin had helped resurrect Stanton and Anthony's standing in the movement, and helped eclipse Stone's.

Stanton and Anthony's monumental writings also served another important function—to sustain the campaign. When they began their work on the *History*, in 1876, the nation's political establishment had abandoned its commitment to remaking political rights, and it became increasingly clear that women's suffrage was unlikely to be won anytime soon. Suffragists' immediate postwar optimism was fading into tired resignation. Now in their late fifties and early sixties, Anthony and Stanton realized that women's suffrage might not be won in their lifetime. "We . . . have been moved," they wrote in their preface to volume one, "by the consideration that many of our co-workers have already fallen asleep, and that in a few years all who could tell the story will have passed away."[67]

Although they originally planned on publishing a single volume, to be dashed off in a summer, the project quickly swelled and consumed the next decade of their lives—a mark of their dogged commitment to, and admirable foresight about, the importance of women's history, well before such a field existed. The minutia and headaches in reconstructing past details from a haphazardly kept archive, culled from across the nation, drove the pair, and their coauthor, Matilda Joslyn Gage, to the brink of madness.[68] But the more they uncovered in their research, the more deter-mined they became that things not be lost or forgotten. In the end, the *History* was colossal in scope, spanning an entire century, from the 1770s to the mid-1880s. Volume one covered the antebellum movement. Volume two addressed the national movement after the Civil War. And the final volume, appearing in 1886, covered the movement in each and every state. It was a stunning achievement—an excruciating labor of love and, in the end, a beautiful valentine to the movement.[69]

Standing for many decades as the first and *only* attempt at a comprehen-sive history of the campaign, the *History* quickly became an invaluable movement resource—one of its main functions. Its authors hoped that by knowing movement his-tory, activists and ordinary Americans would be inspired to continue and support the fight.[70] Readers could better understand the injustices (white) women endured by seeing an endless chronicle of those abuses laid out on center stage. (This was not a history that considered the stark realities of women of color.) Readers could see how hard and how long (mostly white) women had fought, and they would, hopefully, become steadfast and resolved in their commitment to securing women's voting rights. If activists tired or lost faith, they could turn to the *History* for rejuvenation. There, they could find pride, inspiration—and, yes, joy. The massive edifice of the *History* also signaled that the campaign would not be easily torn down. It would, if it needed to, outlive all those who had launched it. This too became the promise of Seneca Falls, its story morphing into the organizing principle for the entire move-ment through the *History*'s three volumes.

Yet the *History* was simultaneously a gift and a lesson, a legacy and a directive. For all its many strengths, it was also a deeply partisan document, and it continued the work of Stanton and Anthony's earlier memory projects, including

adjudicating authority within the movement. Over the 1880s, Stanton and Anthony's National Association, which had resumed its fight for a constitutional amendment, continued to wage battle with Stone's American Association, which still pursued a state strategy. Recounting the history of the bitter 1869 split in the *History*'s pages, Stanton and Anthony positioned the American Association in the most inflammatory way imaginable: as secessionists. "During the autumn of this year," they exhorted, "there was a secession from our ranks, and . . . preliminary steps were taken for another organization."[71] To use this word in the aftermath of the Civil War, in which secession had produced unimaginable carnage, was astonishing, and deliberately damning. This argument only worked, however, if the movement began at Seneca Falls, in 1848—a claim the *History* reiterated, and a date that was by now firmly and almost exclusively grafted onto Stanton and Anthony. In this way, anyone who deviated from them was, by definition, on the wrong side of the movement, and thus on the wrong side of history.[72]

What is invisible in the pages of the *History* is just how effectively this 1848 story helped Stanton and Anthony assume leadership within the postwar movement, a movement that had, in the past, strongly questioned their fitness. A Seneca Falls origin narrative obscured all this by making it seem that the pair was in charge from the very beginning, something the *History* replicated and expanded upon. After telling their version of a Seneca Falls origin tale in the opening volume, Stanton nearly put Anthony there—a sign of how much Anthony had already been drawn into the story's logic by the early 1880s. Stanton claimed the two met in 1848. (This drew the ire of other suffragists and had to be corrected in subsequent editions.) After putting Anthony at her kitchen hearth as early as 1848, Stanton then claims that her home became "the center of the rebellion." A history of their antebellum work in New York, she confidently declared, "would in a measure be the history of the movement."[73] Stanton pulled no punches. Her argument was clear and straightforward: she and Anthony had inaugurated and led the campaign since its inception. They were the campaign.

The adoption of this story line, which continues today, has left us with almost no idea of how Stanton and Anthony cultivated leadership within the movement, which was not foreordained, even if a Seneca Falls mythology insists that it was. Yet to recount history strictly according to the logic of the Seneca Falls origin tale is, in fact, to read the end of the story back onto the beginning. It is to miss just how contested and contingent the outcome was, as well as how important history-telling was to the process.

Not surprisingly, the Lucy Stone–led American Association got short shrift in the *History*, dispatched with in a single, near-appendix-like chapter, stuck in the rear of a volume, and called nothing more than an ineffectual, state-level organization.[74] It was a considerable demotion and certainly did not reflect the able and effective work of that society. The *History* instead detailed the work of the National Association, which focused heavily on Stanton and Anthony's own labors. Stone tried to take down the *History* in an unfavorable newspaper review, in which she warned "no one reading this book would get an accurate or adequate idea of the *real* history

of the woman suffrage movement."[75] Her review, and the protests of other American-aligned suffragists, had little effect on the official standing the *History* quickly acquired. Through this seemingly authoritative document, Stanton and Anthony's bold interpretative lines now appeared to be nothing more than obvious truth. If Stanton and Anthony's earlier memory projects had helped popularize the story and recruit more and more believers, the *History*—as a seemingly official record—helped cement it.

Two years later, in 1890, Stone lost control of national suffrage organizing when Stanton and Anthony took (and, for Anthony, maintained) control of the newly merged National American Woman Suffrage Association, or NAWSA. The old National and American Associations were no more. From here on out, as they had been in the *History*'s pages and on stage at the 1888 anniversary, Lucy Stone and her colleagues would be reorganized as supporting cast members, rather than central players—until they were forgotten altogether. Much later, after the passage of the Nineteenth Amendment, Stone's daughter, Alice Stone Blackwell, would lament that the *History*'s volumes stood unchallenged, calling it "our misfortune" and adding that "it cannot be helped now, for few persons will ever take the trouble to dig out our side from the files [of history]."[76] Indeed, almost no one has. Today, there exists no published history of the American Association, despite its energetic work over twenty years, and we still know far too little about Stone herself, who spent a lifetime in the movement.[77]

Then, in a surprising turn of events, Stanton was cast out of movement memory, showing how flexible and adaptable stories—and history—can be. By the 1890s, the movement had become more conservative, as scores of Christian temperance women flooded into it (hoping to use the vote to end liquor traffic). When Stanton published her inflammatory *Woman's Bible* in 1895, an investigation into how men erroneously interpreted the *Bible* to oppress the opposite sex, Christian women blasted her as heretical. Anthony tried to calm them, but they issued a strident denunciation of Stanton, effectively excommunicating her from NAWSA (see cats. 68–69).[78] Once lauded as the mother of the movement, she was now branded an infidel. As a result, the memory of Seneca Falls began to rest even more heavily on Anthony.

When Stanton died in 1902, two weeks shy of her eighty-seventh birthday, her obituaries predictably put Anthony alongside her at the moment of the movement's ostensible, miraculous creation. As one newspaper explained: "After returning from England with Susan B. Anthony and others she began to agitate for woman suffrage," resulting in the "foundation at Seneca Falls early in 1848 of the National American Woman Suffrage Association."[79] Every detail here was wrong. But it was nevertheless the logical result of decades of Stanton and Anthony's memory work that had framed their lives and their activism, and the movement itself, around this singular event.

By the time Anthony died, four years later, in 1906, these errors and this logic persisted. Unlike Stanton, Anthony had remained sprightly and active into her final years. On returning home from a NAWSA convention and from her own

eighty-sixth birthday celebration, she felt unwell. A doctor diagnosed her with pneumonia, and while her lungs began to recover, her heart remained weak. She had suffered heart trouble during her final years, and heart failure likely took her life on the morning of March 13, 1906. That evening's widely circulated Associated Press story inevitably alleged that "with Elizabeth Cady Stanton and other[s] Miss Anthony called in 1848 the first woman's rights convention, which met at Seneca Falls." Newspapers from Nebraska to New England, when not giving her outright credit for having "called" the meeting, placed Anthony in attendance, as in a much-reprinted statement that she and another woman "were the only survivors of that famous women's rights convention held in Seneca Falls in 1848."[80]

If Stanton increasingly receded in movement memory after the publication of her *Woman's Bible*, the reverse was true of Anthony, partly

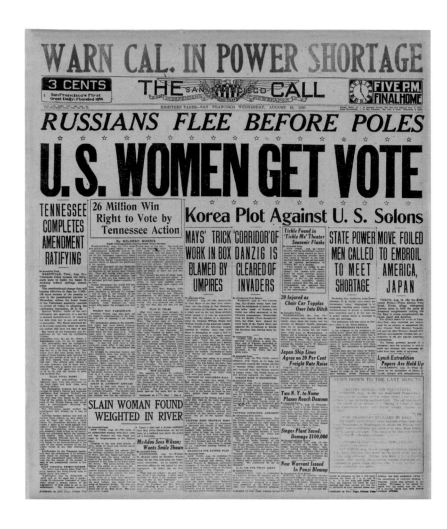

FIG. 16

U.S. Women Get the Vote
Front page of the *San Francisco Call and Post*, August 18, 1920
74.9 × 59.7 cm (29 ½ × 23 ½ in.)
California Digital Newspaper Collection

owing to a new fight within the movement. Just as Stanton and Anthony had done, a new generation of suffragists deployed history to do battle with one another. In the 1910s, suffragists forced another organizational split: with Carrie Chapman Catt's NAWSA on the one side and Alice Paul's National Woman's Party (NWP) on the other. Catt had been Anthony's handpicked successor, and NAWSA had been Anthony's organization. When Paul split with NAWSA, she also tried to legitimate her move by arguing that the will of Anthony and thus the weight of history were on her side. Resurrecting a version of the federal amendment written by Stanton, they strategically dubbed it the "Anthony Amendment." As these suffragists fought with one another, they wielded memory, one that increasingly narrowed to Anthony and the mistaken, if nevertheless carefully curated, impression that she *was* the movement. While she had absolutely been critical to the campaign, intramovement battles after her death meant that she began to assume a singular, heroic stature. She became a blunt weapon, rather than a multifaceted personality, to be wielded in the quest for legitimacy.[81]

It was no surprise, then, that when the Nineteenth Amendment finally cleared ratification in August 1920, Anthony and Seneca Falls framed victory (fig. 16). What is often missed, however, is just how important this story was to achieving

victory. How much the creation of that story, which was of a hard-fought effort, helped sustain as well as direct the movement, and how, at the same time, it helped buttress Stanton and Anthony's struggle for leadership, along with their simultaneous struggle to define and advance a multifaceted women's rights campaign. When we talk about the women's rights story of the nineteenth century as defined by the struggle for the vote, we do so partly because of the continued dominance of this story as our framing narrative.

<p style="text-align:center">• • •</p>

None of this is to say that the Seneca Falls tale is unimportant. Indeed, when we look at its history and functions as an invented story, it has been much, much *more* important than we have realized. To argue that the particular significance assigned to it in the aftermath of the war was retrospective and retroactive does not mean that it was not also important in 1848. To raise questions about where our understanding of that significance arises and to suggest we reexamine the narrative around the events of 1848 is not to demolish Seneca Falls as historically significant. In fact, it is to be responsible in that assessment.

This essay has been dedicated to the proposition that what we remember, and what we forget, matters. In the second half of the nineteenth century, this memory helped Stanton and Anthony to build and sustain their leadership; push for the vote as the most important women's rights demand amid a contested field; make a particular, pointed, public claim for the vote (one that denigrated men of color); and keep the movement afloat through tough times, offering inspiration and guidance. In short, Stanton and Anthony, more than any other suffragists, deployed memory as a weapon in their post–Civil War battle, both inside and outside the movement. But in the end, the story they created, the story of Seneca Falls, may tell us much more about the 1870s and the 1880s than about the 1840s.

As we approach 2020 and prepare to remember this remarkably important, if troubled, campaign, looking back reminds us of the power of memory. And it urges us to be thoughtful in the present in how we remember that past. For in our memories inhere present-day lessons as well, just as they existed in Stanton and Anthony's memories. If we remember 1920 as a victory, *the* victory, the conclusion of the 1848 story, we erase, for example, the long history of struggle for voting rights on the part of women of color. These women were not enfranchised by the Nineteenth Amendment, owing to state laws that barred them on the basis of criteria other than that of "sex." And if we frame our story of the 2020 anniversary with the story of Seneca Falls, as is likely to happen, what lessons are we imparting today? Our tendency to view the past as transparent truth has the potential to blind us to all the work that remains to be done. So, as we continue to struggle for justice and equality in the present, and as we move forward into the future, we must be mindful of what and how we remember.

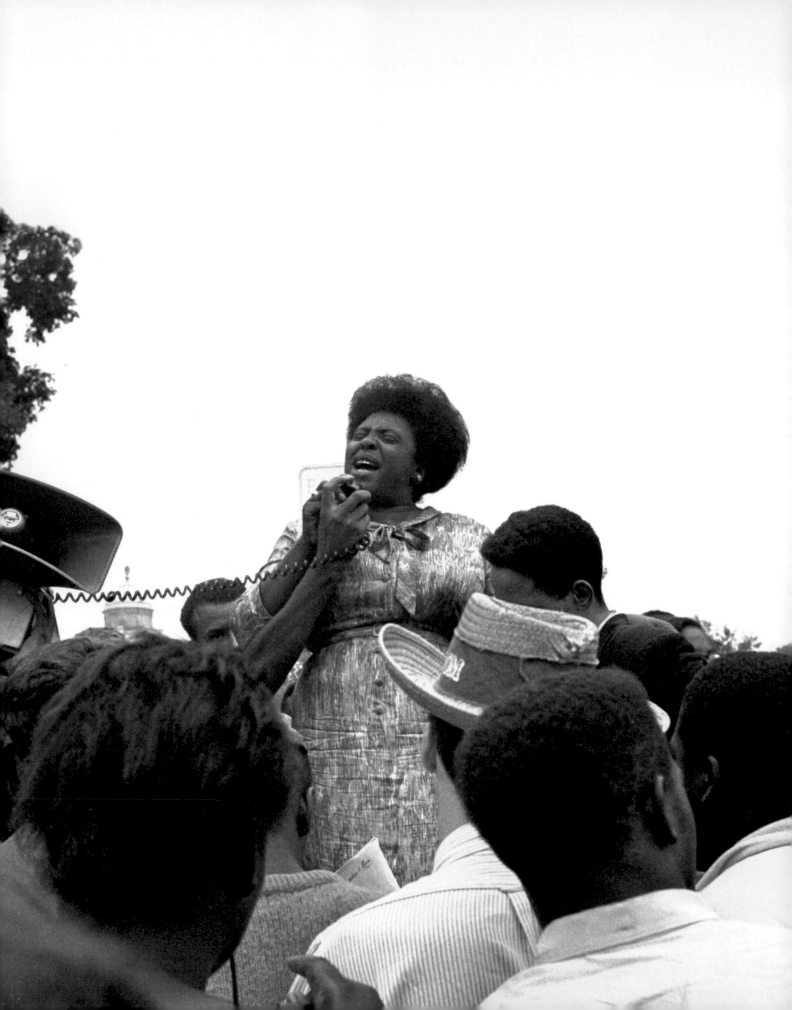

THE POLITICS OF BLACK WOMANHOOD, 1848–2008

Martha S. Jones

Voting Rights as Civil Rights

FIG. I

Fannie Lou Hamer (1917–1977)
William J. Smith
(ca. 1907–1986)
1965
Gelatin silver print
Associated Press

When the activist Fannie Lou Hamer spoke of voting rights, history was never far from her mind (fig. 1). Early in her career as a field secretary for the Student Nonviolent Coordinating Committee (SNCC), she testified about registering as a black woman in rural Mississippi. Hamer's experience, she explained to Democratic Party officials in 1964, was of having been rebuffed, harassed, beaten, and sexually assaulted at the hands of local officials. Such memories were also linked to a more distant past, and Hamer saw her activism of the 1960s and 1970s as one chapter in the long African American freedom struggle.[1]

Hamer, the youngest of twenty children, was born in Montgomery County, Mississippi, in 1917 and spent the first part of her life working as a share-cropper. She turned to securing voting rights in 1962, when she and a group of rural Mississippians were prohibited from registering to vote. This racial discrimination was an offense, as Hamer put it, "based upon the violation of the Thirteenth, Fourteenth, and Fifteenth Amendments to the United States Constitution, which hadn't done anything for us yet," she told a Harlem, New York, audience in December 1964.[2] The US Constitution was important to her. She believed that its principles guaranteed voting rights for black Americans, and her work as a political organizer aimed to compel the nation to make good on that promise (fig. 2).

Hamer spoke on behalf of the millions of black Americans who were denied the exercise of voting rights, even one hundred years after Reconstruction's constitutional revolution. She noted persistent problems, particularly in the Deep South, and described how, in the 1960s, Mississippi's election authorities were still using literacy and understanding tests to disqualify those black men and women who

sought to register. And, while law mattered in Hamer's opinion, she did not draw on the authority of the Nineteenth Amendment, which had guaranteed women the right to vote in 1920. This omission suggests how differently black and white American women could situate themselves in relation to the body politic.

FIG. 2

Black History—Women's History
Women for Racial & Economic
Equality
ca. 1977–1980
Button
3.8 cm (2 in.) diam.
Schomburg Center for Research
in Black Culture, Art, and
Artifacts Division,
New York Public Library

The history of American women's suffrage must always be explained in intersectional terms; gender and race have acted together in shaping women's political lives. The varied ways in which women have viewed the Constitution is a case in point. Many white women of Hamer's generation celebrated the ratification of the Nineteenth Amendment as a turning point for women's suffrage. Black women, however, also had to look to other milestones—the Fifteenth Amendment of 1870, for example—to chart how they came to influence elections. In Hamer's analysis, while the Nineteenth Amendment ensured that sexism would no longer restrict political rights in the United States, racism continued to keep many black women from the polls until the Voting Rights Act of 1965.

The story of African American women and the vote overturns basic assumptions about the history of American political culture and women's suffrage. Through the lens of black women's history, binary notions about interests—such as men versus women or black people versus white people—quickly break down. Black women have lived at a unique crossroads of identity, leading them to develop a self-definition that reflects, rather than overlooks, their vantage point on the nation.

Following the trail of black women's activism leads to new insights about where and in what sorts of organizations the work of women's rights and campaigns for suffrage can take place. African American women have sometimes been active within organizations led by black men, such as churches, and those led by white women, such as suffrage associations. They have also always steered autonomous institutions, forging their own paths to political rights and efficacy. The black women's club movement is one example of autonomous institutions. Finally, black women's histories require us to rethink the very nature of women's interests. Campaigns for black women's rights were linked to their concerns about slavery and abolition, citizenship and the vote, and challenges to Jim Crow and lynching. The interests of family, community, and the race as a whole always defined their political lives. They would never limit themselves to a stand-alone set of women's concerns.[3]

The Right to Preach

From as early as the 1840s, black women's rights mixed with civil rights and antislavery politics. As women surveyed the political terrain, two movements drew

their attention. The first was that of the era's anti-slavery societies, where the immediate end to human bondage and the securing of rights for former slaves drove the agenda. The second was the so-called colored convention movement, where black delegates gathered at both the state and national levels to deliberate on the issues of the day, from slavery and civil rights to education, labor, and the press. Neither space was an easy fit. Still, black women worked toward building cross-racial alliances in women's anti-slavery societies. They supported the work of men's conventions, raising funds and serving meals while also occasionally taking part as speakers and delegates. By the time the first women's conventions met, black women were already on their way to entering public culture — speaking, writing, organizing, and testing the bounds of where womanhood might take them.[4]

A turning point for women's suffrage occurred in 1848. Two movements were born that year, one led by black women, the other by their white counterparts. One story is well known. That summer, women's conventions in the upstate New York cities of Seneca Falls and Rochester convened fledgling women activists and a small number of male allies. Out of those meetings, an ambitious manifesto, termed the "Declaration of Sentiments," leveled a critical gaze at institutions, challenging the unequal customs and regulations to which women were subjected — in politics, in churches, and in their families. No black women took part in these early women's conventions, but many of them would have been aware of the issues therein debated, as they were reported in the African American and anti-slavery press.[5]

Earlier that same year, in spring 1848, black women began a debate about their rights. Female lay leaders and women preachers, who had banded together as the Daughters of Zion, headed to Philadelphia to attend the African Methodist Episcopal (AME) Church's quadrennial general conference. Armed with an agenda and accompanied by allies, they confronted an imposing gathering of 175 ministers and 375 male lay leaders from fourteen states and competed for a place on an "official agenda" that included the election of a bishop, the structure of the church missionary society, the establishment of a book depository, a plan for common schools, and sanctions for divorce and remarriage. The women planned to disrupt the proceedings just long enough to insert a proposal that demanded that the preachers among them be granted licenses.[6]

These were women experienced at challenging gendered customs. Four years earlier, at an 1844 general conference, preaching women had recruited a male delegate, the Reverend Nathan Ward, to act as their spokesperson. Confronting the sixty-eight ministerial delegates in attendance, Ward spoke on behalf of forty "others," all signatories to a petition that called for the amendment of church law to permit the licensing of female preachers. Among the women was Julia A. J. Foote, an upstate New York native who had, despite ridicule and the threat of excommunication, earned a reputation as an effective preacher (fig. 3). Foote had been refused a preaching license a few years earlier and described what she saw unfold following the presentation of Ward's petition: "This caused quite a sensation, bringing many members to their feet at once. They all talked and screamed to the bishop, who could scarcely keep order. The Conference was so incensed at the brother who offered the

petition that they threatened to take action against him." The women's petition met with defeat, but it also launched a campaign that sought rights for all churchwomen.[7]

In 1848, talk of women's rights was not a complete surprise. Again, a male ally, Dr. J. J. Gould Bias of Philadelphia, placed a petition for women's preaching licenses before the church's leadership. Its text has not survived. Still, the dissenting report captures the spirit of the exchange. The women's opponents crafted a shrewd argument. Daniel Payne, a Baltimore-based minister who was moving toward election as bishop, argued that female preaching ran afoul of women's obligations to respectability and domesticity. The licensing of female preachers was "calculated to break up the sacred relations which women bear to their husbands and children," he warned. It would lead to the "utter neglect of their household duties and obligations."[8] This view adapted well-understood arguments made by anti-slavery and temperance advocates of the period. Like slavery, women's rights threatened the sanctity of African American family life. And, just as the consumption of alcohol led men to neglect their families, so too would women become irresponsible if they bore the burdens that being licensed to preach imposed. In 1848, successfully defeating a petition for churchwomen's rights demanded heavy ideological artillery.

Voices at Seneca Falls and Rochester echoed those in Philadelphia: churches were sites of power and contestation over women's rights. At Seneca Falls, the Declaration of Sentiments criticized thinking that deprived women of preaching licenses: "He allows her in Church, as well as State, but in a subordinate position, claiming Apostolic authority for her exclusion from the ministry, and, with some exceptions, from any public participation in the affairs of the Church." That meeting's final resolutions included two demands that endorsed women's right to preach: "Resolved, . . . it is pre-eminently his duty to encourage her to speak and teach, as she has an opportunity, in all religious assemblies," and, "Resolved, That the speedy success of our cause depends upon the zealous and untiring efforts of both men and women, for the overthrow of the monopoly of the pulpit."[9] Women in the AME Church understood the stakes.

Churchwomen's rights arose again weeks later at the women's meeting in Rochester, and a debate ensued. Men there split over the issue, with some advocating the emancipation of women from "all the artificial disabilities, imposed by false customs, creeds, and codes," while others argued that "woman's sphere was home . . . seriously deprecat[ing] her occupying the pulpit." The women persisted, led by Lucretia Coffin Mott, a Philadelphia-based Quaker and anti-slavery activist who explained that she was not surprised to find some men opposed to churchwomen's

FIG. 3

Julia A. J. Foote (1823–1901) Frontispiece of *A Brand Plucked from the Fire* Unidentified photographer Before 1879 Photomechanical reproduction Courtesy of the Department of Special Collections, Memorial Library, University of Wisconsin–Madison

rights. Education had indoctrinated them in this view. Still, she rejected clerical authority and turned to the Bible, explaining that "none of [its] prohibitions in regard to women" included anything that prohibited a woman "from being a religious teacher." The result in Rochester was a final resolution that opposed "restricting her to an inferior position in social, religious, and political life" and insisted instead "that it is the duty of woman, whatever her complexion, to assume, as soon as possible, her true position of equality in the social circle, the church, and the state."[10]

If churchwomen's rights were one among many for women at Seneca Falls and Rochester, then they were paramount for African American Methodist women. This reflected the unique place that churches occupied in African American public culture. Yes, such institutions were associated with spiritual beliefs and sustenance. They were also, however, hubs for mutual aid endeavors, such as burial societies and widow's relief funds. Many churches also sponsored schools in an era during which white-controlled municipalities refused to support black education. And churches were centers of political life. Their sanctuaries doubled as meeting halls; their ministers led conventions; and churchwomen's fund-raising supported newspapers and conventions along with the ongoing needs of religious communities. When black women talked about rights in the church, they were going to the core of their community's associational life and to the heart of its power.

Black and white women's calls for churchwomen's rights remained largely separate throughout the 1840s and 1850s. Those black women who did cross the color line into the conventions led by white women were met with a mix of fascination and skepticism. When Sojourner Truth debuted as a speaker at the 1850 National Women's Rights Convention in Worcester, Massachusetts, she joined a fledgling movement, and she stood out among the other participants (fig. 4). News reports unfailingly framed her remarks as those of "a colored woman, once a slave," as the *New-York Tribune* put it. Truth did attempt to bridge the distance. Women's fates were linked, she explained, but not because they were the same. Instead, when black women had been liberated from slavery in New England, only then did white women begin to endure the "burdens of hard work." Thus, the liberation of some black women led to "complaints" about the "enslavement" of white women, which in turn gave birth to a call for women's rights.[11]

Truth is best remembered for what is often mislabeled her 1851 "Ain't I a Woman" speech, delivered at an Akron, Ohio, women's rights convention. She likely never uttered that precise refrain.[12] Still, her remarks do make plain the degree to which black women, even as they stood at the podium under a women's rights banner, also contended with racism. Truth insisted to her listeners that she was indeed a woman. Her challenge was to claim her rights as such, without disguising her capacities and her strength: "I have plowed and reaped and husked and chopped and mowed." She might have labored like a man, Truth explained, but still she was a woman with standing to make the case for her rights (fig. 5).[13]

This dilemma—how black women could speak by way of both similarity and difference—was never fully resolved for Truth. In her 1850 narrative, she reprinted a letter that showed how far audiences would go to challenge a black woman

Brady New York.

FIG. 4

Sojourner Truth (1797–1883)
Mathew Brady Studio
(active 1844–1894)
ca. 1864
Albumen silver print
8.9 × 5.6 cm (3 ½ × 2 ³⁄₁₆ in.)
National Portrait Gallery,
Smithsonian Institution

FIG. 5

Broadside: Sojourner Truth Lecture
ca. 1878–1879
Printed paper
29.8 × 22.9 cm (11 ¾ × 9 in.)
Berenice Bryant Lowe Papers,
Bentley Historical Library,
University of Michigan

FREE LECTURE!

SOJOURNER TRUTH,

Who has been a slave in the State of New York, and who has been a Lecturer for the last twenty-three years, whose characteristics have been so vividly portrayed by Mrs. Harriet Beecher Stowe, as the African Sybil, will deliver a lecture upon the present issues of the day,

At On

And will give her experience as a Slave mother and religious woman. She comes highly recommended as a public speaker, having the approval of many thousands who have heard her earnest appeals, among whom are Wendell Phillips, Wm. Lloyd Garrison, and other distinguished men of the nation.

☞ At the close of her discourse she will offer for sale her photograph and a few of her choice songs.

who publicly called for her rights. At a northern Indiana anti-slavery meeting, an opponent literally disputed Truth's sex, asserting that some in attendance believed her to be a man and an imposter. Truth replied that she had "suckled many a white babe," and then she "disrobed her bosom," eschewing any pretense to the cloak of respectability that many women maintained when they took to the podium. Some women may have feared compromising their status as ladies, but Truth clearly did not. Yes, she was a woman, but she was also a black one whose womanhood was intertwined with the families of her white audience, not as an equal, but as a subject of exploitation.[14]

If there was one place where black and white women did manage to forge alliances, it was not in churches or in women's conventions. It was instead in anti-slavery societies. The Philadelphia Female Anti-Slavery Society, established in 1833, included black women—members of the influential Forten clan—among its founders. Working together, the black and white members of the society petitioned the state legislature and Congress, and raised funds to support fugitive slaves and local schools.[15] Around this same time, Sarah Parker Remond, a free black woman, ventured away from her home in Salem, Massachusetts, to join the anti-slavery speaking circuit (see cat. 6). Remond had been propelled by the examples of her own brother and the white anti-slavery activist Abby Kelley Foster.[16]

A New Constitution

The upheaval of the Civil War—for black Americans, a war to end slavery—also called into question existing gendered strictures. Through the work of war, free black women stepped into public culture with two feet as teachers, nurses, scouts, and relief workers. Charlotte Forten left the relative comfort of her New England classroom to teach among the free people of the South Carolina Sea Islands. She learned to operate a schoolhouse and a gun. In Washington, DC, Elizabeth Keckley, known best as Mary Todd Lincoln's dressmaker, coordinated with women's organizations throughout the North to offer refugee relief to former slaves. Susie King Taylor graduated from cook to nurse, all the while lending sustenance and care to the Union Army's black soldiers, including men of her own family. The conditions of war meant that women's roles and their visibility were changing.[17]

With so much of the male population fixed on the battlefield, new opportunities opened for women to work collaboratively and with less oversight from men. Enslaved women claimed their freedom through law, policy, and their own initiative. As their liberty became a certainty, new questions arose about who former slaves—men and women—would be to the body politic. The earliest political conventions of the postwar years saw an old coalition resume its work. Abolitionists and women's rights activists met up to chart the meaning of freedom and citizenship, and black women joined the debate.

Within the newly formed American Equal Rights Association (AERA)—men and women, black and white—were soon exchanging ideas about the terms of voting rights in the post–Civil War era. Slavery was abolished in 1865 by the Thirteenth Amendment, leaving unresolved questions about the degree to which former slaves would be incorporated into the body politic. This debate unfolded in Congress, where lawmakers vied with President Andrew Johnson for supremacy over the nation's political reconstruction. At the same time, prewar radicals—once allied variously with the abolitionist and/or the white-led women's movement—came together under the auspices of AERA to refine their ideas about the United States as an interracial democracy.[18]

This promiscuous coalition was very quickly tested by the language of the Fourteenth Amendment, which introduced a distinction between the sexes into the Constitution. Its section two penalized those states that "denied [the vote] to any of the male inhabitants of such State." Within the AERA coalition, those who advocated for universal suffrage—regardless of race or sex—saw in this clause the formal insertion of a gender distinction—the first instance in the Constitution.[19]

A debate ensued over who should vote and under what terms. In principle, few among the veteran activists abandoned the ultimate goal of universal suffrage. Still, factions emerged over how such a goal should be realized when Congress proposed a Fifteenth Amendment that prohibited laws that limited the franchise "on account of race, color, or previous condition of servitude." It was a bold step forward for voting rights but left states at liberty to prohibit women from voting. AERA members wrestled with whether the organization should support what amounted to

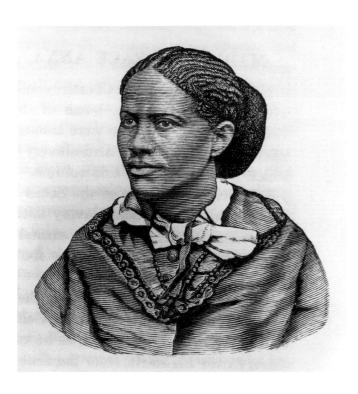

FIG. 6

Frances Ellen Watkins Harper
(1825–1911)
Portrait plate for
The Underground Railroad
John Sartain (1808–1897)
1872
Engraving
10.8 × 7.6 cm (4¼ × 3 in.)
Library of Congress, Prints
and Photographs Division,
Washington, DC

constitutional protection for black men when there was no parallel provision for women in sight. One view was best captured by abolitionist Wendell Phillips's declaration that "this hour belongs to the Negro." Phillips judged that there were practical limits to Reconstruction-era politics and accepted that the new political order would be gendered, with only men exercising formal authority. Elizabeth Cady Stanton, a women's rights advocate, captured the essence of the competing view when she decried the possibility that white women would be made into the political subordinates of black men who were "unwashed" and "fresh from the slave plantations of the South." Educated women, overwhelmingly white in the war's immediate aftermath, should take precedence, she urged.[20]

While black women's interests remained at the rhetorical margins of the debate, they were present during the AERA meetings, in contrast to their absence during the women's meetings of the 1840s. Still, few delegates considered explicitly where black women might stand in a campaign for voting rights that was envisioned as a contest between black men and white women. Nonetheless, at least one black woman—Frances Ellen Watkins Harper—weighed in, asserting that any reenvisioning of the body politic should take place at the intersection of race and gender (fig. 6). In this view, the AERA coalition was urged to consider how the circumstances of black women might guide the future of political culture, including voting rights.[21]

The atmosphere was tense from the start of the AERA meeting of 1869. Delegates charged Elizabeth Cady Stanton and Susan B. Anthony, along with others associated with the publication of the women's magazine the *Revolution*, with having advocated for "educated suffrage," a position that implied that former slaves were not fit to exercise the vote. Delegates took sides. Frederick Douglass tried to chart out common ground by acknowledging women's stake in the vote, but he ultimately deemed their claim to political rights less urgent than that of black men for whom voting was "a question of life and death." An unidentified delegate challenged Douglass, asking if his thinking applied to the case of black women. "Yes, yes, yes," he responded, what was true for black men was "true of the black woman, but not because she is a woman, but because she is black."[22]

After many rounds of debate, Harper took the floor. She was the lone black woman to speak on the record.[23] A teacher, poet, and anti-slavery activist, Harper first weighed in on the question Douglass posed, supporting his view: "If the nation could handle one question, she would not have the black women put a single straw in the way, if only the men of the race could obtain what they wanted." Harper leveled a direct critique at white women's aspirations for the vote: "I do not believe that giving the woman the ballot is immediately going to cure all the ills of life. I do

not believe that white women are dew-drops just exhaled from the skies. I think that like men they may be divided into three classes, the good, the bad, and the indifferent."[24]

Harper underscored how black and white women stood in differing shoes: "You white women speak here of rights. I speak of wrongs."[25] She went on to chronicle how racism kept white women from allying with their black counterparts. Men, including African American men, fared no better in her analysis. She had felt "every man's hand" against her as a black woman. No one, for example, had stepped up to aid the widowed Harper when she settled her family in Boston. These were the circumstances that the vote was intended to remedy. Finally, Harper declared that she stood for a vision that might keep the AERA coalition together: "We are all bound up in one great bundle of humanity, and society cannot trample on the weakest and feeblest of its members without receiving the curse of its own soul."[26] She urged the delegates to reject pitting a "privileged class" against "unprivileged classes." Instead, she demanded that black women be included as part of "one great privileged nation." This was the purpose of the ballot, in her view.[27]

Universal though they were, Harper's ideas were not enough to keep the coalition intact. The bitterness generated during the AERA debates finally brought about the end of radical prewar alliances. Women and men, black and white, would continue to work toward women's suffrage, now through two competing organizations: the American Woman Suffrage Association, led by Lucy Stone, Henry Blackwell, and Julia Ward Howe, and the National Woman Suffrage Association, led by Susan B. Anthony and Elizabeth Cady Stanton. Black women would not join either camp in important numbers and instead focused most of their public work on reconstructing black communities in the wake of war and emancipation. This, however, does not mean that black women were turning away from concerns about women's rights. Quite the contrary, within African American communities, particularly churches, women continued the debates that had so forcefully animated the American Equal Rights Association.

The Power of Churchwomen

The promises of Reconstruction's revolution were vividly manifest in the period immediately following the Civil War. Black men and women, along with philanthropic partners, formed institutions and churches, schools, and mutual aid societies that began to dot the landscape of the South's public culture. Law reform unfolded at the state and local levels, stretching the reach of equality into the lives of former slaves. Black men voted and became officeholders by the hundreds. There was no secret about the major role black women played in these scenes. Their capacities for fundraising and organizing were acknowledged as essential. And in politics, male suffrage did not leave women out. Instead, the early years of Reconstruction were characterized by women's robust presence—as participants in rallies, public meetings, and conventions, as safe keepers of the polls, and as partners with men who exercised

the franchise in a communal or familial approach that reflected the consensus rather than the will of any individual male voter.[28]

Black women also talked about their rights. The first signs that debates over the Fifteenth Amendment were carrying over into religious circles appeared in the 1870s. In churches, black women continued to call for their right to vote. In black Methodist churches, women petitioned to revise governing texts so that the language would read as, in the words of some church activists, "gender neutral." The AME general conference in 1872 agreed that its laws would be amended such that "the word 'male' wherever it occurred as a qualification of electors be struck from the Discipline." Four years later, gender qualifications were struck from all provisions related to Sunday School personnel. In AME Zion, similar revisions were taken up in 1876 when the general conference voted to "strike out the word 'male' in the Discipline." Apparently, this directive was not fully complied with, and in 1880, a group of Boston churchwomen petitioned "to strike out words 'man' and 'men'" in the Discipline, specifying those sections of the church law that had not already been properly amended.[29]

Churchwomen gained the right to vote in church elections through these little-remarked-on but still major changes in denominational governance. There was no debate. Indeed, there was no opposition to women's enfranchisement. Boston-based petitioners in the AME Zion Church explained the amendments as "giving women the same rights in the church as men." Such rights extended to office-holding, and between 1872 and 1876, black Methodist leaders created the office of the Stewardess, authorizing local congregations to designate between three and nine women to sit as a governing board that paralleled the men's office of the Deacon.[30]

Churches had become the center of a black women's movement for rights by 1880. Calls for changes in how churches distinguished between male and female authority were expressly framed in the language of political rights. The *Christian Recorder* weekly published a commentary that asked if offices such as that of the Stewardess would ultimately lead to a political end—woman suffrage—or more likely to women "taking hold" and "speaking" in religious gatherings. Ambivalences about extending new authority to women were present. Still, a consensus among black Methodists led to the chartering of female missionary societies, bodies that formally acknowledged the fundraising work that women had long performed without recognition. One AME Church commentator surveyed the changes and then termed such societies the "'woman movement' of our church."[31]

Black women's religious authority experienced a sea change; women were voting, holding office, and exercising newfound authority over work they had long done under men's oversight. Perhaps, though, by deeming this period a women's movement, the bridge had stretched too far for some male leaders. Eliza Gardner was among the women who felt a backlash (fig. 7). Raised as a free girl in Boston's anti-slavery circles before the Civil War, Gardner was a Sunday School teacher, a missionary society leader, and a lifelong church activist who supported herself as a dressmaker. Her challenge, as she stepped to the podium at the 1884 AME Zion general conference, was to defeat those who sought to halt the expansion of churchwomen's rights

with legislation that read: "Females have all the rights and immunities of males, except the rights of orders and of the pastorate. They may be licensed as evangelists." It was, in essence, a religious glass ceiling. Women would be authorized to travel, occupy the pulpit, and interpret the gospel, and would even be welcomed by local congregations when they did so. Some, such as Julia A. J. Foote, did just that, and they often traveled with male ministers who credited them with winning new converts to Methodism.[32]

Women might have regarded the promise of preaching licenses as a victory. After all, they had sought them as far back as 1844 and 1848. But by the 1880s, not only were Gardner and other churchwomen determined not to lose ground, they also knew that on the horizon, there was a struggle over ordaining women to the ministry, the highest office in black Methodism. Gardner's response began with no sign of deference: "I do not think I feel quite so Christian-like as my dear sisters." While other women implored and appealed to the benevolence of male leaders, Gardner spoke expressly about power.[33]

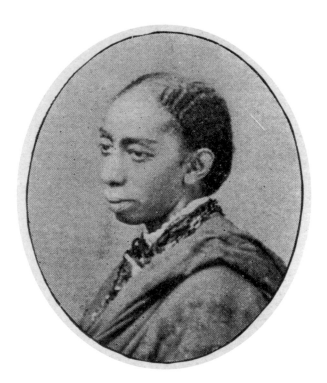

FIG. 7

Eliza Ann Gardner (1831–1922)
Frontispiece of *Historical Records of Conventions of 1895–96 of the Colored Women of America*
Unidentified photographer
1902
Photomechanical reproduction
10.8 × 7.6 cm (4¼ × 3 in.)
The Library Company of Philadelphia

At stake, Gardner made plain, were principles that dated back to the 1840s: "I come from old Massachusetts, where we have declared that all, not only men, but women, too, are created free and equal, with certain inalienable rights which men are bound to respect." Gardner linked the rights of churchwomen directly to the equality and freedom provided for in the constitution of her home state. As well, they were an extension of the "inalienable rights" provided for in the Declaration of Independence. And, in a twist on Justice Roger Taney's notorious pronouncement in *Dred Scott v. Sandford*, she claimed for churchwomen rights that "men were bound to respect." The movement she championed was part of the struggle for women's rights and had been born alongside "other good movements" that were dear to black Methodists, including "temperance reform and the anti-slavery cause." Gardner cast churchwomen's struggles as part and parcel of the long-standing "good" cause of women's rights.[34]

Gardner carried the day by proposing a tough bargain: Women would continue to ensure the well-being of the church but only if they received the support and respect of male leaders. "If you will try to do by us the best you can . . . you will strengthen our efforts and make us a power; but if you commence to talk about the superiority of men, if you persist in telling us that after the fall of man we were put under your feet and that we are intended to be subject to your will, we cannot help you in New England one bit." Her threat was not an idle one. Black Methodist leaders knew well that Gardner and other black women in New England were already organizing in the secular realm.[35]

The Clubwomen's Era

Reconstruction did not fail all at once. Still, by the 1890s, Southern courts, legislatures, and local leaders were all conspiring to narrow the avenues by which black men could take part in public life. Violence, oppressive legislation, and the drawing of a bright color line—in short, the political and legal regime known as Jim Crow—eventually relegated black men to the margins of politics through disenfranchisement, lynching, and segregation. Women's activism took on a new urgency. Organizations formerly devoted to the work of war relief began to address community concerns related to race and rights. As the issues surrounding the racialized body became increasingly urgent, these organizations knit together into a national network of clubs. Black women attempted new alliances with white women for the first time since the late 1860s. These renewed efforts were largely thwarted by the adoption of a "Southern strategy" in a white-led campaign for women's suffrage that sacrificed the incorporation of black women in the interest of winning the support of white women in the South. Still, Northern black women would begin to vote in important numbers.

Eliza Gardner knew that in addition to their church activism, black women were harnessing their influence through secular clubs. By 1895, she was among a cadre of national leaders who convened black women under the auspices of the National Conference of Colored Women. As chaplain, her words provided the opening and closing prayers at that body's inaugural meeting. It was a natural transition for women like Gardner who had already imbibed women's rights ideas in abolitionist and church circles. Now, black women activists were joining forces to tackle national problems under the motto "lifting as we climb."[36]

The 1890s inaugurated what has been termed the "woman's era." This did not reflect the emergence of a neat or single focus on the rights of women. Instead, the woman's era was a companion—indeed, it was a response—to what was also deemed the "nadir" or low point of American race relations. Segregation was being institutionalized, and racial violence was on the rise. As for political rights, black men were losing the right to vote through intimidation and the imposition of racially discriminatory poll taxes, literacy tests, and grandfather clauses. The essence of the women's era lay in the view that black women must organize to combat the rise of Jim Crow. It was a development that embraced the power of women, a power Eliza Gardner had named during her church battles.

Black churchwomen embraced this activism as a way of ameliorating racism's social and political ills (fig. 8). In "A Woman's View on Current Topics," AME Zion member May Brown queried, "what will the Negro of the United States do to gain just and merited recognition?" Brown saw clearly the tension that defined the nadir: "The whites are struggling to retain the supremacy. The Negroes are struggling for right and justice." But if the problem, as Brown saw it, lay in the dire state of race relations, the solution was to be found in women's activism. "The women cannot, must not, dare not be idle," she urged. Brown challenged her "own women" to "read, to study, to keep . . . abreast with the thoughts of the day . . . take part in the

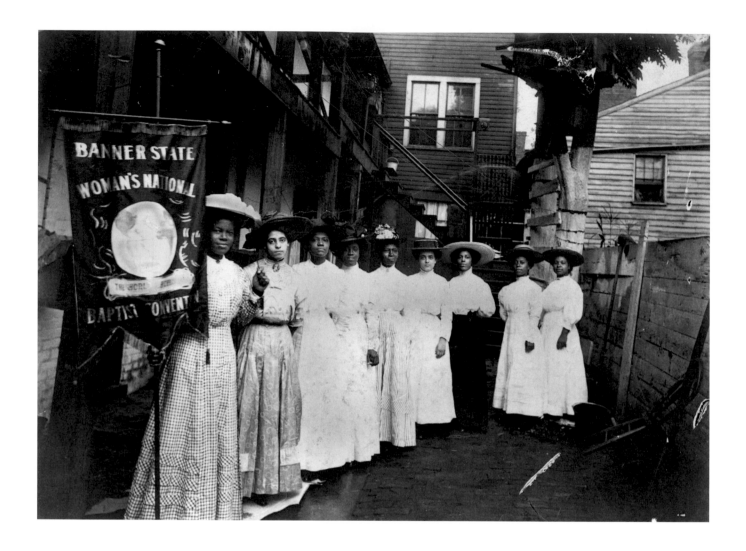

social, religious, philanthropic and intellectual subjects which have never been found so exacting or so diffuse as now." Writing in 1891, Brown captured black women's optimism and ambition: The "New Woman" was a critical agent in battles against the "race problem."[37] Black women had long experienced working on behalf of the race as a whole. They worked by way of a capacious politics that eschewed narrow alliances of race and gender. And their womanhood acted as a sort of cover-up over their ambitions—black men were often Jim Crow's most direct targets, leaving women to do organizing, absent heavy scrutiny.[38]

As black men in the South were being turned away from polling places, black women in the North were gearing up to vote. This was possible, in part, because the terrain of political life for many black Americans was shifting. Major migrations of thousands of black southerners to the North created new hubs of activism and concentrations of potential new voters. And, well before the ratification of the Nineteenth Amendment, polling places in the same northern locales were opening for the first time to women. Black women were entering the body politic; in northern cities, their growing numbers gave them strength, while the lifting of gendered barriers gave them access.[39]

FIG. 8

Nannie Burroughs (1879–1961), left, and eight other African American women gathering for the "Banner State Woman's National Baptist Convention"
Unidentified photographer
1915
Gelatin silver print
21 × 16 cm (8 5/16 × 6 5/16 in.)
Library of Congress, Prints and Photographs Division, Washington, DC

The example of Chicago illustrates these changes. Between 1890 and 1930, the city's black population grew from just under 15,000 to nearly 234,000 residents. Most of this growth was attributable to the arrival of southern migrants, who had been pushed out by the rise of Jim Crow laws, and the pull of better jobs and relief from Jim Crow's strictures. For the women among migrants as well as those women native to Chicago, Illinois's voting regime was undergoing radical change. First in 1891, a Woman's Suffrage Bill authorized women to vote for candidates in school-related offices and to a limited degree in rural areas and unincorporated cities. In 1913, the Presidential and Municipal Suffrage Bill permitted women in Illinois to vote for the US president and for municipal officeholders throughout the state. By 1916, four years before the ratification of the Nineteenth Amendment to the US Constitution, black women in Chicago were readying to cast their first ballots ever for president.[40]

Demographic and structural changes tell one part of this story. But to understand how black women in Chicago arrived at the polls in 1916, and what they did there, requires returning to what occurred in their churches and their women's clubs. These collectives had always been defined in part by the drive to enhance women's power, with rights coming in the form of the vote, officeholding, and structures of independent leadership. And perhaps after voting and holding office in churches, doing the same in the realm of party politics was an obvious shift of focus. What is certain is how through their clubs and their churches, black women transformed into party activists: rallying, marching, vetting candidates, electioneering, voting, and even running for local office.[41]

The women's era was thus distinguished by a new brand of black women's autonomy. Their Republican Party clubs, such as that named for journalist and anti-lynching advocate Ida B. Wells (fig. 9), were spaces that encouraged black women's leadership, independent thought, and activism. Their clubs provided an alternative to church-based gatherings, which were still dominated by men, and differed from existing women's clubs, which were linked through the auspices of the white-led General Federation of Women's Clubs and the Woman's Christian Temperance Union. Black women did not wholly distance themselves from these other organizations—but they continued to be marginalized, encountering sexism in bodies led by black men and experiencing racism when they attempted to ally with white women.[42]

Ida B. Wells was more than a women's club namesake, of course. She was renowned in Chicago and nationally as a journalist, educator, and anti-lynching crusader. Her campaign for the passage of federal anti-lynching legislation is a reminder that for black Americans, the vote was a partial, imperfect instrument of political empowerment. The unabated rise of lynching was both the cause and the effect of ongoing black disfranchisement in the South. Violence sharply discouraged potential black voters from registering or attending the polls. The resulting all-white political and legal structures—including law enforcement agencies, courts, and legislatures—meant that the victims of racial violence and their survivors could expect little in the way of justice or redress.[43]

No amount of political influence in a city like Chicago and no amount of black voting power there could wholly remedy the ills that Wells and other black

clubwomen aimed to relieve. Still, they became voters. And like Wells, many also became documentarians, compiling the evidence of lynching and publishing it in newspapers and pamphlets. They became writers and public speakers, bringing both the facts of racial violence and the necessity of remedial legislation to audiences nationally and internationally. Black women emerged as lobbyists, pressing lawmakers locally, in state capitals, and in Washington for laws that would combat rising inequality. This approach to moving a political agenda forward, especially on behalf of black southerners, regarded voting as only one tactic among many. With so many black Americans disenfranchised, pursuit of their interests could never be channeled into elections or officeholding alone.[44]

The work of Ida B. Wells links these early chapters in the history of black women and the vote to the modern civil rights era of Fannie Lou Hamer. Not only is Wells an icon for the history of black women's clubs, the advent of their voting, and their nimble approach to politics in the era of Jim Crow, she was also present for the founding of the National Association for the Advancement of Colored People (NAACP), the twentieth century's flagship civil rights organization. Women's voting rights would continue to play a role in African American politics going forward. This was especially true in northern cities like Chicago, where black voters could help shape policy and leadership closer to home. Black women there would play a critical role in electing Oscar De Priest to the House of Representatives in 1929, the first African American to be elected to Congress since Reconstruction.[45] But it was the NAACP's multilayered work, from the grass roots to high courts, that chipped away at the foundations of Jim Crow. When, in the 1960s, Hamer began to define her own political identity, she followed on a long tradition of black women demanding that political culture incorporate their approaches to how race and gender might remake the nation.

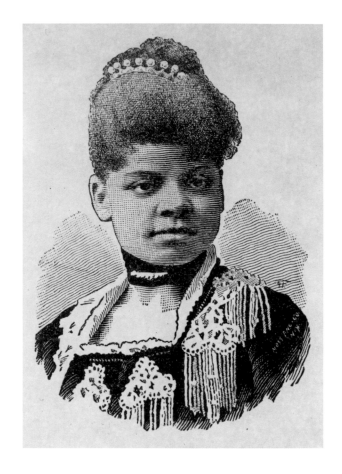

FIG. 9

Ida B. Wells-Barnett (1862–1931)
I. Garland Penn (1867–1930)
ca. 1891, after original
Photomechanical reproduction
(after engraving)
8.5 × 5.5 cm (3 5/16 × 2 1/4 in.)
Library of Congress, Prints
and Photographs Division,
Washington, DC

Still at the Crosscurrents

Between 1848 and 2008, black women traveled a great distance in the quest to fully join the body politic. Their campaigns played out in churches and political conventions. They entered onto the public stage with the advent of women's voting rights, and they remained innovative, versatile, and ever ready to deploy varied tactics as they campaigned for justice—for themselves and for their communities. Still, in 2008, questions resurfaced as Barack Obama and Hillary Rodham Clinton squared off in the Democratic Party's presidential primary contest. Commentators were eager to explain the Clinton-Obama contest in race-versus-gender terms. The *New York*

Times published first Gloria Steinem and then feature writer Mark Leibovich, with each attempting to explain how identity shaped political culture. Their starting place was 1868. Wasn't gender, as in womanhood, a more crippling political liability than race, as in blackness, they queried. The past might provide useful analogies.

Steinem's January 2008 op-ed "Women Are Never Front-Runners" asked, "Why is the sex barrier not taken as seriously as the racial one?" She looked to history for answers: "The abolition and suffrage movements progressed when united and were damaged by division; we should remember that." Steinem then went on to read the terms of the Fifteenth Amendment, concluding: "Black men were given the vote a half-century before women of any race were allowed to mark a ballot." Less than one week later, Leibovich authored a feature piece, "Rights vs. Rights: An Improbable Collision Course," that relied on the "bitter case" of the "abolitionist–women's rights split" to explain how race had trumped gender: "Blacks won the right to vote with the 15th Amendment in 1870," while women won theirs decades later in 1920 with the passage of the Nineteenth Amendment, Leibovich suggested.[46]

Neither here nor elsewhere in the mainstream media landscape was there an explication of how black women were positioned in political culture, past or present. Melissa Harris-Perry, then a professor at Princeton University, confronted Steinem during a broadcast television exchange on Democracy Now! A scholar of political science and African American studies, Harris-Perry had worked with the Obama campaign in Chicago. She also spoke directly as a black woman: "I'm sitting here in my black womanhood body, knowing that it is more complicated." Her tone was stinging as she explained that she was "appalled" and "offended" by Steinem's essay. Harris-Perry's message was about the need for an intersectional analysis: "We have got to get clear about the fact that race and gender are not these clear dichotomies in which, you know, you're a woman or you're black."[47]

When Michelle Obama stepped to the podium at the August 2008 Democratic National Convention, she put false dichotomies to rest (fig. 10). Her speech drew on childhood reminiscences, moral philosophy, and her role as a mother and turned on a view of the American dream as produced through struggle and determination. Struggle was part of our history, Obama insisted, and she placed the occasion of her speech squarely into a historical frame: "This week we celebrate two anniversaries. The eighty-eighth anniversary of women winning the right to vote and the forty-fifth anniversary of that hot summer day when Dr. King lifted our sights and our hearts with his dream for our nation."[48]

Obama claimed two histories: the history of gender—as represented by the passage of the Nineteenth Amendment, and the history of race—as expressed through the civil rights movement. "I stand here today at the crosscurrents of that history, knowing that my piece of the American dream is a blessing hard won by those who came before me," she stated. Obama reintroduced the dichotomies set forth by Steinem and Leibovich and then mapped out the intersections—or, in her terms, crosscurrents—that expressly ran through her life's experience.[49] In Obama's vision of American political culture, she drew her insight from her position as a daughter of both Elizabeth Cady Stanton and Frances Ellen Watkins Harper. She embodied the

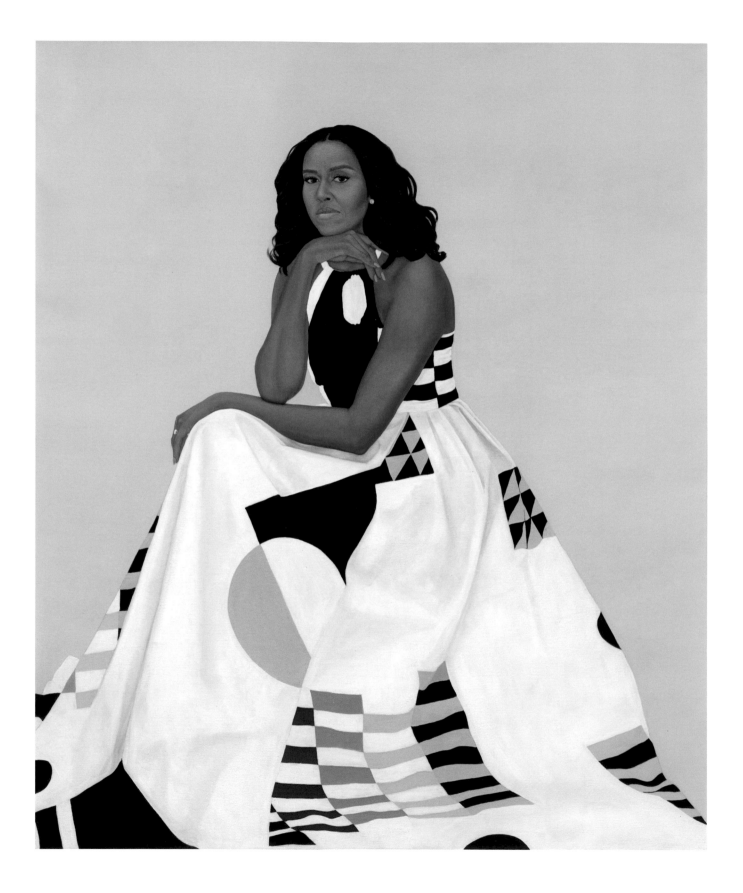

FIG. 10

First Lady Michelle Obama
(b. 1964)
Amy Sherald (b. 1973)
2018
Oil on linen
183.2 × 152.7 cm
(72 ⅛ × 60 ⅛ in.)
National Portrait Gallery,
Smithsonian Institution;
Gift of Kate Capshaw and
Steven Spielberg; Judith Kern
and Kent Whealy; Tommie
L. Pegues and Donald A.
Capoccia; Clarence, DeLoise,
and Brenda Gaines; Jonathan
and Nancy Lee Kemper; The
Stoneridge Fund of Amy and
Marc Meadows; Robert E.
Meyerhoff and Rheda Becker;
Catherine and Michael Podell;
Mark and Cindy Aron; Lyndon
J. Barrois and Janine Sherman
Barrois; The Honorable John
and Louise Bryson; Paul and
Rose Carter; Bob and Jane
Clark; Lisa R. Davis; Shirley
Ross Davis and Family; Alan
and Lois Fern; Conrad and
Constance Hipkins; Sharon
and John Hoffman; Audrey M.
Irmas; John Legend and Chrissy
Teigen; Eileen Harris Norton;
Helen Hilton Raiser; Philip
and Elizabeth Ryan; Roselyne
Chroman Swig; Josef Vascovitz
and Lisa Goodman; Eileen
Baird; Dennis and Joyce Black
Family Charitable Foundation;
Shelley Brazier; Aryn Drake-
Lee; Andy and Teri Goodman;
Randi Charno Levine and Jeffrey
E. Levine; Fred M. Levin and
Nancy Livingston, The Shenson
Foundation; Monique Meloche
Gallery, Chicago; Arthur Lewis
and Hau Nguyen; Sara and John
Schram; Alyssa Taubman and
Robert Rothman

legacies of Martin Luther King Jr. and Fannie Lou Hamer. Race and sex, in her analysis, were not a fraught dyad, they were core facets of black women's political identities and the starting place for their insights.

Obama would go on over the course of eight years to make her mark as a distinctive first lady. But first, like the generations of black women before her, she made plain her unique vantage point and might very well have had the words of Anna Julia Cooper, written in 1892, in mind: "Only the black woman can say when and where I enter, in the quiet, undisputed dignity of my womanhood, without violence and without suing or special patronage, then and there the whole Negro race enter[s] with me."[50] Of course for Michelle Obama, she was ushering in not only other African Americans but also the nation as a whole.

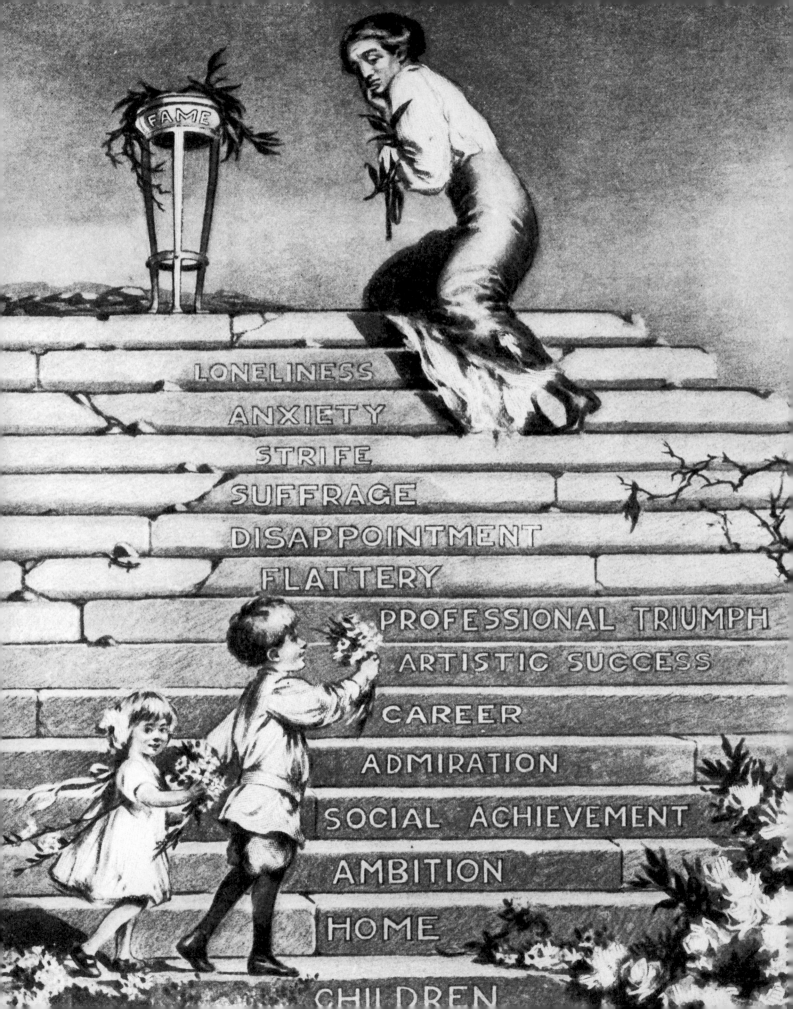

A WOMAN'S PLACE

ORGANIZED RESISTANCE TO THE FRANCHISE

———

Susan Goodier

FIG. I

Looking Backward
Laura E. Foster (1871–1920)
for *Life*, August 22, 1912
Photomechanical reproduction
33.7 × 24.1 cm (13 ¼ × 9 ½ in.)
Library of Congress, Prints
and Photographs Division,
Washington, DC

Until the late nineteenth century, most Americans believed that the proper functioning of the United States depended on the vastly different roles of women and men. Even the most civic-minded individuals were likely to balk at the suggestion of gender equality (fig. 1). For them, granting women the right to vote not only seemed ridiculous and illogical, but even immoral. Susan Fenimore Cooper, the widely respected author of *Rural Hours* (1850), a book detailing a year in the natural and communal life of Cooperstown, New York, represented the dominant thinking of middle-class white people on women's position in the social order (fig. 2). She opposed women's political enfranchisement; the arguments she articulated in an 1870 article, "Female Suffrage: A Letter to the Christian Women of America" for *Harper's New Monthly Magazine*, represent the essence of anti-suffrage ideology throughout the existence of the movement.[1] Coincidently, that same year, Elizabeth Cady Stanton, one of the best-known women's rights activists of the nineteenth century, published the "Address of Mrs. Elizabeth Cady Stanton, Delivered at Seneca Falls & Rochester, N.Y., July 19th & Aug. 2d, 1848," in pamphlet form.[2] Stanton's publication was part of a deliberate attempt to establish the 1848 Seneca Falls Woman's Rights Convention as *the* founding event of the suffrage movement (fig. 3).[3]

Today, as we celebrate the one hundredth anniversary of women having won the right to vote, it is easy to denigrate anti-suffragists, the women who established organizations to prevent women's enfranchisement. It is, indeed, tempting to completely dismiss their arguments and to view them as selfish, elite women who had no sense of politics.[4] Anti-suffragists lost the battle, after all. To sneer at these women or to "scorn" their activism, however, is to miss an opportunity to understand the extraordinary radicalism inherent in the movement *for* the right to vote.[5] Both women's rights activists—those who focused on broad social, political, legal, and economic rights—and suffragists, who focused more specifically on the right to vote, faced incredible hostility as they challenged the dominant customs, practices, and power relations in the late nineteenth and early twentieth centuries. As such, understanding the anti-suffrage movement is critical to understanding the

FIG. 2

Susan Augusta Fenimore Cooper
(1813–1894)
Washington G. Smith
(active 1850–1893)
1850
Daguerreotype
9.5 × 8.9 cm (3 ¾ × 3 ½ in.)
Fenimore Art Museum,
Cooperstown, New York,
Photographic Collection

suffrage movement. The suffrage movement developed, changed, and adapted to the arguments put forth by the anti-suffrage countermovement, helping suffragists clarify their own arguments.

Stanton and Cooper addressed an array of questions about the inherent differences between the sexes and women's "proper" role in the nation-state. Between 1870 and the signing of the Nineteenth Amendment in 1920 granting women the right to vote, the arguments Stanton and Cooper made in 1870 represent the spectrum of thinking on women's position in the country. While no evidence has yet surfaced that proves the two women read each other's articles, Elizabeth Cady Stanton's published speech would have been easily available to the well-informed Susan Fenimore Cooper. Paradoxically, both women's positions aligned with the central ideas of a white middle-class Christian society. Nevertheless, we begin to understand the extremes at either end of this spectrum of thinking about women's place in the nation and the thinking that influenced both sides of the controversy surrounding the concept of women's suffrage. It may never be entirely clear how "shared ideological roots" could have resulted in diametrically opposed stances among politically astute women.[6] Their remarkable focus on parallel arguments offers an opportunity to explore the dramatic shift between 1870 and 1920 in the dominant viewpoints with regard to gender, citizenship, women's rights, and equality in the United States.

By dividing anti-suffragism into four distinct stages, we can better understand the long history and progression of the two sides. During the first stage, roughly 1869 to 1895, most women apparently ignored the demands suffragists made.

FIG. 3

Elizabeth Cady Stanton
(1815–1902)
Napoleon Sarony (1821–1896)
ca. 1870
Albumen silver print
9.7 × 5.9 cm (3 ¹³⁄₁₆ × 2 ⁵⁄₁₆ in.)
National Portrait Gallery,
Smithsonian Institution

G. W. THORNE 60 NASSAU ST. NEW YORK
680 BROADWAY, N. Y.

Susan B. Anthony and her biographer, the journalist Ida Husted Harper, claimed that "in the indifference, the inertia, the apathy of women, lies the greatest obstacle to their enfranchisement."[7] However, the more politically astute anti-suffragists, like Susan Fenimore Cooper, sought to articulate the essential arguments in opposition to women's right to the vote.

Until the 1894 New York State Constitutional Convention, it did not seem necessary for anti-suffragists to take public action to defend their position, but during the second stage, from about 1895 to 1911, the United States witnessed the establishment of state-level anti-suffrage clubs and organizations. These groups worked to counteract the increasing attention suffragists drew from a public that was fascinated by them. At the same time, anti-suffragists often tried to appropriate suffragists' brilliant strategies, such as making and selling buttons, pennants, stamps, and other souvenirs; hosting galas; staging debates with suffragists; or distributing pink anti-suffrage broadsides, but they did so modestly, discreetly, quietly, and, often, behind the scenes, within the limits of what they thought of as proper behavior for women. While defining themselves as "true women" and claiming a limited role in the nation's politics, anti-suffragists behaved in decidedly political ways.

Between 1911 and 1917, anti-suffragists shifted their strategy. They became increasingly political in their behavior, and their movement transitioned from separate state-dominated efforts to one with a central drive and a national focus. Anti-suffrage activities increased as suffrage agitation increased; throughout the years of the movement, that activity would wax and wane in response to the changing levels of suffrage activities. The high point of this period, 1915, saw anti-suffragists win referendum campaigns in four heavily populated eastern states: New York, Massachusetts, Pennsylvania, and New Jersey. The headquarters of the National Association Opposed to Woman Suffrage (NAOWS) relocated from New York City to Washington, DC, to better resist a federal amendment. However, the forces against women's suffrage began to lose energy and enthusiasm for the campaign, primarily because the war in Europe distracted them.

The fourth and final period of the movement, which lasted from approximately 1918 to 1932, found anti-suffrage forces on the defensive. Their tactics grew ugly and shrill as more powerful politicians, including New York Senator James W. Wadsworth Jr. and attorney Everett P. Wheeler dominated the activities of the National Association Opposed to Woman Suffrage. The anti-suffrage organization then devolved into a congressional watchdog agency, which expressed hostility toward virtually all amendments to the US Constitution.[8]

Articulating the Arguments and Early Mobilization, 1869 to 1895

It is not clear how Susan Fenimore Cooper came to write "Female Suffrage" for *Harper's*, but when the article was published in November 1870, she had already won broad, international acclaim for her writing. In one of the essay's footnotes,

George William Curtis, the magazine's editor, distanced himself from Cooper's opinions, claiming that he had published her letter "as the plea of an earnest and thoughtful Christian woman." Curtis elected not to reveal his own position on women's suffrage.[9] Meanwhile, in the same year, the printer Robert J. Johnston published the "Address of Mrs. Elizabeth Cady Stanton" in pamphlet form, which helped perpetuate the "myth" that Seneca Falls birthed the women's rights movement.[10] This publication, then, constituted one important aspect of marketing Stanton's (and her colleague, Susan B. Anthony's) "particular agenda for women's rights and also to insist upon women's place in national memory," as historian Lisa Tetrault argues.[11] These key writings from two prominent women demonstrate the main tenets of their opposing ideologies related to topics of domesticity, religious principles, submissiveness in public and private spheres, and physical and intellectual differences between women and men.

Both Cooper and Stanton discussed harmony in the relationships between women and men in their respective documents. Cooper, claiming that "woman is naturally subordinate" and arguing that "such it has always been throughout the world, in all ages, and in many widely different conditions of society," accepted the inevitability of women's submissiveness. She argued that gender relations should remain unchanged, with women continuing to submit to the authority of men.[12] She believed that healthy, harmonious relationships between women and men required a submissive and dominant dichotomy, not the sameness of equality. For Stanton, subordinate relationships were inherently inharmonious and discordant. She, of course, expressed a minority view; most people believed, like Cooper, that "in no state of society, however highly cultivated, has perfect equality yet existed," and that healthy gender relationships depended on inequality between the sexes. Stanton recognized that most people feared "that if the principles of freedom and equality which [women's rights activists] advocate, were put to practice, they would destroy all harmony in the domestic circle. Here let me ask how many truly harmonious households have we now?" In her opinion, "no true dignity or independence [exists] where there is subordination, no happiness [exists] without freedom."[13] The ideological positions of Stanton and Cooper on the issue of gender equality could not have been more different.

Noting most men's physical size and power in comparison to women, Cooper and Stanton again articulated contrasting views. Cooper observed that "woman in natural physical strength is so greatly inferior to man that she is entirely in his power, quite incapable of self-defense, trusting to his generosity for protection." In "savage life," her phrasing that described the everyday realities people faced, women's need for physical protection made "man the absolute master, woman the abject slave." While the progress of civilization had admittedly lessened the differences between the sexes, she argued that "the difference in physical strength must . . . always prevent such perfect equality."[14] But according to Stanton, man had "no right to claim [physical superiority] until the fact be fully demonstrated, until the physical education of the boy and the girl shall have been the same for many years." Give women the freedom to run and play as children and permit them to take gymnastics classes in school, Stanton argued, and women will grow to be as physically healthy as men.[15]

Discussions of physical superiority led to an exploration of the supposed intellectual superiority of men. Cooper admitted that "while there have been women of a very high order of genius . . . the greatest achievements of the race in every field of intellectual culture have been the work of man." She continued by arguing that "so long as woman, as a sex, has not provided for herself the same advanced intellectual education to the same extent as man . . . we are compelled to believe . . . [in] the inferiority of woman."[16] Because women had not historically shown themselves to be philosophers and intellectuals, she accepted limited options for them in the present. At the same time, she blamed women for not making enough of an effort to educate themselves and contended that they must accept their intellectual inferiority relative to men.[17]

Stanton demanded a reassessment of women's intellectual capabilities, pointing out that "man's superiority cannot be a question until we have had a fair trial. When we [women] shall have had our colleges, our professions, our trades . . . for a century, a comparison may then be justly instituted."[18] Access to and opportunity for education dictated the level of intelligence in women or men, not some gender inheritance. Furthermore, she claimed, "the power of mind seems to be in no way connected with the size and strength of body. Many men of Herculean powers of mind have been small and weak in body."[19] She denied any correlation between intellect and physical prowess, basing any differences between the sexes on the neglect of women's physical and intellectual well-being. While Stanton surely provoked controversy among members of her audiences with her demands to expand women's access to higher education, Cooper expressed the far more accepted thinking on women's post-secondary education, which was that women needed only rudimentary education to function as man's "helpmeet."

In the nineteenth century, most Americans turned to their Bibles for answers to ideological questions. Christianity monopolized people's thinking on women's relationships to men. Religion also informed the argumentative positions of both Cooper and Stanton. Cooper claimed, "no system of philosophy has ever yet worked out on behalf of woman the practical results for good which Christianity has conferred on her." In her view, "Christianity has raised woman from slavery and made her the thoughtful companion of man . . . his helpmeet in every worthy and honorable task."[20] She believed Christianity benefited not only women but also society at large: as women increased their piety and obedience to God and men, the nation would advance. Contemporary literature celebrated this passive, self-sacrificing, and pious woman, as did much of the sentimental writing of the time. The English poet Coventry Patmore, as one example, reinforced the ideal of woman as being the "angel of the house," devoted to her husband, children, and her home. As Patmore wrote, "Man must be pleased; but him to please / Is woman's pleasure."[21] Stanton, of course, sought to dismantle the prevailing ideology of woman as pious and obedient. She said:

> Methinks I hear some woman say, we must obey our Husbands!! Who says so? Why the Bible. No, you have not rightly read your Bible.

The chief support that man finds in the Bible for this authority over woman he gets from the injunctions of Paul. It needs but little attention to see how exceedingly limited that command of St. Paul must be even if you give it all the weight which is usually claimed for it.[22]

Stanton, deeply troubled by what she saw as Christianity's oppression of women, would publish the *Woman's Bible* in 1895 and 1898 to challenge its orthodox dogma (see cat. 68).[23]

In the decades after 1870, critics of women's suffrage frequently pointed to the violence, vulgarity, or immorality of polling places, usually private or public buildings off limits to respectable women. Men often consumed liquor to excess before or after voting; members of political parties used alcohol to bribe voters and election officials.[24] These critics feared that women would be corrupted by the experience of voting. During this period, suffrage expanded for men across the nation. The property requirements had loosened or been eliminated completely in many states, and while black men were frequently turned away from the polls, only men with criminal backgrounds and those deemed mentally incompetent were prohibited from voting.

Cooper took an interesting stance on the point raised by suffragists who purported that women's exclusion from voting rights ranked them with social undesirables. She suggested enlarging "the criminal classes from whom the suffrage is now withheld . . . why not exclude every man convicted of any degrading legal crime, even petty larceny? And why not exclude from the suffrage all habitual drunkards judicially so declared? . . . these are changes which would do vastly more of good than admitting women to vote."[25] Cooper would limit, not extend, voting rights, even among men. Stanton argued that the polls were as dangerous to men as they were to women: "where there is so much to be feared for the pure, the innocent, the noble, the mother surely should be there to watch and guard her sons, who must encounter such stormy dangerous scenes at the tender age of 21." Stanton also pointed out that "much is said of woman's influence . . . might not her presence do much towards softening down this violence—refining this vulgarity?" For the next fifty years, women and men debated the issues that divided the thinking of Cooper and Stanton, becoming increasingly inventive in expounding their arguments.

During the nineteenth century, as many women and men discussed their views on women's access to voting rights, women who opposed their own enfranchisement—the anti-suffragists—were beginning to take action publicly. For example, in 1868–69, about two hundred women from Lancaster, Pennsylvania, submitted a document to the legislature in response to a pro-suffrage petition. The "remonstrants," as anti-suffragists often called themselves in these early years, put themselves forward (albeit reluctantly), because they feared that having the ballot would diminish women's moral influence. The next year, discussions about legislating women's suffrage took place in Vermont and Ohio. In several other states, women joined informal committees to discuss similar topics related to women and their duties in the nation-state.[26]

5 1/2.

Sarah Josepha Hale
Philadelphia
Oct. 22. 1842 –

Mrs Sarah, Josepha Hale Author of Northwood Flora's interpreter, – Ladies Wreath –
Philadelphia 17th Octob. 1842. the Good House Keeper &c &c. and Editor of the Lady's Book.

FIG. 4

Sarah Josepha Hale (1788–1879)
Auguste Edouart (1788–1861)
1842
Ink, chalk, and cut paper on
paper
28 × 21.2 cm (11 × 8 ⅜ in.)
National Portrait Gallery,
Smithsonian Institution;
gift of Robert L. McNeil Jr.

In 1870, anti-suffragists in Washington, DC, led by Madeleine Vinton Dahlgren, widow of the Civil War admiral, created the Anti-Sixteenth Amendment Society on learning that suffragists had proposed another amendment after the Fifteenth Amendment had only enfranchised men.[27] With the support of Senator John S. Harris of Louisiana and Representative George W. Julian of Indiana, Victoria Woodhull, an activist for women's rights and labor reform as well as a supporter of "free love," presented a memorial to Congress that December requesting the right to "vote without regard to sex." Woodhull then testified before the Judiciary Committee in the House of Representatives in January 1871, thrilling the suffragists who crowded into the committee room and shocking the observers who thought women belonged in the home, not in the halls of Congress.[28]

In response to Woodhull's testimony, nineteen women of the Anti-Sixteenth Amendment Society published a petition opposing women's voting in the popular magazine *Godey's Lady's Book*, the quintessential mouthpiece of the ideal "true woman." The magazine's editor, Sarah Josepha Hale (fig. 4), also a popular poet and author, intended her readers to distribute copies of the petition to their friends for signatures; the petition would then be forwarded to Congress. The signers of the first petition included the wives of Republican senators, Civil War generals, President Ulysses S. Grant's cabinet members, and other socially prominent women. A few observers noted the "sophisticated strategies" these women employed to claim an apolitical role for women.[29]

Establishing Organizations and Movement Strategies, 1893 to 1917

When Wyoming became a state in 1869, its women could vote. A few other states, in the western part of the country, including Colorado and Utah, enfranchised women in the late nineteenth century. Some people thought women should vote on areas considered extensions of the female realm, such as educational issues, taxation, and licensing related to temperance, and that they should vote for officials in municipalities. During the 1880s, women in fifteen states won the right to vote for school elections. Women, often members of suffrage or other activist clubs, petitioned legislators for these rights, often believing that full political rights could be wrung from legislators on a step-by-step basis. If women could begin by voting on school board issues, suffragists thought, politicians would see them as capable of voting on other matters.[30] But, as women gained partial suffrage, women anti-suffragists formed committees and temporary societies in Maine, Illinois, Massachusetts, and in other states where they sought to counter what they saw as the threat of enfranchisement.

Preparations for the 1894 New York Constitutional Convention offered suffragists the ideal opportunity to advocate for women's right to vote. Prominent suffragists Susan B. Anthony, Mary Putnam Jacobi, Lillie Devereux Blake, Mary Edwards Walker, Carrie Chapman Catt, Anna Howard Shaw, and others gave

speeches, reaching hundreds, even thousands of people in every county in the state. The coming convention stimulated articles, editorials, and published debates in most of the popular magazines of the day, including *Harper's Weekly*, *Outlook*, and *North American Review*, and newspapers broadly quoted suffragists' speeches in their news reports. Women's suffrage gained "unusual prominence," arousing women and men all over New York to think about the topic.[31] Following one of Anthony's speeches, an audience member asked her if she thought women actually wanted the right to vote. "They do not oppose it," Anthony replied.[32] For women who agreed with the ideas that Cooper had articulated, it was a call to action.

Across the state, committees of prominent women realized that they would have to establish organizations to protect their special sphere of influence. Josephine Jewell Dodge, Helena de Kay Gilder, Abby Hamlin Abbott, and Lucy Parkman Scott, among others, formed temporary organizations to get petitions signed in support of their position that they most certainly did not want the burden of the ballot. Anti-suffragists set up headquarters at the Waldorf Hotel in New York City, and women in Brooklyn, Albany, Utica, and other cities formed temporary committees to publicize their resistance to their enfranchisement. Readers of newspapers around the country watched the suffrage and anti-suffrage contingents with interest.[33]

Further clarification of anti-suffrage ideas came from Helena de Kay, the wife of Richard Watson Gilder, the editor of *Century* magazine (fig. 5). De Kay, who eventually helped establish the Art Students League, only reluctantly gave up a budding art career for marriage to Richard in 1874. She reacted to the debates about removing the word "male" from the New York State Constitution in a letter to her dear friend Mary Hallock Foote, an author and illustrator.[34] When she asked her husband to post the letter, he instead submitted it to the *Critic*, edited by his siblings Jeannette and Joseph B. Gilder. The Gilders had the letter reprinted in booklet form several times and distributed it widely.[35]

Echoing Cooper, Helena de Kay Gilder pointed out that women "are men's equal, and almost as well educated, as good and as intelligent in ordinary matters." Gilder then asks a most poignant question: "What are women for, anyway?" Her answer is that "nature, and not man, has unfitted her for the struggle which a democracy imposed upon every good and conscientious citizen." Gilder argued that the ballot often "proves a means of corruption." Furthermore, she noted that the demands of the ballot would interfere with women's "liberty." For Gilder, the ballot did not represent either a "natural right" or a "great privilege." Rather, it was a burden that women should not have to bear, as it would strain the family relationship. Worst of all, for Gilder, "to make little men of women is so ugly; to unsex them, so intensely inartistic." She argued that women needed to be in control of "the art of living."[36]

For years, anti-suffragists reprinted and referred to this letter; Richard Gilder once remarked that in its text, the antis "seem to think that they have therein found a voice."[37] Its arguments help us understand how much and yet how little the rhetoric of the anti-suffrage movement had evolved since Cooper's 1870 open letter to Christian women. Reading the letter, Sarah Blake Sturgis Shaw, the mother of

FIG. 5

Richard Gilder (1844–1904),
Helena de Kay Gilder (1846–
1916), *and Rodman de Kay Gilder*
(1877–1953)
Augustus Saint-Gaudens
(1848–1907)
1879, cast ca. 1883–84
Plaster
21.9 × 42.9 cm (8 ⅝ × 16 ⅞ in.)
The Metropolitan Museum of
Art; gift of David and Joshua
Gilder, 2002

both Josephine Lowell Shaw, a social justice reformer, and Robert Gould Shaw, who had commanded the Fifty-Fourth Massachusetts regiment and died during the Civil War, expressed her heartfelt disappointment that her dear friend Helena would try to prevent other women from voting.[38] Nevertheless, even after receiving such reactions from some of her friends, Helena Gilder regularly attended anti-suffrage meetings and remained committed to the principles of true womanhood for the remainder of her life.

Anti-suffrage forces did not officially organize themselves until April 8, 1895, and even then, they did so only reluctantly. Late nineteenth-century anti-suffragists tended to be of white, wealthy families, married to or related to men in law or politics. There is virtually no evidence of black women being involved in the organized anti-suffrage movement; black women had advocated for the right to vote since before the Civil War. Anti-suffragists were usually Protestant (especially Presbyterian or Episcopalian), often members of women's nationalistic organizations, such as the Colonial Dames or the Daughters of the American Revolution, and heavily involved in reform activities. If the women worked outside the home, they tended to be involved in journalism, one of the few fields the "true woman" could occupy.[39] Having had access to high-quality education and having gained insights into the law from their husbands helped many anti-suffragists develop sophisticated arguments and strategies. Thus, the conservative ideas of elite white women dominated the movement from 1893 to about 1912.

The viewpoints of anti-suffragists changed little over the years of the movement, although their arguments became more refined in response to the increasing sophistication of the suffragists' discourse. Aware of the need to educate the

electorate as to their aversion to a public life with political responsibilities, anti-suffragists frequently tried to appropriate the marketing strategies suffragists developed (fig. 6). They printed statements from well-known male leaders; held fundraisers, teas, garden parties, and other social events; and spoke before state and federal legislatures. They rented booths at local and state fairs and Old Home Days; distributed roses, anti-suffrage buttons, and pennants; gave speeches; and debated suffragists. Despite their willingness to use new techniques to present the anti-suffrage message to the public, the basic philosophy of anti-suffragists remained unchanged.

Taking the Lead at the National Level, 1911 to 1917

The social activist Josephine Jewell Dodge was deeply committed to true womanhood and emerged as the most prominent leader of the next phase of the anti-suffrage movement (fig. 7). A daughter of Marshall and Esther E. Dickinson Jewell, Dodge's father served three terms as governor of Connecticut, a year as ambassador to Russia, and two years as postmaster general under Ulysses S. Grant. Her mother had "enthusiastically welcomed" the establishment of the Connecticut Woman Suffrage Association in the fall of 1869, having signed the call for the convention, and she and her husband entertained New England suffragists and members of the National Woman Suffrage Association who participated in the convention.[40] Josephine attended Vassar for three years but left, despite parental protests, to accompany her family to Russia. Her 1875 marriage to Arthur Murray Dodge, a son of one of New York City's richest businessmen and philanthropists, resulted in the births of six children. Her husband died in 1896, leaving her with their five surviving sons.[41] Heavily involved in activism and well known for her work in establishing day nursery programs, Dodge founded the Hope Day Nursery for Colored Children in East Harlem and other day nurseries for working-class and immigrant children. She demonstrated a model of her day nursery programs at the 1893 Columbian Exposition in Chicago.[42] Despite her important social justice activism on the part of children, despite having grown up under her suffragist mother's influence, and despite being a widowed mother, she staunchly opposed women's enfranchisement.

Dodge became involved in publicly opposing woman suffrage in 1893. Described as a tiny "bird-like" woman, she feared the loss of women's protective

FIG. 6

Uncle Sam. Suffragee
Dunston-Weiler Lithograph Company (active 1900–1915)
1909
Lithograph
8.9 × 14 cm (3 ½ × 5 ½ in.)
Catherine H. Palczewski
Suffrage Postcard Archive,
University of Northern Iowa,
Cedar Falls, Iowa

FIG. 7

Josephine Jewell Dodge
(1855–1928)
Bradley Studio for *New-York Tribune*, April 2, 1916
Photomechanical reproduction
45.7 × 31.1 cm (18 × 12 ¼ in.)
Library of Congress, Prints and Photographs Division, Washington, DC

legislation, rightfully theirs because of their "lowered physical and nervous vitality" and their ability to bear children. What rights and privileges women held, including the right to alimony, child custody, and property ownership, had been gained without the right to vote.[43] Men, with their "muscular force" traded "the jury box, the cartridge belt, and the sheriff's summons"—responsibilities women did not have—for the right to vote.

The prominent editor and author Rossiter Johnson, the husband of Helen Kendrick Johnson, the author of *Woman and the Republic*, perhaps the most cogent book summary of the arguments of anti-suffrage and anti-suffrage essays, wrote "The Blank-Cartridge Ballot."[44] He contended that women's suffrage "would be a serious mistake," primarily because women did not have the obligation to provide jury service, police service, or military service (figs. 8–9).[45]

Alice Stone Blackwell, the daughter of Bostonians Lucy Stone and Henry Blackwell, wrote about the military argument for the National American Woman Suffrage Association in response to the anti-suffragist Mary A. J. M'Intire. Anti-suffragists argued that only men could enforce laws and that "Nature" had created "man combatant and woman non-combatant." Blackwell responded by saying that it would be logical, then, for any men who could not fight for health or other reasons to be excluded from the vote.[46]

While anti-suffragists organized in many states across the nation, nearly all of the national leadership came from New York State. Anti-suffragists in at least twenty states requested information, advice, or assistance from New York "antis." For most of these years, New York City served as headquarters for the national association of anti-suffragists as well as for suffragists; it was an ideal location because of the city's position as a news media center.[47] Dodge ended her tenure as president of the New York State Association Opposed to Woman Suffrage in 1910 to become president of the National Association Opposed to Woman Suffrage in November 1911. That month, women from across the United States held a meeting in Dodge's Park Avenue apartment, during which they founded the national organization.[48] The officers and board of directors included women from several states of the nation. By 1912, anti-suffrage associations affiliated with the New York–based National Association Opposed to Woman Suffrage represented fourteen states and Washington, DC.[49] Anti-suffrage proponents widely distributed their books and tracts, seeking to influence women and men across the country.

Dodge, in addition to serving as president of the national anti-suffrage organization, edited the anti-suffragists' monthly newspaper, the *Woman's Protest*, presenting its first issue in May 1912.[50] The publication would "endeavor to reach communities where it is not expedient to hold meetings or to send speakers."[51] One of the articles in the debut issue, "The Lesson That Came from the Sea—What It Means to the Suffrage Cause," used the tragedy of the sinking of the *Titanic* to illustrate anti-suffragists' confidence that men could be depended on to take care of

At Thirty-two.

women and that women "were not fitted for men's tasks."[52] This is only one example of how anti-suffragists found ways to expand their arguments for what they saw as the rightness of their cause.

Dodge lived in New York City but frequently traveled to Washington, DC, to meet with legislators and to preside over anti-suffrage conventions. She once astutely noted that hers was a "negative organization," and for her, this meant that anti-suffragists reacted to whatever suffragists did. They "would not crusade in any new areas of controversy, for it was their responsibility simply to resist suffrage in every way they could."[53] While anti-suffragists paid close attention to suffrage activity and responded accordingly, their public events remained circumscribed by the mandates of proper behavior for "true womanhood" long into the twentieth century. The leadership claimed to speak for the silent and apathetic women of the nation who did not welcome political engagement of any kind, but active anti-suffragists often found they had to contradict "proper" womanly behavior to promote their position. For anti-suffragists, simply speaking in a public venue challenged the traditional mores they sought to preserve. Nevertheless, they would appropriate suffrage movement strategies, and, interestingly, many anti-suffragists would become politicized in the process. This did not mean that they converted to suffragism (although a few women certainly did).[54] Rather, it meant that most anti-suffragists remained committed to the idea that women's ability to change society did not rest in politics.

While there had always been men who opposed women's suffrage, during the 1910s, a few of them strong-armed their way into the women's

FIG. 8

Helen Kendrick Johnson
(1844–1917)
Portrait plate of *Helen Kendrick Johnson: The Story of Her Varied Activities*
Unidentified photographer
1876
Photomechanical reproduction
6.3 × 7.1 cm (2 ½ × 2 ¹³/₁₆ in.)
Schlesinger Library, Radcliffe Institute, Harvard University

FIG. 9

Woman and the Republic
Helen Kendrick Johnson
(1844–1917)
1897
Special Collections Library, Western Connecticut State University

anti-suffrage movement. In May 1913, for example, Everett Pepperrell Wheeler, a lawyer and a founder of the American Bar Association, led a group of these prominent men to form the Society for the Prevention of Cruelty to Women. More commonly known as the Man-Suffrage Association Opposed to Woman Suffrage and established in response to the existence of the Men's League for Woman Suffrage, the membership included Elihu Root, US secretary of state and later secretary of war; Lyman Abbott, pastor of Plymouth Church in Brooklyn and influential editor of the popular periodical, *Outlook*; George W. Wickersham, former US attorney general and close William Howard Taft advisor; and James Wolcott Wadsworth Jr., the US senator from Geneseo in western New York. More than three hundred men had joined the association by 1914, arguing that the decision to enfranchise women should remain with the states.[55] Dodge, especially during the campaign for the 1915 referenda in New York, Massachusetts, Pennsylvania, and New Jersey, asked for and reproduced public endorsements of anti-suffragism from the men, adapting a strategy that suffragists had long used.[56] Soon men who opposed women's suffrage would dominate the anti-suffrage movement, essentially taking control of its activities.[57]

Dramatic changes came for anti-suffragists in the late summer and early fall of 1914, with the outbreak of World War I. They spent far more time in war preparedness and Red Cross activities than in anti-suffrage activities. For example, that October anti-suffragist Annie Nathan Meyer (the force behind the founding of Barnard College) donated all proceeds of her play, *The Spur*, to the Belgian Relief Fund.[58] Similarly, by May 1915, Dodge committed the assets of the National Association Opposed to Woman Suffrage to President Woodrow Wilson and called for a truce with suffragists until the end of the war. Issues of *Woman's Protest* increasingly focused on patriotism and war preparedness rather than on anti-suffrage. Their parties, fundraisers, and anti-suffrage enthusiasm waned as members supported war relief measures and volunteered their time and raised funds for the Red Cross. Anti-suffragists "essentially reframed their organization as the patriotic choice for women" in the United States.[59] The war in Europe took the wind out of the sails of the anti-suffragist movement as suffragists (those who were not peace activists) took advantage of their preoccupation with Red Cross volunteer work and other war preparedness and fundraising activities to promote women's suffrage.

Constitutional Challenges, 1917 to 1932

It must have appeared to some observers that anti-suffragists had given up on New York State and deemed blocking the federal amendment to be the more important cause. The July–August 1917 issue of *Woman's Protest* unexpectedly announced the resignation of Dodge, just months before the second women's suffrage referendum in New York State. She had stepped aside in June to allow the politically and socially connected Alice Hay Wadsworth to take the helm of the National Association (fig. 10).[60] Certainly, the sixty-two-year-old Dodge had spent six active years as the national leader, writing articles for *Woman's Protest*, holding a leadership role in the

National Association of Day Nurseries, and traveling across the country; she may have been tired.[61] (She did, however, continue as vice president of the New York State Association Opposed to Woman Suffrage.[62])

At the same time, in 1917 anti-suffragists announced the decision to move the National Association Opposed to Woman Suffrage headquarters to Washington, DC. James W. Wadsworth Jr. and his wife, Alice Wadsworth, who had recently served as president of the District of Columbia Association Opposed to Woman Suffrage, began financially backing the anti-suffrage organization. The couple may have pressured Dodge to step down. With the stronger position of men, usually lawyers and politicians, they added the states' rights argument to the anti-suffrage repertoire. By using this argument, anti-suffragists sought to prevent the federal government from claiming a new power. They referred to the Tenth Amendment to the United States Constitution, which declares that all powers not specified as belonging to the federal government belong to the individual states.

Alice Wadsworth had only become involved in anti-suffragism one year earlier, in May 1916, but during her tenure, the National Association Opposed to Woman Suffrage underwent dramatic changes. Under her leadership, organized anti-suffragism took on a "harsh, almost hysterical tone" as it linked "feminism and socialism to woman suffrage in an evil triumvirate."[63] If the anti-suffrage organization has a reputation for being nasty, it earned it during this period. Reflecting the changes in leadership behavior, the tone and style of the anti-suffrage publication, now called the *Woman Patriot*, changed, as did its format. Increasingly, the antis republished articles from other sources and generated less of their original content.

By February 1918, the founding generation of anti-suffragists had resigned from the movement. While the political machinations that marked the shift in anti-suffrage leadership may never be known, Wadsworth directed a great deal of her animosity toward Carrie Chapman Catt, the president of the National American Woman Suffrage Association. Wadsworth charged Catt with disloyalty to the United States and repeatedly challenged her to debate. Wadsworth then publicly berated Catt for ignoring her invitations. Since about 1907, anti-suffragists and suffragists had engaged in public debates. For example, in 1914, anti-suffragist Lucy Price debated Belle La Follette, the prominent Wisconsin civil rights activist and wife of politician Robert La Follette, in a series of sixty-five debates across Indiana, Michigan, Ohio, and Pennsylvania.[64] However, suffragists had eventually determined that debates did not advance their cause and no longer accepted invitations from anti-suffragists.[65] Catt never did debate Wadsworth.[66]

Meanwhile, anti-suffragists criticized the members of another suffrage group, the National Woman's Party, as they began to picket the White House in January 1917. Then finally, in September 1917, after years of hard work, suffragists won the support of President Woodrow Wilson. The House of Representatives passed the Nineteenth Amendment on January 10, 1918, but it took more demonstrations from the National Woman's Party and the constant lobbying efforts of the National American Woman Suffrage Association for the Senate to finally pass the amendment on June 4, 1919. Anti-suffragists found themselves unable to stem the

FIG. 10

Alice Hay Wadsworth (1880–1960)
Frances Benjamin Johnston
(1864–1952)
Glass negative
c. 1905
8 × 10 cm (3 ¼ × 3 ¹⁵⁄₁₆ in.)
Library of Congress, Prints and Photographs Division, Washington, DC

tide of support for women's suffrage in Congress. Anti-suffragists and suffragists then embarked on a fourteen-month battle over the ratification of the amendment; anti-suffragists used the states' rights argument as they desperately struggled to prevent the ratification of the suffrage amendment.

Marking the upheaval of this time for anti-suffragists, just days after the positive Senate vote, Wadsworth resigned from her position as president of the National Association, claiming illness. One of her colleagues and supporters, Mary G. Kilbreth, a wealthy New Yorker from Southampton who had been president of the Women Voters' Anti-Suffrage Party, sought and won the position as president.[67] She had joined the anti-suffrage movement in New York by 1913 and had increased her involvement by 1916, when she served as chair of the congressional committee of the New York State Association Opposed to Woman Suffrage.[68] With her administration at the national level, the anti-suffrage organization deteriorated even more. All the while, anti-suffragists did everything they could to prevent the enfranchisement of women by federal amendment, ceaselessly claiming that it was a states' rights issue.

The amendment needed thirty-six states to be ratified, and the governor of Tennessee, under pressure from suffragists, called a special session of the legislature to vote for or against ratification. Because of the link between suffrage and abolition, suffragists had had a long and difficult struggle to gain support in the state.[69] Despite the legend that the anti-suffragist Harry T. Burn made a spontaneous decision to endorse woman suffrage during the vote in the Tennessee legislature, suffragists and anti-suffragists had corresponded with him before the legislature met. In fact, Kilbreth had sent Burn at least two telegrams on August 19, 1920, reminding him of his responsibility to the anti-suffrage movement.[70] J. S. Eichelberger, head of public relations for the National Association Opposed to Woman Suffrage and one of the editors for the *Woman Patriot*, testified before a Tennessee grand jury investigation that "improper influences" (implying bribery) had prejudiced the decision of the Tennessee legislature.[71]

Those anti-suffragists still striving to prove the irrationality of women's suffrage changed their name to the "Woman Patriots" in 1921, and the organization essentially became a board of five directors. The group continued to publish the *Woman Patriot*, but content was usually reprinted from other sources and they occasionally skipped issues until they ceased publication altogether in 1932. In addition to focusing on preventing amendments to the United States Constitution, they intensified their efforts to limit the power of people to change the Constitution. They feared the influx of immigrants, any number of whom might have been communists, anarchists, or radicals, and they campaigned to keep "undesirables" out of the United States. Many of the most diehard former anti-suffragists became caught up in the first Red Scare, adding to the sense of hysteria apparent in what remained of the anti-suffrage movement.

Most former anti-suffragists, however, joined the ranks of newly enfranchised women, made use of their political expertise, and voted. Some, like Annie Nathan Meyer, joined the League of Women Voters, the organization descended from the National American Woman Suffrage Association (fig. 11).[72] Alice Hill Chittenden,

FIG. 11

Annie Nathan Meyer (1867–1951)
Unidentified photographer
1920
Gelatin silver print
15.2 × 9.5 cm (6 × 3 ¾ in.)
The Barnard Archives and
Special Collections

once president of the New York State Association Opposed to Woman Suffrage, co-founded the Women's National Republican Club, eventually serving as its president. She focused her activism on instructing women in their political responsibilities. Over the years, anti-suffragists had adapted their activities and strategies for convincing voters that women's enfranchisement would threaten the home, disrupt relations between women and men, oppose the will of God, and destroy the nation. The arguments remained essentially the same until the end of Josephine Jewell Dodge's administration, when the anti-suffragists began focusing on voting as a states' rights issue.[73]

In 1870, when Susan Fenimore Cooper wrote her letter on female suffrage, most people agreed with her, but by the time women won the right to vote, her ideas seemed terribly old-fashioned and rather quaint. That, over the course of a century and a half, we have come to normalize most of Stanton's ideas while we summarily dismiss Cooper's once far more popular ideas allows us to see how much we, as a people, have changed over the previous centuries. Moreover, it helps us consider some of the ways that one's gender, skin color, class status, sexual preference, and place of origin continue to interfere with one's access to full citizenship rights.

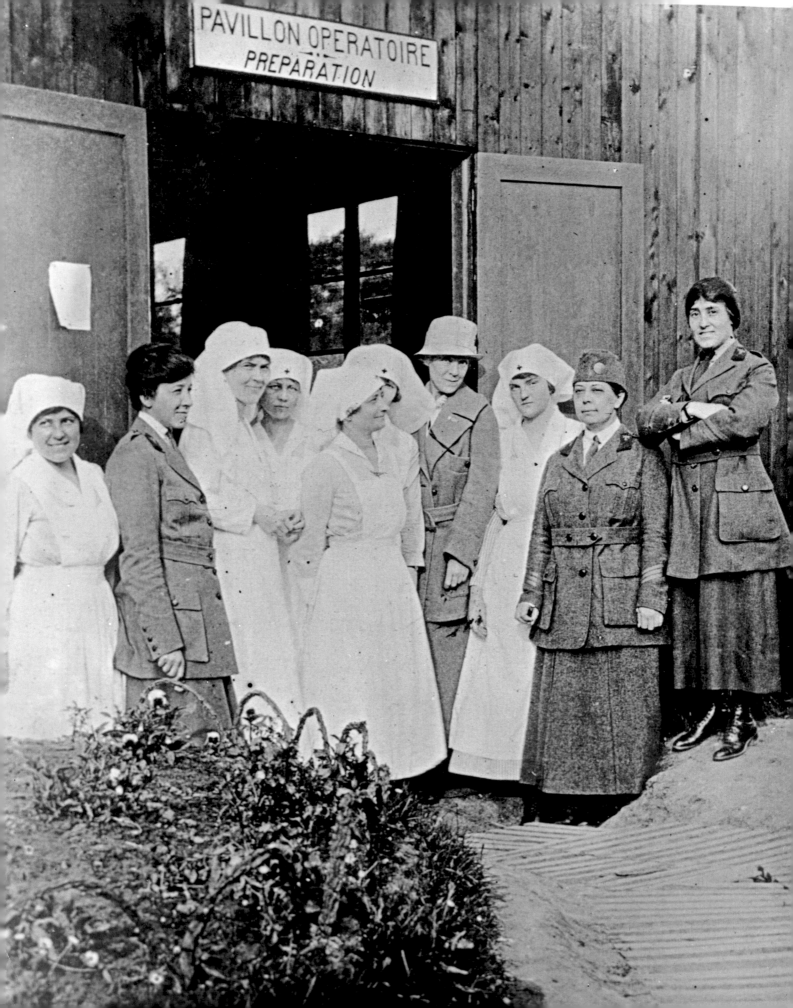

"OÙ SONT LES DAMES?"

SUFFRAGISTS AND THE AMERICAN WOMEN'S OVERSEA HOSPITALS UNIT IN FRANCE DURING WORLD WAR I

Kate Clarke Lemay

FIG. 1

Staff of Military Unit of Women's Oversea Hospitals U.S.A.
Left to right: Dr. Mary
Lee Edward (1885–1980),
Mrs. Raymond Brown (1867–
1956), Dr. Caroline Finley
(1875–1936), and Dr. Anna
Von Sholly (1878–1964)
Unidentified photographer
1918
Glass negative
12.7 × 17.8 cm (5 × 7 in.)
Library of Congress, Prints
and Photographs Division,
Washington, DC

For the first two and a half years of World War I, President Woodrow Wilson adhered to a policy of isolationism, but on discovering that Germany was enticing Mexico into an alliance and promised Arizona, New Mexico, and Texas as a reward, he changed his course.[1] On April 6, 1917, the United States formally declared war. Prior to World War I, Americans lacked a standing army, but within a matter of weeks, Wilson introduced the draft and initiated the training of soldiers as well as the supplying of materiel for war. His administration also created the operational logistics necessary for shipping nearly three million men and women to Europe. For their part, women had to step into the roles that men left behind.

War work, which society deemed necessary, helped women break out of the domestic sphere. World War I shifted women's positions in the United States significantly, and suffragists stood at the forefront of the action.[2] Most suffragists affiliated with the National American Woman Suffrage Association (NAWSA) therefore found themselves in support of the war.[3] They even began to see it as the driving force behind suffrage, the very issue they had been working toward for almost eighty years.[4] Women worked in manufacturing and built machines of war, but suffragists associated with NAWSA pushed even further. The organization's leader, Carrie Chapman Catt, served on the Woman's Committee of the Council of National Defense with another suffragist leader, Anna Howard Shaw.

Catt and Shaw felt that if women were to toil in war work in ways equal to men, then they would prove their citizenship and earn the undeniable right to vote. Shaw declared:

> Our country needs workers, real workers, ready and willing to engage
> in active service, and every able-bodied woman should either be
> engaged in some useful work today or preparing to fill the place of
> some man who will be called in the next roll of the selective draft.

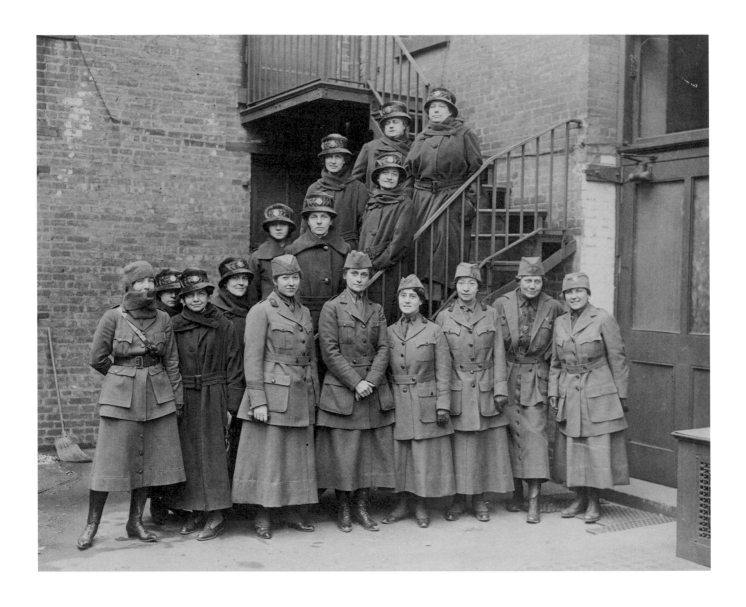

FIG. 2

Therefore, I urge upon women everywhere to discourage multiplicity of organizations and to encourage the training of healthy young women for their country's service, under the woman's committee. They are the nation's army of women defenders.[5]

In the summer of 1917, NAWSA went even further and found a way to send women to France, in the line of danger, rather than have them remain on the home front. NAWSA sponsored a group of American women physicians, who were all suffragists, and created the Women's Oversea Hospitals Unit (figs. 1–2). Amassing a group of approximately one hundred women physicians, nurses, and staff, NAWSA sponsored one of the few all-female medical units sent to France from the United States. The women treated thousands of French soldiers and saved many lives. French soldiers began to ask for them: *"Où sont les dames?"* (Where are the ladies?).[6] With no military training, the American women bravely

The First Contingent of the Women's Oversea Hospitals, Supported by the National American Woman Suffrage Association
Underwood & Underwood
(active 1882–1950)
1917–1918
Gelatin silver print
19 × 24.1 cm (7 ½ × 9 ½ in.)
National Archives at College Park, College Park, Maryland

served in the war—and unfortunately remain, to this day, unrecognized by the US military and government.

For French soldiers, however, these American women were indispensable. Dr. Anna Von Sholly was well aware of how desperately the French military needed medical assistance. She wrote about her experience treating French soldiers: "Some of the sights are pitiful beyond words. Mangled men come in with the trench mud on their boots, some of them never having been seen by a doctor.…They have waited days with no attention." She continued: "The '*médecin chef*' tells us he wants us permanently here. The '*dames américaines*' are in great demand."[7] Likewise, Dr. Mabel Seagrave wrote to her father that, in Labouheyre, a village in southwestern France, the women doctors became known as the "Million dollars," likening them to a lucky charm.[8]

Serving in the war also provided women physicians with ways to expand their medical knowledge and advance in their profession. As male doctors acquired precious medical experience during the war, women knew that they would be at a disadvantage if they were excluded from service. They banded together to ensure that their progress in the professional realm was not inhibited. In June 1917, three hundred women physicians formed the Medical Women's National Association. Historian Kimberly Jensen notes that 58 percent of the women in this new organization registered for war service.[9] However, opportunities to serve in the war were limited, especially for women of color.

Suffragists who were active in NAWSA were almost exclusively white.[10] Black women, although shut out of NAWSA and almost every other organization except for the YWCA and the Red Cross, organized among themselves in order to not be left behind.[11] Rarely were women of color allowed to be sent overseas to offer medical services.[12] Nevertheless, the Red Cross commissioned Dr. Mary L. Brown (1876–1927), a Howard University Medical School graduate, in the spring of 1918. Another black woman, Dr. Harriet Rice (1866–1958), served with the Service de Santé, the French Medical Corps.[13] Suffragists of all races saw the war as an opportunity to prove their deeply rooted social responsibility as Americans, in ways that could not be ignored.[14] Yet in the fight for gender equality, racial equality was left out. Even in 1917, mainstream suffragists remained wary of creating vulnerability on which their anti-suffrage opponents would surely capitalize.

Before the suffragists could recruit female medical professionals, they first had to gather support from those who wanted to see women in such roles. Only then would money or funding follow. With the timely suffrage referendum of November 6, 1917, in New York, which had passed by a surplus of over one hundred thousand votes, NAWSA was able to drum up support.[15] Fittingly, the New York NAWSA chapter capitalized on their success by placing local New York City women doctors as leaders of their suffrage-sponsored unit in France. These women, and the units they built—literally and figuratively—won the respect of both French and American military officials.

Across the United States, chapters of NAWSA worked on several initiatives, including the military census of 1917, which they helped conduct. By

determining how much "manpower" was available—that is, the number of men over the age of sixteen—the national network of women made some of the first steps toward raising an American army.[16] Suffragists also worked coast to coast for Liberty Loans (a war bond that was sold in the United States to support the allied cause). Their efforts were further extended to Herbert Hoover, who, as head of the Food Administration, wrote, "The whole great problem of winning the war rests primarily on one thing: the loyalty and sacrifice of the American people in the matter of food."[17] For his administration, suffragists analyzed food production and food conservation. Finally, suffragists helped to raise a women's "land army" to work on farms; they assisted in the Americanization of aliens; and they formed a committee that monitored equal pay and protection for women in the food industry (fig. 3).[18]

Suffragist war efforts were applauded by Secretary of War Newton D. Baker, who declared, "if all the women in America tonight were to stop doing the things they are doing and the sacrifices they are making to the conduct of this war we would have to withdraw from the conflict."[19] Interestingly, the ambassador of Germany to the United States, Count Johann Heinrich von Bernstorff, was saying almost the exact same thing, but about German women: "In the ultimate analysis, it is the nation with the best women that's going to win the war."[20] (Von Bernstorff was engaged in a diplomatic battle with the British ambassador, Sir Cecil Spring Rice, in trying to influence Wilson and his government's position regarding the war.) On all sides, women were becoming indispensable to a war, that—like suffrage—was to be won at any cost.

At their December 1917 convention, NAWSA pledged $175,000 to sponsor an all-woman team of doctors, nurses, aides, and other support staff to travel to France and help administer medical care to both the war-wounded and the war refugees.[21] The aforementioned Women's Oversea Hospitals Unit was one of many similar groups; approximately twenty-five thousand American women journeyed to France during World War I to support Allied efforts. It was the third group of women to be independently sponsored, and all of its representatives had to be suffragists. Other independent groups of women physicians included a unit sponsored by Anne Morgan at Blérancourt, and one sponsored by Smith College.[22]

Dr. Caroline Sandford Finley, director of obstetrics at the New York Infirmary for Women and Children, organized the overseas NAWSA unit. A graduate of Cornell Medical College, Dr. Finley was in the top ten of her class and had worked her way up to lead the department of obstetrics at the Infirmary (fig. 4).[23] Beginning in July 1917, she and other doctors there, including Anna Von Sholly, Mary Lee Edward, and Alice Gregory—also graduates of Cornell Medical College—had organized fundraising and other logistics (fig. 5).[24] They created a unit nucleus of twelve doctors, twenty-one nurses, and three orderlies, which eventually grew to encompass about eighty staff members. Drawing their example from that of the Scottish Federation of the National Union of Suffrage Societies, which sponsored nine hospital units named the Scottish Women's Hospitals for Foreign Service, the American suffragists hoped to rival them.[25] As the only women-led medical unit operating in the war, the Scottish Women's Hospitals were the logical point of reference.

FIG. 3

Our Right to Democracy!
What's Yours?
Clarence Daniel Batchelor
(1888–1977) for *Woman Citizen*,
December 28, 1918
Photomechanical reproduction
22.9 × 30.5 cm (9 × 12 in.)
Library of Congress, Prints
and Photographs Division,
Washington, DC

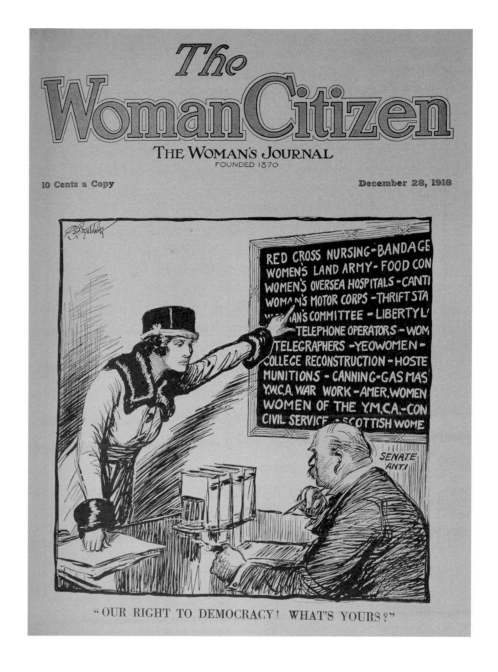

Drs. Finley, Von Sholly, Edward, and Gregory negotiated during the summer months of 1917 with both the American and French governments. American women in the medical profession were legally excluded from the United States Medical Reserve Corps, a peacetime pool of trained civilian physicians.[26] This was the only service branch in which they might have offered their help as medical professionals. During World War I, the US Army never sanctioned the enlistment of women, although the US Navy did (approximately eleven thousand joined in 1917), as well as the Marine Corps in 1918.[27] As historian Ellen S. More points out, "The War Department's refusal to accept women physicians meant that women would have to find war work through private philanthropy, not the military."[28] Finley and her group of women physicians, eager to gain experience in treating the war's wounded, would

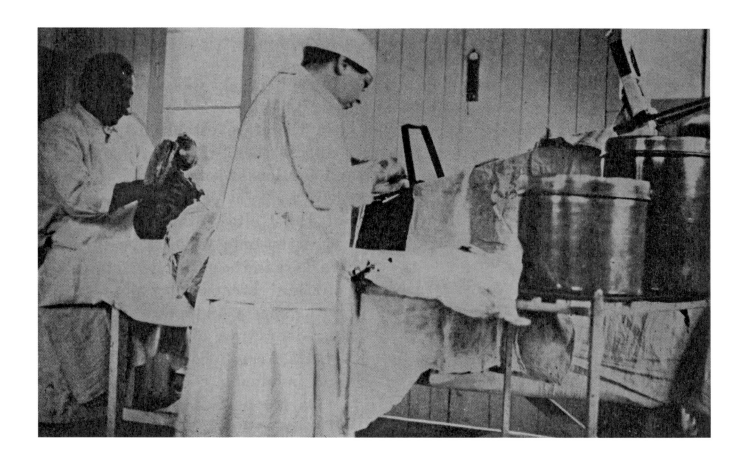

not give up. By the end of the summer, they were accepted into the Service de Santé. French officials arranged for Finley and Gregory, the two most senior women, to be paid the equivalent of a French Army Captain.[29] The other physicians and nurses were to be paid the equivalent of a second lieutenant's salary—approximately $100 a month; and the artisan members were to receive a monthly salary of between $30 and $50.[30]

Not all members of NAWSA supported the idea of independently sponsoring an all-woman unit of medical professionals to serve in France. For example, the president of Bryn Mawr College, M. Carey Thomas, told the *New York Times* that she thought the US Army would allow women physicians to serve "the moment the supply of men doctors gives out . . . until then I think it very reasonable not to have women in the army camps."[31] Katrina Brandes Ely Tiffany, the chairwoman of the NAWSA fund-raising and advisory committees for the Women's Oversea Hospitals, dryly responded, "I hate to think that the American government will accept the services of women who are anxious to help their country only when the last available man gives out."[32] Many women agreed with her, one calling out from the gallery, "Sometimes the women have to take a step in advance of their government."[33]

When Katrina Brandes Ely married Charles Lewis Tiffany, she became an active board member of the New York Infirmary for Women and Children (fig. 6). She advised the hospital's women doctors when they were planning to set up a

FIG. 4

Dr. Caroline S. Finley (1875–1936) *Operating on a Fracture*, from the pamphlet *Women's Oversea Hospitals, U.S.A.*
Unidentified photographer
1919
The University of North Carolina at Greensboro, University Libraries; World War I Pamphlet Collection, Martha Blakeney Hodges Special Collections and University Archives

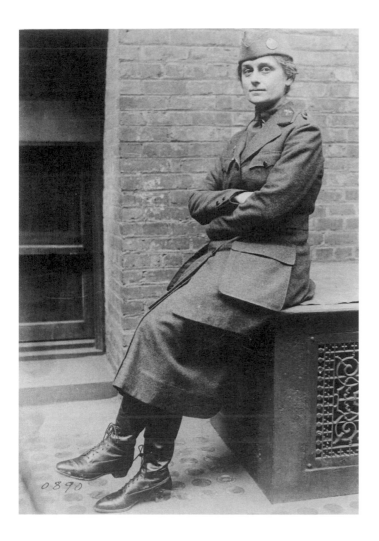

FIG. 5

Dr. Alice Gregory (1876–1953)
of the Women's Oversea Hospitals
Unit, in Uniform
Underwood & Underwood
(active 1882–1950)
1917–1918
Gelatin silver print
10.8 × 15.3 cm (4¼ × 6 in.)
National Archives at College
Park, College Park, Maryland

hospital unit in France. Neither Tiffany's husband nor her famous father-in-law, Louis Comfort Tiffany, supported women's suffrage, but both of her sisters shared her suffragist views and volunteered in France during World War I. Katrina Tiffany, who had worked on the Women's Oversea Hospitals Unit since its inception, had become convinced that there was a dire need for women in the war.[34]

Although the Red Cross eventually incorporated women's organizations into its war relief initiatives, it still held a very conservative stance when the Women's Oversea Hospitals Unit was formed at the NAWSA meeting in December 1917.[35] Tiffany described the tense relationship between the two groups at that time, noting, "Suffragists do not like the Red Cross attitude toward women doctors. They don't like the attitude toward women in general." She further explained that "it is only recently the Red Cross would accept the services of women for civilian relief, and they won't have anything to do with women doctors at all."[36] Tiffany was furious that the Red Cross and the War Department refused to collaborate with the group of women doctors from the New York Infirmary Hospital, but she did not let it stop her. "There was nothing for it," she said, "but to turn to our own organization of women."[37] The advantage of working in the Women's Oversea Hospitals Unit was that the organization was autonomous and self-directed.

Tiffany was right to warn that men would be overworked. Historian Lettie Gavin describes the American male doctors as "close to exhaustion in the final months of the war, and they became easy prey for the influenza epidemic that swept the world in the autumn of 1918. . . . But although the Army was desperate for help, female doctors were permitted only as 'contract surgeons,' or civilians on hire, a designation that made use of their talents and training but withheld military rank, pay and benefits."[38] Fifty-five women doctors were hired as contract surgeons, but only eleven were sent overseas to serve in army base hospitals.[39]

Defying discrimination, NAWSA women were determined to sponsor an all-women medical team. One volunteer dentist for their staff, Sophie Nevin, presumably was a member of her local Brooklyn NAWSA chapter. A product of the local Brooklyn community—Nevin was educated in Brooklyn public schools and graduated from the Brooklyn College of Dental and Oral Surgery in 1913—she was thrilled to receive the opportunity to go abroad. However, she was forbidden to do so because her brother was already serving.[40] Only when her congressman argued that

she be released from the regulation withholding her passport could she make the trip. (Female relatives of male soldiers who were enrolled in the military were not allowed passports, making it impossible for any organization, including the Red Cross, YMCA, Salvation Army, and the Knights of Columbus to enroll women for service in France.) In preparation for her trip, Nevin studied French and knitted four sweaters and two wristlets, most likely for her brother. She said, "This is my way of 'doing my bit.' From the beginning of the war I have wanted to go over. I had enlisted with the National League for Women's Service with the American Ambulance Corps, the American Red Cross, and even the British Red Cross, but to my great disappointment nothing came of it all. Then this unit was organized and you may be sure I wasted no time in becoming part of it."[41]

Not all women in the medical profession were committed to suffrage, but they were committed to furthering their professional reach, including the opening of women's medical colleges, hospitals, and dispensaries; caring for the health of women and children, especially the poor; and joining local women's clubs.[42] However, to be included in the NAWSA group, one had to be a suffragist. Dr. Mabel Seagrave volunteered with the Women's Oversea Hospitals Unit because she felt that by participating in professional groups, she could help promote the acceptance of women physicians (fig. 7).[43] Seagrave attended the Johns Hopkins University for Medicine and Surgery, graduating in 1912. She was awarded the Medal of Valor (Médaille des Services Militaires Volontaires Argent) from the French government for her outstanding services in treating patients with influenza. Before leaving for France, Seagrave anticipated what she would learn abroad and felt confident that there would be "a wonderful advance in surgical knowledge through the enforced operations made necessary by unusual wounds." She continued enthusiastically,

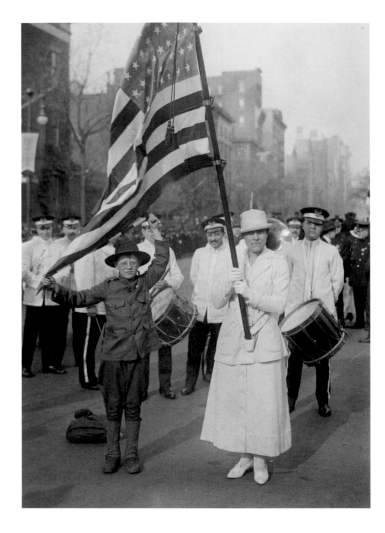

FIG. 6

Katrina Brandes Ely Tiffany
(1875–1927)
Bain News Service
1917
Glass negative
12.7 × 17.8 cm (5 × 7 in.)
Library of Congress, Prints and Photographs Division, Washington, DC

> Just to see such cavities opened up will give the surgeon a chance to demonstrate things which heretofore have been more or less experimental. Experience gained now is going to make it possible to introduce great alleviations of suffering to the race. Military surgery in France today is of the greatest educational value, and an opportunity all surgeons must covet.[44]

FIG. 7

Dr. Mabel Seagrave (1882–1935)
Unidentified photographer
1915
Gelatin silver print
7.6 × 7 cm (3 × 2 ¾ in.)
University of Washington
Libraries, Special Collections

Dr. Seagrave was aware that she had been granted an opportunity that other physicians would eagerly embrace (fig. 8).

Supporting suffrage was required of the members of the all-woman units. Even while in France, they attended lectures on suffrage and the power of the vote. One woman, serving the Labouheyre refugee hospital, lectured on venereal diseases, attributing afflictions to the "double standard of morality." Dr. Seagrave, who attended the lecture, reported that "only [with] this one ballot would women protect their boys from alcohol and immorality . . . it was time for women to go to the polls and support the small percent of men who are moral, for so by doing they would help protect the foundations of the republic of the home."[45] Nevertheless, during the meeting of the National Board of NAWSA in December 1917, suffragists had voted to withhold the word "suffrage" in the name of the Women's Oversea Hospitals Unit, for fear that it would "queer it," meaning that people might find an open affiliation between the unit and suffrage off-putting.[46] However, the women doctors were expected to speak for the cause. Dr. Finley told a reporter that the all-woman hospital units in France were doing "a fine thing for suffrage."[47]

As the war dragged on, millions of men fought and died in the trenches, and the need for medical help in France became dire. By January 1918, France's economy, infrastructures, and industry were in ruins. Despite the patriarchal social normative that would continue to characterize France (women were not permitted to vote until 1946), French leaders knew their country required immediate help. Women physicians were not their choice, but they were in no position to discriminate. The suffragists knew this and even assessed, "The fact that the French War Department accepted all-women units was not due to the French having any higher regard for women surgeons than is the case with the United States Army authorities but simply that their need was greater."[48]

The suffragists capitalized on the opportunity to grow their units in France. Dr. Finley had been in France since November 1917—just after the states of New York, North Dakota, Nebraska, Ohio, Indiana, and Rhode Island each had secured presidential suffrage for women. She recognized the chance to build on the momentum of women's empowerment back home and cabled NAWSA headquarters in early 1918: "Great need for unit. Civilians taken many miles for hospital treatment. Must do much surgery. Need specialists, several dispensaries, ambulance service."[49] With specialists for different diseases and top-notch medical equipment, the Service de Santé advised the women that having a unit with a ground hospital would be more preferable to having individual physicians travel to people in villages.

Finally, the Women's Oversea Hospitals Unit was put into action. The week of February 10, 1918, thirty-one women crossed the Atlantic, including six doctors: Drs. Finley, Gregory, Von Sholly, and Edward, Dr. Marie K. Formad (1861–1944), and Dr. Olga R. Povitsky (1877–1948); a master plumber, Helen Isabel O. Griffiths; an electrician, a mechanic, a carpenter; a dentist—the aforementioned

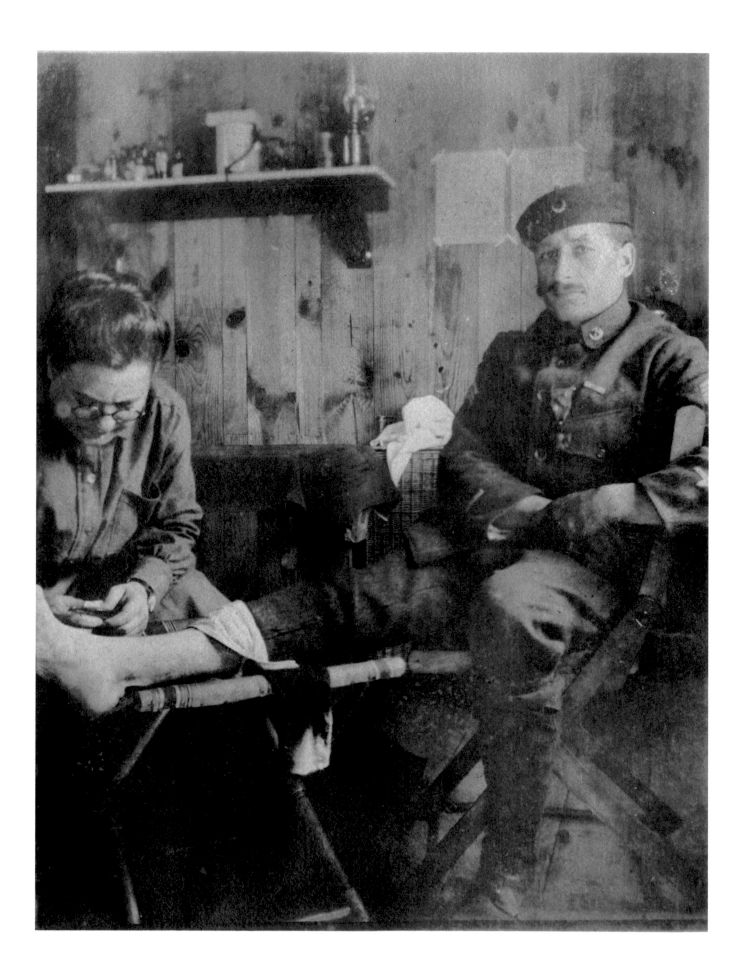

FIG. 8

*Dr. Mabel Seagrave Operating on
a Soldier*
Unidentified photographer
ca. 1918–1919
Gelatin silver print
11 × 8.3 cm (4 ⅜ × 3 ¼ in.)
University of Washington
Libraries, Special Collections

Dr. Sophie Nevin—a seamstress, two drivers, and a number of nurses and aides. Without losing any time, they established the first units by March. One unit for treating military wounded was based in Château Ognon, near Compiègne, while another that cared for the women and children refugees of war was set up in Labouheyre, near Bordeaux.[50]

Originally, it was anticipated that sixty more doctors and nurses (all women) would soon join the first unit and help staff a hospital of fifty beds in Guiscard, in the Department of Aisne (the department just east of the Oise, where the hospital of Château Ognon was set up).[51] However, because the Germans had already advanced into Guiscard when the American women arrived, Dr. Finley's unit of twelve women retreated to Château Ognon. There, they first worked side by side with French military surgeons who were reportedly astonished to find that their American volunteers were women. The *Woman Citizen* reported that the men decried the very notion: "'Women surgeons!' They roared derisively. 'Think of sending women as military surgeons!'"[52] However, within thirty-six hours of their arrival, the women treated 650 cases.[53] Dr. Formad, who had practiced gynecology in Philadelphia for years, described how difficult the situation was.[54] She related,

> We had not a thing to work with, as the hospital had not yet been completed, but the ambulance drivers refused to take the men anywhere else, saying they had been driving around since three o'clock in the afternoon. So we took them in and did the best we could. . . . It was a very sad experience. . . . All we could do was to dress their wounds and put them to bed, giving them what little nourishment we had in the shape of beef tea.[55]

In war, even a doctor as knowledgeable as Formad had little comparative experience.

While adjusting to the circumstances of war during their first several months of service, the women doctors in France worked alongside French doctors before going on to lead their own unit.[56] By late May 1918, however, the hospital in Château Ognon accommodated one thousand beds.[57] Having won over the French military surgeons, Dr. Finley moved up from assisting Dr. Picot, a male French doctor, on fractures to become the director of a pavilion devoted to "shell shock," the term used for soldiers suffering from severe post-traumatic stress disorder.[58] Drs. Von Sholly and Edward were placed in charge of post-operative wards, while most of the nurses were used as anesthetists.[59]

Interestingly, the women slept in a salon that was the picture of French domesticity for the respectable woman. Dr. Edward described the Château as being replete with fine objects, including "velvet tapestries on the walls, and [the] most exquisite chapel and quaint stairways and every luxury of the aristocracy." Even as they worked among such splendor, the women took serious note of only one thing: "luxury . . . but no bathrooms," Edward wrote ruefully.[60]

On June 23, 1918, the hospital for women and children refugees of war opened in Labouheyre (fig. 9).[61] For this hospital, the all-woman unit built fifty

barracks from scratch, only accepting assistance in the framing.[62] German prisoners of war framed the barracks, but the American women outfitted the units. The women took pride in being self-sufficient, at one point building their own incinerator and, when their truck broke down, "disdainfully (and politely) declining masculine aid" when it was offered (fig. 10).[63] Dr. Seagrave and Dr. Formad, who by then had traveled down from Château Ognon, were the main physicians for the camp. Dr. Seagrave, who was hired as an ear, nose, and throat specialist, was likely in awe of Dr. Formad, whom she described as "one of the leading surgeons in the USA . . . about fifty five years old and . . . a very tall, big woman."[64]

Within a month, the doctors had established five hundred beds and were serving ten thousand refugees from the department of Landes (fig. 11). Dr. Formad observed: "It is remarkable to see the confidence the French have in us women physicians, considering that they have so few. We had no difficulty whatsoever in getting a woman to consent to operation for her self or children."[65] Her recollections primarily focus on the medical details of her work as she outlined the many cases of fractures and disease, notably influenza, which had deadly repercussions. The only two women of the unit who died, Winifred Warder and Eva Emmons, both succumbed to the flu in Labouheyre by early October 1918.[66]

The women medical professionals admitted to experiencing shock and trauma, but it seems likely that their reports of such were not permitted to be published. Fannie Marion Gregory, a nurse and the sister of Dr. Alice Gregory, also worked in Labouheyre caring for French civilians and United States Army engineers. She focused less on the medical experience and more on the trauma of war when she described the circumstances: "One had to try to get used to seeing maimed men everywhere. At first it was heartrending for the newcomer, but it was beautiful to see the care and devotion shown the returned *mutilés* [disabled people who had lost limbs] by everyone."[67] Later in 1918, she wrote of her experiences under fire, describing: "The night raids were horrible. No words can convey the sickening sensation of hearing the explosion of a bomb. The firing of the defense is nerve-racking but when the horrible bomb comes one's heart is cold at the thought of what it means."[68] In her assessment of the wartime writings of the American nurse Ellen N. La Motte, historian Margaret L. Higonnet writes, "It is easy to understand why these stories by an American nurse were suppressed during the war. They describe far too truthfully for the interests of war propagandists the human wreckage that was carried off the battlefield into the squalor of a French field hospital."[69] The trauma was real. Yet the NAWSA women doctors forged on, folding themselves into the war as best they could, in hopes for national success in suffrage in the form of the Nineteenth Amendment.

French authorities soon depended on the American women. Probably by the spring of 1918, they asked NAWSA to set up a gas unit for first aid work for gas victims of the front lines in the eastern and northern parts of France. Suffragist doctors soon found themselves in Reims and in Nancy operating the gas recovery units. The mobile gas unit in Reims (which could easily move, according to how the war's front lines moved) was established by late August 1918. Directed by Dr. Marie

FIG. 9

*Nursing Staff and Ambulances
outside of Hospital Buildings in
Labouheyre*
Unidentified photographer
1918–1919
Gelatin silver print
16.8 × 12.1 cm (6 ⅝ × 4 ¾ in.)
University of Washington
Libraries, Special Collections

FIG. 10

*Truck Containing Bath Equipment
and Boiler*, from the pamphlet
Women's Oversea Hospitals, U.S.A.
Unidentified photographer
1919
The University of North
Carolina at Greensboro,
University Libraries; World
War I Pamphlet Collection,
Martha Blakeney Hodges Special
Collections and University
Archives

FIG. 11

Operating Room in Hospital, from
the pamphlet *Women's Oversea
Hospitals, U.S.A.*
Unidentified photographer
1919
The University of North
Carolina at Greensboro,
University Libraries; World
War I Pamphlet Collection,
Martha Blakeney Hodges Special
Collections and University
Archives

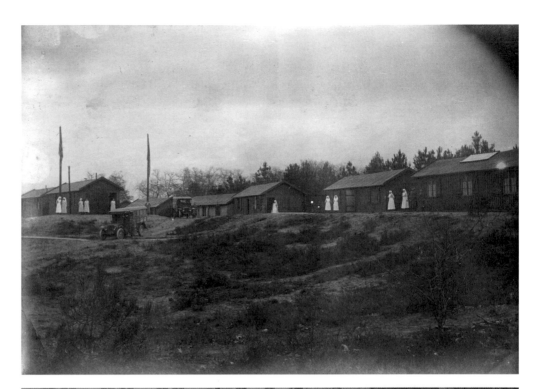

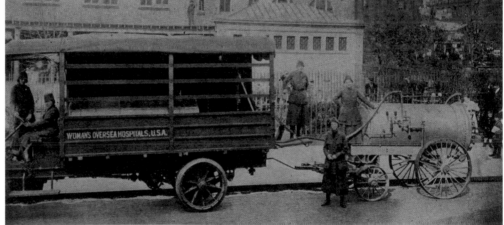

Louise Lefort, a specialist in skin diseases, the unit held six hundred beds for soldiers. One estimate places between fifteen thousand and twenty thousand men as having been in Lefort's care in Reims.[70]

Before the war, Dr. Lefort had been the attending physician at Bellevue Hospital Dispensary, and earlier in her career, she had served as a district physician for the city of Newark, New Jersey.[71] Accompanying Dr. Lefort to Reims were Dr. Adah McMahon (of Lafayette, Indiana); Dr. Irene May Morse (of Clinton, Connecticut); Dr. Elizabeth Bruyn (of Brooklyn, New York); Dr. Alice Flood (of New York); and Mrs. Anna Ellis (of Westerly, Rhode Island) (fig. 12).[72] Their unit was reportedly the first of its kind, and they learned through experience—some, like Dr. Morse, even suffering from gas poisoning themselves.[73]

With such important roles in the war, suffragists were convinced that the macro-experiment of women assuming leadership under perilous circumstances would demonstrate, unquestionably, that women deserved the right to vote.[74] NAWSA leaders in New York heard reports of the women in France and "lifted [their heads] with a renewed sense of pride in the splendid achievements of the women who are representing the suffragists of America in active service at the war front."[75]

FIG. 12

Medical Staff of Gas Unit, from the pamphlet *Women's Oversea Hospitals, U.S.A.*
Left to right: Dr. Alice Flood (life dates unknown), Dr. Marie Louise Lefort (1875–1951), Dr. Irene May Morse (1870–1933), Dr. Elizabeth Bruyn (1878–?), and Dr. Adah McMahon (1869–1942)
Unidentified photographer
1919
The University of North Carolina at Greensboro, University Libraries; World War I Pamphlet Collection, Martha Blakeney Hodges Special Collections and University Archives

FIG. 13

Dr. Nellie N. Barsness
(1873–1966)
Unidentified photographer
1918, printed later
Gelatin silver print, after original
8 × 17.6 cm (3 ¹⁵⁄₁₆ × 6 ¹⁵⁄₁₆ in.)
Legacy Center Archives, Drexel
University College of Medicine,
Philadelphia

Dr. Nellie Barsness (of Saint Paul, Minnesota), who had trained to be an X-ray specialist but instead worked as an ophthalmologist—because that was where she was needed most—also led the hospital in Nancy (fig. 13).[76] Dr. Barsness served as director of a gas unit in Cempuis, where she was exposed to hazardous gas and earned one of the highest military recognitions of the French government, the Légion d'honneur du sous-officier, or the Legion of Honor for a Non-Commissioned Officer.[77] Regrettably, the American government never recognized Dr. Barsness for demonstrating bravery and valor during the war while sustaining wounds.

Dispensary units operated out from the Nancy headquarters and into villages such as Neuve Maison, Lunéville, Épinal, and Château Salins.[78] Its mobile dispensaries managed 180 medical inpatients and 5,280 dispensary patients, delivered seventeen babies, and performed ninety-five operations.[79] By September 1919, Lefort founded the American Memorial Hospital in Reims, where she served as director from 1925 to 1938.[80]

For the American women, these experiences abroad offered invaluable professional growth. While it is true that by 1900, most women physicians trained in coeducational medical schools, they were routinely excluded from internships and hospital staffs.[81] American women physicians were used to being outnumbered by men; for example, in 1915, only 2.6 percent of medical graduates in the United States were women. It was only when they went abroad that these seemingly exotic American expatriates were allowed to become crucial components of wartime medical service.[82]

Dr. Sophie Nevin, the dentist, treated some American soldiers while she was waiting for the refugee hospital in Labouheyre to open.[83] When Nevin realized that the men of the Fourth Battalion, Twentieth Engineer Regiment stationed in Mimizan had no dentist, she began providing dental care, using the equipment of the American army.[84] Reportedly, even after the army dentist finally arrived, the officer in charge asked her to stay on.[85] One source lists her as caring for eleven thousand American soldiers in four months, from April through July 1918, at which time she became ill from influenza, suffered "an affliction of the throat," and was consequently sent home to the United States.[86] Even American military units took advantage of the medical services the women doctors provided. Somewhat surprisingly, given the hard line drawn by the officials stateside, Dr. Alice Gregory, who had helped start up the original hospital in February 1918, was embedded with an American dressing station by July 1918.[87]

On September 3, 1918, the French government recognized three American women physicians—Dr. Caroline S. Finley, Dr. Mary Lee Edward, and

Dr. Anna Von Sholly—and one nurse, Jane McKee, decorating them with the most esteemed French military medal of valor, the Croix de Guerre (fig. 14). The women were promoted to First Lieutenants in the French Army. The French citation for bravery for Dr. Finley read, "Dr. Finley, a woman remarkable for her sterling moral and professional qualities, has rendered the greatest services to the French and American wounded. She is distinguished, with all her staff, for her courage and her scorn of danger during a bombardment of the hospital by enemy aviators."[88] During the bombardment of Château Ognon, eighteen patients were wounded, but the American women "showed their mettle. None thought of seeking shelter and instead went to the succor of the wounded."[89] Dr. Edward wrote of her spring 1918 experience at Château Ognon and recalled the Germans' last offensive, the Third Battle of the Aisne. By lobbing three thousand pieces of artillery there between May 27 and June 16, 1918, the Germans made their most important advance into France since 1914. However, they moved too quickly, and their supply lines could not support their rapid progress. Then, in August, the Americans were finally able to shift approximately one million men to the front, and the Germans lost their advantage.

Immediately after Dr. Edward and her colleagues endured one of the worst twenty-four-hour periods of artillery shelling of the war, she wrote, "May the 28th, operated 5–8 pm, then 9–3 am. Wounded were arriving. . . . Bombs shook the operating room theatre and the barracks. Cannons roared and planes vibrated the atmosphere." Later, on June 13, she wrote: "operated 16 hours on major cases, so big one could not believe they would survive." Two days later she recounted the bombing that she, herself, had survived: "The hospital was quiet. However, near daybreak, chaos disrupted, as our hospital had been bombed. Many of the dead lay in a crater, and body parts were strewn about. Thirteen orderlies and stretcher bearers were killed, 11 were wounded."[90] Although she didn't know it then, in fact, Dr. Edward was witness to the collapse of the Allied front, where there were only very poor defenses put into place. Germany broke through the Allied lines between Soissons and Reims, at the cost of six British divisions. The Germans were then even closer to Paris, which they had been shelling with long-range guns since March. Only months later, in August 1918, when, finally buoyed by American reinforcements, the French finally did ward off the Germans. The German army never made another major offensive again in the war.

For their heroism under fire, the American women physicians had to content themselves with recognition by the French, only. The American government ignored the women doctors' presence in France. Even American professional associations were practically silent; only in one instance, in tiny writing near the end of an issue, does the *Journal of the American Medical Association* report on the valorous medal the three doctors and one nurse received, for "excellent surgery performed under heavy barrage in France."[91] By contrast, one almost cannot imagine the movies that would have been made, the acclaim given, and the books written about these actions—had they been carried out by men.

After the war's end in November 1918, the women physicians requested permission to continue their hospital units in active service for at least six months, a

FIG. 14

Drs. Finley, Edward, Sholly, and Miss McKee Receiving the Croix de Guerre, from the pamphlet *Women's Oversea Hospitals, U.S.A* Unidentified photographer
Left to right: Dr. Caroline Finley (1875–1936), Dr. Mary Lee Edward (1885–1980), Dr. Anna Von Sholly (1878–1964), and Jane McKee
1919
The University of North Carolina at Greensboro, University Libraries; World War I Pamphlet Collection, Martha Blakeney Hodges Special Collections and University Archives

request NAWSA granted.[92] They visited war-torn regions of Soissons, Couey, Compiègne, and Laon. In Laon, Dr. Anna Von Sholly wrote a letter describing how "the fields showed the heavy scars of the fight; the mounds of tossed-up brown earth looked like the billows of the seas in a stiff southwester."[93] As one NAWSA representative reported, "The French are begging us to remain, and we are glad to do all we can."[94] The hospital unit was sent to Germany with the French Army of Occupation to work with returned prisoners of war, but when they reached Metz, the serious and innumerable cases of soldiers with pneumonia and influenza held them there. By the end of January, the Service de Santé transferred Dr. Finley and her unit to Cambrai to offer medical care to the refugees and repatriates, who were returning at the rate of 1,000 to 1,500 a day, most in terrible health.[95] Soon, the women established two more hospitals in Caudry and Le Cateau after requests by the American Commission for Belgian Relief and British medical personnel. These last efforts were committed to women and children, most of whom, due to the war's devastation in France, had had no medical services during the war (fig. 15).[96]

NAWSA's experiment was a success because the French came to depend on the women doctors. Subsequently, American suffragist leaders pointed out that the United States ought to reconsider its policy of excluding women from the army medical corps.[97] More than a hundred American women had been decorated by foreign governments for their military service in World War I, and American

FIG. 15

In the Children's Ward, from the pamphlet *Women's Oversea Hospitals, U.S.A.*
Unidentified photographer
1919
The University of North Carolina at Greensboro, University Libraries; World War I Pamphlet Collection, Martha Blakeney Hodges Special Collections and University Archives

suffragists noted this as one more example of American women's unequal treatment.[98] In a report of the Women's Oversea Hospitals Unit, we learn that suffragists raised $200,000 for the effort, and at the end of the war, $35,000 remained. In 1919, this amount was divided equally between the Women's Oversea Hospitals and the American Hospital for French Wounded based in Reims.[99] At the American Hospital, Dr. Marie Louise Lefort was in charge of fifteen other women, including Dr. Alice Flood, and participants of the Women's Oversea Hospitals and the American Hospital for French Wounded in Reims.[100] NAWSA formally dismantled the Women's Oversea Hospitals Units on September 1, 1919.[101]

While serving in France during the war, the American suffragist doctors and nurses gained invaluable experience in their medical professions, and they went on to become pioneering women in their fields. Dr. Mabel Seagrave was elected to the American College of Surgeons in 1928 and remained active in the Women's Overseas Service League and the Women's University Club of Seattle throughout her career. At the time of her death in 1935, she was chief of staff at Seattle General Hospital. Similarly, Dr. Nellie Barsness continued working in her gas unit in Nancy after the war. On returning to the United States, she achieved a celebrated career as an ear, nose, and throat specialist. She directed state health initiatives in Minnesota and was the regional director for the Northwest Central region of the American Medical Women's Association. Dr. Irene Morse became the first woman professor at the University of Wyoming in 1922 — just before she died from the consequences of the gas exposure she suffered during the war while tending to gassed soldiers.[102]

Almost unbelievably, most of these women doctors and their incredible war services have been lost to history. Not a single female physician or nurse described in this essay has ever been recognized for valorous service by the American

military. Practically no information exists about the women doctors and the Women's Oversea Hospitals Unit outside of the rare obituary and the self-published pamphlet authored by a NAWSA volunteer (fig. 16). However, the wartime accomplishments of these women leave no question regarding the degree to which their trailblazing actions and experiences merit recognition in American history. If women are not treated equally in the historical account, then we have little hope for equality in the present or in the future. Historians must uncover and remove *women's history* from the margins—and boldly assert its place within *American history*.

FIG. 16

Cover of *Women's Oversea Hospitals, U.S.A.*, a pamphlet produced by the National American Woman Suffrage Association in 1919
25 × 16.5 cm (9 5/8 × 6 1/2 in.)
The University of North Carolina at Greensboro, University Libraries; World War I Pamphlet Collection, Martha Blakeney Hodges Special Collections and University Archives

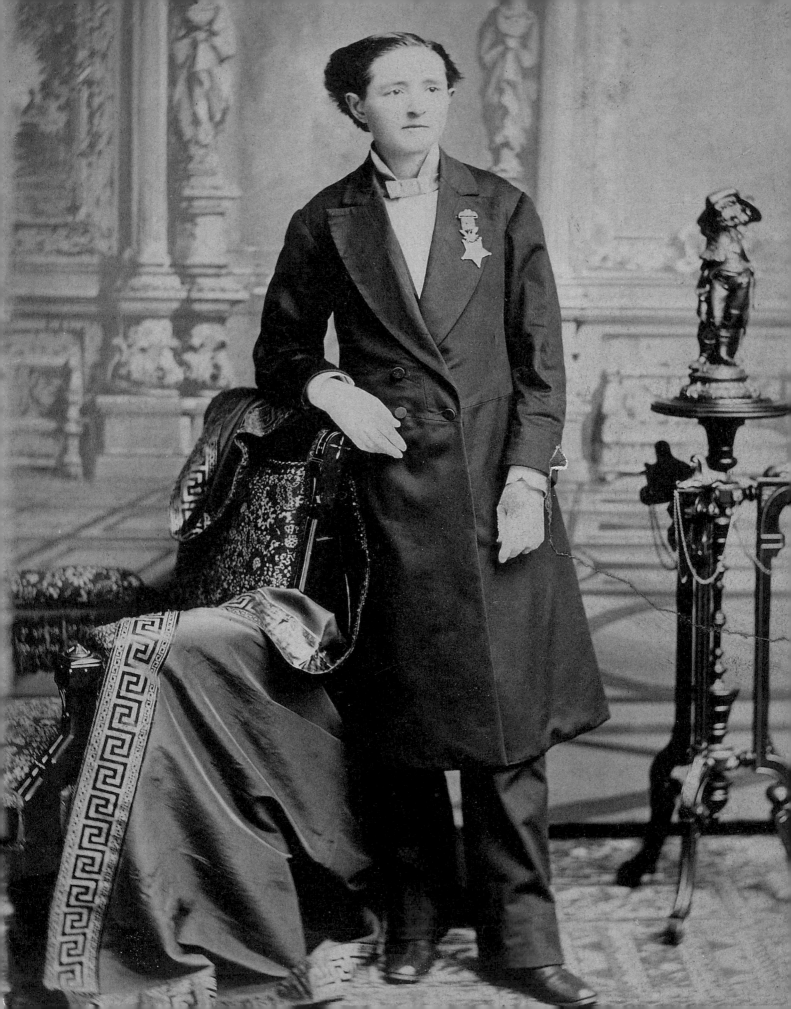

I
RADICAL WOMEN,
1832–1869

In 1832, when more than a million women were enslaved in the United States, the abolitionist newspaper *The Liberator* featured an illustration of an African American woman in chains, kneeling with her hands clasped high in supplication (cat. 1). The galvanizing image appeared in the paper's "Ladies' Department" section and was framed by the printed question, "Am I Not a Woman and a Sister?"[1] Henceforth, representations of the female slave became powerful abolitionist tools in the United States as they attracted more women to join the movement.

Inspired by Josiah Wedgwood's popular medallion for the British abolitionist movement ("Am I Not a Man and a Brother?" ca. 1787), the "Am I Not a Woman and a Sister?" image was so effective on its audiences that the Philadelphia Female Anti-Slavery Society eventually used it for their seal.[2] According to *The Liberator*, the portrayal channeled the moralizing "woman's influence" of the home to "effect an immediate and total restoration of inherent and just rights."[3] It was thought that women, in their domestic sphere, had in their grasp ways to mold young minds and to convince future generations that "the enslaving of human beings is the worst of crimes."[4] The image of the kneeling woman was reproduced on medals that abolitionist women often sold at anti-slavery fairs, using the proceeds to fund their cause (cat. 2).[5]

Sarah Grimké, one of the most prominent and radical anti-slavery writers, called these images "powerful auxiliaries in the cause of emancipation, and [we] recommend that these 'pictorial representations' be multiplied . . . so that the speechless agony of the fettered slave may unceasingly appeal to the heart of the patriotic, the philanthropic, and the Christian" (see fig. 5 in Tetrault).[6]

The women's suffrage movement in the United States has its roots in the radical women reformers of the anti-slavery movement, who created their own societies. Indeed, abolitionist women of the early nineteenth century were among the first to gain experience in activism. They organized among themselves, wrote reforms, and advocated through public speaking. By 1838, more than one hundred female abolitionist auxiliaries were devoted to the fight against the sin of slavery.[7]

The most important springboard for women organizing the abolitionist movement was the Anti-Slavery Convention of American Women in 1837, which drew members from twenty-five women's abolitionist societies. This was probably the first national meeting of American women. There, Angelina Grimké announced

See cat. 21.

IMMEDIATE ABOLITION.

Since the deception practised upon our first parents by the old serpent, there has not been a more fatal delusion in the minds of men than that of the gradual abolition of slavery. *Gradual abolition!* do its supporters really know what they talk about? Gradually abstaining from what? From sins the most flagrant, from conduct the most cruel, from acts the most oppressive! There is not a clergyman, of any denomination, who would not be instantly ousted from his pulpit were he to inculcate such advice. Do our gradualists mean, that slave-dealers shall purchase or sell a few victims less this year than they did the last? that slave-owners shall liberate one, two or three out of every hundred slaves during the same period? that slave-drivers shall apply the lash to the scarred and bleeding backs of their victims somewhat less frequently? Surely not—I respect their intelligence too much to believe that they mean any such thing. But if any of the slaves should be exempted from sale or purchase, why not all? if justice require the liberation of the few, why not of the many? if it be right for a driver to inflict a number of lashes, how many shall be given? Do gradualists mean that the practice of separating the husband from the wife, the wife from the husband, or children from their parents, shall come to an end by an almost imperceptible process? or that the slaves shall be defrauded of their just remuneration, less and less every month or every year? or that they shall be under the absolute, irresponsible control of their masters? Oh no! I place a higher value upon their good sense and morality than this! Well, then, they would immediately break up the slave traffic—they would put aside the whip—they would have the marriage relations preserved inviolate—they would not separate families—they would not steal the wages of the slaves, nor deprive them of personal liberty! This is abolition —*immediate abolition.* It is simply declaring that slave owners are bound to fulfil—now, without any reluctance or delay—the golden rule, namely, to do as they would be done by; and that, as the right to be free is inherent and inalienable in the slaves, there ought now to be a disposition on the part of the people to break their fetters. All the horrid spectres which are conjured up, on this subject, arise from a confusion of the brain, as much as from a corruption of the heart.

I hold the proposition to be self-evident, that no transfer, or inheritance, or purchase, or sale of stolen property, can convert it into a just possession, or destroy the claim of its original owner —the main being universally conceded to be just, that the receiver is as bad as the thief. I utterly reject, as delusive and dangerous in the extreme, every plea which justifies a procrastinated and an indefinite emancipation, or which concedes to a slave owner the right to hold his slaves as *property* for any limited period, or which contends for the gradual preparation of the slaves for freedom; believing all such pretexts to be a fatal departure from the high road of justice into the bogs of expediency, a surrender of the great principles of truth, an indefensible prolongation of the curse of slavery, a concession which places the guilt upon any but those who incur it, and directly calculated to perpetuate the thraldom of our species.

Immediate abolition does not mean that the slaves shall immediately exercise the right of suffrage, or be eligible to any office, or be emancipated from law, or be free from the benevolent restraints of guardianship. It contends for the immediate personal freedom of the slaves, for their exemption from punishment except where law has been violated, for their employment and reward as free laborers, for their exclusive right to their own bodies and those of their children, for their instruction and subsequent admission to all the trusts, offices, honors and emoluments of intelligent freemen. Emancipation will increase and not destroy the value of their labor; it will also increase the demand for it. Holding out the stimulus of good treatment and an adequate reward, it will induce the slaves to toil with a hundred fold more assiduity and faithfulness. Who is so blind as not to perceive the peaceful and beneficial results of such a change? The slaves, if freed, will come under the wholesome restraint of law; they will not be idle, but *enericiently* industrious; they will not rush through the country, firing dwellings and murdering the inhabitants; for freedom is all they ask—all they desire—the obtainment of which will transform them from enemies into friends, from nuisances into blessings, from a corrupt, suffering and degraded, into a comparatively virtuous, happy and elevated population.

Nor does immediate abolition mean that any compulsory power, other than moral, should be used in breaking the fetters of slavery. It calls for no bloodshed, or physical interference; it jealously regards the welfare of the planters; it simply demands an entire revolution in public sentiment, which will lead to better conduct, to contrition for past crimes, to a love instead of a fear of justice, to a reparation of wrongs, to a healing of breaches, to a suppression of revengeful feelings, to a quiet, improving, prosperous state of society!

WHAT MUST BE DONE?

There are three modes in which slavery can be overthrown: by physical force on the part of the free states—by the same force on the part of the slaves—and by an enlightened and benevolent public opinion. The first two modes all discard as revolting and disastrous—the last is our chosen alternative. We must, therefore, organize a National Anti-Slavery Society, which shall concentrate the moral energies of the nation. Auxiliaries must be formed in every State. Every town and village must have an association. The people every where want light on this subject—*nothing but light.* Their hearts are all right—*we* mean those in the free states particularly;—their heads are all wrong. THE EDITOR.

SLAVERY RECORD.

QUESTION.—Well, what is this?
ANSWER.—This is SLAVERY!

Q. In what does Slavery consist?
A. In outrage, in robbery, in every species of cruelty and injustice: in blood, in murder, and all the fiendish passions exercised on the helpless.

Q. For what crimes are all these miseries inflicted on our fellow-creatures?
A. For having been born of black parents; for being poor and friendless.

Q. Have we many Slaves?
A. In the slave States, there are upwards of two millions such wretched beings.

Q. Is Slavery profitable to the Planters?
A. No! on the contrary, it is, of all systems, the most *unprofitable.*

Q. Why, then, do the Planters continue it?
A. Because they have always been accustomed to consider and treat the Negroes as brute beasts. To flog them, as you see the Driver doing, whenever they please; to put them in the stocks, or chain them to the wall; to burn them with hot irons, in order to mark them, to sell them to others, and, should they run away, to send men after them with guns to shoot them, like wild beasts. All men love to exercise despotic power, and, therefore, the Planters will not consent to relinquish the privilege.

Q. Well, but there would be very great danger in setting Negroes free; would there not?
A. Certainly not! The danger arises from keeping them in bondage. As they are now pretty generally aware that they possess a natural right to liberty, they are of course ready to embrace any favorable opportunity that may occur of obtaining it, and of revenging themselves on their oppressors. Now set them free, under proper regulations, and they will at once be converted from dangerous enemies into grateful servants.

Q. You see, then, that self-interest, as well as humanity, call upon you to assist in abolishing Slavery?
A. Yes, I do; and I think the latter motive quite sufficient.

Q. You think right, and talk like a freeborn American. If you knew a hundredth part of the horrible cruelties that have, during two centuries, been exercised on the unoffending Negroes, you would look upon us as worse than savages. Now, were the Negroes all set free, they would soon earn good wages, and live in comfort—many would save money, and some of them would become rich. They would greatly increase in numbers; they would want neither patrols nor soldiers to keep them quiet. So you see that in this, as in every other case, honesty is the best policy.

A. Yes, I do, and I will not only strive myself to do right, but I will endeavor to induce my fellow-workmen to join me, and, by God's blessing on a strong pull, a long pull, and a pull altogether, I doubt not but that this accursed and ruinous SIN OF SLAVERY will be forever abolished: Come Joe, and Jack, and Bill, and Tom, —lay hold, lads! Now then—pull away!!!
Altered from an English Anti-Slavery Dialogue.

MORE INSURRECTIONS. The Western Freeman (published at Shelbyville, Tenn.) of the 6th inst. has the following: 'We have been credibly informed that there has been a considerable excitement among the citizens of Fayetteville, Tenn. within these few days past, in consequence of the discovery of a plot among the negroes in that place and its vicinity for an insurrection, all the particulars of which we have not yet learned. The plot was discovered by a female slave, who, it appears, had honesty enough to communicate the hellish designs of the blacks to some white person, perhaps her master. Their object was to set fire to some building, and amidst the confusion of the citizens to seize as many guns and implements of destruction as they could procure, and commence a general massacre. Many of those who were engaged in this infernal conspiracy have been slashed with all the severity which the iniquity of their diabolical schemes so justly deserved.'

The conspiracy of the Tennessee blacks was just as 'infernal' as the conspiracy of the Poles to overthrow their Russian taskmasters; and their 'schemes' were just as 'iniquitous' as were the schemes of the Polish Patriots. If the expression of these *truths* is calculated to do harm, (which we do not believe,) the blame be on those who elicited them by epithets which are a libel on humanity. N. Y. Daily Sentinel.

'Freemen' in North Carolina. A memorial addressed to the Legislature protesting against the right of emancipated, or as they are usually called, free negroes to vote for members of the General Assembly, and praying for the adoption of a resolution declaratory of the true meaning of the term Freemen, as used in the Constitution, has been prepared, agreeably to a resolution adopted at Newbern.

Extract of a Letter dated Rio de Janeiro.

'I will relate but a single fact at this time, to shew the dreadful character of the Slave Trade. The Brazilian Government derives a large revenue from the importation of slaves, by laying a duty of so much per head immediately on their arrival, without regard to their health or condition. When vessels, therefore, which have slaves on board, arrive off the port, a general survey takes place by the physician, and those poor wretches whose existence is doubtful, are *thrown overboard alive,* in order to save the duty!'

THE SLAVE TRADE.

The following description of this iniquitous traffic, now prevailing on the coast of Africa, is given by R. Lander, who attended the late Captain Clapperton in his last expedition to the interior of Africa.

'By reason of the vigilance of British men of war on the coast, merchants are obliged to use much greater caution than formerly, for eluding observation, and embarking their purchased slaves. The plan now generally adopted is as follows: as soon as a vessel arrives at her place of destination, the crew discharge her light cargo, with the muscles intended for the slaves, and land the captain at the same time. The vessel then cruises along the coast to take in country cloth, ivory, a little gold dust, &c.: and if a British man of war be near, the crew, having nothing on board to excite suspicion, in most cases contrive to get their vessel searched whilst trading with the natives. At such time as they think their presence would be necessary, they return to the place where the cargo had been landed, and communicate with the captain on shore, who during their absence has not been idle; and who then takes the opportunity of acquainting his crew with the exact time in which he will be in readiness to embark. The vessel then cruises a second time up and down the coast; till the appointed day approaches, when she proceeds to take in her living cargo. Immediately on sight of her, every canoe for miles near is put in requisition by the captain; provisions and water are speedily conveyed on board; and last of all, the wretched slaves dragged forcibly towards the boats, and received by the European crew, who, as soon as this is effected, crowd all sail, and the vessel quickly disappears.

'I saw four hundred slaves at Badagry crammed into a small schooner of eighty tons; and the appearance of these unhappy human beings was squalid and miserable in the extreme. They were fastened by the neck in pairs, only a quarter of a yard of chain being allowed for each, and driven to the beach by a parcel of hired scoundrels, whilst their associates in cruelty were in front of the party, pulling them along by a narrow band, their only apparel, which encircled the waist.

'Three British subjects were lately tried at the Admiralty Sessions, and found guilty, of having formed part of the crew of the Midas, a Spanish vessel, engaged in the Slave Trade, and having 369 Negroes, man, woman, and children, on board, taken by an English Ship of War, commanded by Captain Sheerer, off the Bahama Bank. It appears by the evidence, as reported in the papers, that the number of poor Negroes originally taken on board this vessel, was 500; that 100 died during their voyage from the Coast of Africa; that they were in a very wretched state, when taken, from disease, and being closely packed together. It is also stated that many of these poor creatures threw themselves into the sea and were drowned, at the time of the capture, and that only 283 of the whole 500, were delivered by the British Commander at the Havannah. Here then was a barbarous murder of 217 unoffending human beings! What a variety of melancholy reflections crowd upon the mind, at the contemplation of such a scene! we cannot put them into language sufficiently strong.

JUVENILE DEPARTMENT.

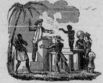

'Canst thou, and honor'd with a Christian's name,
Buy what is woman-born, and feel no shame;
Trade in the blood of innocence, and plead
Expedience as a warrant for the deed!'

THE LITTLE BOSTONIAN.

In the year 1819, a decent looking man, residing at Sturbridge, in the interior of Massachusetts, called at the house of a colored woman in Boston, and inquired if she had not a son, whom she was willing to place on his farm in the country? He promised to feed and clothe him, and to give him an ordinary school education. The poor woman rejoiced at the prospect of obtaining so advantageous a situation for her child, without inquiring into his character, as she ought to have done, gladly gave her consent; and furnishing the boy with all his best clothing, dispatched him on his journey with, as she thought, his future master for the country.

Instead of taking him to Sturbridge as he had promised, this man placed him on board a vessel bound to New-York, and set sail with him the same day for that place. Immediately on his arrival there, he inquired for a vessel bound and ready to sail for a southern port. He soon found one to the eve of departing for Savannah, and took the boy on board; but providentially, a change of wind prevented them from sailing until the next day.

In the mean time, he went on shore to amuse himself, and left orders for the boy to remain in the forecastle, stating to the hands, that he was his property, and that they must not permit him to go on shore lest he should be lost. The poor child remained there according to his directions, ignorant of the fate that awaited him, fearful that something was wrong, but still not suspecting that he could meet with any injury from the person to whom his only surviving parent had entrusted him, with the strongest injunctions of obedience. Whilst he was in that situation, and at times manifesting his grief by tears, the pilot, who was employed to take the ship to sea, when he came on board in the morning, attracted by this interesting appearance, and the mournful expression of his countenance, inquired of him the cause of his being there alone, (for the kidnapper was still on shore,) where he was going, and what was the matter with him?

The boy told him his story in the simplicity of his heart, that he had left his mother to go into the country upon a farm, and that the man whom he was going with, had gone away and left him alone. The humane pilot immediately suspected the truth, took him by the hand, and led him up to a member of the New-York Manumission Society, who made himself acquainted with the particulars of his situation, and promised him his protection.

Shortly after, the kidnapper made his appearance, in pursuit of his prey; and upon his arrival, was taken before the police justices of the city, and committed for his offence. The boy was given up to the members of the Manumission Society, and returned by them to his mother in Boston, to whom he was the first to communicate the particulars of his escape from the dreadful fate which had awaited him.

The miserable wretch who had brought him away, in consequence of the interference and solicitations of his friends, and of some indications which were given of his having been at times insane, was permitted to return to his friends, who promised to prevent him from engaging in similar practices in future.

LADIES' DEPARTMENT.

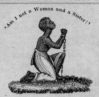

'Am I not a Woman and a Sister?'

This poor woman was much distressed at my inquiries, and it was with difficulty that I prevailed on her to accept of some little relief. I was obliged to tell her repeatedly, but perhaps without convincing her, that all white people were not like those who had treated her with so much barbarity; and that the greater part of them detested such horrid cruelty. Why then, she inquired with much earnestness, bursting into tears, *why then do they not prevent it?*—ABBÉ GIUDICELLY.

☞ The fact that one million of the female sex are reduced, by the slave system, to the most deplorable condition—compelled to perform the most laborious and unseemly tasks—liable to be whipped to an unmerciful degree—exposed to all the violence of lust and passion—and treated with more indelicacy and cruelty than cattle, ought to excite the sympathy and indignation of American women. We have therefore concluded, that a Ladies' Department in the Liberator would add greatly to its interest, and give a new impetus to the cause of emancipation. The ladies of Great Britain are moving the sympathies of the whole nation, in behalf of the perishing slaves in the British Colonies. We cannot believe that our own ladies are less philanthropic or less influential. In their hands is the destiny of the slaves.

The Ladies' Department in the Genius of Universal Emancipation adds vastly to the value of that able periodical. It is conducted by a young lady whose ability and philanthropy, it is not invidious to say, are not exceeded, if equalled, by any other in this country. The following article from her pen is pertinent on this occasion.

OUR OWN SEX.

We have not language sufficiently strong to express our feelings of the necessity there is, that our own sex should become general and efficient workers in the cause of emancipation. That they are called upon to be so, alike by duty and humanity, must we think be freely admitted; and that so large a portion of them are still sitting inert and satisfied, is a circumstance scarcely more to be regretted, than it is surprising. That American ladies, benevolent and enlightened females—those who will abridge their own comforts, and penetrate fearlessly into the gloomy and hidden retreats of poverty, so that they may convey to the afflicted a temporary relief from physical suffering—should calmly suffer hundreds of thousand of their own sex to drink of all the degradation and bitterness of slavery, without one effort to rescue them from their depth of wretchedness, is, indeed, scarcely to be credited, and speaks loudly of the strange inconsistency of the human heart. Education, it is true, has had its share in producing this insipidity of feeling; but the prejudices of education ought not surely to be suffered to pervert, and render of no avail, the plain demonstrations of reason and humanity. It is useless to acknowledge the utter incompatibility of slavery with the tenets of the christian religion, unless at the same time they make some effort to clear themselves from participation in a confessed crime, and to lighten the burdens of those whom they affect to compassionate.

The situation of the slaves of our own sex, certainly claims in a pre-eminent degree the attention of American females, and we know not how they are to answer for their neglect of these poor sufferers, to the God, who has commanded that, as their fellow creatures, their oppressed sisters should be dear to them as their own flesh. We cannot believe this great injustice can continue long unnoticed, for it is not in the nature of the female heart to look unmoved upon scenes of misery. Some have already flung off the unwonted callousness that so long benumbed their hearts, and there has gone forth a spirit of compassion that we doubt not will enter widely into the bosoms of our own sex, and, with God's blessing, bring forth fruit abundantly.

☞ We had the pleasure, a few evenings since, in conjunction with two other friends, of addressing the members of the Society, whose constitution we give below; and a more pleasant evening we never enjoyed. This Society, though recently organized, already embraces a large number of the most respectable females of color: and we cannot doubt that it will be productive of incalculable good to themselves and others.

CONSTITUTION
OF THE
AFRIC-AMERICAN FEMALE INTELLIGENCE
SOCIETY OF BOSTON.

PREAMBLE.

Whereas the subscribers, women of color of the Commonwealth of Massachusetts, actuated by a natural feeling for the welfare of our friends, have thought fit to associate for the diffusion of knowledge, the suppression of vice and immorality, and for cherishing such virtues as will render us happy and useful to society, sensible of the gross ignorance under which we have too long labored, but trusting, by the blessing of God, we shall be able to accomplish the object of our union—we have therefore associated ourselves under the name of the Afric-American Female Intelligence Society, and have adopted the following Constitution.

Art. 1st. The officers of this Society shall be a President, Vice President, Treasurer, Secretary, and a Board of Directors of five—all of whom shall be annually elected.

Art. 2d. Regular meetings of the Society shall be held on the first Thursday of every month, at which

each member shall pay twenty-five cents, and pay twelve and a half cents at every monthly meeting thenceforth.

Art. 3d. The money thus collected shall be appropriated for the purchasing of books, the hiring of a room and other contingencies.

Art. 4th. The books and other articles purchased by this Society, shall be considered as the Society's property; and should the Society cease to exist, said property shall be disposed of by auction, and each member receive her proportional part of the proceeds accruing from such sale.

Art. 5th. It shall be the duty of the President to preserve order at the meetings of said Society, and to call special meetings when occasion may require.

Art. 6th. In the absence of the President, the Vice President shall preside; and in the absence of both, the Secretary shall preside.

Art. 7th. It shall be the duty of the Treasurer to pay all orders drawn on her by the Secretary, and signed by the President. The Treasurer shall give bonds to the Society for the faithful discharge of the duties of her office.

Art. 8th. The Secretary shall keep an account of the receipts and expenditures of the Society.

Art. 9th. All applications shall be made to the Society at the monthly meeting or to the Board of Directors, who shall report it at her next meeting.

Art. 10th. It shall be the duty of the Secretary to call a roll of the members at each meeting, and to keep a book in which the names of the members shall be recorded.

Art. 11th. All candidates for membership shall be of good moral character, and shall be elected by a majority of the votes of the Society.

Art. 12th. All members who shall be absent at the regular monthly meetings, shall be fined six and a quarter cents, unless a satisfactory apology can be offered to the Society.

Art. 13th. The officers of the Society shall be elected annually by a vote of a majority of the Society.

Art. 14th. All vacancies occurring, may be supplied by nomination from the chair.

Art. 15th. Any member of this Society, of one year's standing, having regularly paid up her dues, who may be taken sick, shall receive one dollar per week out of the funds of the Society as long as consistent with the means of the institution.

Art. 16th. No article of the constitution of this Society shall be altered or amended, unless by a vote of a majority of the Society.

Art. 17th. Any member becoming obnoxious, may be removed from the Society by a vote of a majority.

Art. 18th. In case any unforeseen and afflictive event should happen to any of the members, it shall be the duty of the Society to aid them as far as is in their power.

Art. 19th. If any member shall neglect to pay her regular monthly assessment, such person shall be subject to a fine of twelve and a half cents per month until paid; and if not paid at the end of a year, she shall be removed therefrom by a vote of the Society, and forfeit all claim thereto.

Art. 20th. Should circumstances cause any member to withdraw from the Society, she may transfer her certificate of membership to any person approved of by the government of this institution.

Art. 21st. It shall be the duty of the Treasurer to keep a correct account of all the money she receives, and deposit it in the bank as the Board directs.

BY-LAWS.

Art. 1. Each member who wishes to speak, shall rise and address the chair.

Art. 2d. While any member addresses the chair, there shall be no interruption.

Art. 3d. If any member becomes sick, it shall be made known to the President, who will instruct the Directors to visit the sick person, and devise means for her relief.

Art. 4th. Twelve members shall constitute a quorum to transact business.

Art. 5th. Any person or persons who shall rashly sacrifice their own health, shall not be entitled to aid or sympathy from the Society.

Art. 6th. Each meeting of this Society shall begin and end with prayer.

Art. 7th. The Treasurer shall make quarterly reports of the state of the funds.

Art. 8th. The Secretary shall read the proceedings of the last meeting at each succeeding one.

MRS. STEWARD'S ESSAYS.

A few weeks since, we alluded to an excellent little tract, published at this office, entitled 'Religion and the pure principles of morality the sure foundation on which we [the people of color] must build,' by Mrs. Maria W. Steward, a colored lady of this city. We give the following spirited extract:

'I am of a strong opinion, that the day on which we unite, heart and soul, and turn our attention to knowledge and improvement, that day the hissing and reproach amongst the nations of the earth against us will cease. And even those who now point at us with the finger of scorn, will aid and befriend us. It is of no use for us to sit with our hands folded, hanging our heads like bulrushes, lamenting our wretched condition; but to make a mighty effort and arise; and if no one will promote or respect us, let us promote and respect ourselves.

'The American ladies have the honor conferred on them, that by prudence and economy in their domestic concerns, and their unwearied attention in forming the minds and manners of their children, they laid the foundation of their becoming what they now are. The good women of Wethersfield, Connecticut, toiled in the blazing sun, year after year, weeding onions, then sold the seed and procured money enough to erect them a house of worship; and shall we not imitate their examples, so far as they are worthy of imitation? Why cannot we do something to distinguish ourselves, and contribute some of our hard earnings that would reflect honor upon our memories, and cause our children to arise and call us blessed? Shall it any longer be said of the daughters of Africa, they have no ambition, they have no force? By no means. Let every female heart become united, and let us raise a fund ourselves; and at the end of one year and a half, we might be able to lay the corner-stone for the building of a High School, that the higher branches of knowledge might be enjoyed by us; and God would raise us up, and enough to aid us in our laudable designs. Let each one strive to excel in good housewifery, knowing that prudence and economy are the road to wealth. Let us not say, we know this, or we know that, and practise nothing; but let us practise that which we do know.

'How long shall the fair daughters of Africa be compelled to bury their minds and talents beneath a load of iron pots and kettles? Until union, knowledge and love begin to flow amongst us. How long shall a mean set of men flatter us with their smiles, and enrich themselves with our hard earnings,—their wives' fingers sparkling with rings, and they themselves laughing at our folly? Until we begin to promote and patronize each other. Shall it any longer be a by-word among the nations any longer? Shall they laugh us to scorn forever? Do you ask, what can we do? Unite, and build a store of your own, if you cannot procure

CAT. 1

Am I Not a Woman and a Sister?
Unidentified artist for
The Liberator, January 7, 1832
Photomechanical reproduction
47.6 × 33 cm (18 ¾ × 13 in.)
Boston Public Library, Rare
Books and Manuscripts

CAT. 2

"Am I Not a Woman & a Sister?"
Abolitionist Hard Times Token
Gibbs, Gardner, and Company
for the American Anti-Slavery
Society
1838
Copper
2.9 cm (1 ⅛ in.) diam.
Collection of the Smithsonian
National Museum of African
American History and Culture

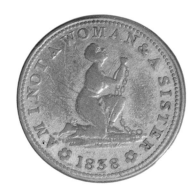

her radical resolution that a woman should do all in her power through "her voice, and her pen, and her purse, and the influence of her example to overthrow the horrible system of American slavery."[8] The idea of women speaking in public, much less voicing their opinions in public, shocked much of their society, as one New York newspaper declared that the women attending these meetings should be "sent to insane asylums."[9]

Yet the leaders of these groups persisted. After the convention, Angelina Grimké published a report of the findings from the Anti-Slavery Convention in "An Appeal to the Women of the Nominally Free States" that was distributed to women in the North (cats. 3–4).[10] Grimké had devoted herself to Quakerism in 1828 after rejecting her Southern parents' Episcopalian faith—and their slaveholding practice.[11] Indeed, the Grimké sisters were among the few Southern women of their era to have publicly rejected slavery. In 1838, Angelina married the renowned abolitionist Theodore Dwight Weld, and the couple invited her older sister Sarah—who was unmarried—to live with them. Angelina continued to lecture on women's rights and abolition while raising the couple's three children.

Sarah Grimké was probably the most influential figure on her younger sister, as in 1821, at the age of twenty-eight, she moved to Philadelphia from their hometown of Charleston, South Carolina, and converted to Quakerism. Although Angelina was the more talented orator, Sarah had a marvelous intellect. In 1838, she published a compilation of essays titled *Letters on the Equality of the Sexes, and the Condition of Woman*, in which she outlined the subordination of nineteenth-century American women (cat. 5). The elder Grimké also addressed the issue of women speaking in religious contexts like church, arguing that women should have the right to preach. To support her claim, she cited verses from the Bible that reveal women's relationships to God, arguing that "man" is a generic term that includes both sexes.[12] She wrote, "We attach to the word prophecy, the exclusive meaning of foretelling future events, but this is certainly a mistake; for the apostle Paul defines it to be 'speaking to edification, exhortation and comfort.'"[13] Grimké continued, "And there appears no possible reason, why women should not do this as well as men."[14]

Letters on the Equality of the Sexes, and the Condition of Woman presents some of the earliest documents that link enslavement with the subordination of women. In a discussion of the legal "disabilities" of women, Grimké notes that white women are "only counted like the slaves of the South."[15] At the same time, her argument makes clear that enslaved women were the victims of the harshest oppression. While many abolitionists rejected Grimké's radical ideas, they nonetheless took effect as more African American and white women worked together, moving door to door, to create petitions.[16] While African American women were eventually excluded by the leaders of the women's suffrage movement, during the antebellum era's focus on abolitionism, the two groups worked alongside each other.

CAT. 3

Theodore Dwight Weld (1803–1895), Angelina Emily Grimké Weld (1805–1899), and Their Children
Ezra Greenleaf Weld
(1801–1874)
ca. 1845
Daguerreotype
10.8 × 8.2 cm (4¼ × 3¼ in.)
Weld-Grimké Family Papers, William L. Clements Library, University of Michigan

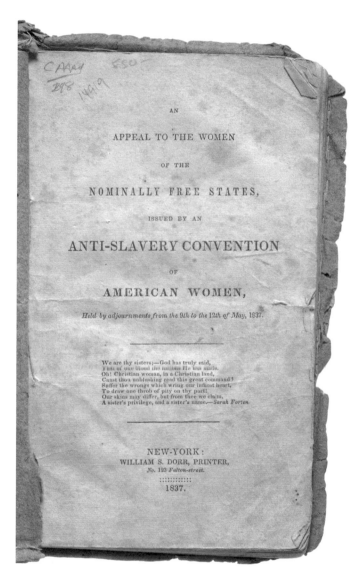

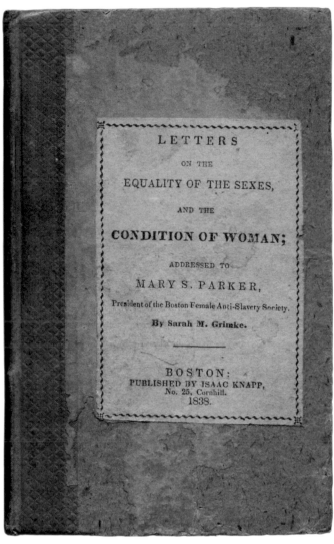

CAT. 4

An Appeal to the Women of the Nominally Free States
Angelina Emily Grimké Weld (1805–1879)
1837
19.1 × 12.7 cm (7 ½ × 5 in.)
Collection of Ann Lewis and Mike Sponder

CAT. 5

Letters on the Equality of the Sexes, and the Condition of Woman
Sarah M. Grimké (1792–1873)
1838
19.9 × 10.2 cm (7 ¹³⁄₁₆ × 4 in.)
The Gilder Lehrman Institute of American History

In 1832, free black women, including Nancy Lenox, organized the first female anti-slavery group in Salem, Massachusetts, spearheading a wave of women's abolitionist organizations.[17] Lenox's daughter, Sarah Parker Remond, participated in the Salem Female Anti-Slavery Society, the Essex County Anti-Slavery Society, and the Massachusetts Anti-Slavery Society (cat. 6).[18] Free African American women, in particular, were helped by anti-slavery groups to better understand their rights. Similar to the situation of white suffragists, activism oriented toward black women's rights in the antebellum era was mainly concentrated in states located in the North. Public culture in which black women could freely move was limited to churches, anti-slavery societies, secret societies, political organizations, and literary clubs. Even so, as educated women, they had some power.

After being forcibly ejected from her seat during an opera at Boston's Howard Athenaeum in 1853 because she was black, Remond sued and was awarded $500 by the First District Court of Essex. In winning, she recognized the power of her words, and in 1856, she joined her brother Charles as a lecturing agent of the Massachusetts Anti-Slavery Society. Audiences revered her.[19] By 1858, she was appointed an official lecturer for the American Anti-Slavery Society. Remond's message was distinct because she drew on her demeanor as a "lady" while recounting episodes of ghastly, forced sexual exploitation of enslaved women. This photograph of Remond pictures her seated against a classical backdrop in an embroidered gown.

In 1866, reformers banded together to found the American Equal Rights Association. Led by Lucretia Coffin Mott, with support from Elizabeth Cady Stanton, Frederick Douglass, Lucy Stone, and Henry Blackwell, the organization sought to "secure Equal Rights to all American citizens, especially the right of suffrage, irrespective of race, color, or sex."[20] These individuals used the framework created by abolitionists of the antebellum.

A catalyzing event for Mott was in 1840, during the World's Anti-Slavery Convention in London. While there, anti-slavery leaders refused to officially recognize Mott because of her sex, and she, along with all of the other women delegates, was forced to sit in gallery seating behind a bar, a humiliating experience.[21] (Although not a delegate herself, Elizabeth Cady Stanton, who was accompanying her husband, sat with the other women, in solidarity.) Within the parameters of this experience and other similar situations, conversations about organizing for women's rights gained traction. Mott was an early leader in these conversations, often leading by example. Her clothing manifested her religious and social beliefs. In addition to wearing the traditional Quaker cap, she often sewed her own garments using fabric that she sourced carefully, as a way to avoid using material that had been produced through slave labor (cat. 7).[22]

Although she is now overshadowed by her close friends, Amy Kirby Post built the foundation for the early women's rights movement in upstate New York (cat. 8). Raised a Hicksite Quaker in a farming community in Rochester, Post fully appreciated the importance of social equality and reform. In 1828 she married her deceased sister's husband, Isaac Post, an ardent abolitionist with whom she founded the Western New York Anti-Slavery Society in 1842. Six years later, she attended the

CAT. 6

Sarah Parker Remond
(1815–1894)
Unidentified photographer
ca. 1866
Albumen silver print
(after ambrotype)
7 × 5.6 cm (2 ¾ × 2 3/16 in.)
Peabody Essex Museum, Salem, Massachusetts; gift of Miss Cecelia R. Babcock

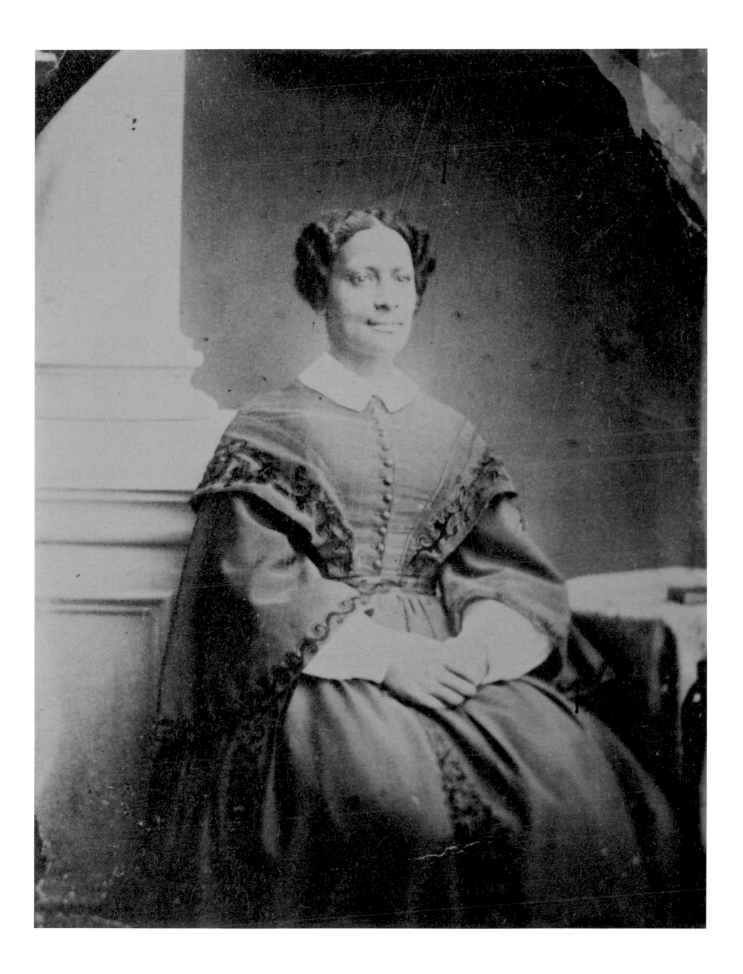

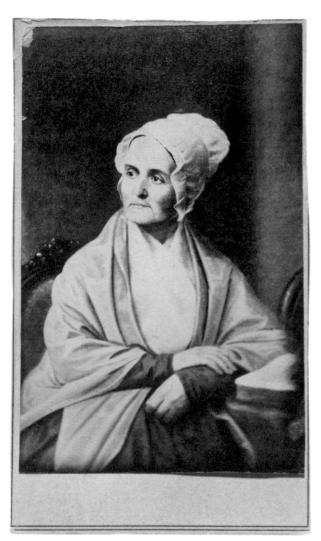

CAT. 7

Lucretia Coffin Mott (1793–1880)
Unidentified photographer
ca. 1865
Albumen silver print
8.6 × 5.4 cm (3 ⅜ × 2 ⅛ in.)
National Portrait Gallery,
Smithsonian Institution;
gift of Frederick M. Rock

CAT. 8

Amy Kirby Post (1802–1889)
Unidentified photographer
ca. 1885
Gelatin silver print
(after collodion print)
18.1 × 12.7 cm (7 ⅛ × 5 in.)
Local History and Genealogy
Division, Rochester (New York)
Public Library

CAT. 9

Elizabeth Cady Stanton (1815–1902) and Her Daughter, Harriot Stanton Blatch (1856–1940)
Unidentified photographer
1856
Daguerreotype
10.8 × 8.2 cm (4 ¼ × 3 ¼ in.)
Seneca Falls Historical Society

Seneca Falls Woman's Rights Convention and signed the Declaration of Sentiments. She then helped organize the 1848 Rochester Woman's Rights Convention. Despite limited financial means, Post opened her home for fugitive slaves and newly arrived immigrants, simultaneously teaching her children to support religious freedom, racial equality, and women's suffrage.[23] Post's home served as a station on the Underground Railroad as well as a haven for abolitionists, drawing in a network of prominent lecturers, notably Frederick Douglass, Susan B. Anthony, Sojourner Truth, William Lloyd Garrison, and Lucretia Coffin Mott. Truth even used Post's home as a base during her lecture circuit—this was particularly unusual, since African American women were rarely allowed to lodge with whites at the time.[24]

Elizabeth Cady Stanton's involvement in women's rights began well before she started organizing for the Seneca Falls Convention in 1848. As a girl, she spent countless hours in her father's law office, where she overheard the stories of widows who had lost all of their property. She studied the law with her father and learned of the discriminatory laws that women faced. Stanton's views on women's rights were greatly shaped by her difficulties managing a household of seven children as a young mother in rural Seneca Falls while her husband traveled for work. In one daguerreotype, a young Stanton poses with her daughter Harriot (cat. 9). Taken in 1856, it shows her just eight years after the famous convention in Seneca

Falls, which launched her into becoming one of the foremost leaders of the movement.

In broad strokes, the common criticism men voiced against women speaking in public reflected how most Americans felt about women "interfering" in politics. Only radical women sought to change the status quo, and they turned to abolitionism to learn how to defend their right to free speech. In this way, women in the nineteenth century banded together, regardless of their race, a fact that made them increasingly empowered—and threatening.

The Difference in Status of Married and Single Women

Woman must have a purse of her own.

—Susan B. Anthony, Diary, November 1853[25]

By studying the plight of enslaved Americans, abolitionist women began to realize that their own freedoms were severely and unfairly limited. Economic prosperity, for example, was often if not almost always out of a woman's control. Under nineteenth-century common law, a married woman was bound by the rules of coverture. This meant that a woman's earnings, as well as property she acquired before or after marriage, were subject to her husband's control. In other words, when women married, their husbands subsumed their legal status, and they forfeited all rights. Married women could not control income from their labor, nor were they allowed to legally own and manage a business, engage in trade, or bear independent responsibility for contracts.[26] Interestingly, Margaret Fuller, Susan B. Anthony, Lucy Stone, and Antoinette Brown all took vows of lifelong celibacy in the 1840s, yet only Anthony would follow through.[27] Although some states passed reforms after 1830, many were slow to grant women's rights. New York, for example, waited until 1848 to pass a bill to protect any property, as hers, that a woman brought to a marriage or inherited.

Margaret Fuller's landmark text, *Woman in the Nineteenth Century*, published in 1845, critically examines the role of women within society.[28] Fuller argues that marriage should be an equal partnership and insists that women be given equal property rights.[29] Her progressive idea certainly countered nineteenth-century common law.[30]

An 1850 daguerreotype of Fuller served as a compositional basis for many subsequent engraved portraits, including the frontispieces for later editions of *Woman in the Nineteenth Century* (cat. 10).[31] In this vignette-style engraving, lace and ribbons surround Fuller's neck and wrists, and she rests her head on her right hand as she turns her gaze to the book in front of her, displaying a keen intellect (cat. 11). While Fuller is often overlooked as an early feminist because of her emphasis on transcendental and theoretical spiritualism, her work consistently focused on divine maternal power, creativity, individuality, and female selfhood.[32]

Women's independence often was subject to their marriage status. In the 1850s, African American women activists Harriet Tubman, Frances Ellen Watkins

Harper, and Sojourner Truth were all unmarried.[33] Scholar Andreá N. Williams describes how, for most African American single women, "they often were presented as sensual assailants in need of the restraining hand of the law and male authority."[34] Yet these three African American women employed portraiture as a means of communication to defy marital status and racial stereotypes. Now revered as an iconic figure of freedom, Tubman remains renowned for her work as conductor of the Underground Railroad, for which she made thirteen trips to the South and rescued approximately seventy enslaved people from the plantation system.[35] She played other important social roles for women, including that of a Civil War veteran, nurse, community organizer, and woman suffragist.

Although married twice, Tubman was able to move freely, literally through miles and miles of space, without being responsible for any man's home. In fact, she took on the traditionally male characteristic of leadership and was referred to as the "Moses of her people." *Scenes in the Life of Harriet Tubman*, the 1869 biography written by Sarah H. Bradford, features a frontispiece printed from a woodcut (cat. 12).[36] Standing with her hands on the barrel of a rifle, Tubman wears a Union soldier's frock coat over a striped dress. Tubman's pose reflects her service during the Civil War as a spy. She commanded eight or nine scouts in this role and also worked as a nurse and cook throughout her three years of service to the Union Army. Tubman received a pension beginning in 1888 for the service of her second husband, Nelson Davis—spurring her to petition Congress for her own pension in 1899.[37]

Truth and Harper also put forth both time and finances in support of abolitionism.[38] Before the Civil War, they were both unmarried.[39] They both maintained the era's ideals of feminine self-sacrifice, yet they were able to pair them, unobtrusively, with self-agency. Born free in Maryland in 1825, Harper worked as a seamstress and teacher before gradually being introduced into the anti-slavery lecture circuit in 1854 (cat. 13). She was notable for achieving success in the face of the paradoxical anti-slavery movement that marginalized single women yet relied on their labor.[40] Even after her 1860 marriage, Harper published short stories featuring unwed women who, through an enlarged social mission, laid claim to respectability.[41] Her poem "Double Standard" (first published in 1870, but republished in *Atlanta Offering* in 1895) condemns gender inequality by describing, "And what is wrong in woman's life / In man's cannot be right."[42] Her portrait greets the reader at the start of *Atlanta Offering*, revealing the author to be a distinguished African American woman.

Perhaps the most effective African American leader in the early stages of the women's movement, Sojourner Truth—middle-aged, illiterate, and utterly radical—achieved her power because she was an enigma: she spoke without conforming to the tenets of respectability. In 1850 at the National Women's Convention in Worcester, Massachusetts, Truth was the first African American woman to address such a crowd.[43] A year later, during the Ohio Women's Convention in Akron, Ohio, Truth began to build on her rhetoric, claiming women's rights were grounded in the premises that women were equal to men in their labor. She argued that the (then accepted) differences in intellect did not justify the curtailing of equal rights; and that men should

CAT. 10

Margaret Fuller (1810–1850)
John Plumbe Jr. (1809–1857)
ca. 1850
Daguerreotype
8 × 7 cm (3 ¼ × 2 ¾ in.)
National Portrait Gallery,
Smithsonian Institution
* Not in exhibition

CAT. 11

Margaret Fuller (1810–1850)
Frederick T. Stuart (1837–1913),
after John Plumbe Jr.
ca. 1870
Engraving, stipple, and roulette
on paper
30.4 × 22.6 cm (11 ¹⁵⁄₁₆ × 8 ⅞ in.)
National Portrait Gallery,
Smithsonian Institution

F.T. Stuart Boston

Margaret Fuller,

WINFIELD ROBBINS

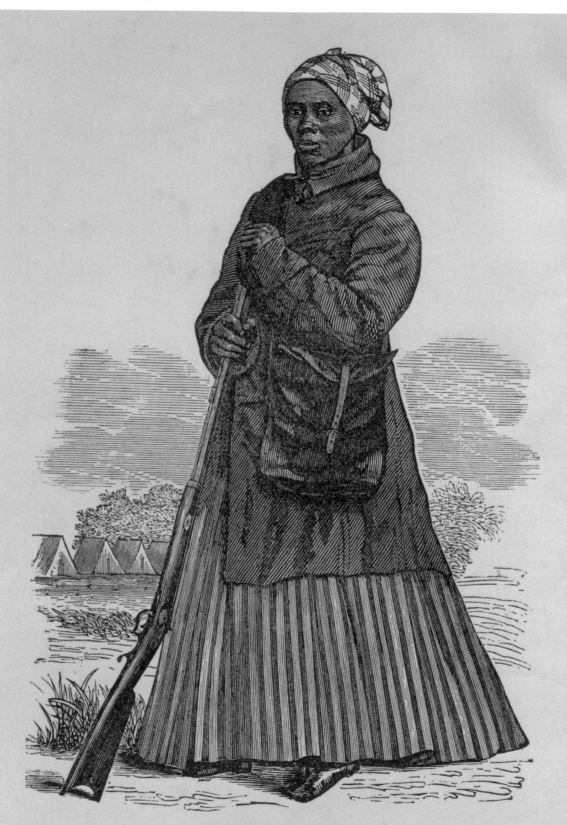

HARRIET TUBMAN.

CAT. 12

Harriet Tubman (1820–1913)
Frontispiece of *Scenes in the Life
of Harriet Tubman*
John G. Darby
(active 1830s–1860s)
1869
Wood engraving
17.8 × 10.4 cm (7 × 4 ⅛ in.)
National Portrait Gallery,
Smithsonian Institution

CAT. 13

Frances Ellen Watkins Harper
(1825–1911)
Frontispiece of *Atlanta Offering*
Unidentified photographer
1895
Photomechanical reproduction
17.3 × 12.9 cm (6 ¹³⁄₁₆ × 5 ¹⁄₁₆ in.)
Stuart A. Rose Manuscript,
Archives, and Rare Book Library,
Emory University

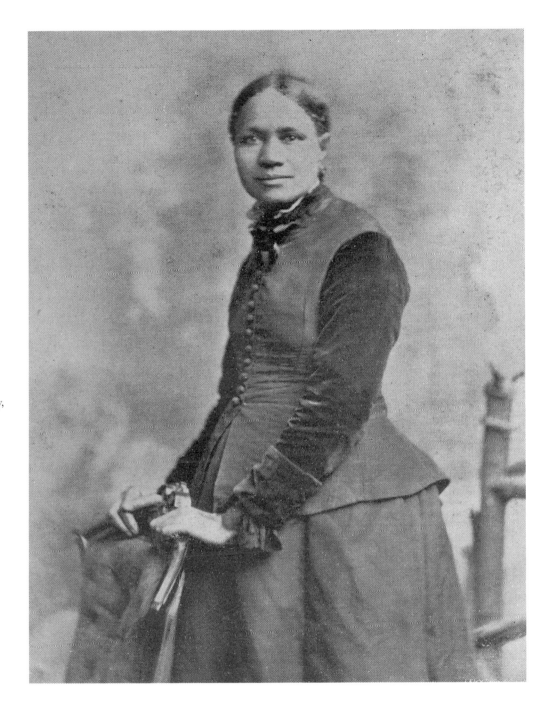

follow the example of Jesus Christ and regard women with respect.[44] Truth adhered to these principles throughout her preaching. As she established her reputation, she also established herself as a figure of respectability through portraiture. In order to support herself financially between 1860 and 1870, she sold hundreds of copies of her autobiography and portraits in the form of cabinet cards and cartes de visite.[45]

In this cabinet card produced by the Randall Studio around 1870, Truth manifests decorum within her carefully arranged posture and dress (cat. 14). She is seated in an elaborate domestic interior, with shelves displaying objects of feminine refinement behind her. Truth poses in a simple yet abundant monochromatic dress that recalls the style of clothing worn by Quaker women.[46] Yet Truth commands the camera, as her self-fashioned image circumvents racial stereotypes. She insisted on the inscription, "I Sell the Shadow to Support the Substance," which she knew would alert to the viewer the agency she maintained in her choice *not* to be depicted as enslaved—an image of which would have garnered her a greater profit.[47]

For white women, remaining unmarried also meant independence. Fully aware of the limitations on married women's freedoms, Lucy Stone ensured that she would enter the contract of marriage on her own terms (cat. 15). After meeting on the lecture circuit in 1853 and a long courtship, Stone and Henry Blackwell married in 1855. Blackwell did not expect Lucy to submit to him, and they coauthored a protest of marriage (cat. 16). "We protest especially against the laws," they wrote, "1. Which give to the husband the custody of his wife's person. 2. The exclusive control and guardianship of her children. 3. The sole ownership and use of her property."[48] Stone never changed her name, preferring to keep her "maiden" name.

During the 1850s, Susan B. Anthony established an enduring relationship with the women's suffrage movement (cat. 17). Beginning as a fervent abolitionist, she later switched her focus to agitate for temperance, women's labor rights, and suffrage. Anthony persisted as a lecturer and organizer and by 1858 forged an alliance with Elizabeth Cady Stanton. As a single woman, Anthony was not tied to the home as many of her fellow suffragists were and could travel across the United States, delivering Stanton's ideas to the greater public. In Stanton's words, "I forged the thunderbolts and she fired them."[49]

Temperance, or the movement to outlaw the consumption of alcohol, gathered increasing support from women's Christian circles during the mid-nineteenth

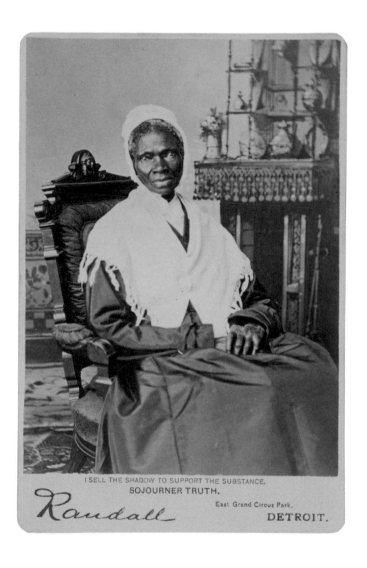

CAT. 14

Sojourner Truth (ca. 1797–1883)
Randall Studio
(active 1865–1875)
ca. 1870
Albumen silver print
14.4 × 10.3 cm (5 11/16 × 4 1/16 in.)
National Portrait Gallery,
Smithsonian Institution

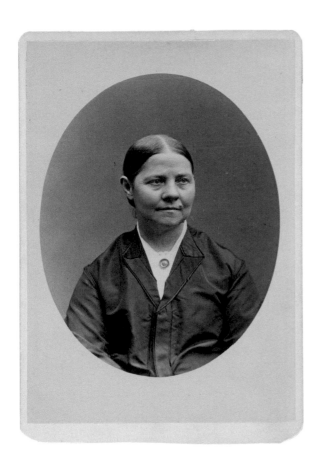

CAT. 15

Lucy Stone (1818–1893)
Sumner Bradley Heald
(1835–1918) for the George
Kendall Warren Studio
ca. 1866
Albumen silver print
11.6 × 9.1 cm (4 %16 × 3 %16 in.)
National Portrait Gallery,
Smithsonian Institution

century. In 1849 Amelia Bloomer founded and edited *The Lily: A Ladies Journal Devoted to Temperance and Literature*, which was among the very first newspapers to be directed entirely by a woman. With contributors such as Stanton, the publication expanded its conversation on temperance to include women's rights at large.

In 1851, in an effort to further women's rights, Bloomer began delivering public lectures, appearing in a "new costume" of trouser-like garment under a knee-length dress (cat. 18). "Bloomers," as they came to be known, offered a revolutionary alternative for women who were accustomed to wearing restrictive garments. During the mid-nineteenth century, dress reform held equal footing with women's political rights.[50] In 1850, radical white women wore bloomers to conventions and private parties (although they were quickly given up as too distracting).[51] The image of bloomers permeated print culture through newspaper woodcuts and sheet music illustrations. Nineteenth-century families sought music as a form of entertainment, and sheet music became decorated with eye-catching designs. In some instances, published sheet music, such as *The New Costume Polka*, became a means of sharing and learning of current events (cat. 19). Suffragists used songs in public meetings, such as conventions, parades, and rallies.[52] The popularity of bloomers was short lived, however; in 1852 Susan B. Anthony remarked, "The attention of my audience was fixed upon my clothes instead of my words."[53] Her example led many reformers—even Bloomer herself—to abandon the pantaloons and focus exclusively on women's rights.

Women increasingly embraced radicalism. On the stage of the 1852 National Women's Rights Convention in Syracuse, New York, an unknown twenty-six year-old boldly proclaimed, "Let Syracuse sustain her name for radicalism!" With these words, Matilda Joslyn Gage propelled herself into the women's suffrage movement and went on to become one of its leaders (cat. 20). Lucretia Coffin Mott made certain that Gage's speech was printed in the convention's paper. Gage, who was a natural intellectual, wrote at great length on the matrilineal society of her Haudenosaunee Iroquois neighbors, whom she hoped to emulate. The Native American culture, so vastly different from her own, regarded women as equals.

For Dr. Mary Edwards Walker, bloomers—with their wide circumference gathered at the hem—were genteel, tame, and impractical. She instead wore tailored trousers and a tunic when she worked as a surgeon for the War Department during the Civil War (cat. 21). Educated at Syracuse Medical College in New York, Walker managed to earn the confidence of General Ambrose Burnside when she maintained her integrity during the battles of Fredericksburg and Chickamauga in 1862 and 1863, thereby securing a rare post as a female contract surgeon. She was captured by Confederate soldiers and imprisoned for four months in 1864. She

In acknowledging our mutual sympathy & affection by publicly assuming the sacred relation of husband & wife, we feel it a duty to record our solemn & united protest against the injustice of the present laws of marriage — which annihilates the legal identity of the woman and no longer recognizes her as an independent rational being —

We protest against which they confers upon the husband injurious & unnatural superiority & invest him with privileges which no honorable man can exercise & no unjust man should possess —

We protest especially against the laws

1 which give to the husband the custody of his wife's person
3 The sole ownership & use of her property — unless previously placed actually invest him in charge of trustee as in case of divorce
2. The exclusive control & guardianship of her children
4 and the disposal of her individual earnings —
5. Which disqualify her to make a will, to sue, or be sued in her own name, or to inherit property —
6 Which makes the widower the heir of the deceased wife's property while it gives the widow a mere life-interest in only one third of her husband's real-estate.

Believing that personal independence & human equality are too sacred to be sacrificed — that true marriage is in theory & ought to be in act a noble & permanent partnership with common rights & common duties we recognize & renounce the radical injustice of existing institutions & will provide against by every means in our power should pledge ourselves that of future domestic difficulties, (which hereafter arise may God forbid) we will never appeal to the decisions of the present unequal laws, but will submit their adjustment to arbitrators mutually agreed upon, who shall decide according to equity and natural justice we will do all that in us lies to

And so, repudiating the tyranny of human enactments We promise to love honor and cherish each other to the utmost of our ability both in this life & that which is to come So long as we both shall live —

Draft of Marriage Protest
Lucy Stone (1818–1893) and
Henry Browne Blackwell
(1825–1909)
1855
Ink on paper
17 × 22 cm (6 11/16 × 8 11/16 in.)
Papers of the Blackwell Family,
1831–1981; Schlesinger Library,
Radcliffe Institute for Advanced
Study, Harvard University

Susan B. Anthony (1820–1906)
Jeremiah Gurney (1812–1895)
1858
Ambrotype
5.1 × 6.4 cm (2 × 2 ½ in.)
National Susan B. Anthony
Museum and House, Rochester,
New York

eventually gained her freedom when there was a prisoner exchange.[54] In 1866, Walker became the first (and as of 2018, the only) woman to receive the highest military recognition, the Congressional Medal of Honor, but it was rescinded in 1917 because she was not a registered military soldier.[55]

The recognition emboldened her, however, and soon after receiving the award in 1866, she was arrested in New York for impersonating a man. During her widely publicized trial, she told the judge she had the right "to dress as I please in free America on whose tented fields I have served four years in the cause of human freedom."[56] The judge ended the trial by ordering the police to never arrest Walker on account of her dress. She continued to wear fitted suits and her Medal of Honor proudly (even after it had been revoked) until her death in 1919.[57]

For African American women, the Civil War probably had the most significant effect on their citizenship rights. During his Second Inaugural Address, President Abraham Lincoln proclaimed the Enlistment Act, which, in order to encourage the enrollment of black soldiers into the Union ranks, emancipated their *wives* and their *children* in states loyal to the Union. Effectively, Lincoln freed almost one hundred thousand women at this revolutionary moment.[58] At the war's conclusion, more than two million African American women gained their freedom.

During the Civil War, white suffragists focused most of their energy on the war but made the suffrage movement a priority once peace was restored. After

CAT. 18

Amelia Bloomer (1818–1894)
Unidentified photographer
ca. 1853
Daguerreotype
12.4 × 8.9 cm (4 ⅞ × 3 ½ in.)
Seneca Falls Historical Society

CAT. 19

The New Costume Polka
James Fuller Queen
(ca. 1820–1886) for Lee
and Walker
1851
Lithograph
34.3 × 26.7 cm (13 ½ × 10 ½ in.)
Collection of Dr. Danny O. Crew

TO Mrs AMELIA BLOOMER.

J. Queen delt. P. S. Duval's Steam lith. Press Philada

THE NEW COSTUME POLKA

COMPOSED

FOR THE PIANO

by

MATHIAS KELLER.

Plain 25 cts. net.
Colored 38

Philadelphia, Lee & Walker, 162 Chesnut St.

SUCCESSORS TO GEO. WILLIG.

NEW YORK, MEMPHIS TEN. NEW ORLEANS.
Wm HALL & SON. P. FLAVIO. Wm T. MAYO.

SOLD BY
HALANT?

CAT. 20

Matilda Joslyn Gage (1826–1898)
Unidentified photographer
1871
Albumen silver print
16.5 × 10.8 cm (6 ½ × 4 ¼ in.)
The Arthur and Elizabeth
Schlesinger Library on the
History of Women in America,
Radcliffe Institute for Advanced
Study, Harvard University

CAT. 21

Mary Edwards Walker
(1832–1919)
Unidentified photographer
ca. 1870
Albumen silver print, with
inscription
17.1 × 10.2 cm (6 ¾ × 4 in.)
The H. Chase Livingston
Suffrage Collection

the war, the suffrage movement separated itself from the concerns that had grown out of the abolitionist movement. In a pinpointed focus, women positioned themselves strategically as having a pure, "maternal-based vision," which reflected the reach and influence of the era's stakes in the cult of domesticity as well as in exalted ideas of motherhood.[59]

The most widely reproduced painter of the mid-nineteenth century, Lilly Martin Spencer evokes the impact of the Civil War on family life in *The War Spirit at Home* (cat. 22). In what some have interpreted as a self-portrait, Spencer depicts a woman with her four children, and a servant in the background.[60] The babe in her lap touches her breast and kicks the newspaper, linking her maternal influence to the next generation—and the next political future. The *New York Times* headline reads, "Great Victory [at] Vicksburg, Miss." The Battle of Vicksburg marked the turning point of the war, and the young children are jubilant. The more sober servant and mother both understand more clearly the terrible cost of human life the war incurred. As the only adults present, the two women symbolize the changing roles within their families. They took on the responsibilities of their absent fathers, husbands, and brothers.

The "Woman Question" of the Nineteenth Century: Why Should Women Count as Citizens?

The parameters of American citizenship (as outlined by the Constitution) never negated their right to enfranchisement, but the language of the Constitution was problematic because women's voting rights were unclear. According to the laws, states were empowered to define voting requirements, leaving women's rights vulnerable and undefined. Every state excluded women from voting rights except New Jersey, which allowed property-owning women to vote between 1776 and 1807. However, when it became evident that women's voting enabled the marginal victory for the Federalist Party in New Jersey, their right to vote was taken away.[61]

Postwar punitive measures thrust women—particularly Southern women—into lobbying the government for relief. The dramatic increase of women lobbyists was noted in the fall of 1866 when southerners approached President Johnson to plea for a pardon—as well as a pension—if their property exceeded $20,000 in value.[62] Women lobbyists were seen as radical and made sensational news. The rare sight of women holding discussions at the White House appeared as an illustration on the front page of *Harper's Weekly* on October 27, 1866 (cat. 23). Formally dressed in elaborate, tiered dresses with trimmings, rounded shoulders, and ceinture waists, the women are the picture of modesty and dignity. While controversial current events were often portrayed through caricature, these *Lady Lobbyists* are presented in a stately manner, positing to the reader that women were capable of lobbying the president.

CAT. 22

The War Spirit at Home
Lilly Martin Spencer
(1822–1902)
1866
Oil on canvas
76.2 × 83.2 cm (30 × 32 ¾ in.)
The Newark Museum, Purchase
1944 Wallace M. Scudder
Bequest Fund

A Movement, Split

American suffragists knew they faced a searing loss when the Fourteenth Amendment (proposed on June 13, 1866, and ratified July 28, 1868), specified "male" in its language in Section 2. This was the first time gender had ever been specified in the Constitution. Written to guarantee the rights of citizenship for formerly enslaved men, the Fourteenth Amendment imposed on the individual states a penalty for interfering with the male citizen's right to vote. Elizabeth Cady Stanton wrote, "If that word 'male' be inserted, it will take us a century at least to get it out." In a damning move that set women back until the Nineteenth Amendment, the Fourteenth Amendment excluded women from the franchise.[63] Almost immediately, white women became hyperconscious that black men's citizenship rights were guaranteed over theirs. As a result, the abolitionist roots of the women's movement unraveled. Suffrage, with its abolitionist roots and its many associated concerns, all of which had knit together the radical women—North and South, black and white, freed or formerly enslaved—broke into factions.

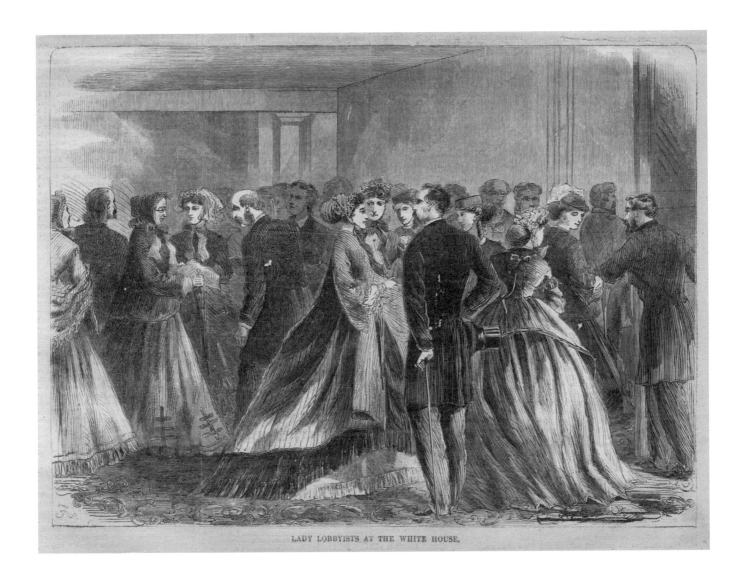

LADY LOBBYISTS AT THE WHITE HOUSE.

CAT. 23

Lady Lobbyists at the White House
Unidentified artist for *Harper's Weekly*, October 27, 1866
Wood engraving
39.4 × 27.9 cm (15 ½ × 11 in.)
White House Historical Association

In the wake of the debates over race and citizenship rights, two points of view divided the American Equal Rights Association. On the one side, Lucy Stone held that women needed to remain in solidarity with African Americans and continue to work on equal rights for all. She declared, "I will be thankful in my soul if anybody can get out of the terrible pit," and it was she who founded the American Woman Suffrage Association (AWSA) in 1869.[64] On the other side, Elizabeth Cady Stanton, Matilda Joslyn Gage, and Susan B. Anthony argued that the movement focus solely on what seemed to always lie just outside their grasp: votes for women—even if it meant votes for women along a color line. And that same year, they founded the National Woman Suffrage Association (NWSA). The two factions would not reunite until 1890, when the National American Woman Suffrage Association was formed.

When Congress passed the Fifteenth Amendment on February 26, 1869, and ratified it on February 3, 1870, suffragists were keenly aware that the extended voting rights to all male citizens placed women in an even worse position.

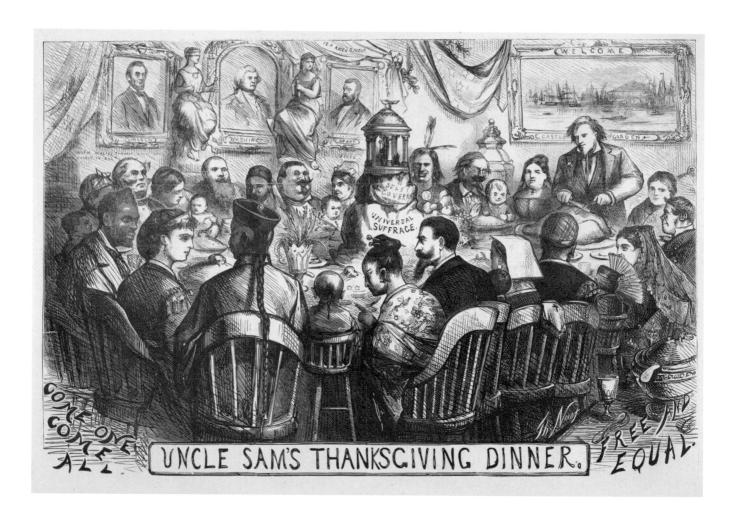

CAT. 24

Uncle Sam's Thanksgiving Dinner
Thomas Nast (1840–1902)
for *Harper's Weekly*,
November 22, 1869
Wood engraving
27.6 × 39.1 cm (10 ⅞ × 15 ⅜ in.)
Collection of Robert P. J.
Cooney Jr.

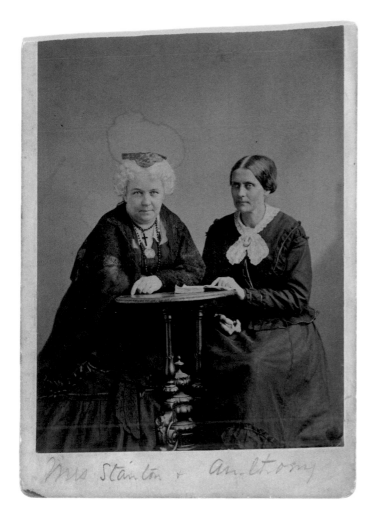

CAT. 25

Elizabeth Cady Stanton (1815–1902) and Susan B. Anthony (1820–1906)
Napoleon Sarony (1821–1896)
ca. 1870
Albumen silver print
13.5 × 9.8 cm (5 5/16 × 3 7/8 in.)
National Portrait Gallery, Smithsonian Institution

The political cartoonist Thomas Nast envisioned political equality when he made this drawing, published in the November 20, 1869, issue of *Harper's Weekly* (cat. 24). Joining the Thanksgiving Day feast of hosts Uncle Sam (carving the turkey on the far right) and Columbia (seated on the far left) are American immigrants from all over the world.[65] However, it would take more than fifty years for women and people of color to come together around one table to join in the celebration of universal suffrage.

Following the Fourteenth and Fifteenth Amendments, Stanton and Anthony felt that they had to do *something* to keep the momentum going. In financial straits after the Civil War, the two radical women saw a way forward when they partnered with the wealthy railroad profiteer George Francis Train. He agreed to sponsor NWSA's official newspaper, the *Revolution*, which urged its readers to support a federal amendment for women's suffrage. With its motto, "Men, their rights and nothing more. Women, their rights and nothing less," the publication reignited the suffrage movement that had flagged in the aftermath of the Civil War. However, Train was an unusual ally for suffragists who had emerged from the abolitionist movement. He was a terrible racist and a passionate proslavery sympathizer. Yet, Stanton and Anthony justified partnering with him because they felt the movement needed to move forward, at any cost.

By the 1870s, Elizabeth Cady Stanton and Susan B. Anthony had become household names, so much so that celebrity photographer Napoleon Sarony portrayed their likenesses at his studio in New York City (cat. 25). In the portrait, the two women are seated around a circular desk, which is reminiscent of the table where Stanton penned the 1848 Declaration of Sentiments. Anthony, who sits beside Stanton, is shown pointing to a book. At this time, it was clear that they, along with other women, isolated from the majority of men's support in their struggle for the vote, had to resign themselves to a long battle.

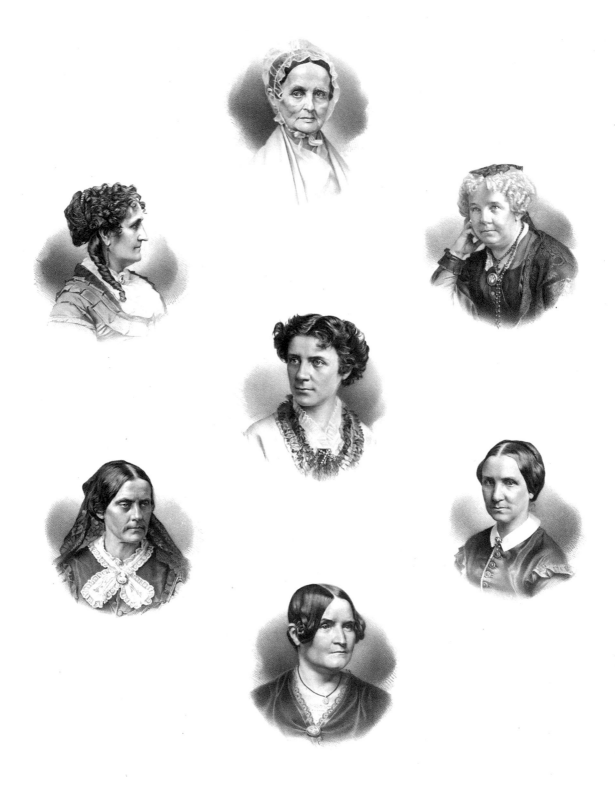

2
WOMEN ACTIVISTS, 1870–1892

CAT. 26

Representative Women

Clockwise, beginning at top:
Lucretia Coffin Mott (1793–
1880), Elizabeth Cady Stanton
(1815–1902), Mary Livermore
(1820–1905), Lydia Maria
Francis Child (1802–1880),
Susan B. Anthony (1820–1906),
and Sara Jane Lippincott (1823–
1904), and *center*: Anna Elizabeth
Dickinson (1842–1932)
L. Schamer for Louis Prang
Lithography Co.
1870
Lithograph
60.5 × 50.8 cm (23 13/16 × 20 in.)
National Portrait Gallery,
Smithsonian Institution

The right of citizens of the United States to vote shall not be denied or abridged by the United States or by any State on account of race, color, or previous condition of servitude. — Fifteenth Amendment, Section 1

In the 1870s, as the undergirding tenets of the abolitionist movement fell away from structuring the women's movement, groups of suffragists developed what became a signature style of bold activism. The Fourteenth and Fifteenth Amendments, which guaranteed both citizenship and the right to vote to African American men, became rallying cries for women suffragists adamant that the vague language and wording, in effect, communicated that all citizens — including women — had the right to vote. Seizing this rhetorical understanding, which they referred to as the New Departure, women went to the polls and voted.

However, roadblocks set up to counter the New Departure eventually forced suffragists down other avenues of bold activism. Some of these activists continued participating in the lecture circuit and continued to follow in the footsteps of their abolitionist antecedents, but many of them chose to blatantly defy society's expectations of women. Through harnessing the power of the press, running for public office, and public protest, suffragists grew accustomed to directly confronting their opposition.

Between 1860 and 1880, it became common for American reformers to gather and use the stage — then called lyceums — to promote abolition, temperance, education reform, and women's rights. Although the majority of lyceums were organized by and for white middle-class men, they often welcomed suffragist speakers.[1] They addressed men and women of diverse backgrounds — across state, racial, and economic divides — and reached wider audiences than they would have through their more formal and traditionally formatted women's organizations.[2] In fact, a number of women made careers as lecturers.

Representative Women is a combinative portrait that brings together seven women who were active on the lecture circuit (cat. 26). The visual power of the image stems from its ability to reveal both the cohesiveness and the individual qualities of the movement. Clockwise from the top are portraits of Lucretia Coffin Mott, Elizabeth Cady Stanton, Mary Livermore, Lydia Maria Child, Susan B. Anthony, and Sara Jane Lippincott, who surround the central figure of Anna Elizabeth Dickinson.

In 1870, Dickinson was more popular than Mark Twain and held the distinction of being the highest paid woman on the lecture circuit.[3] From a young age, she was a vocal supporter of abolition and women's rights (cat. 27). Dickinson delivered her first public address, "The Rights and Wrongs of Women," to the Pennsylvania Antislavery Society when she was eighteen, and within a few years she became one of the most prominent figures on the lecture circuit, often earning more than $20,000 annually.[4] One of her most engaging lectures, "What Shall We Do with Our Daughters?" critiqued societal standards for young girls, specifically their education and required dress. Dickinson's spellbinding lectures moved many women and men to further women's rights.[5]

Although Victoria Woodhull never became a major figure within suffrage organizations, she made history in the 1870s by defying traditional views of women (cat. 28). As a working-class divorcée, Woodhull, along with her sister, Tennessee Claflin, moved from Ohio to New York City in 1868. The two became known as "the Lady Bankers" on Wall Street, financed by Cornelius Vanderbilt.[6] The brokerage firm Woodhull, Claflin and Co. opened in 1870, and shortly thereafter, the sisters began distributing their individual portraits in the form of cartes de visite, prominently inscribing their titles of "broker" underneath their names (cat. 29). Empowered by her financial success, in an April 1870 letter to the *New York Herald*, Woodhull announced that she would run for president of the United States in the 1872 election. In early summer, she and her sister started *Woodhull and Claflin's Weekly*, a reform magazine that sought to secure the rights of women through open discussions on such topics as education, abortion, and free love or sex outside of marriage.[7]

Woodhull saw herself as an example of women's capabilities and potential. In late 1870, she moved briefly to Washington, DC, to lobby for women's suffrage and to present her cause to Congress. On January 11, 1871, she led a group of suffragists, including Susan B. Anthony and Isabella Beecher Hooker, in addressing the House Judiciary Committee (see fig. 13 in Tetrault). Outlining the foundations of the New Departure strategy, Woodhull argued that the Fifteenth Amendment and other sections of the Constitution guaranteed rights to *all* citizens — men and women. Aghast, the Ohio representative John Bingham sputtered in reply, "Madam, you are no citizen — you are a woman!"[8] Later, when the Judiciary Committee issued a minority report supporting Woodhull's position, suffragists distributed copies of their argument throughout the nation.[9]

During the 1871 elections, Woodhull, Claflin, and three other women boldly marched to the polls in an attempt to vote, but they were turned away. *Harper's Weekly* documented the event with this engraving of Woodhull and Claflin amid a crowd of men from diverse socioeconomic and racial backgrounds (cat. 30). Some men appear upset while others look to be supportive of the women in action. Woodhull is shown standing directly behind the ballot box, with her finger pointed in the air as she asserts her right to vote.

Even though Woodhull had not yet reached the constitutionally mandated age of thirty-five and stood no chance of winning the presidency, she decided to run a real campaign for the 1872 election. With Frederick Douglass nominated as

CAT. 27

Anna Elizabeth Dickinson
(1842–1932)
Mathew B. Brady
(ca. 1823–1896)
ca. 1863
Albumen silver print
8.6 × 5.5 cm (3 ⅜ × 2 ³⁄₁₆ in.)
National Portrait Gallery,
Smithsonian Institution;
gift of Laurie A. Baty

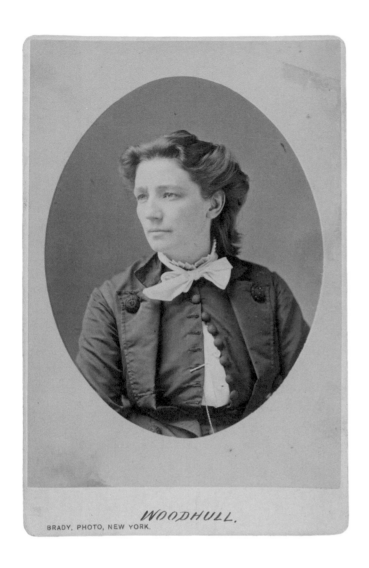

WOODHULL.

BRADY, PHOTO, NEW YORK.

MRS TENNIE C. CLAFLIN.
BROKER.

CAT. 28

Victoria Claflin Woodhull
(1838–1927)
Mathew B. Brady
(ca. 1823–1896)
ca. 1870
Albumen silver print
15.9 × 10.8 cm (6¼ × 4¼ in.)
Fine Arts Library, Harvard
University

CAT. 29

Tennessee Celeste Claflin
(c. 1844–1923)
Unidentified photographer
ca. 1872
Albumen silver print
8.6 × 5.7 cm (3⅜ × 2¼ in.)
National Portrait Gallery,
Smithsonian Institution

her running mate (to his chagrin—he never acknowledged the nomination), she ran on behalf of a party she had helped create: the Equal Rights Party. Just prior to election day, she published *The Origins, Tendencies, and Principles of Government*, in which she outlined her belief in "Pantarchy," which she described as a society in which property and children are overseen by a beneficent state and adults are free to live and, particularly, to love as they see fit.[10] The "Free Love" movement was formed by those who rejected marriage as an oppressive institution and instead embraced sexual freedom—an idea extremely radical and controversial for the late nineteenth century, which garnered negative perception from the press.

During Woodhull's presidential campaign, the political cartoonist Thomas Nast depicted her as "(Mrs.) Satan" (cat. 31). The caricature took up a full-page in *Harper's Weekly*, making it difficult for the magazine's readers to miss the archetypal wife in the background. It is she who carries the heavy burden of both an alcoholic husband and children up the steep and treacherous path of life, all the while repulsing the alternative freedom, or "temptation," as exemplified by Woodhull.[11]

Undaunted by such seemingly damaging representations, Woodhull persevered. Later that year, she responded to her own bad press by using sensationalist, headline-grabbing methods to call out the double standard for men and women, and in doing so, push for women's equality. The most famous example was when she accused the nation's most respected clergyman, Henry Ward Beecher, of having an extramarital affair with Elizabeth Tilton, who was married to Theodore Tilton, the editor of the newspaper the *Independent*. The news story was sensational, one that the *New York Times* referred to as "one of the most pitiful episodes of human experience."[12]

Beecher's sister, Isabella Beecher Hooker, was an ally of Woodhull's (cat. 32). In 1868, she wrote "A Mother's Letters to a Daughter on Woman's Suffrage" for *Putnam's Magazine*; a few years later, in 1871, when she presented to the House Judiciary Committee after Woodhull, she testified to her belief that mothers possessed a unique moral vision that made them well suited for politics. Hooker openly doubted her brother's innocence and denounced the double standard of which Woodhull and Tilton were savagely attacked. When Hooker decried her brother for his adultery, the family shunned her. She urged Beecher to confess, and in return, her relatives questioned her mental stability, proposing she be incarcerated in an asylum.[13] A tintype portrait of Hooker was made around the time of that scandal (cat. 32). Public opinion—largely swayed by the press—viewed Beecher as innocent. Hooker, unmoved, focused on raising her three children and spent the next four decades advocating for women's rights in the context of the home.

Although Hooker attempted to vote in 1872, she could not penetrate the security in the Hartford, Connecticut, polling station. Other women's suffrage activists were successful with the strategy of the New Departure, such as Susan B. Anthony, who cast her vote in Rochester, New York, that year (cats. 33–34). By successfully casting ballots, these women activists carried on some of the radical spirit from which the movement sprung. However, a poll watcher challenged Anthony's credentials to vote, causing the inspectors of elections to follow the state guidelines to determine a voter's qualifications. Under oath, Anthony testified that she was a citizen,

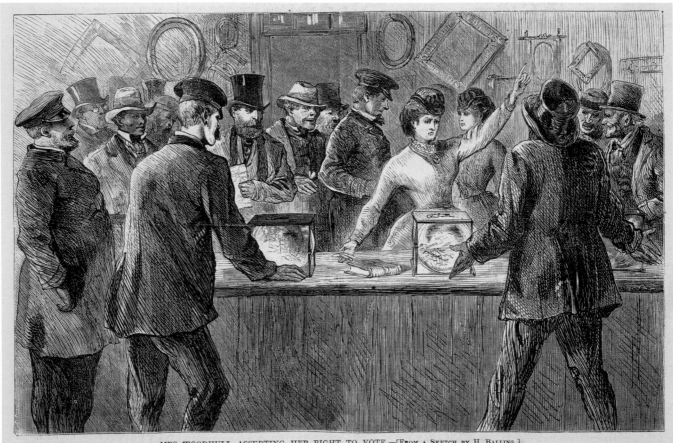

MRS. WOODHULL ASSERTING HER RIGHT TO VOTE.—[From a Sketch by H. Balling.]

CAT. 30

Mrs. Woodhull Asserting Her Right to Vote
Unidentified artist, after
H. Balling, for *Harper's Weekly*,
November 25, 1871
Wood engraving
15.1 × 23.3 cm (5 15/16 × 9 3/16 in.)
Collection of Robert P. J.
Cooney Jr.

CAT. 31

Get Thee Behind Me, (Mrs.) Satan!
Thomas Nast (1840–1902)
for *Harper's Weekly*,
February 17, 1872
Wood engraving
40.5 × 28.2 cm (15 15/16 × 11 1/8 in.)
National Portrait Gallery,
Smithsonian Institution

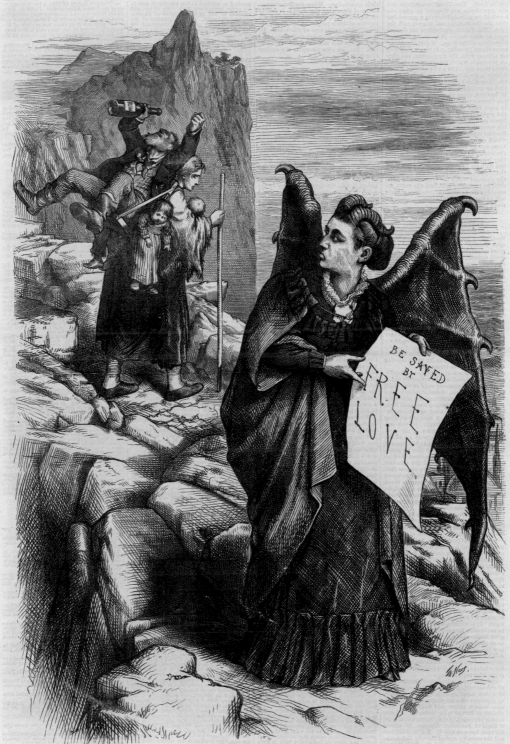

"GET THEE BEHIND ME, (MRS.) SATAN!"—[SEE PAGE 148.]

WIFE (*with heavy burden*). "I'D RATHER TRAVEL THE HARDEST PATH OF MATRIMONY THAN FOLLOW YOUR FOOTSTEPS."

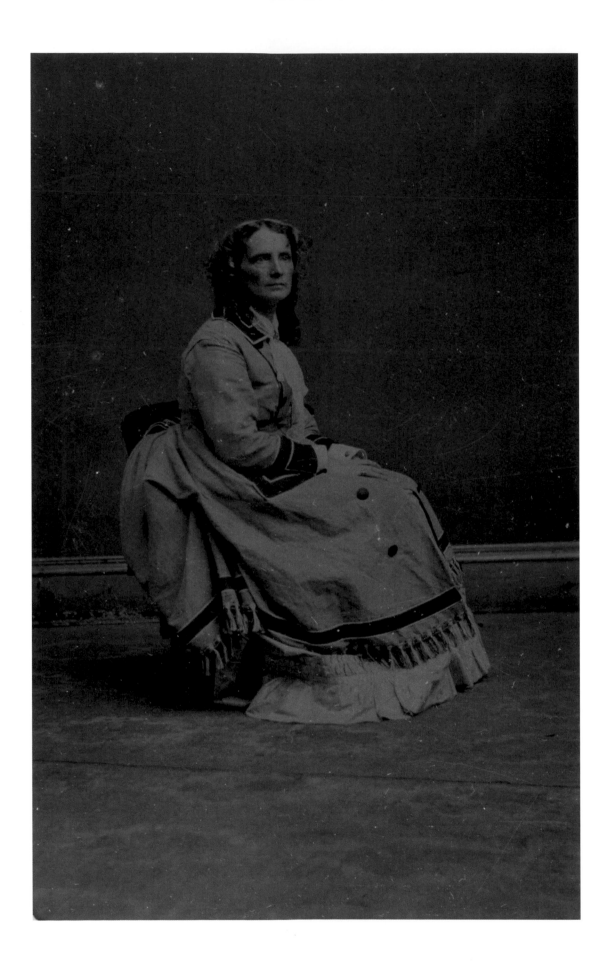

CAT. 32

Isabella Beecher Hooker
(1822–1907)
Unidentified photographer
ca. 1873
Tintype
7.6 × 5.1 cm (3 × 2 in.)
Harriet Beecher Stowe Center,
Hartford, Connecticut

a resident of the district, and that she had not accepted any bribes for her votes. When she answered the questions satisfactorily, the inspectors registered her ballot.[14]

Anthony and fifteen other women were subsequently charged with voting illegally and arrested. They were not alone, as between 1868 and 1873, at least seven hundred women voted or attempted to vote in local, state, and federal elections in eleven states, the District of Columbia, and Washington Territory.[15] African American women also joined the New Departure. On April 20, 1871, a group of over seventy black and white women, led by Frederick Douglass and Mary Ann Shadd Cary, voted at the polls in the District of Columbia.[16]

Susan B. Anthony's famous trial represents the New Departure for two reasons: first, because she refused to apologize or pay her fine; and second, because it closed off the avenue for Anthony to pursue the matter in a lawsuit that would reach the Supreme Court. The trial, *United States v. Susan B. Anthony*, began on June 17, 1873. The presiding judge, Justice Ward Hunt, followed a rule of common law, which prevented criminal defendants in federal courts from testifying. On the second day of the trial, after both sides had presented their cases, Justice Hunt directed the jury to deliver a guilty verdict. Denied a trial by jury, Anthony knew that even if Hunt had allowed the jury to discuss the case, she still would have faced a prejudiced jury because at the time, women were not allowed to be jurors.

Finally, on the third day of the trial, Justice Hunt asked Anthony if she had anything to say. She responded at length and repeatedly ignored the judge, who ordered her to stop talking and sit down. Anthony protested what she called "this high-handed outrage upon my citizen's rights," and continued, "You have trampled underfoot every vital principle of our government. My natural rights, my civil rights, my political rights, my judicial rights, are all alike ignored."[17] Although Justice Hunt sentenced Anthony to pay a fine of $100, she never did. And, in a cunning move, the judge never sent Anthony to jail because if he had, she could have appealed and taken her case to the Supreme Court, and fulfilled the goal of the New Departure.

During the trial, the *Daily Graphic* published the wood engraving *The Woman Who Dared* on its cover (cat. 35). A masculine Susan B. Anthony figure stands triumphantly akimbo in a dress that resembles the one she wore for her iconic portrait by Napoleon Sarony (see cat. 25). She holds an umbrella, a weapon disguised as a feminine accessory, while her top hat displays her appropriation of male power. The satirical middle ground reveals a police*woman* facing a gentleman with a baby. Arguing women in the background carry signs reading "We favor Union to a Man" and "I may do all that doth become a Man." After the trial, Anthony expressed her sentiments toward Justice Hunt in a letter, stating that the federal government "denies [women] the right to a voice in the government" and further expressing her frustration that black men's voting rights were secured by a federal amendment, whereas white men and all women's voting rights were decided by state legislatures.[18]

Anthony's activism was widely publicized, and it is almost certain her example emboldened other women to vote. In the latter part of the nineteenth century, women living in select states and territories had obtained partial voting rights. These rights, however, were quite limited and rarely extended past the local level. For

Rochester July 23. 1873

Yes Young Friend

You shall have the autograph of the United States Citizen in whose case Judge Hunt denies the right to a voice in the Government, the citizens right unless the citizen be a *man of color* — all white men and all women black and white, get their right to vote from the state — all black men from the United States — !!!

Susan B. Anthony

AN
ACCOUNT OF THE PROCEEDINGS
ON THE
TRIAL OF
SUSAN B. ANTHONY,
ON THE
Charge of Illegal Voting,
AT THE
PRESIDENTIAL ELECTION IN NOV., 1872,
AND ON THE
TRIAL OF
BEVERLY W. JONES, EDWIN T. MARSH
AND WILLIAM B. HALL,
THE INSPECTORS OF ELECTION BY WHOM HER VOTE WAS RECEIVED.

ROCHESTER, N. Y.:
DAILY DEMOCRAT AND CHRONICLE BOOK PRINT, 3 WEST MAIN ST.
1874.

CAT. 33

Susan B. Anthony Discussing Her Trial and Unjust Ruling
Susan B. Anthony (1820–1906)
1873
Ink on paper
20.6 × 13 cm (8 ⅛ × 5 ⅛ in.)
The H. Chase Livingston
Suffrage Collection

CAT. 34

An Account of the Proceedings of the Trial of Susan B. Anthony
Susan B. Anthony (1820–1906)
1874
23.5 × 14.9 cm (9 ¼ × 5 ⅞ in.)
The H. Chase Livingston
Suffrage Collection

CAT. 35

Graphic Statues, No. 17—"The Woman Who Dared"
Thomas Wust (active 1870–1900) for *The Daily Graphic*,
June 5, 1873
Wood engraving
53.5 × 36.6 cm (21 × 14 ⁵⁄₁₆ in.)
Library of Congress, Prints and Photographs Division, Washington, DC

THE DAILY GRAPHIC

AN ILLUSTRATED EVENING NEWSPAPER.

39 & 41 PARK PLACE.

VOL. I—NO. 81.　　　NEW YORK, THURSDAY, JUNE 5, 1873.　　　FIVE CENTS.

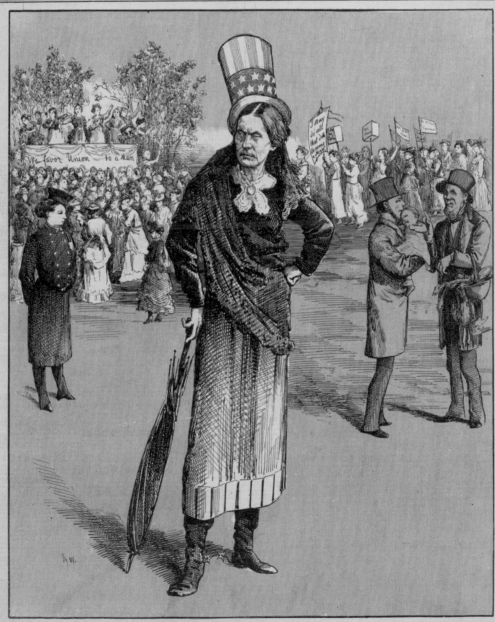

GRAPHIC STATUES, NO. 17—"THE WOMAN WHO DARED."

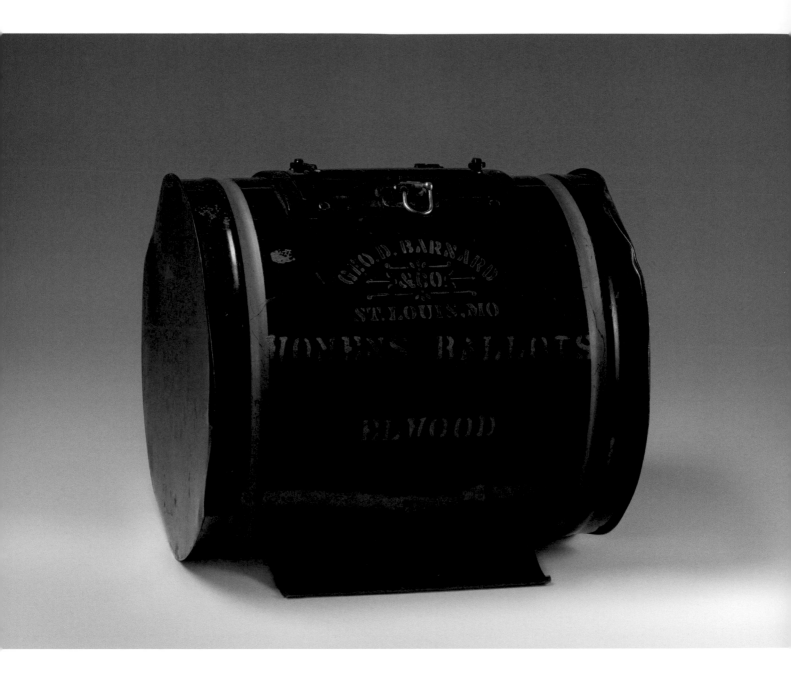

instance, women might be permitted to elect members of the school board, but they probably would not be able to cast their vote for an open senate seat. To keep women from voting for restricted offices, polling places housed separate ballot boxes for women (cat. 36).[19] During the 1870s, Geo. D. Barnard & Co. was a leading manufacturer of mule-mounted ballot boxes in the Midwest.[20] The curved base of the ballot box allowed for it to be strapped to a mule's back so that it could be transported to polling locations in rural areas. This box was used for collecting women's ballots in Elwood, Indiana. Only fifteen states allowed women to vote in presidential elections prior to 1920, and Indiana granted women that right in 1917.

Although outliers like Victoria Woodhull are recalled today with satisfying relish, and Susan B. Anthony's refusal to pay her fine is trumpeted over and over

CAT. 36

Women's Ballot Box
Geo. D. Barnard & Co.
(active 1860–1920)
1870–1892
Tin with black japanned
finish, stenciled gold lettering,
sunbursts, and bands, cast-iron
lid, and wire-bale handle
31.1 × 36.2 × 31.8 cm
(12 ¼ × 14 ¼ × 12 ½ in.)
Ronnie Lapinsky Sax Collection

by feminists, another example remains less known. When Virginia Louisa Minor was blocked from voting in Missouri, she and her husband sued Reese Happersett, the election inspector who refused to allow her to vote.[21] The case reached the Supreme Court, and in 1875, interpreting the Fifteenth Amendment as designed solely to enfranchise formerly enslaved African American men, Chief Justice Morrison Waite delivered a crushing blow to the suffrage movement. His ruling effectively gave authority of individual states to grant or withhold the ballot, except in the specific cases of freedmen. From 1875 on, states empowered to dictate citizenship rights created huge setbacks for vulnerable populations. It was rulings like this that pushed failure on Reconstruction, which endeavored to transform the country from a confederacy of states to a centralized nation.[22]

Nevertheless, suffragists kept their course steady and even joined forces with the Woman's Christian Temperance Union (WCTU). Cofounded by Frances Willard in 1874, the WCTU sought to stop the destructive power of alcohol and end the problems it caused their families and society (cat. 37). With a national membership of over 150,000 women, the WCTU offered the suffrage movement a huge network and much greater resources.[23] Connected to a Christian spiritual practice, temperance advocates first met in churches to pray and then marched to the saloons to ask the owners to close their establishments.[24] As the largest women's religious organization in the nineteenth century, when the WCTU committed itself to the suffrage cause, the faltering movement felt a shock of revivalist energy. The WCTU enacted reform through prayer and appealed to "women's morality," gaining followers by the hundreds of thousands across the United States. Its progressive nature embraced women of color, notably Frances Ellen Watkins Harper, who in 1886 was appointed the Pennsylvania State Superintendent of Work among the Colored People for the WCTU. Two years later, she became the first Superintendent of the Negro Section for the WCTU's national program.[25]

The countless women's clubs across the country picked up where anti-slavery organizations had left off, teaching women how to speak in public and debate, awarding them with medals and other prizes for their abilities (cat. 38). Willard was able to cast the devotees of temperance toward suffrage explaining, "the ballot as one means for the protection of their homes from the devastation caused by the legalized traffic in strong drink."[26] Portraits of Willard often show her wearing an enamel brooch depicting Joan of Arc, a symbol for the heroic crusade she led against temperance. Temperance devotees were drawn to Joan of Arc for her religious zeal, but even more, they wished to emulate her ability to cope with adversity.

In *Woman's Holy War*, a Joan of Arc figure rides sidesaddle atop a horse with a wielded ax in one hand and a heraldic shield in the other (cat. 39). Based on Albrecht Dürer's *Four Horsemen of the Apocalypse* (1498), the crusading woman represents good in the battle over evil. The women behind her break open barrels of alcohol while chasing men out of sight. (The male presence is merely hinted at with the fraction of a man's leg on the right side of the page.) Created first as an engraving on vellum, the work was later mass produced by Currier and Ives in order to engage large audiences. Broadsides like this appeared as fliers, posters, and

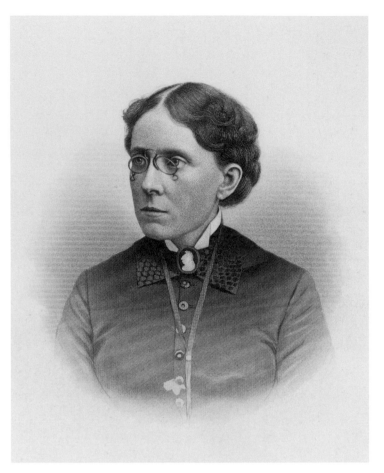

CAT. 37

Frances Willard (1839–1898)
Unidentified artist
1887
Engraving
25.4 × 16 cm (10 × 6 ⁵⁄₁₆ in.)
National Portrait Gallery,
Smithsonian Institution

CAT. 38

Oratorical Prize Medal
Woman's Christian
Temperance Union
ca. 1870s
Silver medal
4.9 × 3.3 cm (1 ¹⁵⁄₁₆ × 1 ⁵⁄₁₆ in.)
Collection of Kate Clarke Lemay

CAT. 39

Woman's Holy War: Grand Charge
on the Enemy's Works
Currier & Ives Lithography
Company (active 1857–1907)
1874
Lithograph
31 × 21.9 cm (12 ⅛ × 8 ⅝ in.)
Museum of the City of
New York; gift of Mrs. Harry T.
(Natalie) Peters, 1956

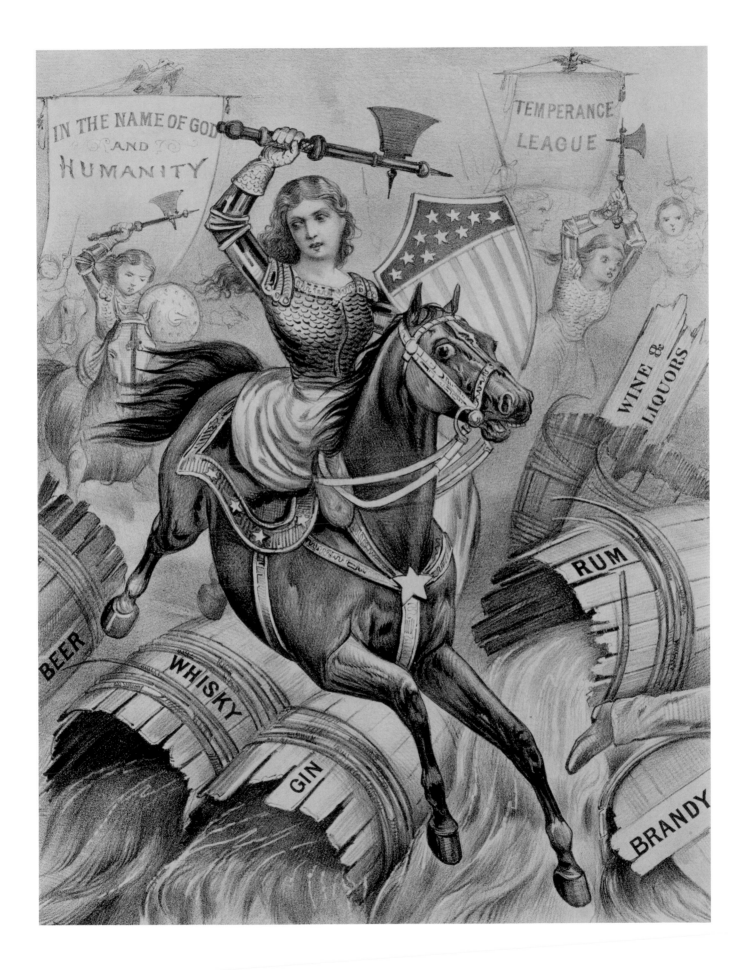

news bulletins, ultimately serving to inspire even more reformers.[27]

Not all suffragists supported the decision to make an alliance with the WCTU. Abigail Scott Duniway opposed the temperance movement because she believed it would alienate too many potential supporters (cat. 40). A lifelong advocate for women's liberty, Duniway used the power of the press when she founded the *New Northwest* in 1871 to record women's history. She was convinced that "when women's true history shall have been written, her part in the upbuilding of this nation will astound the world."[28]

Duniway was involved in the Pacific Northwest suffrage efforts and managed Susan B. Anthony's speaking tour of the region in October 1871. As a consequence of western expansion, new debates over women's suffrage materialized in the later part of the nineteenth century. While the territories of Wyoming and Utah granted women suffrage in the 1860s, during Reconstruction, Washington Territory denied women the vote until it became a state in 1890. Duniway briefly served as vice president for the National Woman

CAT. 40

Abigail Scott Duniway
(1834–1915)
Unidentified photographer
ca. 1890
Albumen silver print
28 × 33 cm (11 × 13 in.)
University of Oregon Libraries;
Special Collections and
University Archives

Suffrage Association, beginning in 1884, but her grassroots approach clashed with that of the national organization, so she returned to focusing her efforts closer to home.[29] "Yours for Liberty, Abigail Scott Duniway" is elegantly inscribed on nearly every photograph taken of the Oregonian suffragist between 1870 and 1900.

In general, suffragists were largely bolstered by the enormous national reach of the WCTU. With the expansion of their network, suffragists refused to give up on what they thought was their best chance: a federal strategy. In 1876, Susan B. Anthony and the National Woman's Suffrage Association began channeling their energy into an appeal and a petition for what they hoped would become the Sixteenth Amendment. Susan B. Anthony argued that if the federal government had the right to intervene negatively in state matters, as it did with *Minor v. Happersett*, then it could do so again, but this time, for a positive outcome.[30] It was optimistic at best, particularly when the federal government was removing troops from the South and allowing white supremacy to run states' citizenship rights into ruins. Nevertheless, in 1876, the centennial anniversary of the Declaration of Independence provided the perfect opportunity for women suffragists to stage an activist event.

On July 4, 1876, the city of Philadelphia planned to commemorate the centennial of the Declaration of Independence with events celebrating the nation's story of progress. During a key presentation in Independence Square, which had amassed some one hundred fifty thousand people, Susan B. Anthony rushed to the

stage and presented the acting dignitary with a three-foot scroll titled "Declaration of Rights of the Women of the United States." As the audience watched the disturbance and as Anthony read the text aloud, Matilda Joslyn Gage and other suffragists handed out printed copies of the declaration (cat. 41). Anthony read the declaration, which referred to "a series of assumptions and usurpations of power over woman."[31] She successfully masterminded a takeover, one that newspapers reported widely. Many reprinted the entire "Declaration of Rights of the Women of the United States," with the names of the original signers of the document emblazoned in print, yet again, white women cut black women out of their activism. Mary Ann Shadd Cary wrote to NWSA on behalf of ninety-four black women requesting that their names be enrolled in the July 4 autograph book as signers of the Woman's Declaration of Sentiments; unfortunately, their names were not included.[32]

Other women capitalized on the energy, including Belva Ann Lockwood, who became the first woman admitted to argue cases before the Supreme Court of the United States (cat. 42). Shortly after she was admitted to the District of Columbia Bar in 1879, she had this photograph made by Benjamin J. Falk. In the three-quarters profile portrait, a distinguished Lockwood wears her hair swept back, fixed with a decorative comb. A white embroidered and ruffled collar frames her neck and makes her day dress slightly more formal. Lockwood subsequently used the image in her political campaigns.

In 1884, Lockwood ran for president. Nominated by Woodhull's Equal Rights Party, her platform focused on women's rights issues, particularly suffrage, temperance, and reform for divorce and marriage laws. While running for president a second time, in 1888, satin ribbons presented a rebus puzzle, phonetically picturing the name Belva Lockwood with images of a bell, the letter *V*, a lock, and a log of wood (cat. 43). Such puzzles were commonly used by illiterate individuals in the nineteenth century, including women voters. Although some consider this ribbon to be satiric, as it implies that supporters of Lockwood were largely illiterate (and therefore understood to be ignorant) women, the ribbon may have been used as part of her serious campaign.

Well into the 1880s, women were repeatedly excluded from securing voting rights. On March 8, 1884, Susan B. Anthony asked the House Judiciary Committee to amend the US Constitution and consider granting women suffrage in what she was determined would be the Sixteenth Amendment. She declared, "We appear before you this morning . . . to ask that you will, at your earliest convenience, report to the House in favor of the submission of a Sixteenth Amendment to the Legislatures of the several States, that shall prohibit the disfranchisement of citizens of the United States on account of sex."[33] As is well known, Anthony's request was not granted for another thirty-six years.

Two weeks after she spoke to the House Judiciary Committee, the satirical magazine the *Judge* portrayed Anthony on its cover. The March 22, 1884, issue also sheds light—more broadly—on the prevalence of stereotypes in the nineteenth century and the attitudes toward marginalized groups at the polls (cat. 44). The tallest figure, representing Anthony, is shown knocking at the door with

DECLARATION OF RIGHTS

OF THE

WOMEN OF THE UNITED STATES

BY THE

NATIONAL WOMAN SUFFRAGE ASSOCIATION,

JULY 4th, 1876.

WHILE the Nation is buoyant with patriotism, and all hearts are attuned to praise, it is with sorrow we come to strike the one discordant note, on this hundredth anniversary of our country's birth. When subjects of Kings, Emperors, and Czars, from the Old World, join in our National Jubilee, shall the women of the Republic refuse to lay their hands with benedictions on the nation's head? Surveying America's Exposition, surpassing in magnificence those of London, Paris, and Vienna, shall we not rejoice at the success of the youngest rival among the nations of the earth? May not our hearts, in unison with all, swell with pride at our great achievements as a people; our free speech, free press, free schools, free church, and the rapid progress we have made in material wealth, trade, commerce, and the inventive arts? And we do rejoice, in the success thus far, of our experiment of self-government. Our faith is firm and unwavering in the broad principles of human rights, proclaimed in 1776, not only as abstract truths, but as the corner stones of a republic. Yet, we cannot forget, even in this glad hour, that while all men of every race, and clime, and condition, have been invested with the full rights of citizenship, under our hospitable flag, all women still suffer the degradation of disfranchisement.

The history of our country the past hundred years, has been a series of assumptions and usurpations of power over woman, in direct opposition to the principles of just government, acknowledged by the United States at its foundation which are:

First. The natural rights of each individual.

Second. The exact equality of these rights.

Third. That these rights, when not delegated by the individual, are retained by the individual.

Fourth. That no person can exercise the rights of others without delegated authority.

Fifth. That the non-use of these rights does not destroy them.

And for the violation of these fundamental principles of our Government, we arraign our rulers on this 4th day of July, 1876,—and these are our

ARTICLES OF IMPEACHMENT.

BILLS OF ATTAINDER have been passed by the introduction of the word "male" into all the State constitutions, denying to woman the right of suffrage, and thereby making sex a crime—an exercise of power clearly forbidden in Article 1st, Sections 9th and 10th of the United States Constitution.

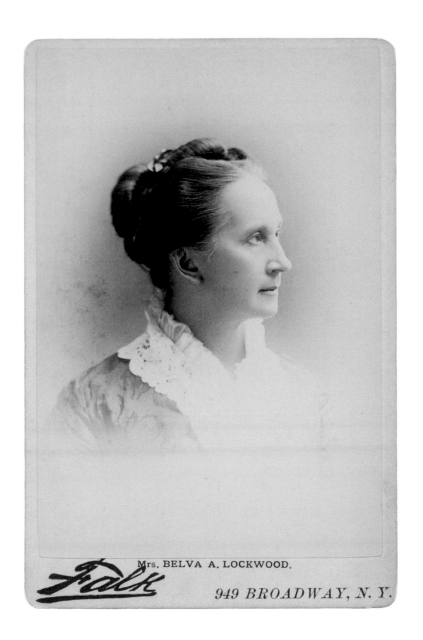

Mrs. BELVA A. LOCKWOOD.

Falk

949 BROADWAY, N.Y.

For President

1888.

CAT. 41

Declaration of Rights of the Women of the United States
National Woman Suffrage Association (1869–1890)
July 4, 1876
Printed paper
28 × 21.5 cm (11 × 8 7/16 in.)
Collection of Ann Lewis and Mike Sponder

CAT. 42

Belva Ann Lockwood (1830–1917)
Benjamin J. Falk
(1853–1925)
ca. 1880
Albumen silver print
14.7 × 9.8 cm (5 13/16 × 3 7/8 in.)
National Portrait Gallery, Smithsonian Institution

CAT. 43

Belva Lockwood Rebus Ribbon
1888
Satin ribbon
16.5 × 5.4 cm (6 1/2 × 2 1/8 in.)
Ronnie Lapinsky Sax Collection

VOL. 5.

NO. 127.

THE JUDGE.

ENTERED AT THE POST OFFICE AT NEW YORK AS SECOND CLASS MATTER. COPYRIGHT 1881 BY THE JUDGE PUBLISHING CO.

Price

NEW YORK, MARCH 22, 1884.

10 Cents.

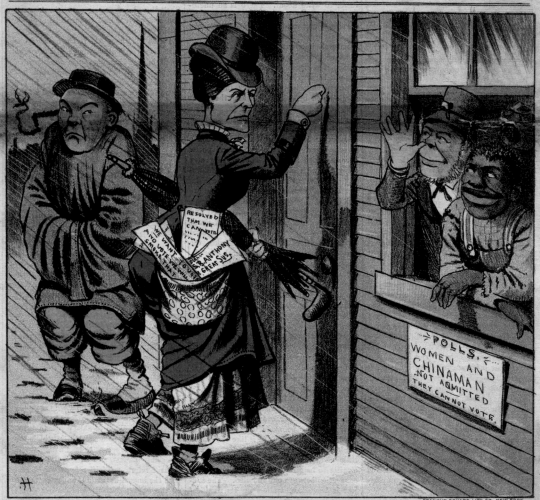

OUT IN THE COLD.

CAT. 44

Out in the Cold
Grant E. Hamilton (1862–1926)
for *The Judge*, March 22, 1884
Chromolithograph
34.3 × 25.4 cm (13 ½ × 10 in.)
Collection of Michael and
Susan Kahn

broadsides sticking out of her dress. The headlines, which are deliberately aimed at the viewer, read: "Resolved That We Can Vote!" and "We Want to Vote and Vote We Will." A shivering Asian man—left out since the Immigration Act of 1882, which suspended Chinese laborers from immigration—stands near Anthony as stereotypical portrayals of an Irish man and an African American man jeer at the two outside in the winter storm.[34] The African American man points to the sign underneath the window that states, "Polls: Women and Chinaman Not Admitted—They Cannot Vote."

As the century progressed, most suffragists felt that the most efficient way to gain voting rights would be for them to propose an amendment to the Constitution, rather than following through with the state-by-state approach, and they argued for a sixteenth amendment.[35] Senator Aaron A. Sargent of California introduced the proposed amendment in 1878, after which Stanton spoke at hearings held by the Committee on Privileges and Elections. In 1887, the measure for Woman Suffrage was voted on in the Senate and defeated by a two-to-one margin. Despite all of their activism and creative energy, women were left out from enfranchisement repeatedly. A change in tactic ensued, focusing on a state-by-state strategy, which spelled out years and years of more work.

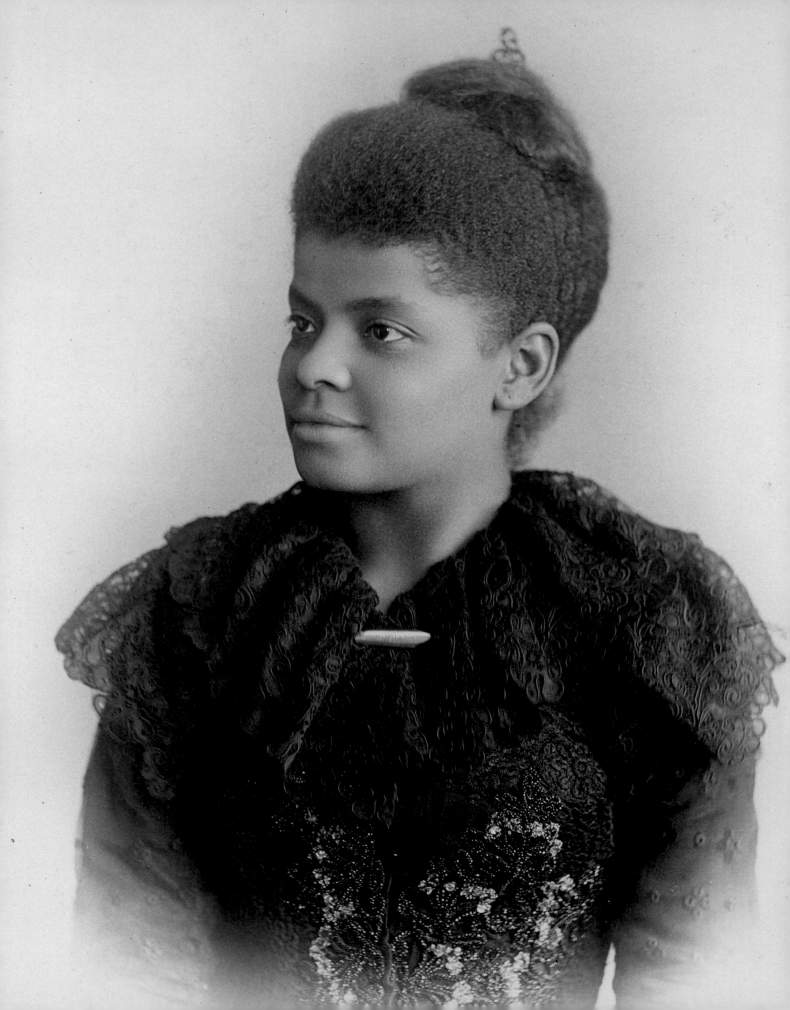

3
THE NEW WOMAN, 1893–1912

In the 1890s, the concept of the New Woman emerged as a radical social force in American society. College educated, independent, devoted to suffrage and progressive reform, she moved more freely throughout society than she ever had before, and she helped usher in the new century by awakening others to gender inequality. While some women could focus solely on women's rights at the turn of the century, others faced racial prejudice, both within and outside of the suffrage movement. African American women often banded together to create clubs and organizations and typically relied on grassroots approaches in working toward social reform. Clubs across the United States worked to make changes and increase the representation of women in the political franchise. Meanwhile, suffrage gained traction in the West. Through state-by-state referendums, Wyoming, Colorado, Utah, Idaho, and Washington granted women the right to vote; in Colorado, women were even elected to the state legislature. But back East, the momentum slowed down. In 1894, for example, not a single state referendum of suffrage was won. And, with the deaths of Elizabeth Cady Stanton in 1902 and Susan B. Anthony in 1906, new leaders helped usher in revitalized energy and a new era.

With the invention of the safety bicycle in the late 1880s, American perceptions of cycling changed. Bicycles, now more stable and controllable, became a viable form of transportation. Many women hopped on the chance to move more freely and quickly through their communities, and as they progressed, images like the one that appeared on the cover of *Scribner's* in June 1895 became associated with women's rights (cat. 45).

In addition to granting riders more autonomy, safety bicycles helped propel dress reform. Women frequently wore cycling suits with knee-length bloomers that allowed them to have more flexibility. In this illustration, by Charles Dana Gibson, the cyclist appears balanced and confident, as revealed by her expression and the symmetry of the composition. Gibson later would recall that he based his archetype on "the young working women of this country."[1] With a circulation of more than one hundred thousand for twenty-five-cent issues, by the 1870s *Scribner's* art department led the golden age of magazine illustration and in turn helped endorse the women's movement.[2]

See cat. 50.

CAT. 45

Scribner's for June
Charles Dana Gibson
(1867–1944)
1895
Zinc engraving
57 × 36 cm (22 7/16 × 14 3/16 in.)
Library of Congress, Prints
and Photographs Division,
Washington, DC

African American Progressives: Cooper, Terrell, and Hunt

The first step women took to improve their opportunities was through education. Access to higher learning was more limited for African American women than it was for white women, but those who attended Oberlin College became the intellectual leaders of the African American clubwomen's movement. Although they all came from differing socioeconomic backgrounds, Anna Julia Haywood Cooper, Mary Church Terrell, and Ida A. Gibbs Hunt each attended Oberlin in the 1880s (cats. 46–48). Anna Julia Haywood Cooper, who was born into slavery, broke all conventions when she graduated from Oberlin College in 1884.[3] She went on to publish her first book, *A Voice from the South by a Black Woman of the South*, in 1892, wherein she gave testimony to radical ideas of inclusion and equality. The M Street Colored High School in Washington, DC, where Cooper served as a teacher and principal between 1902 and 1906, was one of very few college preparatory schools that enrolled African American students at the time. Like W.E.B. Du Bois, she believed that African Americans who achieved a higher education would fare better than those who pursued a vocational education. Cooper chose to resign rather than to steer the school's curriculum away from academics in order to focus on vocational skills.

As African American women gained a public voice through their education, they also banded together. With their collective voices, black women addressed basic human rights. In the 1880s, incidents of lynching rose at an alarming rate. Between 1882 and 1891, there were 1,544 *recorded* lynchings of black men.[4] Records indicate that more than 2,500 people were killed by lynching between 1884 and 1900.[5] African American men were the most common targets, although Latinos and other people of color were also victims.[6] The flouting of the African American's right to due process of law during the last decade of the nineteenth century galvanized African American women from all different backgrounds into social activism.

Born in Memphis, Tennessee, Mary Church Terrell was the daughter of Robert Reed Church, one of the first black millionaires in the South. On graduating from Oberlin College in 1884, Terrell aspired to teach and earn wages, but given the family's social standing, her father felt she should not work. Terrell taught anyway, but when she married in 1891, she was forced to resign due to the school board's policy, which prohibited married women from teaching (cat. 49).[7]

Everything changed for Terrell in 1892 when her childhood friend Thomas Moss, who was also a friend of Ida B. Wells, was lynched. Terrell, along with Frederick Douglass, appealed to President Benjamin Harrison for his public condemnation of lynching, but Harrison refused to act. Terrell devoted the rest of her life to activism and later served in various capacities within the National Association of Colored Women.

Societal normatives forced Ida A. Gibbs Hunt, a classmate of Terrell's at Oberlin College, to abandon her teaching career after marriage.[8] Rather than choosing to lead a strict domestic life, however, Hunt aided her husband in his role as US Counsel in Liberia, France, Madagascar, and Guadeloupe. Despite her involvement overseas, Hunt was a major supporter of black women's clubs in the United

CAT. 46

Anna Julia Haywood Cooper
(1858–1964)
H. M. Platt (active 1870–1890)
1884
Albumen silver print
15.9 × 10.8 cm (6 ¼ × 4 ¼ in.)
Courtesy of the Oberlin College
Archives

CAT. 47

Mary Church Terrell (1863–1954)
H. M. Platt (active 1870–1890)
1884
Albumen silver print
15.9 × 10.8 cm (6 ¼ × 4 ¼ in.)
Courtesy of the Oberlin College
Archives

CAT. 48

Ida A. Gibbs Hunt (1862–1957)
H. M. Platt (active 1870–1890)
1884
Albumen silver print
15.9 × 10.8 cm (6 ¼ × 4 ¼ in.)
Courtesy of the Oberlin College
Archives

CAT. 49

Mary Church Terrell (1863–1954)
with Daughter Phyllis Terrell
Langston (1898–1989)
George V. Buck
(active 1900–1920)
ca. 1901
Platinum print
14 × 10.2 cm (5 ½ × 4 in.)
Moorland-Spingarn Research
Center, Howard University

MISS GARRITY.
PHOTOGRAPHER.

CHICAGO.

CAT. 50

Ida B. Wells-Barnett (1862–1931)
Sallie E. Garrity (ca. 1862–1907)
ca. 1893
Albumen silver print
13.9 × 9.8 cm (5 ½ × 3 ⅞ in.)
National Portrait Gallery,
Smithsonian Institution

States. She organized the first Young Women's Christian Association (YWCA) for black women and later helped support W.E.B. Du Bois in organizing many Pan-African Conferences.[9]

In 1884, the journalist Ida B. Wells filed a lawsuit against the Chesapeake, Ohio and Southwestern Railroad after being forcibly removed from the ladies' train car because she was black (cat. 50). Wells, who had been traveling from Memphis to the nearby town of Woodstock, won the trial in Shelby County but lost the appeal at the Tennessee Supreme Court.[10] After this, she focused on advocating for the civil rights of African Americans.

Wells penned a piece for *Free Speech and Headlight* in 1892 in defense of three friends, including Thomas Moss, who had been lynched. "Nobody in this section of the country believes the old threadbare lie that Negro men rape white women,"

Margaret James Murray Washington (1865–1925)
Unidentified photographer
ca. 1917
Gelatin silver print
13.9 × 9.8 cm (5 ½ × 3 ⅞ in.)
Xavier University of Louisiana

she wrote.[11] Soon she published her essay, but vandals burned her office to the ground while she was out of town. Feeling exiled, she did not return to Memphis for years.

Motivated by her experiences of 1892, she published her anti-lynching speeches, *Southern Horrors: Lynch Laws in All Its Phases*, which first was sold as a pamphlet for fifteen cents.[12] Like other activist black women, Wells felt that most people were unaware of the horrors of mob violence, and it was on her to help to educate and raise awareness. Frederick Douglass's letter in response to her message reads, "Brave woman! You have done your people and mine a service which can neither be weighed nor measured."[13] In the 1890s and beyond, she traveled extensively across the United States presenting lectures on lynching, and she also spoke on the topic in England and Scotland. *Southern Horrors* remains the only extant speech of Wells in its entirety.

"Lifting as We Climb": African American Women and the Long Process of Empowerment

Even as citizenship rights were denied to them, African American women did not give up. Indeed, they saw themselves as responsible agitators for change, working within local community structures like churches.[14] Some groups focused especially on suffrage. In 1895, seventy-three African American women representing women's clubs in twenty-five states and the District of Columbia gathered in Boston for the First National Conference of the Colored Women of America. Josephine St. Pierre Ruffin, who organized the meeting, was a vibrant member of the American Woman Suffrage Association and the Massachusetts School Suffrage Association. She also edited a monthly magazine, the *Woman's Era*, which was published for and by African American women, and sought to join together African American women clubs throughout the United States.

Margaret Murray Washington aided Ruffin in creating the framework of the First National Conference of the Colored Women of America that Wells and Terrell used to found the National Association of Colored Women (cat. 51). Murray, who was born in 1861 in Macon, Mississippi, was the daughter of a washerwoman who was probably enslaved. After graduating from Fisk University, she served as the "Lady Principal" of Tuskegee Institute in Alabama. After marrying Booker T.

Washington in 1892, she kept her position at the school—a sign of her husband's progressive views. Although not a suffragist, Murray worked to ensure African American women would have opportunities through their education. She implemented a world-class domestic science program (also referred to as industrial education) and insisted that her students learn how to make dolls with dark colored skin, as opposed to white. Black women from across the country enrolled at Tuskegee. Another important endeavor Murray undertook was to introduce a program on the history of black Americans to local African American schools in 1915.[15]

The First National Conference of the Colored Women of America was the foundation for Wells and Terrell to establish the National Association of Colored Women (NACW). Both helped to facilitate the merging of several African American women's groups, including the National Federation of Afro-American Women and the National League of Colored Women, in 1896. The other founders were Margaret Murray Washington, Fanny Jackson Coppin, Frances Ellen Watkins Harper, Charlotte Forten Grimké, and Harriet Tubman, who elected Terrell to serve as the association's president. Later, in 1910, Wells founded a club dedicated to suffrage, the Women's Second Ward Republican Club, in Chicago. African American women found their way into public culture through reform movements, notably anti-slavery, women's rights, and temperance. For black women's involvement on both anti-slavery and women's rights, having access to an education was key; one issue was not separated from the other.

As president of the National Association of Colored Women, Terrell addressed the National American Woman Suffrage Association in 1898, during which she discussed the efforts of black women within their homes and communities. Terrell requested equality between black and white women, not because of their shared experience as women, she argued, but because they had proved their worth by improving their communities through industriousness and educational achievements. She closed her speech by saying, "and so, lifting as we climb, onward and upward we go, struggling and striving, and hoping that the buds and blossoms of our desires will burst into glorious fruition ere long."[16] A pin once owned by Mary Church Terrell features two women, one lifting up the other during a treacherous mountain ascent alongside her signature phrase "Lifting as We Climb" (cat. 52).

It would take years of relentless efforts and resources of activists, such as Mary McLeod Bethune, to empower African American women within their communities (cat. 53). While teaching at several schools in South Carolina and Florida, Bethune became keenly aware of the dual oppression that African American girls encountered. To combat this, she founded the Daytona Normal and Industrial Institute for Training Negro Girls in 1904. The classical liberal education that her students received empowered them to become community leaders and commit to advancing their race. Bethune sought to hire African American women as instructors so that they could serve as role models for students who might also wish to become economically independent.

This photograph of Bethune, taken in Daytona, Florida, in 1910 or 1911, shows an educated, independent woman, with a book placed on the table beside her.

CAT. 52

National Association of Colored Women's Clubs Pin
Unidentified artist
ca. 1900
Enamel
2.4 × 1.7 cm (15/16 × 11/16 in.)
Collection of the Smithsonian National Museum of African American History and Culture; gift of Ray and Jean Langston in memory of Mary Church and Robert Terrell
* Not in exhibition

CAT. 53

Mary McLeod Bethune
(1875–1955)
William Ludlow Coursen
(1880–1967)
1910–1911
Gelatin silver print
15.2 × 10.2 cm (6 × 4 in.)
State Archives of Florida, Collection M95-2

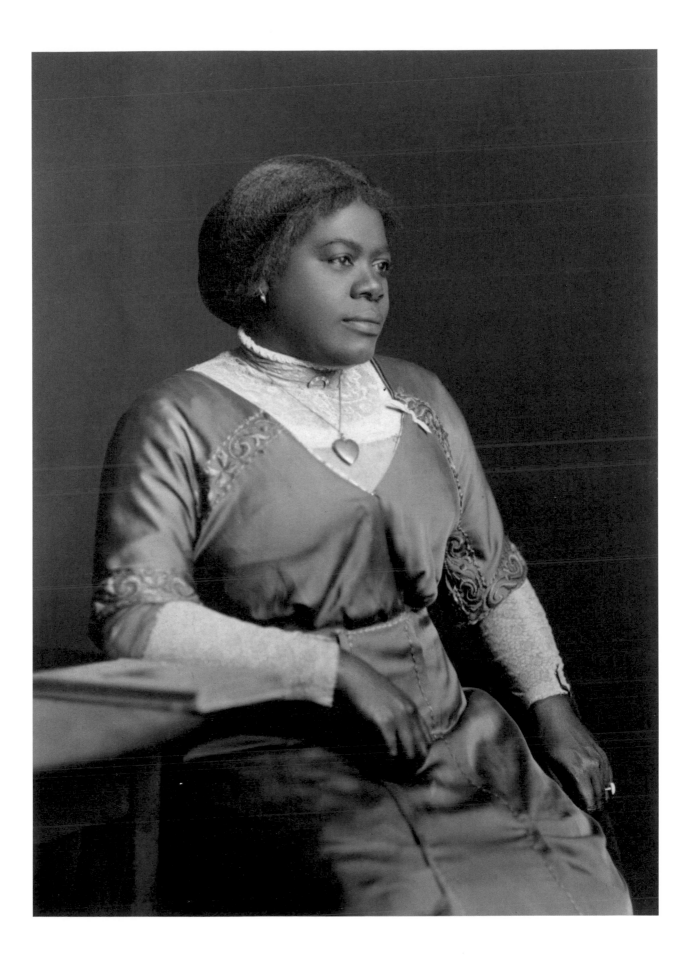

Reuniting the Factions:
The National Woman Suffrage Association

Alice Stone Blackwell, the daughter of Lucy Stone and Henry Blackwell, joined her prominent suffragist parents as an editor of *Woman's Journal* after graduating from Boston University in the early 1890s (cat. 54). While expanding the audience of the publication, Blackwell led the reunification of the American Woman Suffrage Association and the National Woman Suffrage Association, and served the new organization as recording secretary for the next twenty years. The newly formed National American Woman Suffrage Association (NAWSA) would lead the suffrage movement until the Nineteenth Amendment passed in 1920; although progressive in its fight for women's voting rights, it continued to exclude African American women from its leadership.

Carrie Chapman Catt was in attendance when NAWSA was formed at the February 18, 1890, landmark meeting and quickly took to lobbying state legislatures alongside Susan B. Anthony to win the enfranchisement (cat. 55). Catt's strong abilities as an organizer led her to revitalize women's clubs and garner interest in suffrage across the United States.

NAWSA had shifted its focus to a state-by-state strategy in the late 1880s and achieved its first state victory, Wyoming, in 1890. Colorado would be next in 1893. The Woman's Christian Temperance Union was especially popular with Colorado women. Half of the Woman's Christian Temperance Union (WCTU) membership was working-class women, whose populations were made up of immigrants of German, Irish, British, Scandinavian, African, and Chinese descent.[17]

Several African American women were prominent in Colorado history, including Elizabeth Piper Ensley, who helped found the Colorado Equal Suffrage Association in 1890 and later the Colorado Association of Colored Women's Clubs (1904).[18] Colorado's clubwomen demonstrated an ability to mobilize and organize for suffrage while simultaneously keeping in mind their state's interests in farm and labor reform (cat. 56). State-level suffrage measures were more than merely steps to a federal amendment; they represented change from within the ranks of ordinary people. Coalitional politics, specifically between the suffragists and the Populists, helped carry the successful 1893 vote.[19] The success was in large part thanks to Catt, who showed her good instincts for lobbying. While at the national level, women such as Anthony and Stone were ambivalent, at best, about the proposed Colorado State referendum, Catt worked alongside Colorado women to expand contacts between middle-class and more wealthy suffragists. By the end of the summer campaign, the outreach efforts had created a statewide coalition of fifty organizations that supported the suffrage referendum.[20]

Colorado women won the right to vote, the first state referendum victory of the suffragist movement. Historian Rebecca J. Mead attributes the victory to economic crisis, the positive example of Wyoming, and the participation of middle-class clubwomen.[21] Wyoming, however, did not exemplify male electors achieving a majority vote for woman suffrage; Colorado did.[22] Catt, however, thought the victory

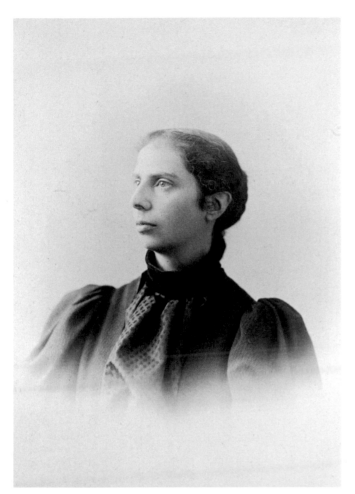

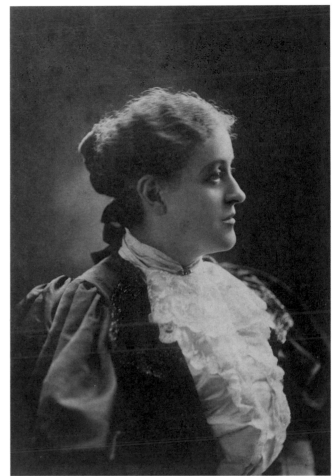

CAT. 54

Alice Stone Blackwell
(1857–1950)
Unidentified photographer
ca. 1885–1895
Gelatin silver print
20.3 × 15.2 cm (8 × 6 in.)
The Arthur and Elizabeth
Schlesinger Library on the
History of Women in America,
Radcliffe Institute for Advanced
Study, Harvard University

CAT. 55

Carrie Chapman Catt
(1859–1947)
Theodore C. Marceau
(1859–1922)
ca. 1901
Gelatin silver print
18.3 × 12.5 cm (7 3/16 × 4 15/16 in.)
National Portrait Gallery,
Smithsonian Institution; gift of
University Women's Club, Inc.

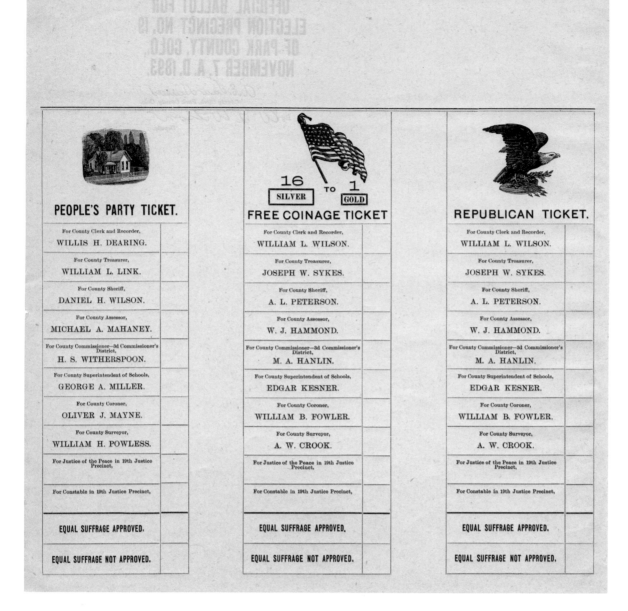

CAT. 56

*Official Ballot for Election Precinct
No. 19, Park County, Colorado*
1893
Photomechanical reproduction
27.3 × 35.1 cm (10¾ × 13¹³⁄₁₆ in.)
Collection of Ann Lewis and
Mike Sponder

CAT. 57

Colorado Women Legislators

Left to right: Agnes L. Riddle (1865–1930), Louise Kerwin (1854–1952), and Louise M. Jones (1859–1927)
Paul Thompson (active 1909–1917)
ca. 1911
Photomechanical reproduction
17.1 × 12.4 cm (6¾ × 4⅞ in.)
Collection of Robert P. J. Cooney Jr.

to be a sign that the state-by-state strategy was working. In 1894, Colorado voters elected three women to the Colorado House of Representatives (cat. 57). Women's suffrage in the state-by-state strategy was achieving success—slowly, but surely. By 1911, fourteen women had served in Colorado's state legislature, an anomaly when compared to the rest of the United States. A group portrait of three of the fourteen women shows Agnes L. Riddle, Louise Kerwin, and Louise M. Jones at their legislative desk alongside a vase of white flowers. Images such as this were used by suffrage publications to illustrate how women could be successful in elected positions.

The state-by-state strategy included women volunteers who distributed sixty-five thousand instructional leaflets to explain the new practice of anonymous voting, known as the secret ballot.[23] One might imagine that they would have made good use of the bicycle, if they owned one. However, suffragists were criticized for being outside of the "woman's domain"—the home—and were thought to be outlandish in general. With his 1892 painting *The New Woman*, artist Edward Lamson Henry captures some of the bewildered reactions of two country women and a farmer to the rather odd sight of the woman who has just gotten off her bicycle in order to drink some water (cat. 58). Dressed in a riding costume complete with bloomers, the woman appears carefree in her modern clothing and free movement, while the rural types appear perplexed, even disapproving.

Women knew that society's expectations of their behavior and "proper domain" were at odds with their public appearances. In 1892, Charlotte Perkins Stetson Gilman published her short story "The Yellow Wallpaper" in the *New England Magazine* (cats. 59 and 60). The narrative centers on a physician's wife who has been confined to a single room in the attic of a large house so that she can recuperate from "temporary nervous depression" and "a slight hysterical tendency."[24] The labels "hysterical" and "nervous" commonly were attributed to nineteenth-century women who suffered from boredom and restlessness. As the story progresses, the yellow wallpaper mutates and reveals itself to be imprisoning another woman, and insanity, it seems, is the protagonist's only recourse from her life in a patriarchal society.[25]

Gilman knew all too well how the confinement of women's freedoms in society were damaging. She was related to the Beechers and married Charles Walter Stetson, an artist, in 1884.[26] After having their only child, Gilman suffered bouts of depression and was ordered to take the "rest cure." After a month's hospitalization, she was able to return home but was told not to write or draw. Following the

CAT. 58

The New Woman
Edward Lamson Henry (1841–1919)
1892
Oil on canvas
39.4 × 55.2 cm (15 ½ × 21 ¾ in.)
Collection of Virginia and Gary Gerst

CAT. 59

Charlotte Perkins Stetson Gilman
(1860–1935)
H. Q. Morton
(active 1870–1889)
ca. 1875–1877
Albumen silver print
9.9 × 6.1 cm (3 ⅞ × 3 ⅜ in.)
The Arthur and Elizabeth
Schlesinger Library on the
History of Women in America,
Radcliffe Institute for Advanced
Study, Harvard University
* Not in exhibition

CAT. 60

The Yellow Wallpaper
Charlotte Perkins Stetson
Gilman (1860–1935)
1899
18 × 12 cm (7 ¹⁄₁₆ × 4 ¹³⁄₁₆ in.)
Kislak Center for Special
Collections, Rare Books and
Manuscripts, University of
Pennsylvania Libraries

divorce from her husband in 1894, she published the treatise *Women and Economics* (1898), which argues that women's liberty is dependent on their economic freedom.

"Give Us a Vote and We Will Cook, the Better for a Wide Outlook"[27]

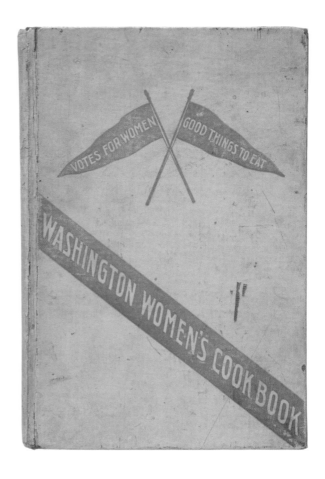

Washington suffragists, as well as other state associations, compiled recipes for cookbooks where, nestled between instructions for walnut cake and plum pudding, inspirational quotes and essays from leading suffragists sought to inspire the domestic worker while she prepared food. Through the good cooking instructions, the authors also hoped to show women that being a suffragist did not require them to abandon their domestic duties.

The *Washington Women's Cook Book*, published by the Washington Equal Suffrage Association, stresses the importance of enfranchisement, often comparing the structure of the home to that of government (cat. 61). The introductory quote to a chapter on vegetables reads, "What is politics? Why, it's housekeeping on a big scale. The government is in a muddle, because it has been trying to do the housekeeping without the women."[28] The cookbooks encouraged more women to join the movement by combating negative portrayals of suffragists while raising money for the cause.

In the 1890s, the West saw great state referendum victories, but in the East, discouraged suffragists went back to work after the referendum in New York State failed. At the 1894 New York State Constitutional Convention, suffragists presented a petition with six hundred thousand signatures in an attempt to bring a woman's suffrage amendment to the attention of voters. However, the referendum failed, as most politicians resisted expanding the electorate for which they would be responsible.[29] Although by law politicians had to accept petitions, throughout the summer, the pages of women's suffrage petitions sat unopened, stacked on shelves in a large committee room. In August, the convention members voted on the suffrage amendment: Ninety-eight opposed, whereas fifty-eight voted in its favor.[30] New York–based cartoonist Charles Jay Taylor illustrated and blithely titled the event "A Squelcher for Woman Suffrage" in *Puck* (cat. 62). The cartoon features a woman in Victorian dress who appears to have dropped her ballots after seeing that she cannot possibly fit into the narrow voting booths. The subtitle, which reads, "How can she vote, when the fashions are so wide, and the voting booths are so narrow?" stresses the public's belief that women would need to adapt in order to receive their enfranchisement.

CAT. 61

Washington Women's Cook Book
Linda Deziah Jennings
(1869–1932)
1909
23.6 × 16 cm (9 5/16 × 6 5/16 in.)
Ronnie Lapinsky Sax Collection

CAT. 62

A Squelcher for Woman Suffrage
Charles Jay Taylor (1855–1929)
for *Puck*, June 6, 1894
Chromolithograph
33.7 × 24.1 cm (13 1/4 × 9 1/2 in.)
Collection of Ann Lewis and
Mike Sponder

VOL. XXXV. No. 900.

PUCK BUILDING, New York, June 6th, 1894.
Copyright, 1894, by Keppler & Schwarzmann.

PRICE 10 CENTS.

Puck

Entered at N. Y. P. O. as Second-class Mail Matter.

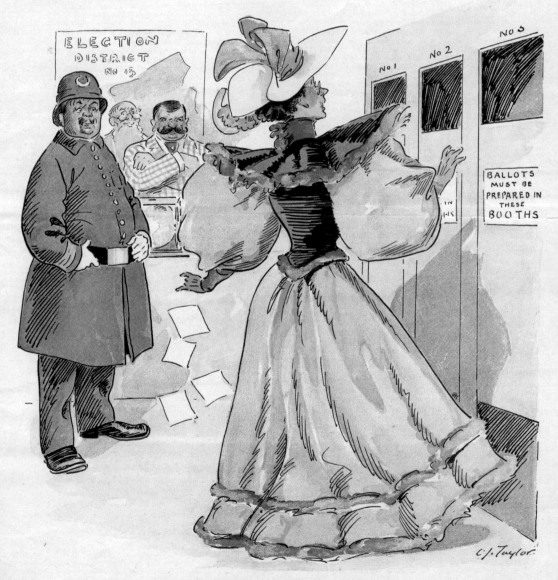

A SQUELCHER FOR WOMAN SUFFRAGE.

How Can She Vote, when the Fashions Are so Wide, and the Voting Booths Are so Narrow?

CAT. 63

Alva Belmont (1853–1933)
Unidentified photographer
ca. 1910–1920
Gelatin silver print
25.4 × 17.8 cm (10 × 7 in.)
National Woman's Party,
Washington, DC

Funding the Women's Movement

The irony that New York—home to so many "New Women"—refused to include them in its electorate was not lost on suffragists. They began to realize that bipartisan electoral incentives were key to winning support for enfranchisement, and this they did not have. Suffragists blamed the liquor industry, for in its fear of prohibition, it created anti-suffrage campaigns in saloons and bars across the nation. Another issue was finding funding for the cause of suffrage. Although during the 1870s Anthony and Stanton were backed by George Train, in the 1880s and 1890s, suffragists lacked a sponsor of means.

Socialite Alva Belmont became involved in suffrage in 1909 when leaders were struggling to finance their campaigns for the vote (cat. 63). As the ex-wife of the railroad heir William Kissam Vanderbilt, she was one of the richest socialites of New York City during its famed Gilded Age. Following her scandalous divorce in 1895 and her remarriage (to Oliver Hazard Perry Belmont) in 1896, she was eager to learn more about women's rights. Belmont first met Carrie Chapman Catt and Harriot Stanton Blatch, among other members of the National American Woman Suffrage Association, at a private lecture in the prestigious, women-only Colony Club in New York in 1908.[31] For several decades, NAWSA benefited greatly from Belmont's donations, which by 2016 standards would amount to many hundreds of thousands of dollars. For example, the organization was able to secure a headquarters building for the National Woman's Party in 1929.[32] Even so, the national organization needed more donors. Fortunately, they found one in 1902 when Miriam Leslie bequeathed an estate of nearly $2 million to Catt for the cause.[33]

Miriam Leslie was married to Frank Leslie, who ran a publishing house that produced *Frank Leslie's Illustrated Weekly*, among other publications. The couple married in 1873—her third marriage; his second. In 1877, while working as a journalist, Leslie traveled out West with her husband. In Utah, she interviewed Brigham Young and his wives about polygamy and women's rights, and in San Francisco, she had a formal portrait taken by the Bradley & Rulofson Studio (cat. 64). Her gown features exquisite pleats that complement the detailed carpeting and furniture in the setting, and at the same time, its draping provides a cozy place for her beloved Yorkshire terrier to rest.

When Frank Leslie died in 1880, Miriam legally changed her first name to Frank, perhaps because it gave her more commanding authority. Heralded as the "Empress of Journalism," Leslie revitalized the business—which was failing—by producing modern illustrations for her magazines (cats. 65–66). Selling for ten cents, some publications, like *Popular Monthly*, increased to a circulation of two hundred thousand after just four months of Leslie's direction.[34] She also ensured that the messaging of the weekly publications supported the women's movement.[35]

While serving as the twenty-second and twenty-fourth president in the 1880s and 1890s, Grover Cleveland rarely spoke about women's suffrage, but in 1905, he voiced his opinion for the *Ladies' Home Journal*. Cleveland argued that the "aggressive" and "extreme" suffrage movement was negatively affecting American family life.

CAT. 64

Miriam Follin Leslie (1836–1914)
Bradley & Rulofson
(active 1863–1878)
1877
Albumen silver print
16.5 × 10.8 cm (6½ × 4¼ in.)
Wells Fargo and Company

CAT. 65

Votes for Women
P. J. Monahan (1882–1931),
for *Leslie's The People's Weekly*,
November 7, 1912
Chromolithograph
40.3 × 27.9 cm (15⅞ × 11 in.)
Collection of Robert P. J.
Cooney Jr.

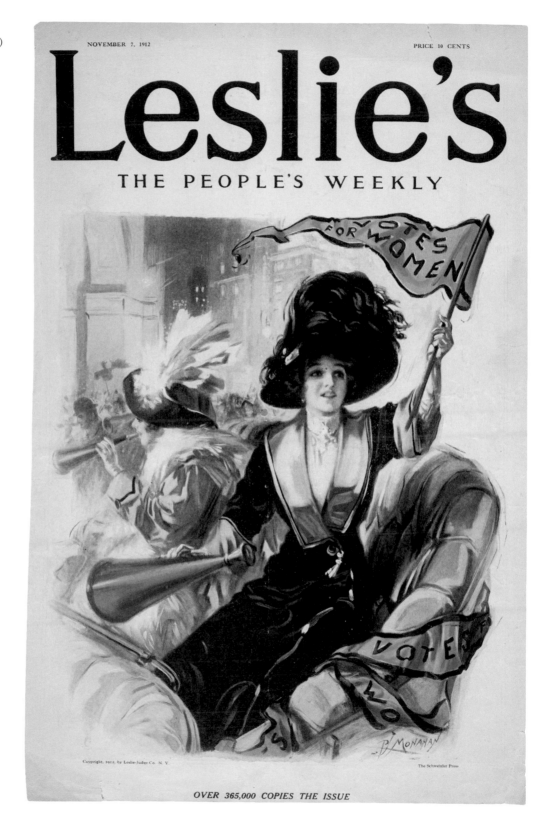

THE "OLD GUARD."
Left to right: Mrs. Hasbrook, Mrs. Richardson, Mrs. Holbrook, Mrs. Morse.

IN THE FRONT RANK.
Left to right: Miss Sarah McPike, Miss Alberta Hill, Miss Inez Milholland.

THE CROWD LISTENING TO THE SPEAKERS IN UNION SQUARE.
The small picture in center is that of Mrs. W. L. Colt, the grand marshal. (Photo E. Levick.

HEAD OF THE PROCESSION PASSING DOWN FIFTH AVENUE.

"Votes for Women!"

On Saturday, May 6, Three Thousand Women Paraded Forty-three New York Blocks in the Most Remarkable Woman Suffrage Demonstration Ever Seen in America. Fully 150,000 Persons Witnessed the Procession.

CAT. 66

Votes for Women! New York City
Unidentified artist for
Leslie's Weekly, May 1911
Photomechanical reproduction
40 × 26.2 cm (15 ¾ × 10 ⁵⁄₁₆ in.)
Collection of Robert P. J.
Cooney Jr.

CAT. 67

*What Shall We Do with Our
Ex-Presidents?—Susan B. Anthony
Knows*
Charles Lewis Bartholomew
(1869–1949)
1905
India ink and graphite on paper
55.5 × 45 cm (21 ⅞ × 17 ¹¹⁄₁₆ in.)
Library of Congress, Prints
and Photographs Division,
Washington, DC

He saw it not as progress but as "harmful in a way that directly menaces the integrity of our homes and the benign disposition and character of our wifehood and motherhood."[36] Although nearing the end of her life, Susan B. Anthony remained a forceful agent for suffrage and rebuked his characterization of "progress." She asked, "Why isn't the woman herself the best judge of what woman's sphere should be?"[37]

The artist Charles Lewis Bartholomew captured the tense argument between Anthony and Cleveland with this drawing (cat. 67). Anthony wields an umbrella labeled "Woman Suffrage" and chases after the former president, with a journal titled *Ladies' Home Trouble* tucked under her arm. Meanwhile, Uncle Sam stands in the background, laughing at it all. Anthony's response to Cleveland was highly publicized and often illustrated by Bartholomew's cartoon.

Suffragists experienced a setback when Elizabeth Cady Stanton published *The Woman's Bible* (1895 and 1898), a highly controversial best seller (cat. 68).

THE WOMAN'S BIBLE.

PART I.

THE PENTATEUCH.

"In every soul there is bound up some truth and some error, and each gives to the world of thought what no other one possesses."—*Cousin.*

NEW YORK.
EUROPEAN PUBLISHING COMPANY.
35 WALL STREET.
1895.

PRICE 50 CENTS.

CAT. 68

The Woman's Bible, Part 1
Elizabeth Cady Stanton
(1815–1902)
1895
22.9 × 15.2 cm (9 × 6 in.)
The H. Chase Livingston
Suffrage Collection

CAT. 69

Broadside: The Woman's Bible
ca. 1920–1925
Printed paper
41.9 × 24.1 cm (16½ × 9½ in.)
Collection of Ann Lewis and
Mike Sponder

THE WOMAN'S BIBLE

Editor
ELIZABETH CADY STANTON

Carrie Chapman Catt, President of the National Suffrage Association, one of the Revising Committee.

In the early nineties a group of leading Suffragists decided that the "Christian Bible, the Christian religion and the Christian ministry were the greatest obstacles to the spread of woman suffrage."

They concluded that the Bible should be rewritten from the woman's standpoint, but they could not persuade any scholars to make the desired changes in the translation, and so they were compelled to take the English version as it stood, and say how it should have been written.

(See preface to Woman's Bible.)

A Committee of "women of liberal ideas" was selected, and a portion of the Bible assigned to each one for revision. Mrs. C. C. Catt, the president of the National Suffrage Association; Miss Alice Blackwell, now editor of the leading suffrage magazine; Mrs. Robert Ingersoll, and other well known suffragists, were on this Committee. Mrs. Elizabeth Cady Stanton acted as editor and the book was copyrighted in her name. (See title page.)

The first volume was issued in 1896, the second in 1898, and two more editions have been printed. This Woman's Bible was distributed as a suffrage tract.

In their comments the Committee claim that the Bible is not inspired, that Christ is not divine, that the keeping of Sunday has done harm, and that the Christian Church and the Christian ministry have been agents of evil.

The Woman Suffrage Association is the only political body to hold its convention meetings on Sunday. At the convention in Chicago in February, 1920, the social reception to the delegates was held on Sunday evening. In May, 1920, the women who invaded Connecticut to try to force Governor Holcomb to call a special session, met in New York on Sunday and had a big political dinner on that day. Thus the party today lives up to the theory "that much injury has been done to the world" by the keeping holy the seventh day. (Page 68.)

The following quotations will be enough to show why the book was written and what it teaches.

"That even the most enlightened nations are not yet out of barbarism is due to the teachings of the Bible." (Page 209.)

"The truth of the matter is that whatever progress woman has made in any department of effort, she has accomplished in opposition to the so-called inspired 'Word of God'; and this Book has been of more injury to woman than any other book which has ever been written." (Page 203.)

"It does not need a knowledge of Greek or Hebrew to show that the Bible degrades women. We have made a fetich of the Bible long enough. The Bible has been the great block in the way of civilization." (Preface Volume 2.)

"The Bible has been and will continue to be a stumbling block in the way of the truest civilization." (Page 187.)

"The Bible always has been, and is at present, one of the greatest obstacles in the way of the emancipation and advancement of the sex." (Page 201.)

"Women especially need enlightenment as to the true nature of the Bible. Their religious nature is warped and twisted, which fact is the greatest stumbling block in the path of equal suffrage today." (Page 143.)

"Priestly power has done more to block woman's way to freedom than all other earthly influences combined." (Page 111.)

The attacks on ministers are too numerous and long to quote, but again and again women are urged to throw off these old superstitions, to free themselves from the authority of the churches, "to leave the priestly mendicants who demand their devotion and their dollars" and to stop giving their time and money to support that man-made religion, Christianity.

The Divinity of Christ is denied and the statement made: "That thousands of people have lived since the time of Jesus as good, as tender, as loving, as true, as faithful as He." (Page 115.)

They say that "The widow should have been blamed and not commended for casting in her mite, for 'self-development is a higher duty than self-sacrifice should be woman's motto.'" (Volume 2, Page 131.)

"No institution in modern civilization is so tyrannical and so unjust to woman as is the Christian Church." (Page 205.)

"Christianity feeds and fattens on the sentiment and credulity of women." (Page 207.)

"Why should women obey a man's religion?"

"Our religion is the real source of women's disabilities." (Page 79.)

"The Episcopal Church is most demoralizing. Whole congregations of educated men and women, day after day, confessing themselves miserable sinners." (Page 99.)

"The struggle of today among the advanced of our sex is to regain what has been lost since the establishment of Christianity." (Volume 2, Page 22.)

"The civilization of Moslem Spain far surpassed that of Christian Europe." (Page 206.)

Saint Paul is spoken of as the most stultifying influence in the history of civilization, and the following couplet is often quoted:

"This doctrine of Jesus as set forth by Paul,
If believed in its fullness would ruin us all."

The future woman suffragists are thus described: "A countless host of women will move in majesty down the centuries. These are the mothers of the coming race who have locked the door of the Temple of Faith and thrown the key away." (Page 198.)

This is the teaching of National Suffrage Leaders.
Are you willing for women who hold these views to become political powers in our country?

WOMAN'S SUFFRAGE

GIVE HER OF THE FRUIT
OF HER HANDS, AND LET
HER OWN WORKS PRAISE
HER IN THE GATES.

CAT. 70

Woman's Suffrage
Evelyn Rumsey Cary
(1855–1924)
1905
Oil on canvas
108 × 63.5 cm (42 ½ × 25 in.)
The Wolfsonian–Florida
International University, Miami
Beach, Florida; The Wolfson
Mitchell Jr. Collection

In producing the two-volume publication, Stanton and other members of a "revising committee" selected biblical passages that pertained to women and then inserted commentary and analysis after each text. Its publication, a radical rejection of the Bible in its traditional interpretations, severed ties between Stanton and Anthony, and the National American Woman Suffrage Association—which Stanton had once led—condemned it.

Stanton completely alienated herself from the suffrage movement, and her book fueled anti-suffragists for decades. As late as 1920, anti-suffragists continued to hold *The Woman's Bible* as evidence that the suffragists were misguided, unconventional, and damaging to society. One anti-suffragist broadside cites several excerpts from the publication, then asks, "This is the teaching of National Suffrage Leaders. Are you willing for women who hold these views to become political powers in our country?" The header of the poster falsely suggests that Carrie Chapman Catt, then the president of NAWSA, was Stanton's accomplice in writing the text (cat. 69).

Knowing they were victims of bad press, suffragists began to turn even more to visual culture as a means to communicate the complexities of their argument. In 1905, Evelyn Rumsey Cary, a painter from Buffalo, New York, created the oil sketch that would become a popular poster for women's suffrage (cat. 70). Reflecting values of the maternalism movement popular in the late nineteenth and twentieth centuries, the painting promotes the idea that women's place in the world, as mothers, is to make it a better place for their children.[38] The figure's arms stretch upward to become branches bearing fruit, whereas her legs descend into treelike roots.[39] At the bottom, a quotation from Proverbs 31:31 of the Old Testament reads: "Give her the Fruit of her hands, and let her own works praise her in the gates." This passage refers to women doing the work of God as women doing the work of the good. Behind the woman is a neoclassical building that suggests her potential for bettering her political sphere.

Between 1896 and 1910, the so-called doldrums of the movement defined the era, when not a single state referendum of suffrage was won. However, suffragists sustained hope despite the fact that their first generation had died. New strategies and ideas influenced by the British suffragette movement ushered in the 1910s, and with them, a renewed sense of energy and purpose.

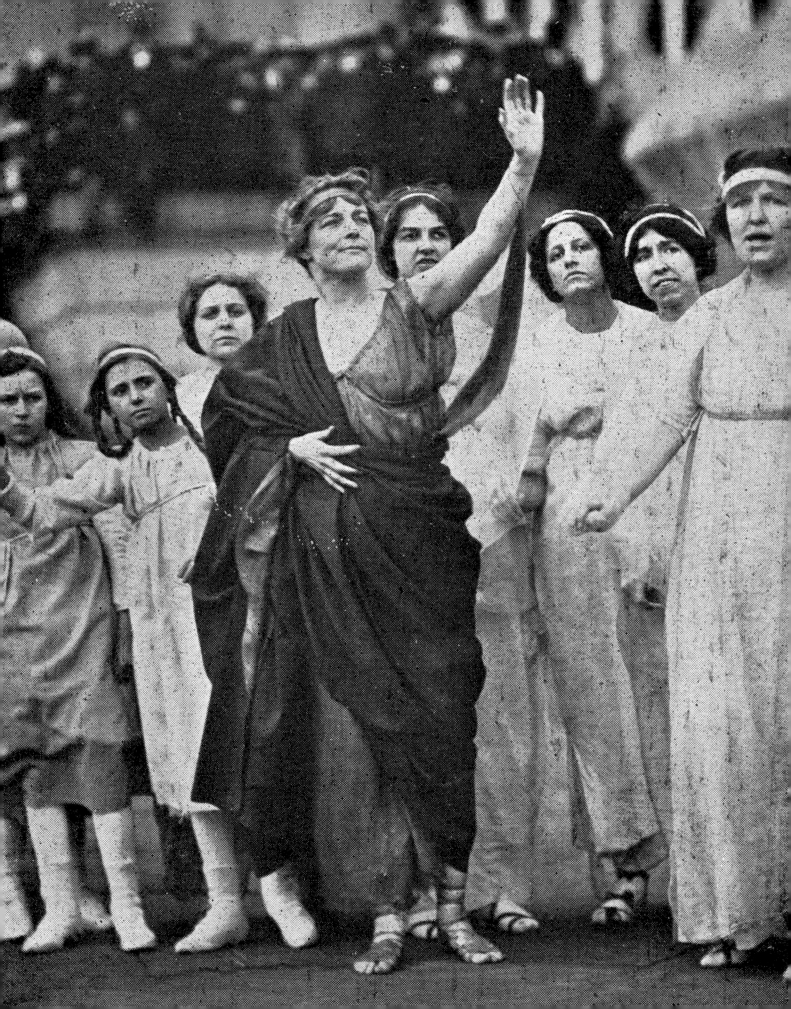

4

COMPELLING TACTICS, 1913–1916

In the 1910s, suffragists began to embrace strategies that the labor movement was employing, such as rallies, parades, and pageants. At the same time, groups of young American women returning from their academic studies in Great Britain brought over ideas from the British suffragette movement. (Note that British reference is "suffragette," whereas American women preferred the nongendered word "suffragist.") Alice Paul and Harriot Stanton Blatch, for example, were inspired by the suffragettes' use of spectacle and the media as one tool to make progress.[1] They were also impressed by the ways in which British women from varying socioeconomic classes joined together to support the cause. These new, often more assertive, methods reinvigorated their efforts, which had ebbed at the turn of the century.[2]

Paul brought militancy to the women's suffrage movement through parades and protests. However, members of the National American Woman Suffrage Association (NAWSA) decided to continue their traditional approach of petitioning legislatures and lobbying politicians on the state level. This disagreement led to the formation of the Congressional Union, founded in 1913 by Alice Paul and Lucy Burns, which set its eyes on protesting and lobbying nationally for a federal amendment. Nevertheless, NAWSA persisted in lobbying and petitioning for women's suffrage.

The grassroots efforts worked. In 1914, Nevada and Montana adopted women's suffrage. Two years later, Montana voted Jeannette Rankin to serve in the US House of Representatives, promising to advocate for women's suffrage in Congress. Women's political voices were growing louder, and securing the vote no longer seemed so far out of reach.

A Spectacle of Respectable Women

Alice Paul, who participated in the British suffragette movement in the 1900s while studying abroad (cat. 71), masterminded the 1913 women's suffrage parade in Washington, DC (cat. 72). On returning to the United States, she saw a parade in Washington as a necessary step in drawing public attention to the cause, and she had already fastened her eye on the goal of a federal amendment. Importantly, Paul

STARTING OF SUFFRAGETTE'S PARADE COMING UP PENNA. AVE. MARCH 3-1913 WASHINGTON-D.C.

CAT. 71

Alice Paul (1885–1977)
Underwood & Underwood
(active 1882–1950)
ca. 1923
Gelatin silver print
24.2 × 16.4 cm (9 ½ × 6 7/16 in.)
National Portrait Gallery,
Smithsonian Institution; gift of
Francis A. DiMauro

CAT. 72

*Starting of Suffragette's Parade
Coming Up Penna. Ave. March 3,
1913, Washington, D.C.*
I&M Ottenheimer
(active 1890–1930)
1913
Photo postcard
8.9 × 14 cm (3 ½ × 5 ½ in.)
Ronnie Lapinsky Sax Collection

introduced a soft militancy to the women's suffrage movement through these initial parades, which later would develop into protests and hunger strikes.

Paul knew how to attract attention, as her portrait demonstrates. In a publicity image from 1923 that was created by the news bureau photography firm Underwood & Underwood, an elegant Paul wears a lavish fur coat, gazing off into the distance.

Parades brought women into the public eye but allowed them to remain cloaked in respectability. The Women's Suffrage Parade in Washington on March 3, 1913, drew the attention of the nation when it staged a procession of between five and eight thousand suffragists.[3] Prior to March 13, 1913, the only large march to take place in Washington had been in 1894 when five hundred men, referred to as "Coxey's Army," walked four hundred miles to the steps of the Capitol to protest increasing unemployment.[4] Instead of achieving their goals, the workers terrified the nation. Although the suffragists' event was of a different nature, they knew that it could nonetheless be just as threatening. They purposefully scheduled their parade for the day before president-elect Woodrow Wilson's inauguration. In organizing a crowd of distinguished women to make a spectacle of themselves, suffragists were in effect displaying their power.

The parade, which was organized thematically, commenced with the grand marshal, Jane Burleson, astride a horse. She was followed by other mounted

marshals. Banners such as *Failure Is Impossible* employed the traditional medium of textile and very strong messaging (cats. 73–74). By carrying these slogans, suffragists amplified their message in a distinctly feminine way. Handcrafted from threads of gold, purple, and cream, banners first were used in heraldic processions like the 1913 parade and then later for public display at the National Woman's Party headquarters.

The mounted marshals were followed by Inez Milholland Boissevain, who sat atop a white horse, appropriately named Grey Dawn (cat. 75). Her beauty and costume recalled depictions of Joan of Arc, the historic figure of female martyrdom.[5]

The Joan of Arc figure appeared earlier in the woman suffrage movement, particularly in the temperance chapter. It was a popular motif in 1913, so eye-catching that Benjamin Moran Dale, a Philadelphia-based illustrator who created materials for popular magazines like *Ladies Home Journal*, featured it on the parade's program (cats. 76–77). As the cover image for the "Woman Suffrage Procession," the illustration, which Dale painted using gouache, features a trumpeting Joan of Arc on a horse marching forward toward the Capitol as women follow behind her. Militant suffragists saw themselves as constrained and restricted within their society; thus, they looked to a woman from the past, specifically Joan of Arc, as an example of a powerful and liberated woman of purpose, a model many suffragists sought to follow.[6]

After the eye-catching Milholland Boissevain, Anna Howard Shaw, the president of NAWSA, led the organization's national board and delegates, who were dressed in white with yellow sashes. Paul had carefully planned the sequence of the program to ensure that the display reflected the respectability of the women as well as the desired symbolism for the movement (cat. 78).[7]

Anna Howard Shaw, who originally served as a Methodist Protestant minister, was president of the NAWSA from 1904 to 1915 (cat. 79). She was first "discovered" and supported by Susan B. Anthony and quickly rose to power within NAWSA. While Shaw was lauded for her beautifully moving speeches, she lacked the administrative abilities needed for organizing a nationwide movement.

In processions, Shaw preferred to wear her academic robes reflecting her MD degree, but otherwise, she gravitated toward conservative dark gowns featuring a white lace collar and punctuated with a pin at her neck. Many suffragists remarked that her choice of clothing contradicted her lively wit and personality.[8]

Paul then placed approximately eight floats featuring *tableaux vivants* that grounded the contemporary moment in the past (cat. 80). The floats pictured both women and men enacting historical scenes, creating visual links between women's struggle for justice with their triumphs in former years. One float presented the Bible Lands, in which women represented figures including Debora, judge of all Israel and commander in chief of the army.[9] These displays also portrayed women in a variety of roles and occupations, including nurses, artists, and seamstresses. Once the floats passed by, bannered groups, including homemakers and mothers, helped to characterize suffragists as "respectable." Educated women then processed, identified by their professions and various women's clubs. These individuals

CAT. 73

Forward Out of Darkness
National Woman's Party
(1916–1997)
ca. 1913–1920
Paint on cotton
142.2 × 78.7 cm (56 × 31 in.)
National Woman's Party,
Washington, DC

CAT. 74

Failure Is Impossible
National Woman's Party
(1916–1997)
ca. 1913–1920
Paint on cotton
138.4 × 81.3 cm (54½ × 32 in.)
National Woman's Party,
Washington, DC

CAT. 75

Inez Milholland Boissevain
(1886–1916)
Harris & Ewing Studio
(active 1905–1945)
1913
Gelatin silver print
10.2 × 15.2 cm (4 × 6 in.)
Library of Congress, Prints
and Photographs Division,
Washington, DC
*Not in exhibition

FORWARD
OUT OF DARKNESS
LEAVE BEHIND
THE NIGHT
FORWARD
OUT OF ERROR
FORWARD
INTO LIGHT

FAILURE

IS

IMPOSSIBLE

CAT. 76

Mockup of Official Program—
Woman Suffrage Procession
Benjamin M. Dale (1889–1951)
1913
Gouache on paper
61 × 50.8 cm (24 × 20 in.)
Collection of Laura Wathen
Greiner and Family
*Not in exhibition

VOTES FOR WOMEN

Washington
D.C.
March 3, 1913

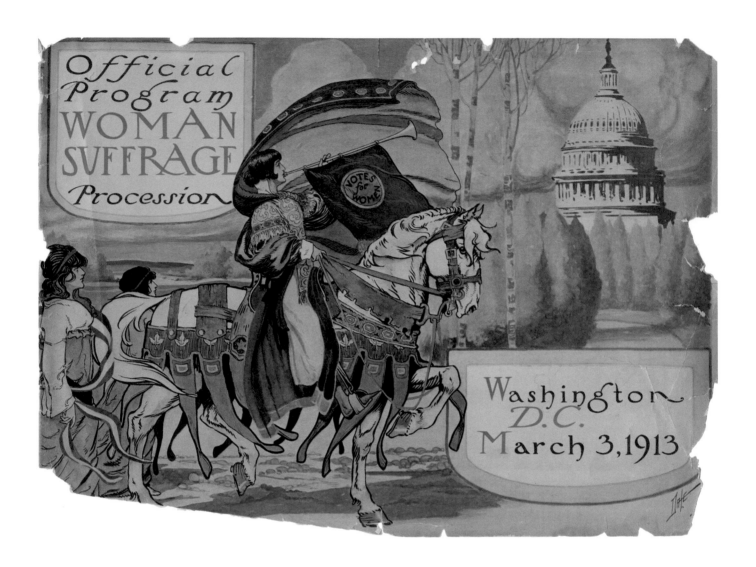

CAT. 77

*Official Program—Woman
Suffrage Procession, Washington,
D.C., March 3, 1913*
Benjamin M. Dale (1889–1951)
1913
Photomechanical reproduction
22.9 × 31.1 cm (9 × 12 ¼ in.)
Collection of Ann Lewis and
Mike Sponder

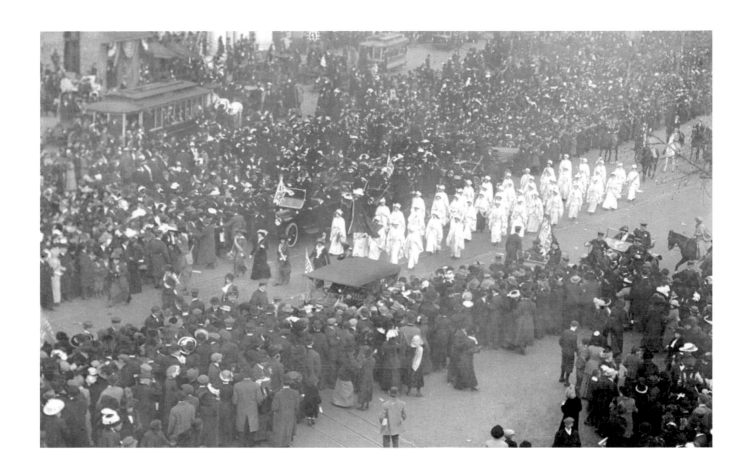

CAT. 78

Woman Suffrage Postcard
Unidentified photographer
1913
Photo postcard
9 × 14 cm (3 ½ × 5 ½ in.)
National Museum of American
History, Smithsonian Institution;
gift of Edna L. Stantial
*Not in exhibition

CAT. 79

Anna Howard Shaw (1847–1919)
Unidentified photographer
ca. 1915
Brown-toned gelatin silver print
24.5 × 18 cm (9 ⅝ × 7 ¹⁄₁₆ in.)
National Portrait Gallery,
Smithsonian Institution; gift of
University Women's Club, Inc.

represented the International Council of Nurses, the Army Nurse Corps, and the Red Cross Volunteers, along with conservative groups like the Woman's Christian Temperance Union.

Paul recognized that the route of the procession would greatly influence the amount of media it received (cat. 81). She wanted the suffragists to proceed down Pennsylvania Avenue, symbolically connecting the Capitol to the White House, the future home of Wilson, a Democrat, who was infamously recalcitrant and frustratingly slow to support women's voting rights.

Through the efforts of the National Association of Colored Women, African American women participated as well.[10] Nellie Quander led twenty-five women—the Delta Sigma Theta Sorority—from Howard University in the college section of the parade. Ida B. Wells refused to be sidelined and joined the Illinois contingent at its head.[11] To placate racist objections to African Americans marching in the procession, Paul separated the Howard University contingent from the rest of the college women. These groups of women were followed by more floats, one of which featured a huge map of the country that highlighted the nine states where women had won the right to vote.

Some African American women refused to be shut out of the national women's suffrage movement. As the head of the rural department for the National Association of Colored Women from 1910 to 1913, Adella Hunt Logan worked alongside Mary Church Terrell to resist efforts to keep African American women from participating in the 1913 suffrage parade.[12] Logan, pictured center left in a 1913 portrait of the Logan family, used her fair complexion to her advantage (cat. 82). While living next door to Booker T. and Margaret Murray Washington in the early 1910s, Logan conducted monthly suffrage meetings for the Tuskegee Woman's Club. With her light skin, she often passed as white to be able to attend the National American Woman Suffrage Association's segregated meetings in Alabama. She addressed her views on race in suffrage in the *Colored American Magazine*: "If white American women with all their natural and acquired advantages need the ballot . . . how much more do black Americans, male and female, need the strong defense of a vote?"[13] Educated and eloquent, Logan crossed social barriers with ease. Indeed, the portrait of Adella and Warren Logan on the occasion of their twenty-fifth wedding anniversary challenges many social, racial, and political assumptions. Dressed in a graceful, ivory satin gown topped by a bolero jacket with embroidered paillettes and an asymmetrical drape, an assured Adella knew her own influence. Photographer Arthur P. Bedou caught the family in a proud moment as they posed on the porch of the home of the Booker T. Washington family.

The procession concluded on the steps of the Treasury Building with a tableau dedicated to the ideals of American womanhood. In the eyes of Alice Paul, complementing the controversial procession with a traditional pageant at the end would establish suffrage as a patriotic practice. As trumpets sounded, Columbia—a woman embodying the United States—summoned the allegorical figures of Justice, Charity, Liberty, Peace, Plenty, and Hope, who had been standing alongside the building's marble columns.[14]

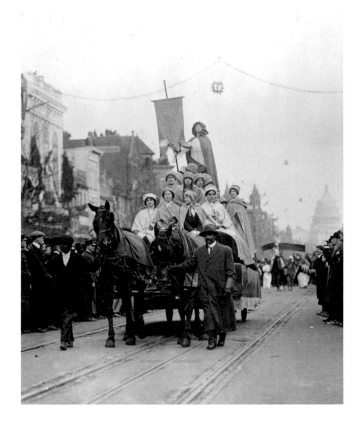

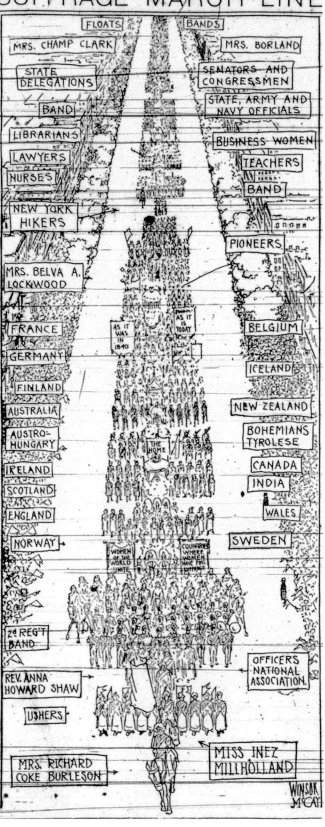

CAT. 80

Suffrage Parade on Pennsylvania Ave., Washington, D.C.—Women on Wagon
Unidentified photographer
1913
Gelatin silver print
8.9 × 14 cm (3 ½ × 5 ½ in.)
Library of Congress, Prints and Photographs Division, Washington, DC
*Not in exhibition

CAT. 81

Suffrage March Line—How Thousands of Women Parade Today at Capital
Zenas Winsor McCay (1871–1934) for *New York Evening Journal*, March 4, 1913
1913
Photomechanical reproduction
Original dimensions unknown
Library of Congress, Prints and Photographs Division, Washington, DC

*Adella Hunt Logan (1863–1915)
and Her Family on the Occasion of
Her and Her Husband's Twenty-
Fifth Wedding Anniversary*
Arthur P. Bedou (1882–1966)
1913
Gelatin silver print
22.9 × 17.1 cm (9 × 6 ¾ in.)
Collection of Adele Logan
Alexander, PhD

The postcard *Liberty and Her Attendants* features Florence Fleming Noyes, a renowned classical dancer, as Liberty dressed in "swaying gauzes" of scarlet (cat. 83).[15] For Noyes's dramatic entrance, which was accompanied by the "Triumphal March" from *Aida*, she seemingly hovered for several minutes and then elegantly swept down the Treasury steps with her attendants dressed in white.[16] *Liberty and Her Attendants* was one in a set of six "real photo" postcards depicting the 1913 suffrage procession and pageant, which were intended to be sent out "one by one" to those who were unable to attend the event.[17]

All these attributes, suitably represented by notable women in the arts, accompanied Columbia, the allegorical figure of the United States, played by Hedwig Reicher, who stands tall in anticipation of receiving the suffragists (cat. 84).[18] Reicher, a German-born actor who had thus far had a successful Broadway career, had enough experience to handle the massive crowd's interruption to what was a very carefully choreographed procession-pageant. Even though the performance had to be repeated twice to achieve the appropriate effect, Reicher carried it off.[19]

To step before Columbia and her entourage was the ultimate goal of the approximately five thousand women suffragists processing down Pennsylvania Avenue. As they appeared at the bottom of the steps of the Treasury Building and passed by the female representation of the United States, Columbia gave them her approval and endorsement of their cause, effectively enacting the pageantry of what would become the Nineteenth Amendment.

Although no doubt a frightful experience, the surging of the crowds of approximately five hundred thousand around the parade marchers helped attract widespread media attention. When seen together, two photographic postcards, by the Leet Brothers, reveal striking contrasts of police protection during the suffrage procession and Wilson's inaugural parade (cats. 85–86).[20] Interestingly, while the image is titled *Police Protection for Woman's Suffrage Procession March 3, 1913, Fifteenth and Pennsylvania Avenue*, the suffragists never received real police protection. Paul had petitioned the city's chief of police, Major Richard Sylvester, for weeks, asking him to help secure the safety of participants, but her requests went unanswered. Nevertheless, Secretary of War Henry L. Stimson placed members of the Army Cavalry (today's equivalent of the National Guard) nearby at Fort Myer, Virginia. As the suffragists increasingly faced assault by the huge swarm of mostly men surrounding them, Sylvester finally called in the cavalry to ensure their security.[21] The image of the same location on March 4, 1913, reveals an organized—yet minimally attended—inauguration celebration of President Wilson, under control by the police force.

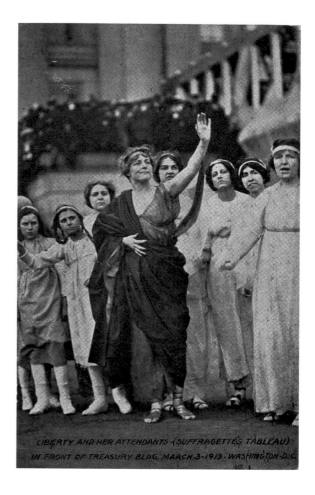

CAT. 83

Liberty and Her Attendants (Suffragettes Tableau) in Front of Treasury Bldg March 3-1913-Washington DC
I&M Ottenheimer
(active 1890–1930)
1913
Photo postcard
13.3 × 8.9 cm (5 ¼ × 3 ½ in.)
Ronnie Lapinsky Sax Collection

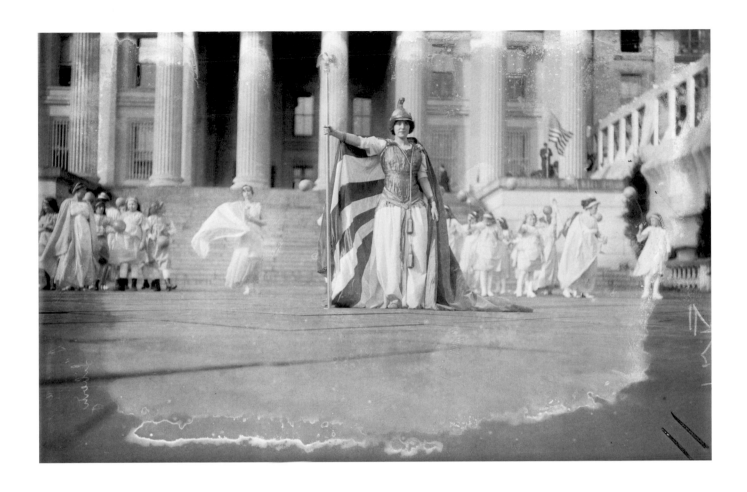

CAT. 84

Hedwig Reicher (1884–1971)
as Columbia in Suffrage Pageant
Bain News Service
1913
Glass negative
12.7 × 17.8 cm (5 × 7 in.)
Library of Congress, Prints
and Photographs Division,
Washington, DC
*Not in exhibition

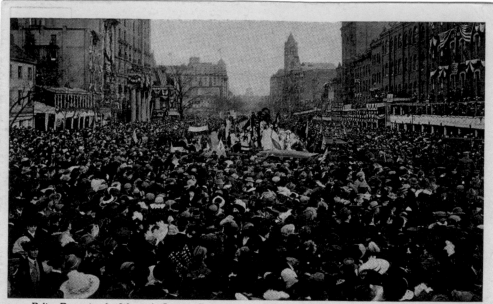

Police Protection for Woman's Suffrage Procession March 3, 1913, Fifteenth and Pennsylvania Avenue

Police Protection for Inaugural Procession March 4, 1913, Fifteenth and Pennsylvania Avenue

CAT. 85

Police Protection for Woman's Suffrage Procession March 3, 1913, Fifteenth and Pennsylvania Avenue
Leet Brothers
(active 1900–1935)
1913
Photo postcard
8.9 × 14 cm (3 ½ × 5 ½ in.)
Collection of Robert P. J. Cooney Jr.

CAT. 86

Police Protection for Inaugural Procession March 4, 1913, Fifteenth and Pennsylvania Avenue
Leet Brothers
(active 1900–1935)
1913
Photo postcard
8.9 × 14 cm (3 ½ × 5 ½ in.)
Collection of Robert P. J. Cooney Jr.

CAT. 87

Harriot Stanton Blatch
(1856–1940)
Unidentified photographer
ca. 1910
Gelatin silver print
12.7 × 7.6 cm (5 × 3 in.)
National Woman's Party,
Washington DC

Harriot Stanton Blatch sent a telegram to President Wilson the next day, his Inauguration Day. She described how "women while passing in peaceful procession in their demand for political freedom [were] at the mercy of a howling mob on the very streets which are being at this moment efficiently officered for the protection of men."[22] Some women claimed to have been harangued, bullied, and physically assaulted. The *Washington Post* reported on some of these altercations, describing how the women "practically fought their way foot to foot up Pennsylvania Avenue."[23]

Blatch bore a striking resemblance to her mother, Elizabeth Cady Stanton, in terms of both her physical appearance and ideals (cat. 87). Blatch extended the suffrage movement to working-class women and became a powerful force for unifying women across socioeconomic divides.[24] As the founder of the Equality League of Self-Supporting Women (later named the Women's Political Union), Blatch's advocacy for working-class women complemented Alice Paul's talents for compelling tactics.[25]

"General" Rosalie Jones and her Ambassadors of Justice traveled by foot from New York City to Washington, DC, to participate in the suffrage procession on March 3, 1913 (cat. 88). Several news outlets covered their trek, likening the group of hikers to pilgrims. In an interview with the *New York Tribune*, Jones was asked why women would make the long and arduous journey, and she said, "The people in the small towns don't see suffrage literature. They can't go to great, inspiring suffrage meetings. We had to bring them the message in person."[26] Clad in hooded, heavy brown cloaks and carrying knapsacks and walking staffs, these women pilgrims surely made a visual statement in rural communities.

The "General" and her pilgrims often walked for their cause. In a March 1914 *Puck* illustration, artist Gordon Grant shows five young women walking down a road, ostensibly to distribute literature to less-traveled rural areas (cat. 89). They refuse a ride but encourage the farmer to vote for woman enfranchisement: "Can't I give ye a lift, girls?" Jones, pictured as the "General," responds, "You can, sir, by voting for the cause!"

Indeed, the walking took its toll, physically, on the women. In this 1913 photograph of Jones, she reads a suffrage publication while relaxing in a chair with crossed legs. Close looking reveals that her shoes have holes in them, conveying how much her seventeen-day hike of over two hundred and thirty miles cost her.

The parade was a huge success in every way; the NAWSA 1913 Annual Report described it as "the most elaborate pageant procession the country had ever known."[27] Although at times chaotic and certainly not quite what Paul had planned

CAT. 88

Rosalie Gardiner Jones
(1883–1978)
Unidentified photographer
ca. 1913
Gelatin silver print
17.8 × 12.7 cm (7 × 5 in.)
The H. Chase Livingston
Suffrage Collection

CAT. 89

Giddap!
Gordon Grant (1875–1962) for
Puck, March 14, 1914
Photomechanical reproduction
34.4 × 26 cm (13 ⁹⁄₁₆ × 10 ¼ in.)
Collection of Robert P. J.
Cooney Jr.
*Not in exhibition

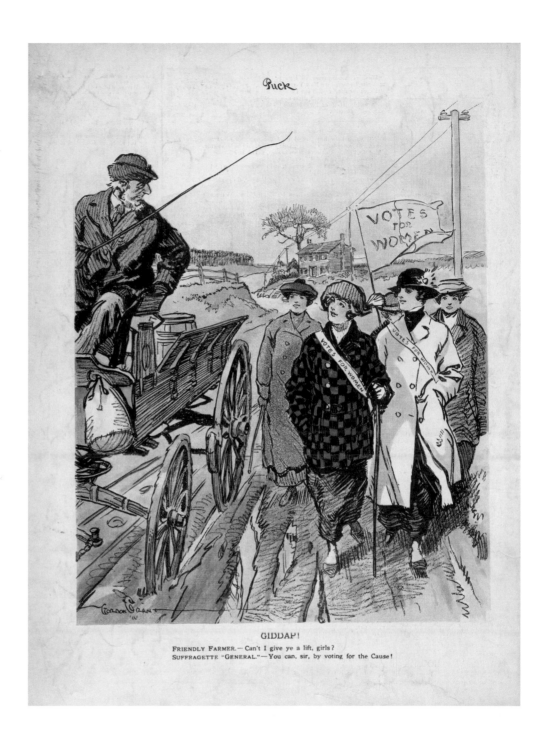

GIDDAP!

FRIENDLY FARMER.— Can't I give ye a lift, girls?
SUFFRAGETTE "GENERAL."—You can, sir, by voting for the Cause!

so carefully, the organization of a large number of respectable women to make a spectacle of themselves in effect placed power into their own hands—and by the very timing of the event, out of those of the president-elect Woodrow Wilson, whom suffragists increasingly targeted.

Visual Strategies of Suffrage

Beyond headline-grabbing events, at the most basic level, material culture greatly enhanced suffrage efforts. For example, in 1911, the San Francisco College Equal Suffrage League hosted a poster contest for the best illustration supporting women's voting rights. A crushing defeat in 1896 of a state referendum in California had knocked suffragists back to their foundational organization, but from that time until 1911, they forged strong connections between women's clubs and progressive organizations, and many of these women turned toward publicity and art as a way to galvanize support.[28]

The winning design of the 1911 competition, by Bertha Margaret Boyé, pictures a woman resplendent in a loose gown (cat. 90). The modern, art nouveau–influenced curving lines at the bottom of her robe complement the unfurled banner she holds at her waistline. Inscribed with the words "Votes for Women," the woman gazes outward with purpose. The sun forms a halo around her head, and two rising mountains, reminiscent of the Golden Gate Strait, frame her shoulders. Boyé's poster creates a symbolic parallel between California's famous seaside hills and women's rights. Its style also reflects the era's burgeoning California Arts and Crafts style, which focused on lush landscapes and distinctly California aesthetics.

From its use of grassroots activism, California played a key role in establishing the "states' rights" approach. During the early 1900s, suffragists argued their cause was a direct reform measure born out of democracy. They developed visual culture to capitalize on this idea. The states in the West were held up as the model of an awakening of democracy, one that suffragists hoped would affect the rest of the United States. In an illustration for *Puck*, an allegorical figure representing liberty bears a torch as she strides across a map of the country, symbolizing the movement's state-by-state progress (cat. 91). Starting in the western states that have granted women full suffrage, Lady Liberty strides toward the East, enfranchising women as she crosses the nation.

The state-by-state strategy was the main vehicle for suffrage reform used by the National American Woman Suffrage Association (NAWSA). This approach involved petitioning legislatures and lobbying politicians on the state level, and had ended in terrible frustration during the "doldrums" of 1894 to 1910. Carrying out the state-by-state referenda tactics, Alice Blackwell's publication, *Woman's Journal and Suffrage News*, featured headlines on state-by-state suffrage referendums, anti-suffragists converting to the enfranchisement of women, and women judges hearing criminal cases of women. However, Blackwell also applied visual culture tactics, and she placed a graphic designed by Egbert C. Jacobson on the journal's front page (cat. 92).

CAT. 90

Votes for Women
Bertha Margaret Boyé
(1883–1930)
1911
Lithograph
58.4 × 38.1 cm (23 × 15 in.)
The Arthur and Elizabeth Schlesinger Library on the History of Women in America, Radcliffe Institute for Advanced Study, Harvard University

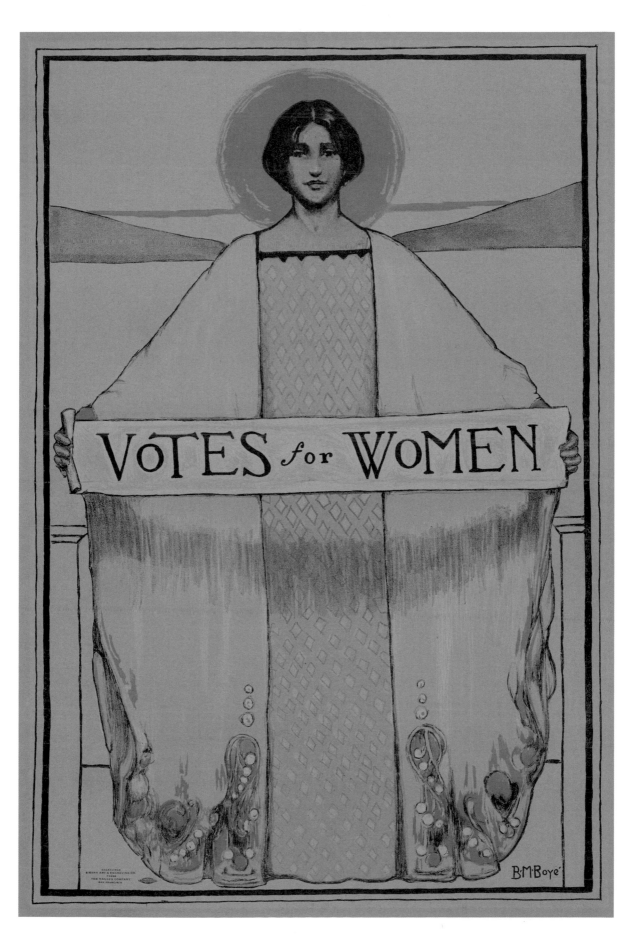

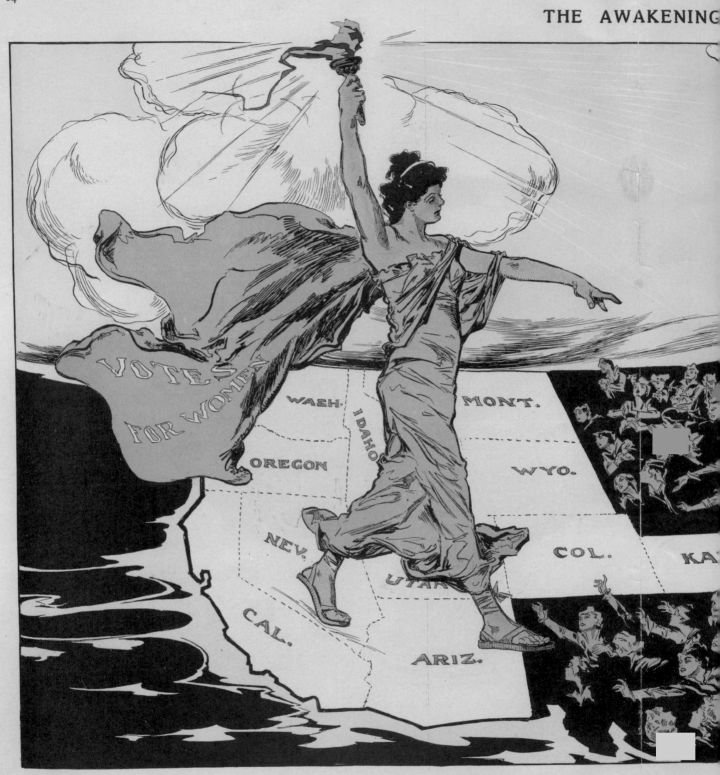

Look forward, women, always; utterly cast away
 The memory of hate and struggle and bitterness;
Bonds may endure for a night, but freedom comes with the day,
 And the free must remember nothing less.

Forget the strife; remember those who strove—
 The first defeated women, gallant and few,
Who gave us hope, as a mother gives us love,
 Forget them not, and this remember, too:

How at the later call to come forth and unite,
 Women untaught, uncounselled, alone and apart,
Rank upon rank came forth in unguessed might,
 Each one answering the call of her own wise hea

By HY MAYER

They came from toil and want, from leisure and ease,
 Those who knew only life, and learned women of fame,
 Girls and the mothers of girls, and the mothers of these,
 No one knew whence or how, but they came, they came.

The faces of some were stern, and some were gay,
 And some were pale with the terror of unreal dangers;
But their hearts knew this: that hereafter come what may,
 Women to women would never again be strangers.

Alice Duer Miller.

CAT. 91

The Awakening
Henry Mayer (1868–1954)
for *Puck*, February 20, 1915
Chromolithograph
35 × 53 cm (13 ¾ × 20 ⅞ in.)
Cornell University—The PJ
Mode Collection of Persuasive
Cartography

The use of allegories, whose visual language appealed to more conservative nineteenth-century values, effectively communicated to the more traditional viewer that suffrage was indeed for the respectable woman. In *Equality Is the Sacred Law of Humanity*, Jacobson depicts a woman in profile wearing a winged petasos as a way to illustrate her role as a divine messenger of equality (cat. 93). The labrys in the background serves as a matriarchal symbol that further stresses the woman's significance.[29] The application of such symbolism also reveals the expertise of Jacobson, who was a leader in color theory and typography—and married to a prominent suffragist, Franc Delzell Jacobson.[30]

Suffragist messages and imagery permeated material culture in the early part of the twentieth century. Tea sets and trays decorated with the slogan "Votes for Women," for example, became a parlor feature for suffrage meetings. The socialite suffragist Alva Belmont designed and ordered "Votes for Women" tableware from the English manufacturer John Maddock and Sons (cat. 94). Belmont used the china for Political Equality Association events and other suffrage meetings at her Newport, Rhode Island, Gilded Age mansion. Suffrage tableware was not reserved for the elite.[31] A 1915 tray prominently displays a woman dressed in gold (the color associated with the movement) and wearing a large "Merry Widow" hat (cat. 95). Images on utilitarian objects demonstrated that suffrage was both fashionable and practical.

Suffrage pennants were also extremely popular in the 1910s. One, created by New York's Woman Suffrage Party, features an image of the sculptor Ella Buchanan's *The Suffragist Arousing Her Sisters* (1911). At the center of the work is a triumphant clarion figure representing the suffragist, and surrounding her are four women embodying degradation, vanity, conventionality, and wage earners in various stages of slumber.[32] As the figures awaken to the trumpet, they turn to the side of the pennant that reads "Votes for Women." Pennants such as this were used as gifts and displayed in support of the cause (cat. 96).[33]

The suffrage narrative overlooked Native American women almost entirely, as most white suffragists knew very little about them.[34] Nevertheless, white suffragists upheld that Native women in matriarchal societies, such as the Haudenosaunee, or Iroquois, did not see themselves in need of "liberation." The reality is, Native American rights under the federal government would be complicated for years, through 1924, when the Citizenship Act granted citizenship to Native Americans. However, states were allowed to decide who was enfranchised, and some, like New Mexico, did not give Native Americans the right to vote until 1962. Native women remain among the most vulnerable populations in the United States, as they number in unparalleled proportions as victims of domestic abuse and sexual abuse.[35]

In the caricature *Savagery to "Civilization"* Udo Keppler pictures (on the front left) Harriot Stanton Blatch and (on the front right) Anna Howard Shaw, as marching with an unfurled suffrage banner (cat. 97). Meanwhile, Iroquois women peer down at them, puzzled by the mainstream (white) woman's inequality in her society. The text beneath the Native women reads, "The Indian Women: We whom you pity as drudges reached centuries ago the goal that you are now nearing." Published in the humorous illustrated weekly *Puck*, which Keppler's father founded, one is not sure what, exactly, is supposed to be funny in the dichotomy between white

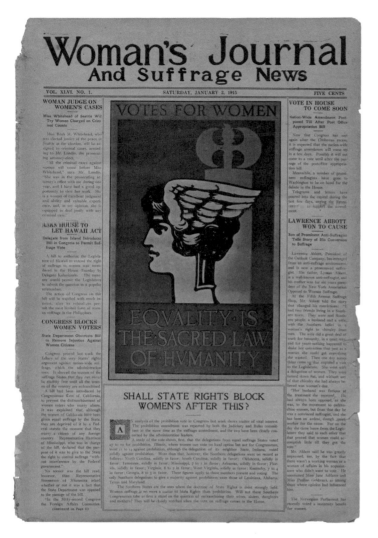

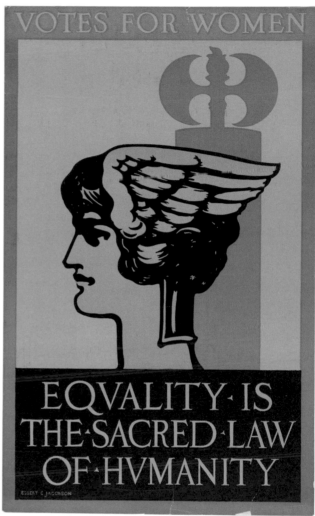

CAT. 92

*Votes for Women, Equality Is the
Sacred Law of Humanity*
Egbert C. Jacobson (1890–1966)
for *Woman's Journal*,
January 2, 1915
Photomechanical reproduction
47 × 31.8 cm (18 11/16 × 12 1/2 in.)
Ronnie Lapinsky Sax Collection

CAT. 93

*Votes for Women, Equality Is the
Sacred Law of Humanity*
Egbert C. Jacobson (1890–1966)
ca. 1903–1915
Lithograph
66 × 40.6 cm (26 × 16 in.)
The Arthur and Elizabeth
Schlesinger Library on the
History of Women in America,
Radcliffe Institute for Advanced
Study, Harvard University

CAT. 94

Votes for Women Tableware
1901–1915
Porcelain, silver, and printed
paper
Dimensions variable
Ronnie Lapinsky Sax Collection

CAT. 95

Votes for Women Tray
Unidentified artist
ca. 1915
Wood and embroidery
30.5 × 45.7 cm (12 × 18 in.)
Ronnie Lapinsky Sax Collection

CAT. 96

Votes for Women Pennant
New York Woman Suffrage Party
(1909–1919)
ca. 1913
Wool felt
32.4 × 80 cm (12 ¾ × 31 ½ in.)
Ronnie Lapinsky Sax Collection

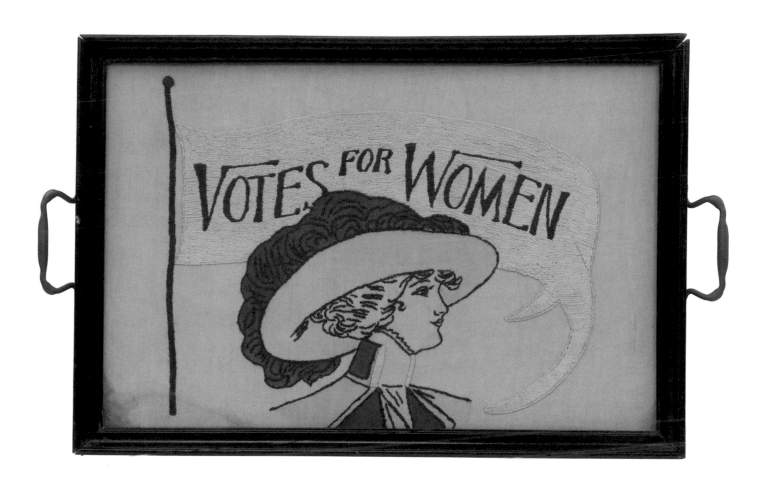

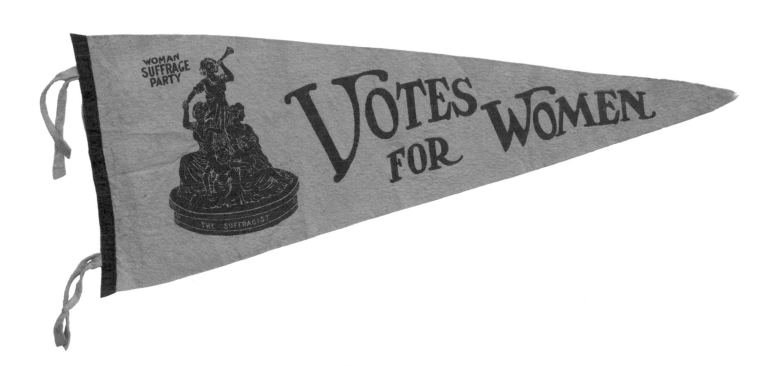

SAVAGERY TO "CIVILIZATION"

THE INDIAN WOMEN: We whom you pity as drudges reached centuries ago the goal that you are now nearing

WE, THE WOMEN OF THE IROQUOIS:

Own the land, the lodge, the children.
Ours is the right of adoption, of life or death;
Ours the right to raise up and depose chiefs;
Ours the right of representation at all councils;
Ours the right to make and abrogate treaties;
Ours the supervision over domestic and foreign policies;
Ours the trusteeship of the tribal property;
Our lives are valued again as high as man's.

Drawn by JOSEPH KEPPLER

suffragists and Iroquois women. Keppler's illustration does an injustice to the social importance of Iroquois women within their own society and overly simplifies a very complex and difficult relationship between whites and Natives. Most educated Native women by 1914 were graduates of mission and government schools, where they were forbidden from speaking their Native languages. Emerging as bilingual and bicultural, and working together, many became intellectual activists, fighting U.S. federal Indian policy and demanding social justice. Native intellectual activists focused on efforts to improve conditions on reservations and to gain citizenship (and the right to vote) for all Native Americans.

CAT. 97

Savagery to "Civilization"
Udo J. Keppler (1872–1956) for
Puck, May 16, 1914
Photomechanical reproduction
25.4 × 34.3 cm (10 × 13 ½ in.)
Collection of Robert P. J.
Cooney Jr.

Other Compelling Tactics

Alice Paul wanted to show that committed suffragists were willing to put themselves in danger for the cause.[36] So, in 1915, when it was still rare to see women operating automobiles, she sent Oregon suffragist Sara Bard Field on a coast-to-coast road trip (cat. 98).[37] Field was in the company of her drivers, Ingeborg Kindstedt and Maria Kindberg, and was later accompanied by Mabel Vernon, but she was the one who received the credit as the sole diplomat of the transcontinental business—that

Sara Bard Field (1882–1974)
Johan Hagemeyer (1884–1962)
1927
Gelatin silver print
23 × 16.6 cm (9 1/16 × 6 9/16 in.)
National Portrait Gallery,
Smithsonian Institution

is, the business of suffrage (cat. 99).[38] Field took three months to complete her journey, stopping frequently to give talks, participate in parades, or gather petitions to Congress (cat. 100). Her route was highly publicized, and she managed to gather over a half-million signatures in petitions, effectively accomplishing Paul's goal.

Nina Evans Allender, suffragist and official artist for the Congressional Union, made drawings that challenged the stereotypical images of suffragists. Loosely based on the Gibson Girl, the "Allender Girl" recurs in her cartoons as a confident and intelligent young woman devoted to suffrage. In *His District*, a woman pores over a book titled "Campaign Text Book!" while other titles, including "List of Voters" and "Women Voters!" rest on her desk alongside various paper documents (cat. 101). The informational cards kept by the women of the Congressional Union serve to this day as the basic components of lobbying strategy. In fact, suffragists developed the foundations of modern-day lobbying.[39]

The "Map of His District" appears superimposed over a map of the United States, illustrating the Congressional Union's lobbying efforts between 1914 and 1915. The Congressional Union met with legislators and compiled information about them so that suffragists could better "connect" with the individuals. They also channeled that information back so that they could work in a united way. The suffrage lobbyists made sure to meet regularly within their groups to share, chart, and

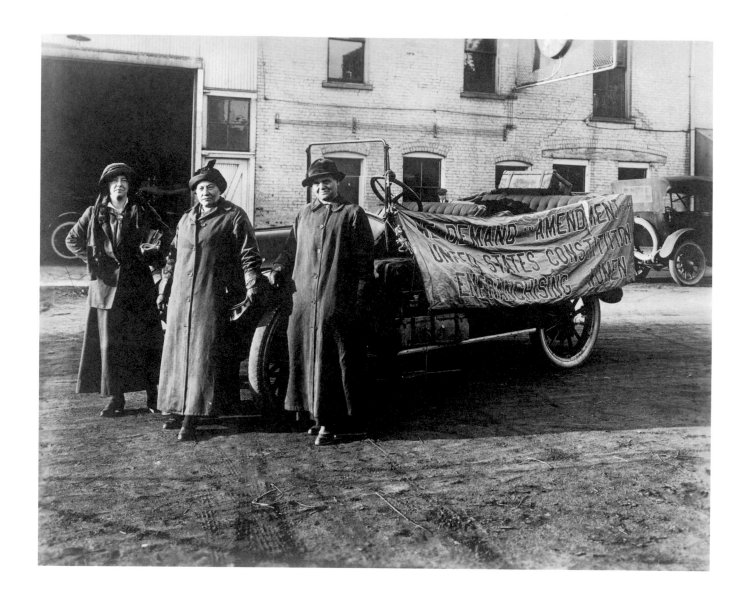

CAT. 99

Women Voters Envoys
Left to right: Sara Bard Field
(1882–1974), Maria Kindberg
(1857–1940), Maria Ingeborg
Kindstedt (1865–1950)
Unidentified photographer
1915
Gelatin silver print
19.1 × 24.1 cm (7 ½ × 9 ½ in.)
National Woman's Party,
Washington, DC

ROUTE OF ENVOYS SENT FROM EAST BY THE CONGRESSIONAL UNION FOR WOMAN'S SUFFRAGE, TO APPEAL TO THE VOTING WOMEN OF THE WEST

MISS ALICE PAUL, NATIONAL CHAIRMAN, CONGRESSIONAL UNION FOR WOMAN SUFFRAGE

CALL TO WOMEN VOTERS TO ASSEMBLE IN CHICAGO JUNE 5, 6, AND 7
TO LAUNCH A NATIONAL WOMAN'S PARTY

CAT. 100

*Route of Envoys Sent from East by the
Congressional Union for Woman's Suffrage,
to Appeal to the Voting Women of the West*
Unidentified artist
1916
Photochemical reproduction
14 × 16.5 cm (5 ½ × 6 ½ in.)
Library of Congress, Prints and
Photographs Division, Washington, DC

CAT. 101

His District
Nina E. Allender (1873–1957)
1916
Charcoal on paper
35.6 × 30.5 cm (14 × 12 in.)
National Woman's Party,
Washington, DC

CAT. 102

Jeannette Pickering Rankin
(1880–1973)
L. Chase (active 1910s)
ca. 1917
Gelatin silver print
17.2 × 11 cm (6 ¾ × 4 ⁵⁄₁₆ in.)
National Portrait Gallery,
Smithsonian Institution; gift of
Margaret Sterling Brooke

brainstorm their progress toward gaining support for their proposed suffrage referendums.

In 1916, Jeannette Rankin became the first woman elected to Congress when she won the contest to serve as a representative of Montana (cat. 102). Rankin, whose first career was in social work, uncovered her passion for the women's suffrage movement while living in Seattle. She was active in the movement there until 1910, when Washington State granted women full suffrage. On returning to Montana, Rankin became a lobbyist for the National American Woman Suffrage Association, and her efforts with the organization contributed to women "winning the vote" in Montana in 1914.

Rankin secured a GOP nomination for one of Montana's House seats in 1916. Once she was in office, the all-male club of Congress and the media's focus on her appearance posed new challenges. Newspapers commented on her hair, her height, and her clothing. The *Washington Post* reported on her first day in Congress by describing her as "a woman who is thoroughly feminine—from her charming coiffed swirl of chestnut hair to the small, high and distinctively French heels."[40] An outspoken pacifist, she focused her platform on social welfare issues, ending World War I, and working toward a constitutional amendment for women's suffrage. Her pacifism lost her the Republican nomination in 1918, but she was elected again to the House in 1940.

The same year Rankin was elected to Congress, Inez Milholland Boissevain died of pernicious anemia while in Los Angeles on the suffrage lecture circuit. Only thirty years old, she became the "Joan of Arc" she had so often symbolized: a martyr of suffrage. Suffragists later would commemorate her final plea to President Wilson as an inscription on the militant Silent Sentinels' banner: "Mr. President, How Long Must Women Wait for Liberty?" (see cats. 106–7). When the young Milholland Boissevain died in 1916, suffragists were sickened by President Wilson's antipathy to what they saw as her sacrifice. Alice Paul felt that a more aggressive strategy was needed—no longer would they merely accept being dismissed, especially after Milholland Boissevain's death. Paul's Congressional Union combined with the Women's Party of Western Voters to create the National Woman's Party in March 1917. Their strategy, they decided, would be that of aggressive, nonviolent civil disobedience.

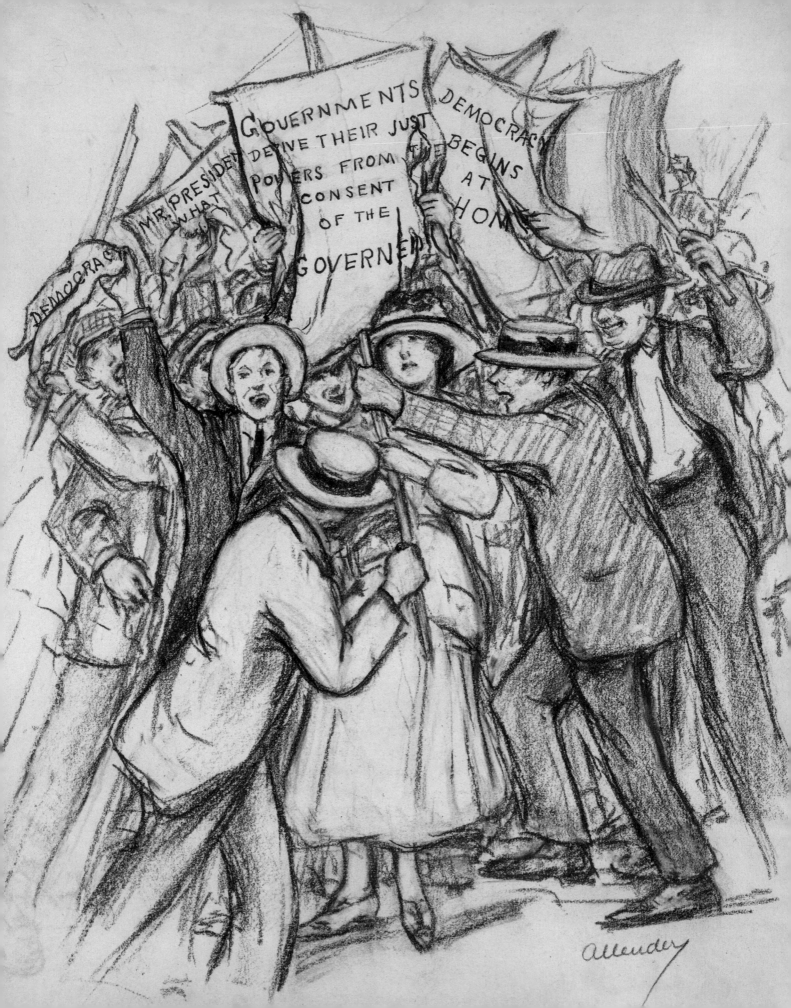

5

MILITANCY IN THE AMERICAN SUFFRAGIST MOVEMENT, 1917–1919

After the success of the 1913 Suffrage Procession in Washington, DC, Alice Paul knew that more parades and protests would draw media attention and spur legislation for a federal suffrage amendment. The leadership of the National American Woman Suffrage Association (NAWSA), however, opposed her tactics. Carrie Chapman Catt and the others at the helm of NAWSA felt uncomfortable with the negative attention that Paul's headline-grabbing events received. Therefore, they instead chose to continue devoting their resources to lobbying and petitioning in order to achieve the slow, state-by-state referenda. The two suffrage groups operated separately but achieved varying levels of success for suffrage.

Suffragists Take On President Wilson
"An Autocratic Ruler . . . toward Women," — Alice Paul, August 18, 1917[1]

Led by Alice Paul, the National Woman's Party (NWP) began protesting outside the White House in early 1917, the year they began calling themselves *militant*. By targeting the White House, the women protesters, known as "pickets," placed enormous pressure on President Woodrow Wilson, who blocked women's suffrage invariably throughout his first term and well into his second (1913–21). Newspapers gave picketing suffragists the epithet "the Silent Sentinels." With beliefs rooted in the writings of Mary Wollstonecraft, Elizabeth Cady Stanton, and Susan B. Anthony, these suffragists distinguished themselves as militants when they decided to employ nonviolent tactics to resist and defy authority. Their constant protest served to remind Wilson—and all who watched him—that American women had not yet achieved citizenship rights equal to men.

The militants were the most visible organizers during this period, but many nonmilitant Americans were fighting for women's right to vote. The progressive suffragists involved in NAWSA, for example, who were concerned with labor rights, saw suffrage as the only way for women to protect their rights as workers. In

See cat. 111.

201

NO VOTE MEANS NO REMEDY
FOR LONG HOURS AND SHORT PAY

CAT. 103

No Vote Means No Remedy for Long Hours and Short Pay
Mary Taylor for *Maryland Suffrage News*, May 22, 1915
Photomechanical reproduction
34 × 28 cm (13 ⅜ × 11 in.)
H. Furlong Baldwin Library,
Maryland Historical Society

CAT. 104

Broadside: To the 8,000,000 Working Women in the United States
National American Woman Suffrage Association
(1890–1920)
ca. 1915–1917
Printed paper
26.7 × 18.7 cm (10 ½ × 7 ⅜ in.)
Collection of Ann Lewis and Mike Sponder

1915, illustrator Mary Taylor created a caricature whose message still bore relevance two years later: "No Vote Means No Remedy for Long Hours and Short Pay." Printed on the cover of *Maryland Suffrage News*, Taylor's work pointed to the complexities of labor rights for working women (cat. 103). The seamstress is at her treadle, but instead of sewing, she rests her head on the men's dress shirt in front of her in a display of exhaustion.

In an effort to gain traction for labor rights, other suffragists involved in NAWSA distributed broadsides including one declaring,

> YOU HAVE NO VOTE / All working people should have every possible weapon to enable them to control the conditions under which they must live and work. / Men have one weapon that women lack. They have the vote. / Women should have every weapon that men have, but men deny them the vote. Is this right? / DEMAND VOTES FOR WOMEN! (cat. 104)

The National Woman's Party—the first organization ever to picket the White House—communicated their message through their bodies, on which

To the 8,000,000 Working Women in the United States

Are you satisfied with your working conditions?
Are you satisfied with your living conditions?

What Is Wrong?

You want better food, better homes, better clothes.
You want shorter hours, bigger pay, safe and sanitary workshops.

How Can You Get What You Want?

By UNITING, in the industries, to force the bosses to better your conditions.
 You can do this now.

By UNITING, as women, to secure laws that will protect you.
 You cannot do this now, because

YOU HAVE NO VOTE

All working people should have every possible weapon to enable them to control the conditions under which they must live and work.
Men have one weapon that women lack. They have the vote.
Women should have every weapon that men have, but men deny them the vote.
Is this right?

DEMAND VOTES FOR WOMEN!

MAKE WORKING MEN DEMAND
VOTES FOR WORKING WOMEN!

National American Woman Suffrage Association
505 Fifth Avenue New York City

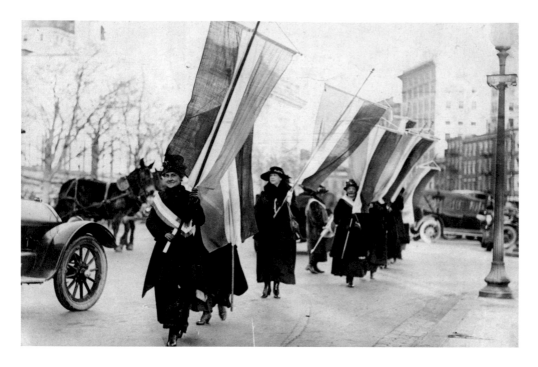

CAT. 105

Suffrage Procession
Unidentified photographer
1917
Gelatin silver print
14.6 × 17.8 cm (5 ¾ × 7 in.)
National Museum of American
History, Smithsonian Institution;
Alice Paul Centennial
Foundation, Inc.

CAT. 106

*College Women Picketing in
front of the White House*
Unidentified photographer
1917
Gelatin silver print
8.9 × 19.1 (3 ½ × 7 ½ in.)
National Woman's Party,
Washington, DC

CAT. 107

*Pickets in front of the White House,
New York State Day*
Unidentified photographer
1917
Gelatin silver print
12.7 × 17.8 cm (5 × 7 in.)
National Woman's Party,
Washington, DC
*Not in exhibition

they displayed banners and sashes. Women protesting in the public sphere was highly unusual for the period, resulting in much attention from the press. Handsewn banners emblazoned with sensational slogans for suffrage drew in passersby. Tricolor sashes of purple, gold, and cream denoted to the onlooker that the pickets stood in solidarity with each other and with their single cause, votes for women (cat. 105). The NWP scheduled participants based on their associations. Special days included Women's Voters' Day, Patriot Day, College Day, and State Days. On College Day, women wore sashes emblazoned with the name of their alma mater, communicating to the spectator that contrary to assumptions that they were disagreeable women of ill repute, they were, in fact, highly educated and often charming. In this photo, representative graduates of Bryn Mawr, Oberlin, the University of Kansas, Leland Stanford, Oberlin, Smith, and Swarthmore participated, carrying banners with the slogans: "Mr. President How Long Must Women Wait for Liberty" and "Mr. President What Will You Do for Woman Suffrage" (cats. 106–7).[2]

In April 1917, days prior to the entry of the United States into World War I, the Anthony Amendment was reintroduced in the Senate and House of Representatives, with the Senate Committee on Woman Suffrage holding hearings for the proposed amendment.[3] In an effort to urge Congress to act, the Silent Sentinels strengthened their numbers on the picket lines. By summer, their criticism of Wilson had grown more hostile. They began calling the president "Kaiser Wilson," in reference to Kaiser Wilhelm II, the last German emperor and king of Prussia, who was the enemy of the United States in 1917 (cat. 108). Many viewed the Silent Sentinels as being unpatriotic, while suffragists had become increasingly frustrated with the lack of democracy at home, particularly when considering the fight for freedom abroad. Tensions spiked again outside the White House in August 1917, when a group of men

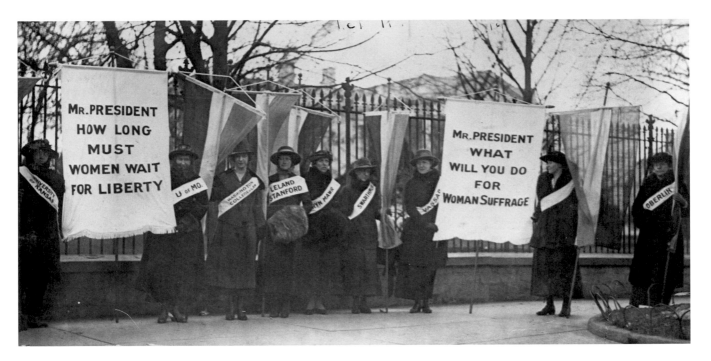

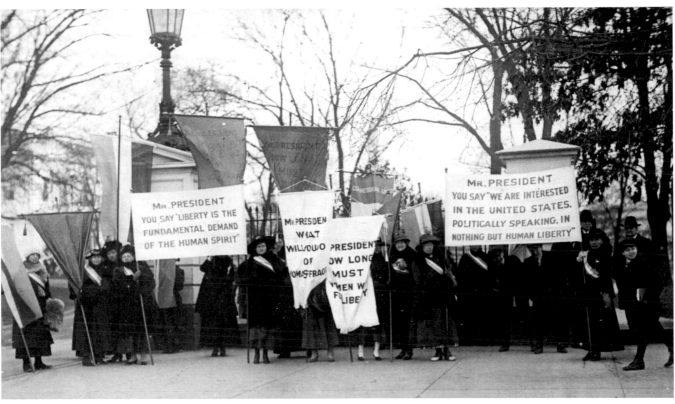

ganged up on women activists and tore up several of their banners.

Unlike Catt and the obedient women of NAWSA, militant suffragists were subject to enormous criticism during wartime. The National Woman's Party, led by Paul, openly maintained a pacifist policy and thus came under fire during the initial stages of World War I. Many people viewed their efforts as "wasting" valuable energy and believed they were negatively affecting the national image. One man wrote, "Now, millions of young men must leave for France and die for their country's honor. Is it right, is it justice to them that at the same time females . . . are permitted to disgrace and insult the government and the manhood of this country?"[4] Despite the negative reactions, the press coverage served as momentum and inspired countless citizens across the United States to support the cause.

The militant suffragists were mindful of their behavior, not yet daring to cross the lines of being perceived as "unwomanly" as they began their acts of civil disobedience through protests. Nevertheless, aghast NAWSA women regarded their picketing as "foolishness."[5] In March 1917, just weeks before the United States entered the war, one spectator estimated that one thousand suffragists, of all ages, had marched in a freezing downpour.[6] President Wilson ignored them, drawing the ire of the women. British suffragettes endured similar circumstances, but they had embraced guerilla militancy and violence on feeling ignored by their government; therein lies the difference between American suffragists and their British sisters. The militants' leader Alice Paul, a Quaker, never did resort to outward violence (see cat. 71). Instead, she and the other militants endured physical attacks on their bodies. By using their own corporal beings, they became martyrs, putting their reputations, health, and professions on the line.[7]

During the summer of 1917, those in the picket lines endured intensified hostility. On July 4, as they carried banners reading, "Governments derive their just powers from the consent of the governed," "Democracy begins at home," and "Mr. President What Will You Do for Woman Suffrage," crowds of men and police were waiting for them at the White House. When the suffragists neared the gate, men surrounded them and police placed them under arrest. Some of the men yelled, "Send them over to the Kaiser!" and "They ought to be sent up for life!"[8] (cats. 109–10).

Although some news photography survives from the arrest of the Silent Sentinels, the pictures do not adequately capture the dramatic nature of these historic moments. Nina Allender's small sketch *Training for the Draft* (1917),

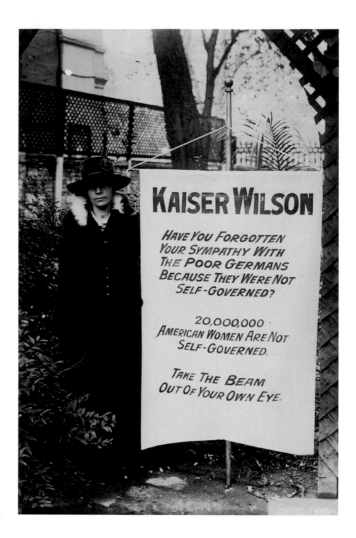

CAT. 108

Virginia Arnold Holding Kaiser Wilson Banner
Harris & Ewing Studio
(active 1905–1945)
1917
Gelatin silver print
10.8 × 17.8 cm (4¼ × 7 in.)
Library of Congress, Prints and Photographs Division, Washington, DC
*Not in exhibition

CAT. 109

*Suffrage Campaign, Pickets,
Arrest and Imprisonment*
Barnett McFee Clinedinst
(1862–1953)
1917
Gelatin silver print
10.2 × 15.9 cm (4 × 6¼ in.)
National Woman's Party,
Washington, DC

CAT. 110

Arrest of Picketing Suffragists
Barnett McFee Clinedinst
(1862–1953)
1918
Gelatin silver print
12.7 × 17.8 cm (5 × 7 in.)
National Museum of American
History, Smithsonian Institution;
Alice Paul Centennial
Foundation Inc.

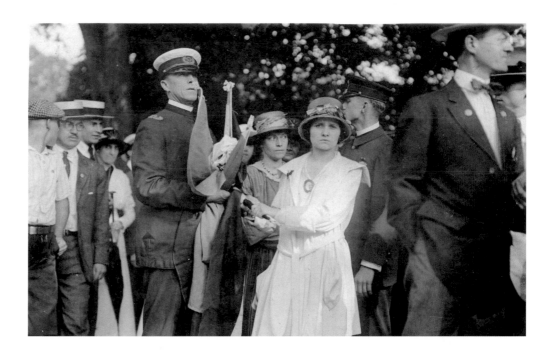

however, manages to shed light on the physicality that the pickets endured on that fateful Independence Day (cat. 111). The young woman at the center of the drawing is surrounded by furious men who attempt to pry the banner out of her hands. By giving the scene the title *Training for the Draft*, the artist suggests that the women are preparing for combat.

When the arrested pickets refused to pay the $25 that they had been fined, they were sentenced to the Occoquan Workhouse, where 168 women arrested on the picket lines served their sentences. Daily life in Occoquan, which served the District of Columbia but was located in Lorton, Virginia, was meant to be miserable. The women wore coarse fabric dresses, labored in the heat of the gardens, and with their blistered hands, spent hours in the sewing room. In an act to record their experience, Natalie Gray embroidered her name as well as the names of fellow Silent Sentinels into a fragment of fabric, an embroidered petition of their time at Occoquan (cat. 112).

In October 1917, Lucy Burns led a campaign demanding that she and the other suffragists, who had been jailed as criminal offenders, be treated as political prisoners. To declare their status as political prisoners, Burns and thirteen other imprisoned suffragists distributed and signed petitions, refusing work at the prison, and threatened to hunger strike. In an attempt to silence and intimidate the fourteen women, they were placed in solitary confinement. Documented by the media, the women imprisoned at Occoquan were not afraid to own their militancy. In a 1917 portrait of Burns at Occoquan, her dressed hair sags out of its bun yet she gazes determinedly at the camera. Clad in a coarse prison dress, she holds the newspaper, perhaps hoping to see news of the status of the federal suffrage amendment. This photograph of Burns was captured by Harris & Ewing, a photography firm that supplied documentary portraits to newspapers throughout the United States (cat. 113).

Like many militant suffragists, Burns was aware of public perceptions of suffragists and sought ways to circumvent those stereotypes through portraiture. In a studio portrait by Barnett McPhee Clinedinst, she sits in an elegant wooden armchair while wearing an evening gown edged with feathers (cat. 114). Her red hair, drawn back in a pompadour hairstyle, hits notes of both fashion and decorum.

In early November, Alice Paul and Rose Winslow began a hunger strike immediately after the demands for political prisoner status were rejected. After one week, the women were force-fed three times a day for nearly three months. Outside the prison walls, suffragists protested the treatment of Alice Paul and others. A 1917 photograph shows Lucy Branham, a Columbia University PhD candidate,

CAT. III

Training for the Draft
Nina E. Allender (1873–1957)
for *The Suffragist*, September 29, 1917
Charcoal on paper
42.5 × 34.7 cm (16¾ × 13 ¹¹⁄₁₆ in.)
National Woman's Party, Washington, DC

Lavinia L. Dock
Madeleine M. Watson.
Lucy H. Ewing.
Catherine M. Flanagan.
Edna A. Dixon

Occoquan Workhouse
Lorton Virginia

Natalie N. Gray

CAT. 112

*Piece of Cotton Embroidered in
Occoquan Workhouse*
Natalie Gray (1894–1955)
1917
Embroidered cotton
22.9 × 19.1 cm (9 × 7 ½ in.)
National Woman's Party,
Washington, DC

CAT. 113

Lucy Burns in Jail (1879–1966)
Harris & Ewing Studio
(active 1905–1945)
1917
Gelatin silver print
17.8 × 12.7 cm (7 × 5 in.)
National Woman's Party,
Washington, DC

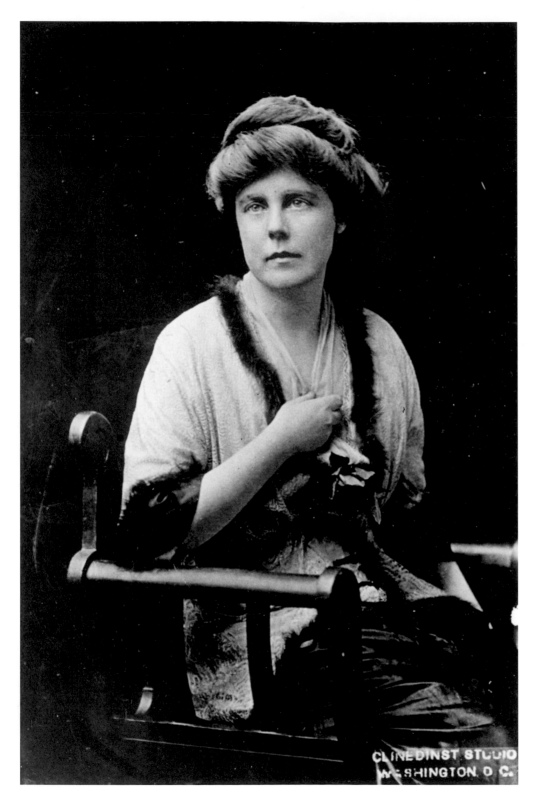

CAT. 114

Lucy Burns (1879–1966)
Barnett McFee Clinedinst
(1862–1953)
1913
Gelatin silver print
12.1 × 9.5 cm (4¾ × 3¾ in.)
National Woman's Party,
Washington, DC

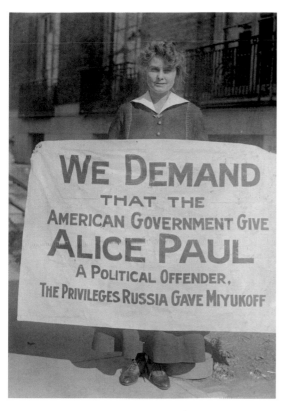

CAT. 115

Lucy Branham (1892–1966)
with Banner
Harris & Ewing Studio
(active 1905–1945)
1917
Gelatin silver print
17.1 × 12.7 cm (6¾ × 5 in.)
National Museum of American
History, Smithsonian Institution;
Alice Paul Centennial
Foundation, Inc.

protesting the imprisonment of Alice Paul by holding a banner that reads, "We Demand That the American Government Give Alice Paul, a Political Offender, the Privileges Russia Gave Miyukoff" (cat. 115).[9] The message, which highlighted the strife and danger the jailed women endured, sought to argue that the Russian government—another enemy of the United States during the war—treated its political prisoners better than American prisons treated the suffragists. Branham, who had chosen to put her history studies on hold to join the NWP and the suffrage movement, was also arrested on the picket line, in September 1917, and consequently served for two months in the Occoquan Workhouse and District Jail.

On November 14, a group of thirty-three imprisoned suffragists endured the "Night of Terror," during which they were reportedly beaten with club-like batons, thrown down stairs, handcuffed with hands high above their heads to their cell doors, and choked by guards. The next morning, sixteen women went on hunger strike, and the guards responded by forcibly feeding the prisoners.[10] Increasing public pressure ultimately led to the suffragists' unconditional release from prison.

While the militants were being imprisoned, suffragists affiliated with NAWSA, led by Carrie Chapman Catt, did their best to focus their support on the war. By October and November 1917, however, they made a conscious effort to tie suffrage to those efforts (cats. 116–17). One New York State broadside reads:

> Give votes to women as part of the nation's defense / . . . The government is calling on women to help in factories, in the production and conservation of food, to make munitions, and hardest of all, to give their sons to war. / Women are responding to the call. They are eager to serve. Either in war or in peace they wish to serve their country. / Men Of New York State, Don't Wait Until The War Is Over To Admit The Justice And Necessity Of Woman Suffrage Here. For The Sake Of The Strength It Will Add To The Nation, Vote For Woman Suffrage November 6th.

Broadsides were used by the New York State Woman Suffrage Party to encourage men to vote for women's suffrage in state elections. *Give votes to women as part of the nation's defense* addresses the argument that because women were not called to serve in the military, they were not entitled to the vote. Listing examples of women's responses to the war effort in "factories, in the production and conservation of food, to make munitions, and . . . to give their sons to war," suffragists in New York were successful in encouraging men to vote. On November 6, 1917, 53 percent voted in favor of a woman suffrage amendment granting women full suffrage in New York.[11]

Give votes to women as part of the nation's defense

Men have denied votes to women because they said that women are not called on to serve the State, and therefore not entitled to vote.

This war has proved that women must serve the state equally with men.

The **Census** taken by New York State of its Military Resources included **both men and women.**

The government is calling on women to help in factories, in the production and conservation of food, to make munitions, and hardest of all, to give their sons to war.

Women are responding to the call. They are **eager to serve.** Either in war or in peace they **wish** to serve their country.

MEN OF NEW YORK STATE, DON'T WAIT UNTIL THE WAR IS OVER TO ADMIT THE JUSTICE AND NECESSITY OF WOMAN SUFFRAGE HERE. FOR THE SAKE OF THE STRENGTH IT WILL ADD TO THE NATION, VOTE FOR WOMAN SUFFRAGE NOVEMBER 6th.

NEW YORK STATE WOMAN SUFFRAGE PARTY
303 Fifth Avenue 154 **New York City**
Printed by N. W. S. Pub. Co.
October, 1917.

CAT. 116

Give Votes to Women as Part of the Nation's Defense
New York State Woman Suffrage Party (1909–1919)
1917
Printed paper
20.3 × 13.3 cm (8 × 5 ¼ in.)
Ronnie Lapinsky Sax Collection

CAT. 117

Are You with Us?
National American Woman
Suffrage Association
(1890–1920)
1918
Printed paper
17.1 × 12 cm (6¾ × 4¾ in.)
Collection of Ann Lewis and
Mike Sponder

ARE YOU WITH US?

Are you awake

to the fact that 14,000,000 women throughout the world have been enfranchised in war time?

Are you aware

that the women of nineteen states can vote for the President of the United States?

Are you alive

to the enormous demand of the women of this state who in large numbers are petitioning for the vote?

Are you ready

to fight in this great war for democracy?

SIGN THE PETITION

Support the Federal Suffrage Amendment.

NATIONAL AMERICAN WOMAN SUFFRAGE ASSOCIATION
171 Madison Avenue 154 **New York City**
Printed July 1918

Fifty thousand suffragists joined the National Woman's Party between 1913 and 1916, a time when labor concerns were vital.[12] Most of the women who joined were white. While black women had argued for representation during the 1913 women's procession, they were not allowed to take part in the militant actions of picketing the White House or publicly voicing their cause. A vulnerable population, African American women were often targets of interracial violence in the 1910s, and racial tensions were high due to the black northward migration.[13] Furthermore, black women often suffered brutal abuse in prison, which created higher stakes for them and made them less inclined to participate in militant actions. Paul excluded black women from the suffragist sisterhood of the National Woman's Party, but black women organized among themselves—often within clubs that supported the war effort, proving that they were deserving of the vote.

For example, with the outbreak of World War I in April 1917, the teacher, writer, and activist Alice Dunbar-Nelson used the existing structure of the black women's club movement to mobilize women to support the Council of National Defense. An ardent supporter of the war effort, she believed that "pure patriotism" would lead to racial and gender equality.[14] Dunbar-Nelson expressed her vision in "Negro Women in War Work" within *Scott's Official History of the American Negro in the World War*. This portrait of Dunbar-Nelson from 1919, which was featured in the publication and shows her on the home front, wearing civilian clothing, stands out among the book's illustrations of men and women in uniform (cat. 118).[15]

As they organized in their various groups and causes, women across the nation were becoming more and more empowered. Finally, in January 1918, President Wilson had no choice but to declare his support for the federal women's suffrage amendment. For the next six months, the NWP began an intense lobbying campaign that accompanied White House picketing and public demonstrations in Lafayette Park. A final push for suffrage, targeting President Wilson, began on New Year's Day 1919, as suffragists placed an urn containing a lighted fire directly in line with the White House's front door (cat. 119). Paul described later,

> We had a sort of perpetual flame going in an urn outside our head-
> quarters in Lafayette Square. I think we used rags soaked in kerosene.
> It was really very dramatic, because when President Wilson went to
> Paris for the peace conference, he was always issuing some wonder-
> ful, idealistic statement that was impossible to reconcile with what he
> was doing at home. And we had an enormous bell—I don't recall

CAT. 118

Alice Dunbar-Nelson (1875–1935)
Unidentified photographer
Before 1919
Gelatin silver print
12.5 × 8.9 cm (5 × 3 ½ in.)
Alice Dunbar-Nelson Papers,
Special Collections, University
of Delaware Library, Newark,
Delaware

Party Watchfires Burn Outside
White House
Harris & Ewing Studio
(active 1905–1945)
1919
Gelatin silver print
12.7 × 17.8 cm (5 × 7 in.)
Library of Congress, Prints
and Photographs Division,
Washington, DC

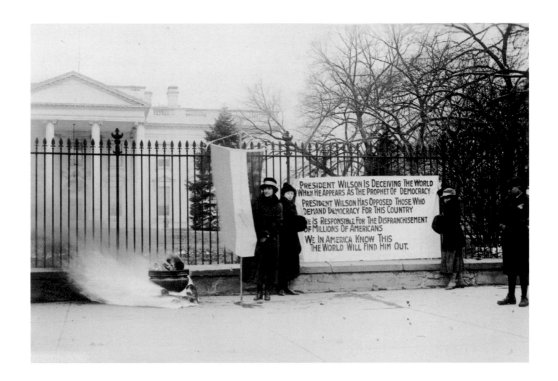

how we ever got such an enormous bell—and every time Wilson
would make one of these speeches, we would toll this great bell, and
then somebody would go outside with the President's speech and,
with great dignity, burn it in our little caldron.[16]

In this watchfire, they burned every word President Wilson had spoken in regard to
democracy.[17] An upcoming vote on the amendment in the Senate motivated suf-
fragists to amplify their frustrations. Knowing that President Wilson "always put
forth more effort under fire of protest," the militant suffragists showed their con-
tempt for him by burning his effigy, a cardboard likeness.[18]

Marching from the National Woman's Party Headquarters to Lafayette
Square, with tricolor banners, an urn, and the effigy, suffragists encountered mem-
bers of the police. Every time women tried to light the fire to burn the effigy, the
policemen would extinguish the fire. Police arrested thirty-nine women; twenty-five
of whom served prison terms. Unfortunately, the effigy watchfire protest had little
impact on the Senate decision, and the amendment failed to materialize.[19]

Nonetheless, through creating a relentless public presence, suffragists
eventually won American sympathy, and it was through this pressure that they forced
the Wilson government to grant women the right to vote. By June 1919, the federal
suffrage amendment was approved by both the House of Representatives and the
Senate, and sent to the states for ratification. However, to obtain the then-required
three-fourths majority, thirty-six state legislatures would also have to ratify the
amendment. The battle was not yet over. Suffragists had to spend the next fourteen
months leading campaigns of ratification all across the country.

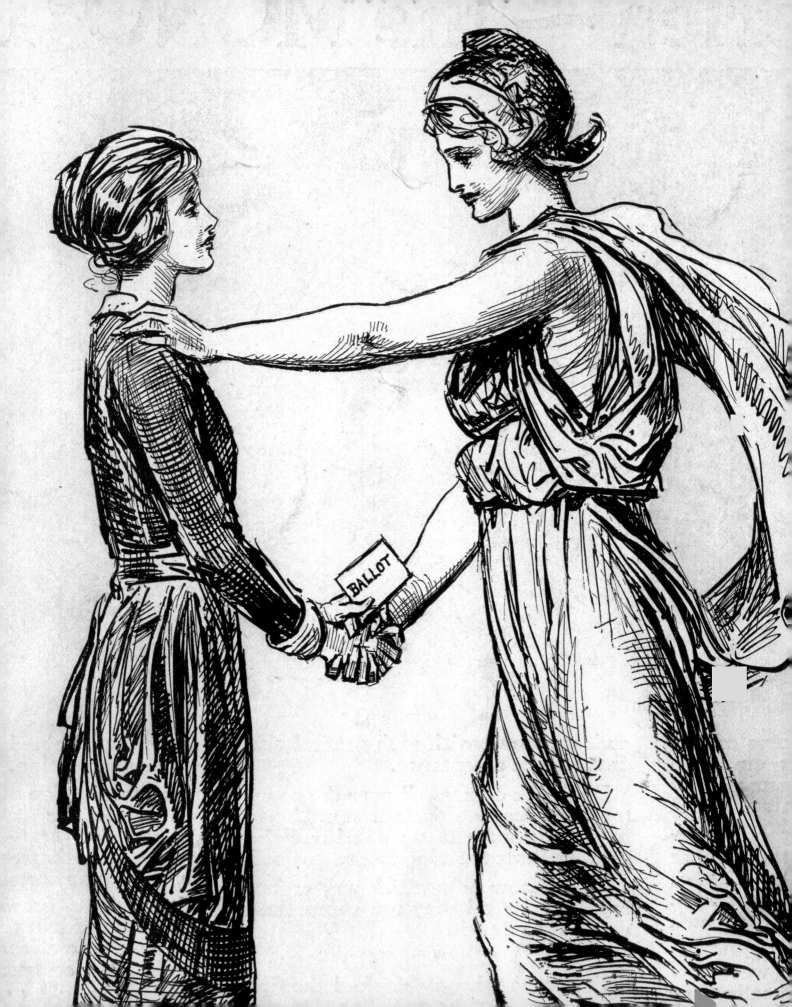

6

THE NINETEENTH AMENDMENT AND ITS LEGACY, 1920 TO TODAY

The right of citizens of the United States to vote shall not be denied or abridged by the United States or by any State on account of sex. — Nineteenth Amendment, Section 1

The federal woman suffrage amendment was introduced to Congress on May 21, 1919, during a special session called by President Wilson. It was passed by the House of Representatives, and two weeks later, on June 4, it was passed by the Senate, becoming the Nineteenth Amendment.[1] Following constitutional law, the amendment then needed to be ratified by three-fourths, or thirty-six states, of the then forty-eight states. Suffragists turned their well-organized attention to lobbying at the state level to pressure state legislatures to approve the amendment (cat. 120).

By loosely joining forces, the National American Woman Suffrage Association (NAWSA) and the National Woman's Party (NWP) achieved twenty-two state ratifications of the Nineteenth Amendment. Working with state representatives, they arranged countless meetings and held special sessions during which they drummed up support among the thousands of legislators.[2] However, they were met with staunch opposition from anti-suffragists who, in addition to the traditional objections toward women interfering in politics, grew nervous about the possibility of black women using their enfranchisement to counter segregation laws in the Jim Crow South.[3] As a result, the women's suffrage movement—from its beginning to its end—was marked by racial prejudice—if not enacted by the white suffrage leaders, then imposed on them by the leading political legislators.

Illustrator Elmer Andrew Bushnell used the passage of the Nineteenth Amendment to predict what opportunities American women would have in the future (cat. 121). His drawing *The Sky Is Now Her Limit*, created in August 1920, features a young working-class girl with a milkmaid's yoke as she looks up from the base of a ladder that ascends toward the sky. The bottom rungs of the ladder, labeled "Slavery" and "House Drudgery," are the subject's first hurdles. The next rungs are labeled with careers typical for women in the early twentieth century, such as "Nurse—Governess."

See cat. 125.

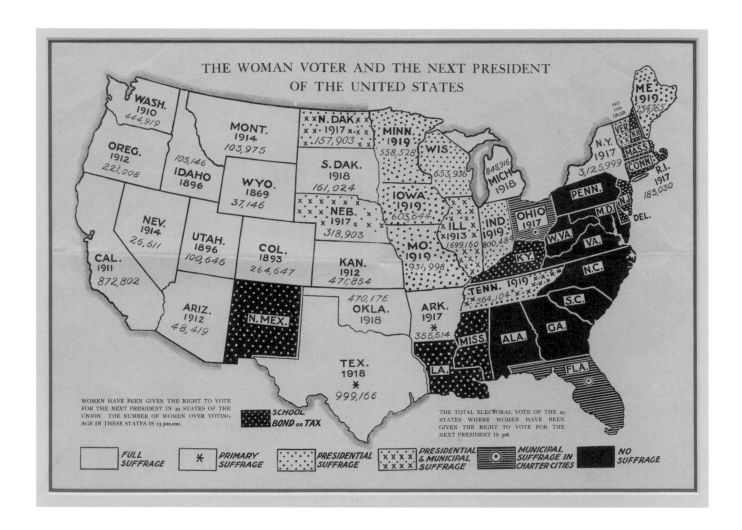

CAT. 120

*The Woman Voter and the Next
President of the United States*
Unidentified artist for *Woman
Citizen*, March 1919
Photomechanical reproduction
46.4 × 58.4 cm (18 ¼ × 23 in.)
Ronnie Lapinsky Sax Collection

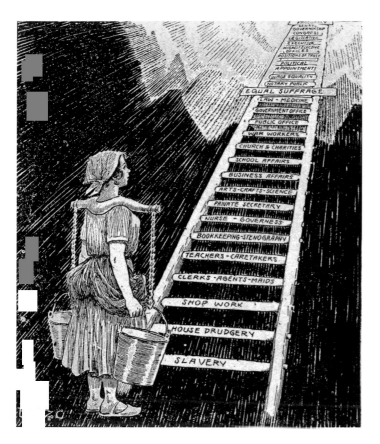

The labels on the ladder, from top to bottom, read:
PRESIDENCY / SENATE / GOVERNORSHIP / CONGRESS / LEGISLATIVE / EXECUTIVE / HIGHER ELECTIVE / OFFICES / POSITIONS OF TRUST / POLITICAL / APPOINTMENT / WAGE EQUALITY / NOTARY PUBLIC / EQUAL SUFFRAGE / LAW - MEDICINE / GOVERNMENT OFFICE / PUBLIC OFFICE / WAR WORKERS / CHURCH & CHARITIES / SCHOOL AFFAIRS / BUSINESS AFFAIRS / ARTS-CRAFTS-SCIENCE / PRIVATE SECRETARY / NURSE - GOVERNESS / BOOKKEEPING-STENOGRAPHY / TEACHERS-CARETAKERS / CLERKS -AGENTS-MAIDS / SHOP WORK / HOUSE DRUDGERY / SLAVERY

CAT. 121

The Sky Is Now Her Limit
Elmer Andrews Bushnell (1872–
1939) for *New York Times Current
History*, October 1920
Line photoengraving
9.5 × 8.3 cm (3 ¾ × 3 ¼ in.)
Library of Congress, Prints
and Photographs Division,
Washington, DC

Three-quarters of the way up the ladder, writing on a rung reads "Equal Suffrage." Those that follow feature governmental positions, and at the top, the last step announces the pinnacle of her climb: "Presidency." As she must balance her pails, it is clear the young woman will have difficulty moving up the ladder, but the image nonetheless seems to suggest that, one day, she will make it to the top.

To keep track of their progress toward the ratification of the Nineteenth Amendment, the National Woman's Party created a "ratification banner," on which they sewed a star for each new state that passed the amendment (see fig. 1 in Tetrault).[4] On August 18, 1920, Tennessee barely ratified the legislature with only fifty of ninety-nine members voting "yes." Finally, after more than eight decades of hard work and sacrifice, the longest reform movement in American history had reached a resolution.

Before that day in August, suffragists had discovered that many of Tennessee's legislators had not yet committed to one side or the other. Catt directed some of NAWSA's members to "collect a group of earnest and well-informed local women . . . and visit these men yourself."[5] She later recalled how these "women trailed these legislators, by train, by motor, by wagons and on foot, often in great discomfort, frequently at considerable expense to themselves." She spoke of how "they went without meals, were drenched in unexpected rains, and met with 'tire troubles,' yet no woman faltered."[6]

During the summer months of 1920, Tennessee had witnessed one of the most intense lobbying efforts in American history. Then, on August 9, the state called a special session of its legislative congress to hold the ratification of the Nineteenth Amendment. The session lasted a long time, and by the eighth day, suffragists had prepared themselves for yet another crushing defeat. So, it was to their surprise (and enormous relief) when on Saturday, August 21, 1920, headlines across the United States, including that of the *Beloit Daily News*, exclaimed, "Tennessee Vote Upholds Suffrage" (cat. 122).

The turning point had come when legislator Harry T. Burn changed his vote from "nay" to "yea," thereby breaking a tie and making history. The young legislator reported that he had channeled the encouragement of his mother. The day after the vote, while on the floor of the House, he said, "I want to state that I changed my vote in favor of ratification, because I believe in full suffrage as a right . . . and my mother wanted me to vote for ratification. I knew that a mother's advice is always safest for her boy to follow."[7]

Maternalism, or the progressive philosophy that motherhood instilled values and purified the character of children—and made women ideal for roles

THE WEATHER.
Fair tonight and Sunday; cooler tonight

Read the Classified Section Today

THE BELOIT DAILY NEWS

Established 1885—Vol. 35—No. 198 BELOIT, WISCONSIN, SATURDAY, AUGUST 21, 1920—Ten Pages Price Three Cents.

TENNESSEE VOTE UPHOLDS SUFFRAGE

FINLAND IS WINNER OF DECATHLON

CLASSIC ALL-ROUND CONTEST AT ANTWERP IS CAPTURED BY EUROPEAN STAR.

U. S. IS SECOND

HAMILTON OF MISSOURI GIVES WINNER HARD BATTLE—BREAK WALKING RECORD.

Communist Riots Spread In German Mining Districts

BOY FALLS FROM BOAT AND DROWNS

BYRON DUXTON BASFORD, 11, PLUNGES TO DEATH AT BASFORD BEACH

REACHES FOR OAR

TOPPLES OVERBOARD INTO ROCK RIVER—BODY FOUND LATE LAST NIGHT

Nation Plans Registration Of All Women

STATES INCREASE ELECTION MACHINERY TO MEET SUFFRAGE DEMANDS.

WISCONSIN READY

FEMININE VOTERS IN ILLINOIS WILL REGISTER NEXT WEDNESDAY.

Sugar Prices On Toboggan, Federal Figures Indicate

RUSS DEMAND CIVIC MILITIA FOR POLAND

NEW TERMS PROVIDE FOR ARMING OF WORKERS BY MUNITIONS OF REDS

GRODNO IS GOAL

POLES CHANGE TACTICS, SWINGING TOWARD NEW BOLSHEVIK HEADQUARTERS

Lake Steamers Collide; 32 of Crew Missing

NO QUORUM CONTENTION OF "ANTIS"

MOST OPPONENTS ABSENT SELVES AS FILIBUSTER AGAINST ACTION

CONFUSION REIGNS

SUFFRAGISTS CLAIM VICTORY AND RING BELL—"NOT LEGAL," FOES' VERSION.

G. O. P. FRAMES NEW PLAN FOR WORLD PEACE

PROMISE TO BE ANNOUNCED SOON MAY PROVIDE JUDICIAL ASSOCIATION

LENROOT AVERS IF CHARGE WERE TRUE HE'D QUIT

OFFERS TO RETIRE IF OPPONENT CAN REVEAL GUARANTEE ON WATERED STOCK

"INSIDE JOB" PULLMAN MAIL THEFT THEORY

BANDITS "HELP" BOYS WITH $100,000 POUCH—KNEW OF SHIPMENT.

WINE FOR SALE, IF TAKEN WITH HOME WORTH $1,500,000

PACINI ASSISTANT MANAGER RELEASED

ALLIANCE OF RUSSIA AND GERMANY FEARED

MATES, EACH RIOT DEAD, MEET AGAIN

CAMPAIGN PROBERS TO MEET MONDAY

THREE TRAINMEN KILLED IN WRECK

FORECAST FAIR, COOL WEATHER FOR WEEK

SOUTH DAKOTA BANK FAILS; OFFICIAL HELD

COLUMBIA COUNTY'S POPULATION 60,468

THREE AUTO BANDITS GET $4,200 PAYROLL

COUPLE, 74, NEVER WED, WILL MARRY

OFFICERS CLASH OVER PRISONER; 2 KILLED

CAT. 122

Tennessee Vote Upholds Suffrage
Front page of *Beloit Daily News*,
August 21, 1920
Printed paper
57.5 × 46.4 cm (22 ⅝ × 18 ¼ in.)
Collection of Robert P. J.
Cooney Jr.

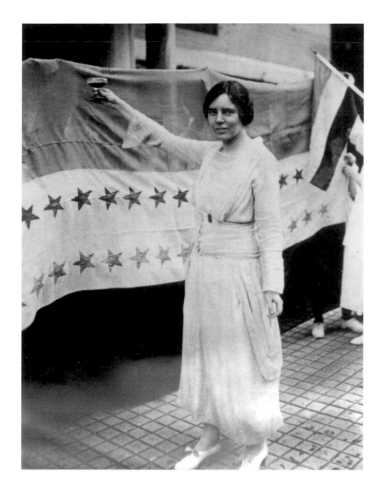

CAT. 123

Alice Paul Raises a Glass in Front of the Ratification Banner, August 26, 1920
Harris & Ewing Studio
(active 1905–1945)
1920
Gelatin silver print
18 × 13 cm (7 1/16 × 5 1/8 in.)
National Woman's Party, Washington, DC

outside of the domestic sphere, especially for roles in the government—may be the underlying, resonating thought that propelled Burn to change his vote. Indeed, people with progressive leanings had championed the idea of maternalism from the nineteenth to the mid-twentieth centuries.[8]

With the news that Tennessee ratified the Nineteenth Amendment and became the thirty-sixth state needed for a three-fourths majority, the final star was sewn onto the ratification banner. In celebration, Alice Paul hung the ratification banner from the balcony of the National Woman's Party Headquarters in Washington, DC.[9] In a publicity photograph produced by Harris & Ewing, Paul stands in front of the completed tricolor banner, triumphantly raising her arm in a toast to the success of the suffragists. She is elegantly dressed in white, effecting an image of the democratic values of her purpose (cat. 123). While she undoubtedly celebrated the victory in 1920, Paul marched on as a leader in the crusade for women's political rights. In 1923, she introduced the Equal Rights Amendment, but the bill did not pass through Congress until 1972 because it had to be ratified by three-fourths of the states. At that time, Paul was eighty-seven years old.

The weekly publication of the National Woman's Party, *The Suffragist*, celebrated the passage of the Nineteenth Amendment in Congress with the cover of its June 21, 1919, issue (cat. 124). The allegorical figures of Justice and American Womanhood embrace while the title below them, "At Last," alludes to the long road leading up to the event. Justice clutches the suffrage amendment in one hand and balance scales in another, as she is finally able to give American women what they rightfully deserve.

Charles Dana Gibson no doubt used *At Last* as inspiration for his October 1920 cover for *Life* magazine (cat. 125). In *Congratulations*, the "Gibson Girl," who came to symbolize a new generation of suffragists, is pictured receiving the ballot from Columbia, or Lady Liberty.

Visions of the Vote and Its Reality

While one might have expected voter turnout to increase in the fall of 1920, many women did not, in fact, get out and vote. In reality, turnout declined. Some have attributed this fact to the idea that women never formed their own voting bloc, in part because they often would have voted "as their husbands and thus only

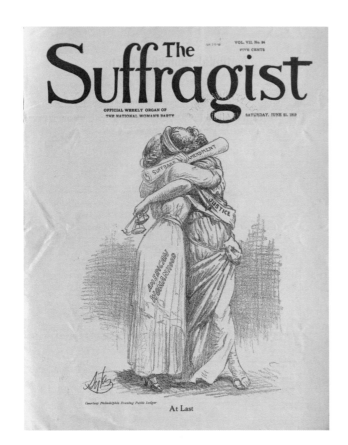

The Suffragist

OFFICIAL WEEKLY ORGAN OF
THE NATIONAL WOMAN'S PARTY

VOL. VII. No. 24
FIVE CENTS

SATURDAY, JUNE 21, 1919

At Last

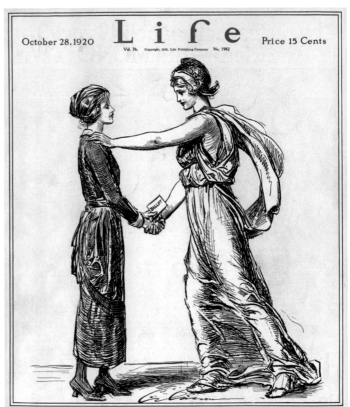

October 28, 1920

Life

Vol. 76. Copyright, 1920, Life Publishing Company No. 1982

Price 15 Cents

replicated the male vote."[10] Women's voter turnout for the 1920 elections largely depended on where they lived—the state in which they were enfranchised, among other factors.[11]

Despite the absence of women voters, Republicans managed to gain votes by courting women to vote for them in the November elections. A page from the October 1920 issue of *Vogue*, for example, features portraits of the Republican presidential nominee, Warren G. Harding, and his running mate, Calvin Coolidge, issuing a message encouraging women to vote Republican in order to help end the war abroad (cat. 126).[12] Yellow badges were offered to women who voted the straight Republican ticket during their first presidential election on November 2, 1920. A woman in Lancaster, Pennsylvania, was one of many who proudly wore her voter badge featuring the phrase, "I Cast My First Vote" (cat. 127).

Even though women had finally won the right to vote after nearly a century of agitating, states often found ways to exclude individuals. An overwhelmingly racist American society in the South did not view the Nineteenth Amendment as decisive. There, and in other places, women of all races and religions continued to be repressed at the polls. Five individual examples help us understand the difficulties women of color faced when attempting to exercise their voting rights between 1879 and 1965.

Native populations faced a particularly difficult time with enfranchisement because they weren't granted citizenship until 1924, and even then, states

CAT. 124

At Last
Charles H. Sykes (1882–1942)
for *The Suffragist*, June 21, 1919
Photomechanical reproduction
34.3 × 26.3 cm (13 ½ × 10 ⅜ in.)
Bryn Mawr College Library,
Special Collections

CAT. 125

Congratulations
Charles Dana Gibson (1867–
1944) for *Life*, October 28, 1920
Photomechanical reproduction
27.9 × 22.9 cm (11 × 9 in.)
Collection of Ann Lewis and
Mike Sponder

restricted their voting rights. Susette La Flesche Tibbles is one example of how native Americans persisted in their fight to be recognized as equal citizens in the United States. In 1877, Tibbles witnessed the forced removal of the Ponca from Nebraska and the subsequent imprisonment of Ponca Chief Standing Bear, and others, who attempted to return to their homeland. Bilingual and bicultural, Tibbles served as an expert witness and worked as an interpreter in court cases that Native peoples brought against the federal government. Specifically, she testified during the landmark civil rights case when the laws of the United States ruled, "An Indian is a person within the meaning of the law of the United States." Consequently, Native Americans were able to choose where they would live. Like other people of color, Native women did not have the privilege of a single-issue focus like suffrage. Native activists, such as Tibbles, strenuously lobbied for the improved conditions of Indians living on reservations and for U.S. citizenship. The trial served as a springboard for Tibbles and Standing Bear to voice the harsh realities of Native Americans within the United States on the lecture circuit. A studio portrait of Tibbles by Cuban American photographer José Maria Mora captures the activist in New York during her speaking tour. In the portrait, Tibbles wears a simple black dress with a white collar and decorative neckpiece symbolizing her biculturalism (cat. 128).[13]

As exemplified by Tibbles, the situation of Native Americans living within the parameters of governing forces of the United States is a storied history of agitation and activism in which native women have long played major roles. Zitkala-Sa, part of the Sioux Nation, was another pioneer in a generation of Indian rights activists (cat. 129). She and her peers were the graduates of mission and government schools where Native children were forbidden from speaking their Native languages. Working together, these intellectual activists, from a multitude of tribal backgrounds, used their formal educations and flawless English, as well as ease in mainstream and urban (i.e., white) society, to fight U.S. federal Indian policy and demand social justice. They formed professional organizations such as the Society of American Indians. The Society of American Indians, founded in 1907, was the first national all-Indian organization that advocated for Indian rights. As one of its leaders, Zitkala-Sa tirelessly fought for Native American citizenship rights and was described as "a Jeanne D'Arc to lead her people into citizenship."[14] Her activism was successful, and in 1924, Congress passed the Indian Citizenship Act, which extended citizenship to all Native American noncitizens. Nevertheless, the southwestern states of Arizona, New Mexico, and Utah continued to find ways to deny voting rights to Native Americans.[15] Zitkala-Sa later founded one of the most important Native rights organizations, the National Council of American Indians in 1926.

Women became the voices for other marginalized groups. In Puerto Rico, *literate* women did not have the right to vote until 1932. Felisa Rincón de Gautier was active in this initial campaign for women's suffrage (cat. 130). Only later, in 1935, was universal voting written into law in Puerto Rico. In 1946, Rincón de Gautier was appointed the first woman mayor of San Juan after Roberto Sánchez Vilella resigned. In 1948, she ran for mayor—and won. During her period in office, she worked closely with Governor Luis Muñoz Marín, whom she had met years ear-

"I believe in holding fast to every forward step in unshackling child labor and elevating conditions of woman's employment."
—WARREN G. HARDING

"Look well then to the hearthstone. Therein all hope for America lies."
—CALVIN COOLIDGE

Women! For Your Own Good

Vote the Republican Ticket

From the beginning of time woman has been the enemy of War.

From the beginning of time she has been its most unhappy victim.

In proportion as woman's influence molds the politics of nations wars will diminish.

For woman is for peace.

* * * * * *

American women are being asked in this campaign to vote for the Democratic candidate for President because he is pledged to the *Treaty of Versailles* and the *Covenant* for a *league of nations* contained therein. They are told this covenant creates the league of peace of which good and great men have dreamed through many centuries. They are told it is a covenant of peace that will end all war.

Four years ago the same party asked for votes for the Democratic President because "he kept us out of war." He got them and five months later the United States entered the world war.

Is it wise to recall that, now that we are asked once more to vote for a Democratic candidate because he will commit us to a covenant that will keep the world out of war?

The American woman asks

The American woman asks of her country:

That it be a secure place for her home and for her children and that it be security with honor.

That it give her children opportunity to lead their lives even better than she and her husband led theirs.

That it be just in its relations with other nations and merit the pride which the best of its citizens have in it, in its history and its ideals.

A policy which has these purposes will have the support of American womanhood and American motherhood. That is the Republican policy and has been Republican policy from the days of Abraham Lincoln.

The Republican policy is to protect the security of the United States by preserving its right to make decisions regarding its action in the future as events in the future demand. The Republican party is unwilling to pledge now that it will protect European boundary lines and to deprive congress of the power to say in each case what the action of the United States will be.

(Advertisement)

The Republican party believes that to be dangerous to the children of the nation who will be of soldier age in years to come because it prevents them, through the congressmen they elect, from deciding what they would do and say now that they then will defend European territory.

Mothers' duty to their sons

No mother would make that pledge for her son when he was two years old and have it rest upon him when he was twenty-one. No wise woman would have her nation make that pledge and have it rest upon the citizens of the next generation who are children today.

Citizenship is a trusteeship and such a pledge is a violation of the rights of a ward. The American scheme of government, which has made this a land of freedom and security, provides that decisions shall be made by congress. That protects the people who must act.

* * * * * *

If Harding and Coolidge are elected no such pledge will be made. The United States will enter an association of nations to promote peace and humanity but the sons of no American mother will go to war, unless the representatives elected by the people and responsible to them say that it is necessary. In that case mothers will give their sons. In no other case ought they to give them.

* * * * * *

The making of war is a solemn and terrible duty when it comes. Some mothers may be mistaken. They may be misled by the false promises of the Democratic party. They may think that the league of nations will stand between their sons and rifles. There is greater probability that it will put rifles in the hands of their sons. President Wilson's covenant pledges American boys to every war in Europe and Cox upholds that covenant.

The Republican party insists upon protecting the security of the American home and the future of American children. Every war in Europe is not necessarily an American war. Let congress in each case decide, without a pledge in advance.

Fair deal and fair chance

The second point in a woman's concern is that her children should find conditions of life encouraging, inspiring and fit to produce comfort and character. The Republican domestic policy is for the strengthening and protecting of all elements which keep life on a high plane. It has been under Republican administration that this country has been an asylum for the less happy peoples of Europe, the land of promise and a haven.

The Fair Deal was the Roosevelt doctrine. The Fair Chance is the Harding doctrine. That is what the American woman wants for her children—the Fair Deal and the Fair Chance.

Under Republican administration the United States has been just in its relations to other nations and its ideals are the ideals of peace and humanity. A Republican administration freed Cuba. A Republican administration freed Porto Rico. A Republican administration gave the Filipinos a system of self government with free schools and the advantages of peace. A Republican administration gave back the indemnity to China when other nations held her financially responsible for the Boxer rebellion.

Our only war of conquest

The only war we ever fought that could in any sense be called a war of conquest, the war with Mexico, was declared by a Democratic President and Congress.

The Republican has been at all times a party of honorable peace, but it has always stood and stands today for the independence of the United States and puts its trust in the righteousness of the American people to serve the cause of peace in their own way, according to the dictates of their own conscience and in the exercise of their own free will.

Your needs demand a change

You demand a change in the White House in Washington.

You demand this change in the interests of your overburdened life, your overtaxed purse, your overanxious mind.

You know how you have fared under this Democratic administration.

You know how doubly hard it has been for you as manager of the family funds.

Yours has been one constant struggle trying to keep the home and the table supplied—trying to pay big bills with little dollars.

You know we have always had good times under Republican management of our public affairs.

Your interest as a woman, your interest as a mother, your interest as a citizen, your interest as the financial manager of the home, combine to require the return to Republican principles.

Republican National Committee

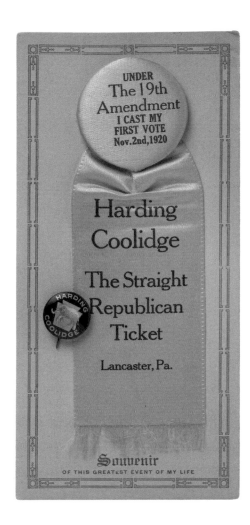

CAT. 126

Women! For Your Own Good. Vote the Republican Ticket
Republican National Committee for *Vogue*, October 1920
Photomechanical reproduction
27.9 × 22.9 cm (11 × 9 in.)
Collection of Ann Lewis and Mike Sponder

CAT. 127

First Vote Badge
J. H. Shaw (active 1890s–1920s)
1920
Satin ribbon
12.7 × 5.7 cm (5 × 2 ¼ in.)
Ronnie Lapinsky Sax Collection

lier through the Popular Democratic Party. She made several trips to New York City in the 1960s urging the city's Puerto Ricans to vote by encouraging children to help their parents with voting literacy tests.[16] Fondly called "Doña Fela" by her electorate, she served as mayor until 1968.

Puerto Rican artist Antonio Martorell sketched Rincón de Gautier near the end of her life, when her signature bouffant-style hair and oversized glasses had become iconic. Until her death at age ninety-seven, in 1994, she continued her association with Democratic politics.[17]

The Democratic party in the 1960s was an important platform for civil rights. Fannie Lou Hamer, a daughter of sharecroppers, gravitated toward activism in 1961, after surgeons performed a hysterectomy on her without her consent (cat. 131; see also figs. 1–2 in Jones). She had been undergoing a surgery to remove a uterine tumor, and on learning what had happened, she grew furious and sought ways to make her voice heard.[18] Unfortunately, this was one of innumerable incidents in a long and dark history of medical experimentation on African American women.[19] In order to effect change, activists like Hamer first had to amplify the voices of African Americans in the South who had been disenfranchised by "Jim Crow" laws.[20]

When Hamer and seventeen others went to the courthouse in Indianola, Mississippi, to register to vote, they were told that they could only enter the courthouse two at a time and that they would need to take a literacy test to vote. Hamer, who was forced to leave school at twelve so she could help her family pick cotton, failed the test. She subsequently became an active member and leader of the civil rights movement. Hamer gained national attention for her emotional and memorable testimony before the credentials committee of the 1964 Democratic National Convention, during which she revealed the unfortunate circumstances African Americans were continuing to face at the polls. She also spoke to a national television audience about the conditions and challenges of everyday people in Mississippi, her home state.

Civil rights photographer Charmian Reading captured Hamer's activism in a dramatic image of her during the March Against Fear, spanning over two hundred miles from Memphis, Tennessee, to Jackson, Mississippi. The march, which took place before the Voting Rights Act of 1965, sought to bring attention to African Americans' full citizenship rights.

Patsy Takemoto Mink became the subject of national attention when at the 1960 Democratic National Convention she linked the anti-discrimination efforts of Asian Americans to the largely African American civil rights movement. She asked the audience, "how can America stand as the land of golden opportunity if indeed there is only that opportunity for some and not all?"[21] Mink, a Japanese American from Hawaii, overcame much prejudice to become the first woman of color

707 BROADWAY, N.Y.

CAT. 128

Susette La Flesche Tibbles
(1854–1903)
José Maria Mora (1849–1926)
ca. 1879
Albumen silver print
14 × 9.7 cm (5 ½ × 3 ¹³⁄₁₆ in.)
National Portrait Gallery,
Smithsonian Institution

CAT. 129

Zitkala-Sa (1876–1938)
Joseph T. Keiley (1869–1914)
1898 (printed 1901)
Photogravure
15.9 × 9.5 cm (6 ¼ × 3 ¾ in.)
National Portrait Gallery,
Smithsonian Institution

CAT. 130

Felisa Rincón de Gautier
(1897–1994)
Antonio Martorell (b. 1939)
1992
Charcoal on paper
98.3 × 127 cm (38 11/16 × 50 in.)
National Portrait Gallery,
Smithsonian Institution;
framed with funds from
the Smithsonian Women's
Committee

in Congress. After joining the House of Representatives in 1965, she served as a life-long advocate for women of color and shaped legislation for the Voting Rights Act. Another of Mink's accomplishments as a legislator was the passage of the Title IX or the Equal Opportunity in Education Act, which prohibited gender discrimination in federally funded educational institutions. Mink's lengthy career in Congress spanned twenty-six years. A reelection poster, from 1970, features her congressional portrait, in which she wears a white jacket, signaling, to our eye, the suffragists who came before her (cat. 132).

The mid-twentieth century activism of American women such as Felisa Rincón de Gautier, Fannie Lou Hamer, Patsy Mink, and other civil rights activists helped spark a national discussion on voting rights. Minorities throughout the United States had been barred from voting through poll taxes, registrar prejudice, literacy tests, and automatic disqualification for certain crimes committed. These legal barriers, put forth by states, especially discriminated against Americans of color.[22]

The nation's increasing awareness of discriminatory voting laws and practices eventually led the federal government to intervene, and in 1965, President Lyndon B. Johnson signed the Voting Rights Act (VRA) into law. With the bill's lawful power, discrimination based on race became illegal in the United States.

Although the VRA is regarded as the most successful civil rights legislation, it did not completely eliminate voter discrimination. Multiple amendments to the VRA were added between 1970 and 2006, however, including those that ended literacy tests and gave eighteen-year-olds the right to vote. In 2006, the bill was unanimously passed by the Senate with a 98–0 vote, thereby extending the VRA's special provisions until 2031.

When enfranchised women finally voted, the United States witnessed the largest expansion of the electorate in American history. It is worth asking, on the centennial anniversary: Did the women's vote act as a disruptor? Did the reality of women voting transform and effectively moralize the systems of power? What can we take as accomplishments, and what do we still have to work toward insofar as women's citizenship rights in the United States are concerned?

These questions remain at the forefront of our minds in the current moment. A groundbreaking 309 women ran for the House in the 2018 midterm elections, and two-thirds of women running in the primary elections won.[23] One hundred and two women won races to become members of the House of Representatives. Among these individuals, a record total of forty-three are women of color, including two Native Americans. Of the twenty-three women representatives in the United States Senate, four are women of color. Women, who had no political voice one hundred years ago, now work in the US government in historic numbers: more than 120 women serve in the 116th Congress. Moreover, deepening disparities between Democrats and Republicans have affected the path to equality. In the 116th Congress, twenty-four women serve in the Senate (seventeen Democrats and seven Republicans). The number of Republican women serving in the House of Representatives dropped by ten between 2018 and 2019. Four states, Alaska,

CAT. 131

Fannie Lou Hamer (1917–1977)
Charmian Reading (1930–2014)
1966
Gelatin silver print
27.9 × 35.2 cm (11 × 13 ⅞ in.)
National Portrait Gallery,
Smithsonian Institution

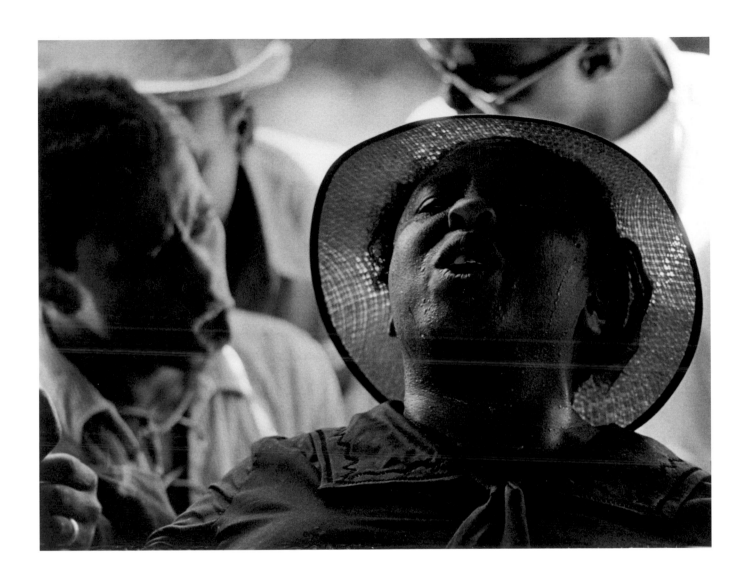

With Warmest Aloha,
Patsy T. Mink

Please Re-Elect

PATSY T. MINK
U.S. CONGRESS ★ DEMOCRAT

Friends for Patsy Mink Committee, Oahu chairman: Ronald Okana, 1366 Ala Moana Blvd., Honolulu, Hawaii.

CAT. 132

Patsy Takemoto Mink (1927–2002)
Unidentified artist
ca. 1970
Photomechanical reproduction
30.5 × 22.9 cm (12 × 9 in.)
Collection of the US House of
Representatives

Mississippi, North Dakota, and Vermont, have never elected a single woman to Congress to represent their citizens.

The increasing number of women in political office demonstrates some progress—albeit slow—toward a fully integrated American awakening toward women's equality. Yet even today, restrictive voter identification laws target Native Americans and African Americans in specific regions. Alice Paul's call for an Equal Rights Amendment, begun in 1923, which legally puts women on par with men, has never been fully ratified. The United States, where women earn four-fifths of what men earn, is one of only three countries that does not guarantee paid maternity leave, and only 4.8 percent of Fortune 500's CEOs in 2018 are women.[24]

There are many issues left to resolve, but if the history of the women in the United States reveals anything, it reveals a national character defined by both persistence and perseverance.

NOTES

INTRODUCTION

1. Elizabeth H. Maurer et al., *Where Are the Women? A Report on the Status of Women in the United States Social Studies Standards*, National Women's History Museum, http://www.womenshistory.org/social-studies-standards (2017).

TO FIGHT BY REMEMBERING, OR THE MAKING OF SENECA FALLS

1. This chapter is derived from my book, Lisa Tetrault, *The Myth of Seneca Falls: Memory and the Women's Suffrage Movement, 1848–1898* (Chapel Hill: University of North Carolina Press, 2014). The chapter here is a shorter, selected version of the argument made there. Myth in my title refers not to the falsehood of Seneca Falls but to the *story* of Seneca Falls (to distinguish it from the *convention*). I use myth to denote a particular type of story that became so well known, so often repeated, and so codified that, I argue, it has assumed mythological proportions, giving shape and meaning to the suffrage campaign. In this piece here, I have chosen to use the term *story*, rather than *myth*. But I see the two terms as tightly related, with myth being a particular type of story, rather than a falsehood.

See "Ratification Flag Is Flying," *Los Angeles Times*, August 19, 1920.

2. For examples of the United Press wire story, see "Woman's Long Fight for the Ballot," *Fort Wayne News and Sentinel*, August 19, 1920; "Outline Story of Suffrage in the United States," *Olwein Daily Register*, August 19, 1920; and "Nineteenth Amendment Is Living Monument to Late Susan B. Anthony," *Sandusky Star Journal*, August 20, 1920.

3. The rest of the Nineteenth Amendment reads, "Congress shall have power to enforce this article by appropriate legislation."

4. Liette Gidlow, "Resistance after Ratification: The Nineteenth Amendment, African American Women, and the Problem of Female Disfranchisement after 1920," March 2017 essay published in the Alexander Street Press's Women and Social Movements Database (Alexandria, VA: Alexander Street, 2017).

5. Tetrault, *Myth of Seneca Falls*.

6. The literature on memory and the subjectivity of history is vast. See, for example, Tetrault, *Myth of Seneca Falls*; Pierre Nora, "Between Memory and History, Les Lieux de Mémoire," *Representations* 26 (Spring 1989): 7–24; Daniel L. Schacter, *Searching for Memory: The Brain, the Mind, and the Past* (New York: Basic Books, 1996); and David Noble, *The "Objectivity Question" and the American Historical Profession* (New York: Cambridge University Press, 1988).

7. On storytelling, a literature that is also vast, see Thomas King, *The Truth about Stories: A Native Narrative* (Minneapolis: University of Minnesota Press, 2008); and Jerome Bruner, *Making Stories: Law, Literature, Life* (Cambridge, MA: Harvard University Press, 2003).

8. Tetrault, *Myth of Seneca Falls*, 2.

9. Carol Faulkner, *Lucretia Mott's Heresy: Abolition and Women's Rights in the Nineteenth Century* (Philadelphia: University of Pennsylvania Press, 2011); Lori D. Ginzberg, *Elizabeth Cady Stanton: An American Life* (New York: Hill and Wang, 2009); Judith Wellman, *The Road to Seneca Falls: Elizabeth Cady Stanton and the First Woman's Rights Convention* (Urbana: University of Illinois Press, 2004); Elisabeth Griffith, *In Her Own Right: The Life of Elizabeth Cady Stanton* (New York: Oxford University Press, 1984); and Elizabeth Cady Stanton, Susan B. Anthony, and Matilda Joslyn Gage, eds., *History of Woman Suffrage*, vol. 1, 1848–1861 (New York: Fowler and Wells, 1881; reprint, New York: Arno Press, 1969) (hereafter HWS).

10. Ginzberg, *Elizabeth Cady Stanton*, 37–47; Wellman, *Road*; Griffith, *In Her Own Right*; HWS, vol. 1; and *Proceedings of the General Anti-Slavery Convention* (1840), 1–46.

Mott would remember this differently, that they struck on the idea later, in Boston. And her 1840 diary makes no mention of the plan. Lucretia Mott to Stanton, March 16, 1855, in Beverly Wilson Palmer, ed., *Selected Papers of Lucretia Coffin Mott* (Urbana: University of Illinois Press, 2002), 236; and Frederick B. Tolles, ed., "'Slavery and the Woman Question': Lucretia Mott's Diary of Her Visit to Great Britain to Attend the World's Anti-Slavery Convention of 1840," supplement no. 23 to the *Journal of the Friends'*

Historical Society (Haverford, PA: Friends' Historical Association and Friends Historical Society, 1952).

11. HWS, 1:67.

12. Faulkner, *Lucretia Mott*, 139–40; Ginzberg, *Elizabeth Cady Stanton*, 57; Wellman, *Road*, 189; and HWS, vol. 67–75.

13. Ginzberg, *Elizabeth Cady Stanton*; and Wellman, *Road*; *Proceedings of the Woman's Rights Conventions at Seneca Falls and Rochester, N.Y., July and August, 1848* (New York: Robert J. Johnston, 1870), emphasis mine.

14. Today we do not know who was there. We have only the names of maybe a third of the attendees, those who signed the "Declaration of Sentiments." The congregants were clearly mixed sex, and there appear to have been working-class women in attendance. We do not know of any black women who attended.

15. Faulkner, *Lucretia Mott*, 209; Ginzberg, *Elizabeth Cady Stanton*, 60; Wellman, *Road*, 201; and *Proceedings of the Woman's Rights Conventions at Seneca Falls and Rochester* (1870).

16. Timothy C. Terpstra, "The 1848 Seneca Falls Woman's Rights Convention: Initial American Public Reaction" (master's thesis, Mississippi State University, 1975); Wellman, *Road*, 204; and *Report of the Woman's Rights Convention, Held at Seneca Falls, N. Y., July 19th & 20th, 1848* (Rochester, NY: printed at the *North Star* Office, 1848).

17. The literature on the more conventional interpretation of women's rights in the early republic and antebellum era is robust and is undergoing revision, as questions of chronology, legality, race, and class reframe this history. See, for example, Marilyn Richardson, ed., *Maria W. Stewart: America's First Black Woman Political Writer, Essays and Speeches* (Bloomington: Indiana University Press, 1987); Jean Fagan Yellin, *Women and Sisters: The Antislavery Feminists in American Culture* (New Haven, CT: Yale University Press, 1989); Shirley Yee, *Black Women Abolitionists: A Study in Activism, 1828–1860* (Knoxville: University of Tennessee Press, 1992); Nancy Isenberg, *Sex and Citizenship in Antebellum America* (Chapel Hill: University of North Carolina Press, 1998); Ann M. Boylan, *Origins of Women's Activism: New York and Boston, 1797–1840* (Chapel Hill: University of North Carolina Press, 2001); Rosemarie Zagarri, *Revolutionary Backlash: Women and Politics in the Early American Republic* (Philadelphia: University of Pennsylvania Press, 2007); Laura F. Edwards, *The People and Their Peace: Legal Culture and the Transformation of Inequality in the Post-Revolutionary South* (Chapel Hill: University

of North Carolina Press, 2009); and Nancy Hewitt, ed., *No Permanent Waves: Recasting Histories of U.S. Feminism* (New Brunswick, NJ: Rutgers University Press, 2010).

18. "Remember the Ladies," Abigail Adams to Mercy Otis Warren, April 27, 1776, in *The Feminist Papers: From Adams to de Beauvoir*, ed. Alice S. Rossi (Lebanon, NH: University Press of New England, 1973), 12.

19. Zagarri, *Revolutionary Backlash*, 29–30; and Boylan, *Origins of Women's Activism*.

20. Judith Apter Klinghoffer and Lois Elkins, "'The Petticoat Electors': Women's Suffrage in New Jersey, 1776–1807," *Journal of the Early Republic* 12 (Summer 1992): 159–93; and Jan Ellen Lewis, "Rethinking Women's Suffrage in New Jersey, 1776–1807," *Rutgers Law Review* 63 (January 2011): 1017–35.

21. Margaret Sarah Fuller, *Woman in the Nineteenth Century* (New York: Greeley and McElrath, 1845), 18; and Megan Marshall, *Margaret Fuller: A New American Life* (New York: Houghton Mifflin Harcourt Publishing, 2013), 387–88.

22. Lori Ginzberg, *Untidy Origins: A Story of Women's Rights in Antebellum New York* (Chapel Hill: University of North Carolina Press, 2005); and Jacob Katz Cogan and Lori Ginzberg, "1846 Petition for Woman's Suffrage, New York State Constitutional Convention," *Signs* 22 (Winter 1997): 427–39.

23. Kathryn Kish Sklar, "Women's Rights Emerges within the Anti-Slavery Movement: Angelina and Sarah Grimké in 1837," in *Women and Power in American History*, ed. Kathryn Kish Sklar and Thomas Dublin, 2nd ed. (Upper Saddle River, NJ: Prentice Hall, 2002).

24. Yellin, *Women and Sisters*; and Yee, *Black Women Abolitionists*, 111.

25. Andrea Moore Kerr, *Lucy Stone: Speaking Out for Equality* (New Brunswick, NJ: Rutgers University Press, 1992), 50; Joelle Million, *Woman's Voice, Woman's Place: Lucy Stone and the Birth of the Woman's Rights Movement* (Westport, CT: Praeger: 2003), 85; and Sally McMillen, *Lucy Stone: An Unapologetic Life* (New York: Oxford University Press, 2015), 70.

26. Paula Doress-Worters, ed., *Mistress of Herself: Speeches and Letters of Ernestine L. Rose, Early Women's Rights Leader* (New York: Feminist Press at the City University of New York, 2008), 187–88; and Bonnie Anderson, *The Rabbi's Atheist Daughter: Ernestine Rose, International Feminist Pioneer* (New York: Oxford University Press, 2017), 89–90.

27. Sally McMillen, *Seneca Falls and the Origin of the Women's Rights Movement* (New York: Oxford University Press, 2008), 110–11; Sylvia Hoffert, *When*

Hens Crow: The Women's Rights Movement in Antebellum America (Bloomington: Indiana University Press, 1995), 95.

28. Ginzberg, *Elizabeth Cady Stanton*, 77–80; Wellman, *Road*, 221; Kathleen Barry, *Susan B. Anthony: Biography of a Singular Feminist* (New York: New York University Press, 1988).

29. Their careers were so collaborative and so inextricable that the editors of the documentary papers project about their lives, who have just completed their work, judged it necessary to treat Stanton and Anthony together. This project's remarkable work has produced an invaluable collection of microfilm by and about them as well as six selected and annotated volumes of their joint papers—all testifying to the amazing productivity of their friendship. Patricia G. Holland and Ann D. Gordon, eds., *The Papers of Elizabeth Cady Stanton and Susan B. Anthony: Microfilm Edition* (Wilmington, DE: Scholarly Resources, 1992) (hereafter cited as *SAP*); and Ann D. Gordon et al., eds., *The Selected Papers of Elizabeth Cady Stanton and Susan B. Anthony*, vols. 1–6 (New Brunswick, NJ: Rutgers University Press, 1997–2013). On their friendship in particular, see Alice Rossi, "A Feminist Friendship: Elizabeth Cady Stanton . . . and Susan B. Anthony," in Rossi, *Feminist Papers*, 378–96. Quotation in Anthony to Ida Husted Harper, October 28, 1902, Gordon et al., eds., *Selected Papers*, 6:455; and "Elizabeth Cady Stanton Dies at Her Home," *New York Times*, October 27, 1902.

30. Tetrault, *Myth of Seneca Falls*, 19–46.

31. Several scholars have examined the effects of Reconstruction on women's rights; see James McPherson, *Battle Cry of Freedom: The Civil War Era* (New York: Oxford University Press, 1988); Eric Foner, *Reconstruction: America's Unfinished Revolution, 1863–1877* (New York: Harper and Row, 1988).

32. Foner, *Reconstruction*; and Foner, "The Meaning of Freedom in the Age of Emancipation," *Journal of American History* 81 (September 1994): 435–60.

33. This story is found in my book, *Myth of Seneca Falls*, and with different inflections in Ellen DuBois, *Feminism and Suffrage: The Emergence of an Independent Women's Movement in America* (Ithaca, NY: Cornell University Press, 1978); Roslyn Terborg-Penn, *African American Women in the Struggle for the Vote, 1850–1920* (Bloomington: Indiana University Press); Ginzberg, *Elizabeth Cady Stanton*; and Faye Dudden, *Fighting Chance: The Struggle over Woman Suffrage and Black Suffrage in Reconstruction America* (New York: Oxford University Press, 2011). Membership lists are found in

Stuart Galloway, "The American Equal Rights Association, 1866–1870: Gender, Race, and Universal Suffrage" (PhD Diss., University of Leicester, UK, 2014).

34. Tetrault, *Myth of Seneca Falls*; DuBois, *Feminism and Suffrage*; Ginzberg, *Elizabeth Cady Stanton*; and Dudden, *Fighting Chance*. See also Ann D. Gordon, "Stanton and the Right to Vote: On Account of Race or Sex," and Michele Mitchell, "'Lower Orders,' Racial Hierarchies, and Rights Rhetoric: Evolutionary Echoes in Elizabeth Cady Stanton's Thought during the last 1860s," both in *Elizabeth Cady Stanton, Feminist as Thinker: A Reader in Documents and Essays*, ed. Ellen Carol DuBois and Richard Candida Smith (New York: New York University Press, 2007). For an account of racism in the movement more generally, see Louise Newman, *White Women's Rights: The Racial Origins of Feminism in the United States* (New York: Oxford University Press, 1999).

35. "Women of the Period," *New York World*, May 13, 1869, in *SAP*, reel 15, images 501–2; taken from Tetrault, *Myth of Seneca Falls*, 28.

36. "Women of the Period," *New York World*, May 13, 1869, in *SAP*, reel 15, images 504–5; taken from Tetrault, *Myth of Seneca Falls*, 28–29.

37. DuBois, *Feminism and Suffrage*, 188–89; "Women of the Period," *New York World*, May 13, 1869, in *SAP*, 15:504; "Equal Rights," *New York Times*, May 13, 1869, in *SAP*, 13:517; Terborg-Penn, *African American Women*; from Tetrault, *Myth of Seneca Falls*, 29–30.

38. DuBois, *Feminism and Suffrage*; Dudden, *Fighting Chance*; Tetrault, *Myth of Seneca Falls*, 31–35.

39. DuBois, *Feminism and Suffrage*; Dudden, *Fighting Chance*; Tetrault, *Myth of Seneca Falls*, 31–35.

40. Mary Livermore, *The Story of My Life* (1899; reprint, New York: Arno Press, 1974), 493.

41. Rebecca Mead, *How the Vote Was Won: Woman Suffrage in the Western United States, 1868–1914* (New York: New York University Press, 2004).

42. Amanda Frisken, *Victoria Woodhull's Sexual Revolution: Political Theater and the Popular Press in Nineteenth-Century America* (Philadelphia: University of Pennsylvania Press, 2004); Joanne Passet, *Sex Radicals and the Quest for Women's Equality* (Urbana: University of Illinois Press, 2003); Ann Braude, *Radical Spirits: Spiritualism and Women's Rights in Nineteenth-Century America*, 2nd ed. (Bloomington: Indiana University Press, 2001); Barbara Goldsmith, *Other Powers: The Age of Suffrage, Spiritualism, and the Scandalous Victoria Woodhull* (New York: Alfred A. Knopf, 1998); Kerr, *Lucy Stone*.

43. *SAP*, 15:30; Ellen DuBois, "Taking the Law into Our Own Hands: Bradwell, Minor, and Suffrage Militance in the 1870s," in *One Woman, One Vote: Rediscovering the Woman Suffrage Movement*, ed. Marjorie Spruill Wheeler (Troutdale, OR: New Sage Press, 1995); Frisken, *Victoria Woodhull's Sexual Revolution*, vii, 8; Anthony Diary, January 10, 1871, *SAP*, 15:326; "The Ballot," *Daily Morning Chronicle*, January 13, 1871, *SAP*, 15:330; "The Campaign Opened," *National Republican*, January 12, 1871, *SAP*, 15:332.

44. Susan B. Anthony, *An Account of the Trial of Susan B. Anthony on the Charge of Illegal Voting, at the Presidential Election in Nov., 1872, and on the Trial of Beverley W. Jones, Edwin T. Marsh and William B. Hall, the Inspectors of Election by Whom Her Vote Was Received* (Rochester, NY: Daily Democrat and Chronicle Book Print, 1874); DuBois, "Taking the Law."

45. For the fullest list of illegal women voters to date, see Gordon et al., eds., *Selected Papers*, vol. 2, Appendix X.

46. Lois B. Underhill, *The Woman Who Ran for President: The Many Lives of Victoria Woodhull* (New York: Penguin Books, 1996); and Ellen Fitzpatrick, *The Highest Glass Ceiling: Women's Quest for the American Presidency* (Cambridge, MA: Harvard University Press, 2016).

47. Myra MacPherson, *The Scarlett Sisters: Sex, Suffrage, and Scandal in the Gilded Age* (New York: Twelve, Hatchette Book Group, 2014); and Richard Wightman Fox, *Trials of Intimacy: Love and Loss in the Beecher-Tilton Scandal* (Chicago: University of Chicago Press, 1999), 296.

48. As a few examples, in the 1850s, Mott corrected Stanton's dating of the movement, saying it began in 1837, at the national Anti-Slavery Convention of American Women. As late as 1861, on the eve of the Civil War, one activist wrote: "It is difficult to tell when this idea of human equality first took to itself form and purpose . . . with respect to the inferior position of woman." And in 1866, when Mott recited movement history before the AERA, her story had no clear beginning, but various beginnings, and she did not single out Seneca Falls as a watershed. Up through the 1860s, suffragists simply did not have a shared, stock origins story. Mott to Stanton, March 16, 1855, in Palmer, *Selected Letters of Lucretia Mott*, 236; J. Elizabeth Jones, unidentified newspaper clipping, [1861], annotated by Anthony, bound before #18 in a collection of pamphlets Anthony compiled, labeled Reports of Woman's Rights Conventions, 1848–1870, in the Susan B. Anthony Collection, Rare Books Room, Library of Congress; and "The Anniversaries," *New York Daily Tribune*, May 11, 1866, as well as *Proceedings of the Eleventh National Woman's Rights Convention*, 1866, 49–51.

49. The prominent reformer, Mary Livermore, for example, who entered the movement after the Civil War, often in her lectures, dated the beginning of the suffrage movement to 1869. Anthony was highly critical of Livermore's speech and new postwar suffragists for not knowing their antebellum women's rights history and thinking they invented the movement. Anthony to Barbara Binks Thompson, August 18, 1881, in Gordon et al., eds., *Selected Papers*, 4:104–7; and Wendy Hamand Venet, *A Strong-Minded Woman: The Life of Mary Livermore* (Amherst: University of Massachusetts Press, 2005), 202.

50. "Woman's Rights," *New York Herald*, May 7, 1873, *SAP*, 17:63; and "Woman Suffragists," *New York World*, May 7, 1873, *SAP*, 17:60. Even at this event, Mott did not use her remarks to position Seneca Falls as the beginning of the movement. Rather, she gave "considerable credit for it to the Quakers." See "The Woman Suffrage Cause," *New York Tribune*, May 7, 1873, *SAP*, 17:68.

51. "Woman's Rights," *New York Herald*, May 7, 1873, *SAP*, 17:63.

52. Theodore Tilton, "Mrs. Elizabeth Cady Stanton," in *Eminent Women of the Age*, ed. James Parton (Hartford, CT: S. M. Betts, 1869; reprint, New York: Arno Press, 1974), 346.

53. The database WorldCat of the Online Computer Library Center (OCLC) lists only nineteen repositories that hold an original printing of the Seneca Falls convention report.

54. The 1870 reprint did not match the 1848 version exactly. *Proceedings of the Woman's Rights Conventions at Seneca Falls and Rochester, N.Y., July and August, 1848* (New York: Robert J. Johnston, 1870); Anthony to Mary Post Hallowell, April 11, 1867, in Gordon et al., eds., *Selected Papers*, 2:52–53n4. For additional information on the differences, see Tetrault, *Myth of Seneca Falls*, 217n130.

55. "Woman-Suffrage," *Pioneer*, May 29, 1873, *SAP*, 17:66.

56. "Woman-Suffrage," *Pioneer*, May 29, 1873, *SAP*, 17:66.

57. For a much larger discussion of how this happened, see Tetrault, *Myth of Seneca Falls*.

58. Tetrault, *Myth of Seneca Falls*, 75–111; and Tetrault, "Women's Rights and Reconstruction," *Journal of the Civil War Era* 7 (March 2017), n.p.

59. For this abolitionist memory and postwar remembering about emancipation, see David Blight, *Race and Reunion: The Civil War in American Memory* (Cambridge, MA: Harvard University Press, 2001); Julie Roy Jeffrey, *Abolitionists Remember: Antislavery Autobiographies and the Unfinished Work of Emancipation* (Chapel Hill: University of North Carolina Press, 2008); Caroline Janney, *Remembering the Civil War: Reunion and the Limits of Reconciliation* (Chapel Hill: University of North Carolina Press, 2013).

60. The long history of this is embodied by the title and content of a 1982 anthology of black women's writing. Gloria T. Hull, Patricia Bell Scott, and Barbara Smith, eds., *All the Women Are White, All the Blacks Are Men, But Some of Us Are Brave: Black Women's Studies* (New York: Feminist Press, 1982).

61. On black women and post–Civil War suffrage work, see, as examples, Terborg-Penn, *African-American Women*; Ann D. Gordon and Bettye Collier-Thomas, eds., *African American Women and the Vote, 1837–1965* (Amherst: University of Massachusetts Press, 1997); Elsa Barkley Brown, "Negotiating and Transforming the Public Sphere: African American Political Life in the Transition from Slavery to Freedom," *Public Culture* 7 (Fall 1994): 107–46. On black women's post–Civil War activism, see as examples, Evelyn Brooks Higginbotham, *Righteous Discontent: The Women's Movement in the Black Baptist Church, 1880–1920* (Cambridge, MA: Harvard University Press, 1993); Tera Hunter, *To 'Joy My Freedom: Southern Black Women's Lives and Labors after the Civil War* (Cambridge, MA: Harvard University Press, 1997); Martha Jones, *All Bound Up Together: The Woman Question in African American Political Life, 1830–1900* (Chapel Hill: University of North Carolina Press, 2007); and Crystal Feimster, "'What If I Am a Woman': Black Women's Campaigns for Sexual Justice and Citizenship," in *The World the Civil War Made*, ed. Gregory Downs and Kate Masur (Chapel Hill: University of North Carolina Press, 2015); and Treva Lindsey, *Colored No More: Reinventing Black Womanhood* (Urbana: University of Illinois Press, 2017).

62. Stanton pegged this date, and its companion causal date of 1840, as the beginning of the movement as early as the 1850s, when she first considered writing a history of the movement. This was always how Stanton understood the campaign.

63. The scholarship on the civil rights movement in the United States has been particularly helpful on this question of beginnings and their endless problems. As that scholarship eschews such a quest, scholars of women's suffrage have a lot to learn from their insights. The most emblematic work here is Jacquelyn Dowd Hall's "The Long Civil Rights Movement and the Political Uses of the Past," *Journal of American History* 91 (March 2005): 1233–63.

64. Stone to Stanton, August 30, 1876, in the Papers of Ida Husted Harper, box 1, Manuscripts Division, Huntington Research Library, San Marino, California. For more on all of these projects, see Tetrault, *Myth of Seneca Falls*, 104–44.

65. Lucy Stone, unpublished manuscript, February 4, 1882, in the American Equal Rights Association (AERA) File, The Records of the National American Woman Suffrage Association, microfilm edition (Washington, DC: Library of Congress, 1981), reel 26, images 25–42.

66. Stone to Antoinette Brown Blackwell, n.d. [winter 1888], in Carol Lasser and Marlene Deahl Merrill, eds., *Friends and Sisters: Letters between Lucy Stone and Antoinette Brown Blackwell, 1846–1893* (Urbana: University of Illinois Press, 1987), 225.

67. HWS, 1:7.

68. Stanton to Elizabeth Boynton Harbert, September 19, [1876], in Gordon et al., eds., *Selected Papers*, 3:264; Stanton to Mathilde Franz Anneke, October 20, [1876 or 1878], in the Mathilde Franz Anneke Papers, box 5, folder 4, Library-Archives Division, Wisconsin Historical Society, Madison, Wisconsin; Stanton to Theodore Stanton, November 2, 1880, in Gordon et al., eds., *Selected Papers*, 4:14–15; Matilda Joslyn Gage to Laura de Force Gordon, December 29, 1880, in the Laura [de Force] Gordon Papers, box 1, Bancroft Library, Berkeley, California; Anthony to Harbert, March 20, 1881, in Gordon et al., eds., *Selected Papers*, 4:53–54; and Stanton, *Eighty Years and More: Reminiscences, 1815–1897* (1898; reprint, Boston: Northeastern University Press, 1993), 326–27.

69. For a much fuller history of the *History of Woman Suffrage*'s production and content see Tetrault, "We Shall Be Remembered: Susan B. Anthony and the Politics of Writing History," in *Susan B. Anthony and the Struggle for Equal Rights*, ed. Christine Ridarsky and Mary Huth (Rochester, NY: University of Rochester Press, 2012); and Tetrault, *Myth of Seneca Falls*, 112–44.

70. They make this point throughout; see, for example, this claim in their preface, HWS, 1:7.

71. HWS, 2:406.

72. They then drove home the point for good measure by repeatedly calling themselves the only "true woman suffragists." HWS, 2:28, 99, 322–23. They also drove home all their other messages about how black men's voting over white women was a travesty of justice and how the women's suffrage movement was "the most momentous reform that has yet been launched on the world," swiping at abolition and making a very pointed public case for the vote. Quotation from HWS, 1:7; and for swipes at black men's voting, see HWS, vol. 2, especially 66–88, but the protest is made throughout.

73. HWS, 1:456, 472.

74. See AWSA chapter in HWS, 4:406–33.

75. Lucy Stone, "Woman Suffrage History," *Woman's Journal*, March 10, 1883. Other American Association partisans also publicly criticized the *History of Woman Suffrage* when it was published. Thomas Wentworth Higginson, for example, signaled his anger much more stridently than Stone had, revealing by his review title that he thought the *History*'s interpretations were entirely backward. Higginson, "The Reverse of the Picture," *Woman's Journal*, March 10, 1883. The children of William Lloyd Garrison, the esteemed abolitionist and American Association supporter, were also so incensed that they diverted their biography of their father to write a dissenting narrative about when and where women's rights had begun, rooting it earlier, in abolitionist women's oratory. Wendell Phillips Garrison and Francis Jackson Garrison, *William Lloyd Garrison, 1805–1879* (New York: Century, 1885–89), see especially vol. 2, 204, 380–81, and vol. 3, 262.

76. Alice Stone Blackwell to Maud Wood Park, January 30, 1945, typed transcript, excerpt, National Woman Suffrage Association file, in *The Records of the National American Woman Suffrage Association* (Washington, DC: Library of Congress, 1981), microfilm, 47:322.

77. The one account of the American Woman Suffrage Association is an older, unpublished dissertation. Lois Bannister Merk, "Massachusetts and the Woman-Suffrage Movement" (PhD thesis, Radcliffe College, 1956). Stone's daughter's biography of her mother and the new biography of Stone both lament her historical eclipse and argue for her historical significance. Alice Stone Blackwell, *Lucy Stone: Pioneers of Women's Rights* (Boston: Little, Brown, 1930); and McMillen, *Lucy Stone*. See also, Kerr, *Lucy Stone*; and Million, *Woman's Voice, Women's Place*.

78. Kathi Kern, *Mrs. Stanton's Bible* (Ithaca, NY: Cornell University Press, 2002), 207.

79. "Famous Advocate of Woman's Rights Dead," *Washington Times*, October 27, 1902.

80. Associated Press, "Susan B. Anthony Dead," as carried in the *Daily Northwestern*, March 13, 1906, 7. And "Susan B. Anthony Dead," *Burlington Free Press*, March 15, 1906, 7, carried the subheading "Only One Other Survivor." On the complexity of Anthony and the difficulty of recovering her from underneath layers of present-day purposes, see Ann D. Gordon, "Knowing Susan B. Anthony: The Stories We Tell of a Life," in Ridarsky and Huth, *Susan B. Anthony and the Struggle for Equal Rights*. Perhaps because she has proved so vexing to interpret, we currently have no biography of her written by a historian.

81. Tetrault, *Myth of Seneca Falls*, 181–93.

THE POLITICS OF BLACK WOMANHOOD, 1848–2008

1. Fannie Lou Hamer, "Testimony before the Credentials Committee at the Democratic National Convention, Atlantic City, New Jersey, August 22, 1964," in Hamer, *The Speeches of Fannie Lou Hamer: To Tell It Like It Is*, ed. Maegan Parker Brooks and Davis W. Houck (Jackson: University of Mississippi Press, 2010): 63–66. On Hamer's life generally, see Chana Kai Lee, *For Freedom's Sake: The Life of Fannie Lou Hamer* (Urbana: University of Illinois Press. 1999).

2. Fannie Lou Hamer, "'I'm Sick and Tired of Being Sick and Tired': Speech Delivered with Malcolm X at the Williams Institutional CME Church, Harlem, New York, December 20, 1964," in Hamer, *Speeches of Fannie Lou Hamer*, 75–81.

3. On the black women and voting rights generally, see Rosalyn Terborg-Penn, *African American Women in the Struggle for the Vote, 1850–1920* (Bloomington: Indiana University Press, 1998); Ann D. Gordon et al., *African American Women and the Vote, 1837–1965* (Amherst: University of Massachusetts Press, 1997); and Lisa G. Materson, *For the Freedom of Her Race: Black Women and Electoral Politics in Illinois, 1877–1932* (Chapel Hill: University of North Carolina Press, 2009).

4. On black women and the anti-slavery movement, see Shirley Yes, *Black Women Abolitionists: A Study in Activism, 1828–1860* (Knoxville: University of Tennessee Press, 1992); Julie Winch, *Philadelphia's Black Elite: Activism, Accommodation, and the Struggle for Autonomy, 1787–1848* (Philadelphia: Temple University Press, 1988); Mary Kelley, "'Talents Committed to Your Care': Reading and

Writing Radical Abolitionism in Antebellum America," *New England Quarterly* 88, no. 1 (March 2015): 37–72; Willi Coleman, "Architects of a Vision: Black Women and Their Antebellum Quest for Political and Social Equality," in Gordon et al., *African American Women and the Vote*, 24–40; and Bettye Collier-Thomas, "Frances Ellen Watkins Harper, Abolitionist and Feminist Reformer, 1825–1911," in Gordon et al., *African American Women and the Vote*, 41–65. On black women in the colored convention movement, see Martha S. Jones, *All Bound Up Together: The Woman Question in African American Public Culture, 1830–1900* (Chapel Hill: University of North Carolina Press, 2007).

5. On the early women's rights meetings, see Lisa Tetrault, *The Myth of Seneca Falls: Memory and the Women's Suffrage Movement, 1848–1898* (Chapel Hill: University of North Carolina Press, 2014); Ellen Carol DuBois, *Woman Suffrage and Women's Rights* (New York: New York University Press, 1998); and Sally G. McMillen, *Seneca Falls and the Origins of the Women's Rights Movement* (New York: Oxford University Press, 2008).

6. Women had served as exhorters in black Methodist churches since at least the early nineteenth century. That position was unlicensed and uncompensated. By seeking licenses, women were asking for authority to lead congregations, interpret the Bible, and be supported by the denomination in their work.

7. Jones, *All Bound Up Together*, 67.

8. Jones, *All Bound Up Together*, 76.

9. Martha S. Jones, "Overthrowing the 'Monopoly of the Pulpit': Race and the Rights of Churchwomen in Nineteenth Century America," in *No Permanent Waves: Recasting Histories of U.S. Feminism*, ed. Nancy Hewitt (New Brunswick, NJ: Rutgers University Press, 2010), 126.

10. Jones, "Overthrowing the 'Monopoly of the Pulpit.'"

11. Nell Irvin Painter, *Sojourner Truth: A Life, A Symbol* (New York: W. W. Norton, 1996), 4.

12. Historian Nell Painter explains how memory of the contemporaneous record of Truth's remarks was eclipsed by the later publication of an embellished version of the Truth speech. In 1863, Frances Dana Gage published her recollections of the proceedings, attributing to Truth a rural southern voice, though Truth's first language was likely Dutch, and including the phrase "ain't I a woman," though no such words had been included in the original report of Truth's remarks. Painter, *Sojourner Truth: A Life, A Symbol*, 7–8.

13. Painter, *Sojourner Truth: A Life, A Symbol*, 125.

14. Painter, *Sojourner Truth: A Life, A Symbol*, 139–40.

15. Janice Sumler-Lewis, "The Forten-Purvis Women of Philadelphia and the American Anti-Slavery Crusade," *Journal of Negro History* 66, no. 4 (Winter 1981/82): 281–88; and Julie Winch, "'You Have Talents—Only Cultivate Them': Philadelphia's Black Female Literacy Societies and the Abolitionist Crusade," in *The Abolitionist Sisterhood*, ed. Jean Fagan Yellin and John C. Van Horne (Ithaca, NY: Cornell University Press, 1994), 105–17.

16. Willi Coleman, "'Like Hot Lead to Pour on the Americans . . .': Sarah Parker Remond—From Salem, Mass. to the British Isles," in *Women's Rights and Transatlantic Antislavery in the Era of Emancipation*, ed. James Brewer Stewart (New Haven, CT: Yale University Press, 2007), 173–88.

17. For an in-depth look at African American women's involvement in the Civil War, see Charlotte Forten Grimké, *The Journal of Charlotte Forten Grimké*, ed. Brenda Stevenson (New York: Oxford University Press, 1988); Elizabeth Keckley, *Behind the Scenes: Thirty Years a Slave, and Four Years in the White House* (New York: Oxford University Press, 1989); and Susie King Taylor, *Reminiscences of My Life in Camp with the 33rd United States Colored Troops* (Boston: The author, 1902).

18. Ellen Carol DuBois, *Woman Suffrage and Women's Rights* (New York: New York University Press, 1998).

19. DuBois, *Woman Suffrage and Women's Rights*; Jones, *All Bound Up Together*.

20. DuBois, *Woman Suffrage and Women's Rights*; Jones, *All Bound Up Together*, 141.

21. Jones, *All Bound Up Together*, 142.

22. DuBois, *Woman Suffrage and Women's Rights*; Jones, *All Bound Up Together*.

23. Historian Louise Newman has made the most explicit case for how racism within the postwar women's suffrage movement and the willingness of some among the movement's leadership to partner with anti-black factions discouraged black women from joining women's suffrage organizations in significant numbers. Louise Michele Newman, *White Women's Rights: The Racial Origins of Feminism in the United States* (New York: Oxford University Press, 1999).

24. DuBois, *Woman Suffrage and Women's Rights*; Jones, *All Bound Up Together*.

25. Frances Ellen Watkins Harper, "We Are All Bound Up Together" (Speech, New York City, May 1, 1866).

26. This is likely Harper's most quoted phrase. At a moment when the AERA coalition was on the brink of

rupture, hers was a lone voice calling for deference to a universal principle that would keep the longtime allies together. Beyond the conference itself, Harper's political philosophy remains influential for its capacity to simultaneously recognize the specific burdens borne by black women while charting a way forward through coalition across lines of race and gender.

27. Jones, *All Bound Up Together*.

28. Historian Elsa Barkley Brown illustrates this point in her study of black Richmond during Reconstruction. Elsa Barkley Brown, "To Catch a Vision of Freedom: Reconstructing Southern Women's Political History, 1865–1880," in Gordon et al., *African American Women and the Vote*, 67–99.

29. Jones, *All Bound Up Together*, 157; Bettye Collier-Thomas, *Jesus, Jobs, and Justice: African American Women and Religion* (New York: Knopf, 2010), 94.

30. Jones, *All Bound Up Together*, 66.

31. Jones, *All Bound Up Together*, 159.

32. Bishop Alexander Walters credited Julia Foote with a unique capacity to bring new congregants into the church when the two traveled together. Alexander Walters, *My Life and Work* (New York: Fleming H. Revell, 1917); Jones, *All Bound Up Together*, 162.

33. Martha S. Jones, " 'Make Us a Power': African American Methodists Debate the Rights of Women, 1870–1900," in *Women and Religion in the African Diaspora*, ed. R. Marie Griffith and Barbara D. Savage (Baltimore: Johns Hopkins University Press, 2006).

34. Jones, "Make Us a Power," 141.

35. Jones, "Make Us a Power," 141.

36. Deborah Gray White, *Too Heavy a Load: Black Women in Defense of Themselves, 1894–1994* (New York: W. W. Norton, 1998); Evelyn Brooks Higginbotham, "Clubwomen and Electoral Politics in the 1920s," in Gordon et al., *African American Women and the Vote*.

37. Jones, *All Bound Up Together*.

38. Glenda Elizabeth Gilmore, *Gender and Jim Crow: Women and the Politics of White Supremacy in North Carolina, 1896–1920* (Chapel Hill: University of North Carolina Press, 1996), 176.

39. Lisa G. Materson, *For the Freedom of Her Race: Black Women and Electoral Politics in Illinois, 1877–1932* (Chapel Hill: University of North Carolina Press, 2009).

40. Materson, *For the Freedom of Her Race*, 185.

41. Materson, *For the Freedom of Her Race*.

42. Materson, *For the Freedom of Her Race*; White, *Too Heavy a Load*; Higginbotham, "Clubwomen and Electoral Politics in the 1920s."

43. Materson, *For the Freedom of Her Race*; Mia Bay, *To Tell the Truth Freely: The Life of Ida B. Wells* (New York: Hill and Wang, 2009); Gordon et al., *African American Women and the Vote*.

44. Materson, *For the Freedom of Her Race*.

45. Materson, *For the Freedom of Her Race*.

46. Martha S. Jones, "Histories, Fictions, and Black Womanhood Bodies: Rethinking Race, Gender, and Politics in the Twenty-First Century," in *Toward an Intellectual History of Black Women*, ed. Mia Bay, Farah Griffin, Martha S. Jones, and Barbara D. Savage (Chapel Hill: University of North Carolina Press, 2015), 274.

47. Jones, "Histories, Fictions, and Black Womanhood Bodies," 276.

48. Jones, "Histories, Fictions, and Black Womanhood Bodies," 279.

49. Jones, "Histories, Fictions, and Black Womanhood Bodies," 279.

50. Anna Julia Cooper, "Womanhood: A Vital Element in the Regeneration and Progress of a Race," in *The Voice of Anna Julia Cooper* (Lanham, MD: Rowman and Littlefield, 2000), 63.

A WOMAN'S PLACE

1. Susan Goodier, "Susan Fenimore Cooper," in *Dictionary of Literary Biography: American Women Prose Writers 1820–1870*, vol. 239, ed. Amy E. Hudock and Katharine Rodier (Detroit: Gale Group, 2001), 39–49. Cooper was the daughter of author James Fenimore Cooper and grew up in Cooperstown, New York; the town was named after her grandfather.

2. Published by Robert J. Johnston, who served on committees of women's suffrage organizations and published other suffrage documents during the same period. See, for example, https://www.loc.gov/item/ca10003542/. Also see text of speech and commentary by Ann Gordon at http://ecssba.rutgers.edu/docs/ecswoman1.html (accessed December 13, 2017).

3. Whether or not Stanton presented a version of this speech in 1848, it is probable that Cooper did not see or hear it until the publication of the 1870 version. See text of speech and commentary by Ann Gordon at http://ecssba.rutgers.edu/docs/ecswoman1.html (accessed December 13, 2017). For an argument that Stanton presented parts of the speech in 1848, see Belinda A. Stillion Southard, "To Transform and Be Transformed: Elizabeth Cady Stanton's 'Address on Women's Rights,'

1848," *Voices of Democracy* 2 (2007): 152–69. See also Judith Wellman, *The Road to Seneca Falls: Elizabeth Cady Stanton and the First Woman's Rights Convention* (Urbana: University of Illinois Press, 2004), 203.

4. Thomas J. Jablonsky, *The Home, Heaven, and Mother Party: Female Anti-Suffragists in the United States, 1868–1920* (Brooklyn, NY: Carlson Publishing, 1994), xxiii.

5. A point about some scholars treating anti-suffragists with scorn is from Robert D. Cross, "Josephine Marshall Jewell Dodge," *American National Biography*, vol. 6 (New York: Oxford University Press, 1999), 690. Carrie Chapman Catt and Nellie Rogers Shuler, *Woman Suffrage and Politics: The Inner Story of the Suffrage Movement* (New York: Scribner's, 1926), 271–72.

6. Susan E. Marshall, *Splintered Sisterhood: Gender and Class in the Campaign against Woman Suffrage* (Madison: University of Wisconsin Press, 1997), 10.

7. Susan B. Anthony and Ida Husted Harper, eds., *History of Woman Suffrage*, vol. 4 (1883–1900) (Indianapolis: Hollenbeck Press, 1902), xxiv.

8. For more on former anti-suffragists becoming an agency opposing amendments to the Constitution, see Susan Goodier, *No Votes for Women: The New York State Anti-Suffrage Movement* (Urbana: University of Illinois Press, 2013), 135–41.

9. Susan Fenimore Cooper, "Female Suffrage: A Letter to the Christian Women of America," *Harper's New Monthly Magazine* 41 (June–November 1870): 438–46, 594–600.

10. Lisa Tetrault, *The Myth of Seneca Falls: Memory and the Women's Suffrage Movement, 1848–1898* (Chapel Hill: University of North Carolina Press, 2014), 8–9. According to Ann Gordon, the editor of the six-volume set of the Elizabeth Cady Stanton and Susan B. Anthony papers, there is no evidence that suggests that Stanton delivered such a long speech in 1848, either at Seneca Falls or in Rochester, New York, just two weeks later. The speech, Gordon argues, is far more likely a compilation of some of Stanton's best ideas, drawn from her thinking and speaking in several speeches presented between 1848 and 1870, then printed and distributed as part of the celebration of the two decades of agitation for women's rights in 1870. Ann Gordon, ed., *In the School of Anti-Slavery, 1840 to 1866*, vol. 1, *The Selected Papers of Elizabeth Cady Stanton and Susan B. Anthony* (New Brunswick, NJ: Rutgers University Press, 1997), 94–123; http://ecssba.rutgers.edu/docs/ecswoman1.html (accessed December 13, 2017).

11. Tetrault, *Myth of Seneca Falls*, 9.

12. Cooper, "Female Suffrage," 439.

13. Gordon, *In the School of Anti-Slavery*, 111.

14. Cooper, "Female Suffrage," 439.

15. Gordon, *In the School of Anti-Slavery*, 101.

16. Cooper, "Female Suffrage," 439–40.

17. Cooper, "Female Suffrage," 439–40.

18. Gordon, *In the School of Anti-Slavery*, 98.

19. Gordon, *In the School of Anti-Slavery*, 102.

20. Cooper, "Female Suffrage," 439.

21. See Charles Strickland, *Victorian Domesticity: Families in the Life and Art of Louisa May Alcott* (Tuscaloosa: University of Alabama Press, 1985), esp. chap. 1.

22. Gordon, *In the School of Anti-Slavery*, 108.

23. Originally published in two volumes, in 1895 and 1898, at least twenty-four women contributed to the *Woman's Bible*. The full text is available at http://www.sacred-texts.com/wmn/wb/index.htm and at https://archive.org/stream/thewomansbible09880gut/wbibl10.txt.

24. Richard Franklin Bensel, *The American Ballot Box in the Mid-Nineteenth Century: Law, Identity, and the Polling Place* (New York: Cambridge University Press, 2004), 9, 20.

25. Cooper, "Female Suffrage," 601n2.

26. Jablonsky, *Home, Heaven, and Mother Party*, 2–3.

27. Goodier, *No Votes for Women*, 20.

28. Elizabeth Cady Stanton had addressed Congress on January 20, 1869, so Woodhull was the second woman to do so. *Congressional Globe*, Forty-First Congress, Third Session, Part I, 218, 272, https://memory.loc.gov/ammem/amlaw/lwcglink.html#anchor41 (accessed May 25, 2018); Elizabeth Cady Stanton, Susan B. Anthony, and Matilda Joslyn Gage, *History of Woman Suffrage* (Rochester, NY: Charles Mann, 1887), 443–48.

29. Marshall, *Splintered Sisterhood*, 19–21.

30. Jill Norgren and Wendy Chmielewski, "Before Universal Woman Suffrage: A 'Crazy Quilt' of Towns, Counties, and States Where Women Held Partial Voting Rights and Became Candidates for Elective Office," http://nationalwomansparty.org/before-universal-woman-suffrage-a-crazy-quilt-of-towns-counties-and-states-where-women-held-partial-voting-rights-and-became-candidates-for-elective-office/ (accessed May 25, 2018).

31. "Woman Suffrage," *Harper's Weekly* 38, June 16, 1894, 554. See also Susan Goodier, "Susan B. Anthony, the 1894 Constitutional Convention, and Anti-Suffragism in New York State," https://urresearch

.rochester.edu/institutionalPublicationPublicView
.action?institutionalItemId=2245 (accessed May 25,
2018).

32. Ida Husted Harper, *The Life and Work of Susan B. Anthony*, vol. 2 (Indianapolis: Hollenbeck Press, 1898), 765–66.

33. Goodier, *No Votes for Women*, 16; "Battle Goes On," *New York Tribune*, May 22, 1894, 11; "How the Battle Goes," *Clarion Democrat* (Clarion, PA), June 14, 1894, 1.

34. The Art Students League continues to exist. See http://www.theartstudentsleague.org/history-art-students-league-new-york/ (accessed February 10, 2018) for more about the league. De Kay's name does not appear among the artists or founders of the school. Gilder and Foote, who lived in the West during most of her life, wrote letters to each other over the course of fifty years. Gilder's youngest daughter, Rosamond Gilder, collected the letters for possible publication, tentatively titled "Dialogue." Gilder MSS, Lilly Library Manuscript Collections, Indiana University, Bloomington. Their letters "radically transformed" the approach Carroll Smith-Rosenberg used to understand women's history. Carroll Smith-Rosenberg, *Disorderly Conduct: Visions of Gender in Victorian America* (New York: Oxford University Press, 1985), 27.

35. Helena de Kay Gilder, "A Letter on Woman Suffrage, from One Woman to Another" (1894), "List of Works in the New York Public Library Relating to Woman," *Bulletin of the New York Public Library* 9 (January to December 1905): 566; "Full Names," *Library Journal* 21, August 1896, 386; H. de K. G., "A Letter on Woman Suffrage, from One Woman to Another," (New York: De Vinne, 1909).

36. "A Letter on Woman Suffrage: From One Woman to Another," *Critic* 25, no. 650 (August 4, 1894): 63–65.

37. Rosamond Gilder, ed., *Letters of Richard Watson Gilder* (Boston: Houghton Mifflin, 1916), 258.

38. Shaw was the mother of both Josephine Lowell Shaw (1843–1905), a social justice reformer, and Robert Gould Shaw (1837–1863), the commander of the Fifty-Fourth Massachusetts regiment who was killed during the Civil War. Letter, August 22, 1894, Sarah B. Shaw to Helena de Kay Gilder, box 14, Gilder MSS, Lilly Library Manuscript Collections, Indiana University, Bloomington.

39. For more on anti-suffrage women's characteristics, see Goodier, *No Votes for Women*, esp. chap. 1, and 87–91.

40. Carole Nichols, *Votes and More for Women: Suffrage and After in Connecticut* (New York: Haworth Press, 1983), 6, 15. Dodge's mother died in 1883, so she would not have known that her daughter prominently opposed votes for women. "Mrs. Marshall Jewell," *Evening Gazette* (Port Jervis, New York), February 28, 1883, 1. Cross, "Josephine Marshall Jewell Dodge," 689.

41. James P. Louis, "Josephine Marshall Jewell Dodge," in *Notable American Women, 1607–1950*, ed. Edward T. James (Cambridge, MA: Belknap Press of Harvard University Press, 1971), 492.

42. Hope Day Nursery operates as the East Harlem Block Nursery 2 today. See also, "Mrs. Arthur Murray Dodge," *New York World*, March 22, 1928.

43. Mrs. Arthur M. Dodge, "Woman Suffrage Opposed to Woman's Rights," *Women in Public Life: The Annals of the American Academy of Political and Social Science* 56 (1914): 99–104.

44. The full text of *Woman and the Republic: A Survey of the Woman Suffrage Movement in the United States and a Discussion of the Claims and Arguments of Its Foremost Advocates* (New York: Appleton, 1897) (published again in 1913) can be accessed online at Archive.org: https://archive.org/details/womanrepublicsur00johnuoft. Rossiter Johnson, "The Blank-Cartridge Ballot" (New York: J. J. O'Brien and Son, n.d.) is also accessible on Archive.org: https://archive.org/details/blankcartridgeba00johnuoft.

45. Johnson, "Blank-Cartridge Ballot," 7, 9.

46. Alice Stone Blackwell, "The Military Argument," Philadelphia: Published for The National American Woman Suffrage Association: Press of Alfred J. Ferris, 1897. National American Woman Suffrage Association Collection, Rare Book and Special Collections Division, Library of Congress, Washington, DC.

47. Goodier, *No Votes for Women*, 45.

48. Vice presidents included Elizabeth H. [Mrs. Henry P.] Kidder, wife of the bank founder, of Boston, and Deborah Norris Coleman [Mrs. Horace] Brock of Philadelphia, wife of the treasurer of the American Iron and Steel Company. Fannie Briggs Houghton [Mrs. Morgan G.] Bulkeley of Hartford, Connecticut, wife of the former Connecticut governor and president of the Aetna Life Insurance Company, served as secretary, while Mary Sloan Frick [Mrs. Robert] Garrett, president of the B and O Railroad, of Baltimore, Maryland, became the treasurer. Louis, "Josephine Marshall Jewell Dodge," 493.

49. The fourteen states included Connecticut, Illinois, Iowa, Maryland, Massachusetts, New Hampshire,

New Jersey, New York, Ohio, Oregon, Pennsylvania, Rhode Island, Virginia, and Wisconsin. They also had a representative from the District of Columbia.

50. The *Woman's Protest* absorbed the Albany, New York–based *Anti-Suffragist*; the Boston-based *Remonstrance* would continue publication until April 1919.

51. "The National Association," *Woman's Protest* 1, no. 1 (May 1912): 3.

52. "The Lesson That Came from the Sea — What It Means to the Suffrage Cause," *Woman's Protest* 1, no. 1 (May 1912): 8.

53. Goodier, *No Votes for Women*, 41.

54. For example, the anti-suffragist Jennie Dewey [Mrs. Julian] Heath, president of the National Housewives' League, converted to suffragism. See Goodier, *No Votes for Women*, 53, 63, 193n144.

55. Goodier, *No Votes for Women*, 81.

56. Marshall, *Splintered Sisterhood*, 75.

57. Goodier, *No Votes for Women*, 79–81.

58. "Theatrical Notes," *New York Times*, October 27, 1914, 11.

59. Goodier, *No Votes for Women*, 94.

60. "Mrs. Wadsworth Now Head of Anti-Suffragists of Nation," *Brooklyn Daily Eagle* (New York), June 30, 1917, 10. Alice Hay Wadsworth was the daughter of John Milton Hay, who had served as secretary to Abraham Lincoln and secretary of state under William McKinley and Theodore Roosevelt. Alice married James Wadsworth in 1902 and had three children. Senator Wadsworth remained virulently opposed to women's right to vote even after his constituency had decided in favor of women's enfranchisement.

61. Jablonsky, *Home, Heaven, and Mother Party*, 96.

62. Goodier, *No Votes for Women*, 109–10.

63. Goodier, *No Votes for Women*, 119.

64. Goodier, *No Votes for Women*, 64, 76.

65. Goodier, *No Votes for Women*, 103.

66. Goodier, *No Votes for Women*, 125.

67. "The Antis Are Still on the Job," *New-York Tribune*, August 10, 1919, 65; Goodier, *No Votes for Women*, 119.

68. "Claims an Amendment Disfranchises the Voters," *Press and Sun-Bulletin* (Binghamton, New York), September 29, 1916, 6.

69. Kathleen C. Berkley, "Elizabeth Avery Meriwether, An Advocate for Her Sex: Feminism and Conservatism in the Post–Civil War South," *Tennessee Historical Quarterly* 34 (1984): 390–407; Anastatia Sims, "Powers That Pray and Powers That Prey: Tennessee and the Fight for Woman Suffrage," *Tennessee Historical Quarterly* 50 (1991): 203–25; Marjorie Spruill Wheeler, ed., *Votes For Women! The Woman Suffrage Movement in Tennessee, the South, and the Nation* (Knoxville: University of Tennessee Press, 1995), 264–65.

70. Mary G. Kilbreth to Harry T. Burn, telegrams (2), August 19, 1920, Harry T. Burn Papers, C. M. McClung Historical Collection, Knox County Public Library, Knoxville, Tennessee; "The Case of Harry T. Burn," *Nashville Tennessean*, August 21, 1920; "Word from Mother Won for Suffrage," *Nashville Tennessean*, August 20, 1920; "Burn Changed Vote on Advice of His Mother," *Commercial Appeal*, August 20, 1920.

71. "Charges of Fraud in Suffrage Fight Made in Tennessee," *New York Times*, August 20, 1920; Kathryn Kish Sklar and Beverly Wilson Palmer, eds., *The Selected Letters of Florence Kelley, 1869–1931* (Urbana: University of Illinois Press, 2009), 288.

72. Goodier, *No Votes for Women*, 161.

73. Suzanne M. Marilley, *Woman Suffrage and the Origins of Liberal Feminism in the United States, 1820–1920* (Cambridge, MA: Harvard University Press, 1996), 196.

"OÙ SONT LES DAMES?"

1. "Bernstorff Sad, but Unsurprised," *New-York Tribune*, February 4, 1917, 4.

2. More recently Christopher Capozolla has written about American citizenship and World War I. See Christopher Capozolla, *Uncle Sam Wants You: World War I and the Making of the Modern American Citizen* (Oxford: Oxford University Press, 2008); see also Jennifer Keene, *Doughboys, the Great War, and the Remaking of America* (Baltimore: Johns Hopkins University Press, 2006).

3. These suffragists did not include those who followed the Quaker pacifist Alice Paul and her militant suffragists.

4. Capitalizing on this, militant suffragists of the National Woman's Party, led by Alice Paul, connected the war directly to their cause and picketed outside the White House. Carrying banners that openly criticized President Woodrow Wilson for waging a war in Europe for democracy while not supporting full democracy at home, they were arrested and jailed for their disobedience. Their anti-war stance did not curry favor with society at large, and although they gained attention in the media, it was not felt to be the "right" kind of attention. Carrie Chapman Catt would later

quip that her preferred approach was to cultivate Wilson rather than "harass" him. Cited in Christine Bolt, "The War, the Vote and After: Doldrums and New Departures," in *The Women's Movements in the US and Britain from the 1790s to the 1920s* (Amherst: University of Massachusetts Press, 1993), 247.

5. As reported in "Concentrate Your War Work," a speech by Anna Howard Shaw, *Atlanta Constitution*, February 17, 1918, B11.

6. André Tardieu described, "Meanwhile, between Paris and the front military services which no one had foreseen were spontaneously growing up. American women volunteers who had come to do works of peace, gave themselves up wholeheartedly to war. . . . [French soldiers] asked on the road, '*Où sont les dames?*' Here American hearts beat in unison with French hearts. Rural friendship had developed into a comradeship of arms. Day by day, a wealth of mutual comprehension was amassed at dusty halts. Hearts that had shared the same trials needed no interpreters to understand one another." See "Reconstruction: The Wrath of Attila," in *France and America: Some Experiences in Cooperation* (New York: Houghton Mifflin Company, 1927), http://www.ourstory.info/library/2-ww1/Tardieu/fram4.html (accessed March 21, 2018).

7. Anna Von Sholly, cited in "American Women Doctors Work Close behind Firing Lines," *New York Times*, April 28, 1918, 11.

8. Correspondence, July 10, 1918. Mabel Seagrave Papers, University of Washington.

9. By contrast, 40 percent of medical women who were members of the American Medical Association registered for war service. See Kimberly Jensen, *Mobilizing Minerva: American Women in the First World War* (Urbana: University of Illinois Press, 2008), 83.

10. The suffrage movement had started in the United States with an awakening that went hand in hand with the anti-slavery movement. Abolitionists soon turned their energies to women's rights and focused on equality in law. By 1869, however, the suffrage movement split, as the Fifteenth Amendment recognized black men over educated white women. Factions supported either equality for all women, black and white, or only white women's right to vote. The latter group accepted money from a known racist, George Train, who financed their newsletter and other endeavors; under his patronage, there was no way African Americans were to be included. The movement remained segregated up through the ratification of the Nineteenth Amendment. See the essay by Martha S.

Jones in this volume, and also see Martha S. Jones, *Al Bound Up Together: The Woman Question in African American Public Culture, 1830–1900* (Chapel Hill: University of North Carolina Press, 2007).

11. Nikki Brown addresses black women's roles in the YWCA and the Red Cross. See Nikki Brown, *Private Politics and Public Voices: Black Women's Activism from World War I to the New Deal* (Bloomington: Indiana University Press, 2006), esp. 66–83.

12. Kimberly Jensen cites Dolores M. Pinero as the only woman serving in the army in Puerto Rico; Pinero was in Río Piedras when the war began. See Jensen, *Mobilizing Minerva*, 87.

13. Jensen, *Mobilizing Minerva*, 88.

14. African American women were concerned about how to support African American soldiers. Nikki Brown outlines how "A Crispus Attucks Circle and the Circle for Negro War Relief in Philadelphia, for instance, rallied public support for a hospital for black soldiers and insisted that black doctors and nurses be hired to meet the demand. . . . When charitable donations fell short, black women filled in the blanks and picked up the slack by forming their own groups on the local and state levels." See Brown, *Private Politics and Public Voices*, 35. See also "1,000,000 War Aid Sought by Negroes," *Philadelphia Inquirer*, May 26, 1918.

15. The *Finger Lake Times* reports, "The suffragists' effort in New York had over $500,000 for its 1917 campaign, compared to only $90,000 for the 1915 effort. Some of it came from the National American Woman Suffrage Association, which had received $500,000 from the estate of Mrs. Frank Leslie. New York City suffragists organized a well-planned door-to-door campaign in the city.

"Given the pro-suffrage momentum and the well-organized efforts, the November 6, 1917, woman suffrage referendum was approved by 54 percent of the voters statewide. The biggest change in voter sentiment came in the New York City metropolitan area, where 59 percent approved it. Overall upstate, 51 percent of the voters were against woman suffrage." See Walt Gable, Seneca County Historian, "Women's Suffrage Series, Part 4: Finally, Triumph in New York!", *Finger Lakes Times*, March 26, 2017. http://www.fltimes.com/news/women-s-suffrage-series-part-finally-triumph-in-new-york/article_d8ab8744–11c4–11e7-b60f-8bf9bc113e62.html (accessed July 20, 2018).

16. The Connecticut State Archives explains the significance of the 1917 poll, "Approximately 502,980 sheets of the manpower census were completed and

arranged in numerical order. An index card was prepared for each sheet and arranged under each town alphabetically by surname. Each card gives the name, address, and form number. Known as the Military Census, the most significant part was a manpower census of all male inhabitants over the age of sixteen taken in 1917–18. However, additional surveys included such things as farms, crops, livestock, automobiles, doctors, nurses, and factories." See "RG 029, Military Census, 1917–1920," https://ctstatelibrary.org/RG029 .html (accessed July 20, 2018).

17. Elizabeth Cafer du Plessis, "Meatless Days and Sleepless Nights: Food, Agriculture, and Environment in World War I America" (PhD diss., Indiana University, 2009); see also "Member of United States Food Administration," ca. 1917–18, U.S. Food Administration Documents, AG15 Box 8, Herbert Hoover Presidential Library, West Branch, Iowa.

18. *HWS*, 5:731.

19. Baker, cited in "Lauds Women in War: Without Their Sacrifice It Would Fail," *New York Times*, December 15, 1917. The United States was not the only nation to be employing women en masse to support the war. In Germany, 500,000 women were employed in the munitions industry alone; in France, 400,000 women were working in arms factories. See Lettie Gavin, *American Women in World War I: They Also Served* (Boulder: University Press of Colorado, 1997), x.

20. Cited in Gavin, *American Women in World War I*, x.

21. In a NAWSA suffrage convention hosted in Poli's Theater in New York City on December 14, 1917, NAWSA voted to finance the unit organized by Finley and pledged $175,000 a year. See "Lauds Women in War: Without Their Sacrifice It Would Fail," *New York Times*, December 15, 1917.

22. Women composed 6 percent of physicians in the United States in 1910. See Jensen, *Mobilizing Minerva*, 13. For the statistic of 25,000 women serving in the medical profession, see Dorothy Schneider and Carl J. Schneider, *Into the Breach: American Women Overseas in World War I* (New York: Viking, 1991), 11, 287–89. For the specification that all the doctors were suffragists, see "Suffragists Play Big Part in War Activities of U.S.," *New York Tribune*, August 26, 1918.

23. "Third Annual Commencement," *Cornell Alumni News* 3, no. 26 (June 12, 1901): 1, https://ecommons .cornell.edu/bitstream/handle/1813/25825/003_36 .pdf?sequence=1 (accessed March 21, 2018). On November 22, 1919, the Prince of Wales awarded her an MBE on the HMS *Renown* in recognition of her care

in Metz of former British POWs suffering from influenza. See E. M. Foxwell, "The U.S. Female Doctors Who Served in WWI," March 9, 2017. https://americanwomeninwwi.wordpress .com/2017/03/09/the-u-s-female-doctors-who-served -in-wwi/ (accessed March 22, 2018).

24. Drs. Finley and Von Sholly both graduated from Cornell Medical College in 1901 and 1902, respectively. For more on Von Sholly, see Elaine Engst and Blaine Friedlander, "Cornell Rewind: A Great School Faces the Great War," January 22, 2015. http:// news.cornell.edu/stories/2015/01/cornell-rewind-great -school-faces-great-war (accessed March 21, 2018). See also "American Women Physicians in World War: Service in the War," https://www.amwa-doc.org /service-in-the-war/ (accessed March 21, 2018); and "Dr. Anna Von Sholly, Won Croix de Guerre," *New York Times*, September 19, 1964. Alice Gregory's paternal grandfather was Dudley S. Gregory, the first mayor of Jersey City, New Jersey, and a congressman from that state. Significantly, her maternal grandfather, J. Marion Sims, was known as the "father of modern gynecology." Dr. Sims experimented on enslaved African American women, and his place in medical history has been revised accordingly. See "Biographies of World War I Veterans: Abel–Isdell," https://www .green-wood.com/2017/biographies-of-world-war-i -veterans-part-one (accessed March 21, 2018).

Edward was a Canadian citizen until 1936, when she became a US citizen. She was the first woman to graduate from the University of Toronto Medical School, where she described being "pelted with chalk, chalk brushes, and assailed with cat calls and a song 'Hop Along Sister Mary.'" Dr. Edward met Finley and others when she began to work for the New York Infirmary for Women and Children, which sent her to Vienna on scholarship for a year, before she took the position as chief resident surgeon. See Noraleen Duvall Young, "Dr. Mary Lee Edward: A Leading Woman," *Kappa Alpha Theta Magazine* (Winter 2014): 30. https:// heritage.kappaalphatheta.org/documents/synchronized /ask_an_archivist/2014_Winter.pdf (accessed March 21, 2018). Unfortunately, Mary Lee Edward was sometimes referred to as Mary Lee Howard, Mary Lee Edwards, or Lee Edwards. See "How Women Proved Worth," *New York Times*, September 19, 1918, which refers to Edward as Howard.

25. "Women Give Hospital Unit: Suffragists, with N.Y. Infirmary Doctors, Assist the Government," *New York Times*, July 8, 1917, 8. For Scottish Federation, see also

Elene Foster, "The American Women's Hospital Overseas," *New York Herald Tribune*, February 17, 1918. Elsie Inglis started the Scottish hospital unit by working with the executive committee of the Scottish Federation of Women's Suffrage Societies. Unfortunately, for women of the United Kingdom, none of their experiences as combat surgeons during World War I helped advance their career prospects. Leah Leneman outlines how, with the exception of the Royal Free in London, women were prevented from gaining valuable clinical instruction until after World War I. For a history of British medical women 1914–1918, see Leah Leneman, "Medical Women at War, 1914–1918," *Medical History* 38 (1994): 160–77.

26. The forerunner for the entire Army Reserve system, the Medical Reserve Corps provided an important source of trained physicians to the army. See Jaffin, "Preparation for War," http://history.amedd.army.mil /booksdocs/wwi/Jaffin/chapter2.pdf (accessed July 20, 2018).

27. Gavin, *American Women in World War 1*, x. Gavin notes, "Several thousand U.S. women, of course, did serve as Army and Navy nurses. They had no rank or benefits, but they were accorded full veteran's status when the war ended. Women doctors, on the other hand, were never accepted by the Army, although doctors were badly needed, especially during the heavy fighting as the war ground to a close in 1918." The ban on sisters and wives of enlisted soldiers, women who were nurses but unable to participate, was lifted by August 1918. See "Wives of Soldiers May Go to France As Army Nurses," *New York Tribune*, August 17, 1918.

28. Ellen S. More, *Restoring the Balance: Women Physicians and the Profession of Medicine, 1850–1995* (Cambridge, MA: Harvard University Press, 1999), 127.

29. Finley traveled to Washington, DC, to negotiate with André Tardieu, high commissioner of France (the era's term for ambassador) in charge of the permanent French war mission, who represented French interests in the United States. See "Women Doctors to Serve France in War Region," *New York Times*, September 26, 1917. On behalf of Prime Minister Alexandre Ribot of the French government, Tardieu accepted the services of the Women's Oversea Hospital units on August 28, 1917. See Minnie Fisher Cunningham Papers, University of Houston Libraries, Houston, Texas.

30. "Tells of Work of Women Medical Units Overseas: Mrs. Charles Lewis Tiffany," *St. Louis Post-Dispatch*, May 8, 1918, 3. See also Mabel Seagrave to Arthur A.

Seagrave, July 13, 1918. Mabel Seagrave Papers, University of Washington.

31. M. Carey Thomas cited in "Red Cross Ignored by Suffragists," *New York Times*, December 14, 1917.

32. Katrina Tiffany, cited in "Red Cross Ignored by Suffragists," *New York Times*, December 14, 1917. The meeting also included a woman describing how during the War of 1898 Mrs. Whitelaw Reid paid the salaries of women when the government would not recognize them.

33. "Red Cross Ignored by Suffragists," *New York Times*, December 14, 1917.

34. "Report of the Recording Secretary," December 17, 1917. "Miscellany," Box 83, NAWSA Papers, Library of Congress. During this December meeting, Dr. Anna Irene Von Sholly was appointed representative treasurer in France.

35. By February 1918, however, the suffragists' relationship with the Red Cross had improved, as it supplied all the medical equipment accompanying the initial team when they sailed over to France in March. See Elene Foster, "The American Women's Hospital Overseas," *New York Herald Tribune*, February 17, 1918. In January, 1918, Henry P. Davison, chairman of the Red Cross War Council, offered to furnish all the medical equipment for the Women's Oversea Hospital Units. The equipment included materials necessary for an "X-Ray Department, Pathological Laboratory, Pharmacy and Operating Room." At this time, NAWSA committed to fund-raising $125,000. The hospital units were endorsed by "eminent doctors," including: Dr. Pearce Bailey, Major Medical Reserve Corps; Dr. Alexander Lambert, Chief Medical Officer of the Red Cross in France; Dr. Samuel J. Lambert, Dean, College of Physicians and Surgeons; Dr. Haven Emerson, Health Commissioner, New York City; Dr. Percy Ashburn, Major Medical Reserve Corps; and Dr. William H. Park, Director, Bacteriological Laboratory, Health Department, New York City. See Minnie Fisher Cunningham Papers, University of Houston Libraries, Houston Texas.

36. Mrs. Charles Tiffany, cited in "Red Cross Ignored by Suffragists," *New York Times*, December 14, 1917. See also More, *Restoring the Balance*, 127. More writes that although the medical war work of the American Women Hospitals and Women's Oversea Hospitals was similar, the NAWSA unit was more concerned with promoting woman suffrage than with professional advancement. See More, *Restoring the Balance*, n. 30, 299.

37. Katrina Tiffany, cited in "This Woman Gets Things Done Whether in War Work or in Politics," *St. Louis Post-Dispatch*, May 10, 1918, 21.

38. Gavin, *American Women in World War 1*, 157.

39. Jensen, *Mobilizing Minerva*, 87.

40. "Sisters Can Come as Relief Workers," *Stars and Stripes*, August 9, 1918. The regulation withheld passports from relatives of its members, making it impossible for the Red Cross, YMCA, Salvation Army, and the Knights of Columbus to enroll an adequate number of women workers for service in France.

41. Cited in "Brooklyn Sends First Woman Dentist to Do War Relief Work in France," *Brooklyn Daily Eagle*, December 16, 1917. See "This Woman Gets Things Done Whether in War Work or in Politics," *St. Louis Post-Dispatch*, May 10, 1918, 21.

42. More, *Restoring the Balance*, 58. More notes "Women physicians, who generally were excluded from all hospital staffs except those founded by and for women physicians, also were excluded from the staffs of most dispensaries. As medical educators became increasingly convinced of the importance of hospital-centered education for their students, women physicians' exclusion from clinical educational settings took on ever greater significance. While women's hospitals were the preferred remedy, often the cost of establishing one was prohibitive. Women's dispensaries offered a reasonable alternative. By the 1880s, women physicians had founded dispensaries in New York, Boston . . . In New York, for example, Elizabeth Blackwell opened a one-room dispensary for women and children in 1854 that was expanded into the New York Infirmary for Women and Children in 1857."

43. See Mabel Seagrave Papers, University of Washington, http://archiveswest.orbiscascade.org/ark:/80444/xv32437 (accessed March 21, 2018).

44. Mabel Seagrave, as cited in "A Message from the Hospitals," *Woman Citizen*, July 6, 1918, 114.

45. Mabel Seagrave to Arthur A. Seagrave, "Sunday," n.d. (July 1918). Papers of Mabel Seagrave, University of Washington. The lecturer is identified only as the "wife of one of the doctors here."

46. "Meeting of the New York Headquarters Committee of the National Board," December 27, 1917, "Miscellany," Box 83, NAWSA Papers, Library of Congress.

47. *Woman Citizen*, May 4, 1918, 449–50. See also More, *Restoring the Balance*, 126; n. 30, 299.

48. *Women's Oversea Hospitals, U.S.A., of the National American Woman Suffrage Association* (New York: National Woman Suffrage Publishing, 1919), 21.

49. Cited in Elene Foster, "The American Women's Hospital Overseas," *New York Herald Tribune*, February 17, 1918. For placement of Finley in France in November, see "Women's Oversea Hospital, U.S.A., Now in France," *Nassau Post*, April 26, 1918.

50. See "Dr. Olga Povitsky, 71, Bacteriologist, Dies," *New York Times*, May 23, 1948, 68; and "Women's Oversea Hospital, U.S.A., Now in France," *Nassau Post*, April 26, 1918. Conflicting dates of the crossing as well as conflicting numbers of women who voyaged have been cited in historic newspapers. I have chosen to follow the first report by Elene Foster, "The American Women's Hospital Overseas," *New York Herald Tribune*, February 17, 1918; however, "Tells of Work of Women Medical Units Overseas: Mrs. Charles Lewis Tiffany," *St. Louis Post-Dispatch*, May 8, 1918, 3, cites February 17 as the crossing and twenty-seven women as the number of the original team.

51. Elene Foster, "The American Women's Hospital Overseas," *New York Herald Tribune*, February 17, 1918. The Colony Club of New York gave a truck for the unit, and the Sorosis Club of New York donated an ambulance, which the women of Labouheyre hospital fittingly nicknamed "Sorosis." See Anne Hirst Curry, "From the Refugee Hospital," *Woman Citizen*, July 27, 1918.

52. "With the Suffrage Hospitals in the French War Zone," *Woman Citizen*, July 13, 1918, 115.

53. "Women Doctors Cut Army Red Tape to Care for Wounded," *New York Tribune*, July 4, 1918.

54. A surgeon and gynecologist, she was one of the first women physicians in Philadelphia, where she moved in 1883 from Moscow. See "Dr. Marie K. Formad, Obituary," *New York Times*, February 24, 1944.

55. Marie K. Formad, "Women's Overseas Unit," cited in Transactions of the Forty-Fourth Annual Meeting of the Alumnae Association of the Woman's Medical College of Pennsylvania June 19 and 20, 1919. Archives of the Woman's Medical College of Pennsylvania Alumnae Association Transactions (R747 W82), Drexel University.

56. "War Relief Work" *Hartford Courant*, March 31, 1918. See also "American Women Doctors Work Close behind Firing Lines," *New York Tribune*, April 28, 1918.

57. The hospital in Château Ognon was first reported in "Tells of Work of Women Medical Units Overseas: Mrs. Charles Lewis Tiffany," *St. Louis Post-Dispatch*, May 8, 1918, 3. The number of beds is listed as having

been increased to one thousand in "American Women Won French Praise for Hospital Work," *New York Tribune*, February 23, 1919.

58. When writing about the Women's Oversea Hospitals, Kimberly Jensen focused on the positions under French male doctors that the women had to initially take, describing, "Even though the women who went to the Château Ognon evacuation hospital gained more responsibilities in the coming months, they could not entirely disguise the fact that they were under the authority of men. They were not serving side by side with male colleagues, nor were they operating a military unit on their own in which they could set priorities for the medical care for women." See Jensen, *Mobilizing Minerva*, 103–7. However, as in any military system, the American women were integrated under a commanding officer, which is how I read the situation. It is possible that the women were disappointed to not have established their own unit in the Oise, but the tone in their writing communicates that they felt their presence was making a big difference for the Allied soldiers.

59. "This Woman Gets Things Done Whether in War Work or in Politics," *St. Louis Post-Dispatch*, May 10, 1918, 21. See also "With the Suffrage Hospitals in the French War Zone," *Woman Citizen*, July 13, 1918, 115.

60. Edward as cited in "Dr. Mary Edwards Tells of Her Work in the War Zone," *New York Tribune*, July 20, 1919.

61. Anne Hirst Curry, "From the Refugee Hospital," *Woman Citizen*, July 27, 1918, 164.

62. "American Women Won French Praise for Hospital Work," *New York Tribune*, February 23, 1919.

63. Anne Hirst Curry, "From the Refugee Hospital," *Woman Citizen*, July 27, 1918, 164.

64. See "A Message from the Hospitals," *Woman Citizen*, July 6, 1918, 114. For Seagrave's description of Formad, see correspondence, July 10, 1918. Mabel Seagrave Papers, University of Washington.

65. Marie K. Formad, "Women's Overseas Unit," cited in Transactions of the Forty-Fourth Annual Meeting of the Alumnae Association of the Woman's Medical College of Pennsylvania June 19 and 20, 1919. Archives of the Woman's Medical College of Pennsylvania Alumnae Association Transactions (R747 W82), Drexel University.

66. "Two American Nurses Die in France," *New York Times*, October 20, 1918, 17; see also "Trunk Is Restored to Kin of War Nurse," *Los Angeles Herald*, April 1, 1920. Thanks to Lisa A. Oberg for her help with this research.

67. See "Biographies of World War I Veterans: Abel—Isdell," https://www.green-wood.com/2017/biographies-of-world-war-i-veterans-part-one (accessed March 21, 2018).

68. See "Biographies of World War I Veterans: Abel—Isdell," https://www.green-wood.com/2017/biographies-of-world-war-i-veterans-part-one (accessed March 21, 2018).

69. Margaret Higonnet, ed., *Nurses at the Front: Writing the Wounds of the Great War* (Boston: Northeastern University Press, 2001), xxvi, citing Ellen N. La Motte, "Book Parade," *Forum* 92 (December 1934): x.

70. "Fresh News from France of That Nation's Needs," *New York Tribune*, September 21, 1919, D1. Note that this article incorrectly places the gas unit's base location as Beauvais, not Reims.

71. See Jennifer E. Samuels, "Mary-Louise Lefort," in *Past and Promise: Lives of New Jersey Women* (Syracuse, NY: Syracuse University Press, 1997), 164. Lefort was the first woman to be appointed to the role of district physician for Newark. She graduated in 1897 from the Woman's Medical College of the New York Infirmary.

72. See "Hospital Unit to Care for Gas Victims," *Hartford Courant*, August 18, 1918, 5. For a photo of the group, see "Base Hospital Manned by Women," *Washington Post*, October 7, 1918. Miss Anne McNamara was listed as chief mechanic, in charge of a three-ton truck and a stationary steam engine. See "Women Will Care for Troops Gassed by Huns in France," *New York Tribune*, August 18, 1918. Other women listed as accompanying the group were Stella Fuchs, Anna Ellis, Edith Lacey, and Clara Paquet. See "Send First Gas Hospital," *New York Times*, August 18, 1918.

73. "Dr. Irene Morse, Obituary," *Hartford Courant*, June 21, 1933. See "Activities of Women," *Atlanta Constitution*, July 9, 1922. The obituary describes her as dying at age sixty-three after a long illness—which most scholars would agree means her illness was probably a consequence of damaged lungs from World War I mustard gas exposure. She was a graduate of Tufts Medical School.

74. NAWSA's news journal the *Woman Citizen* estimated that the new gas unit would cost $75,000. More women's groups offered support, including the "Women's Apparel Association"—consisting of women of garment trades all over the United States who raised $75,000 to make clothing for the refugees cared for in Labouheyre. See "An Aladdin's Lamp Story," *Woman Citizen*, August 10, 1918, 197. The Women's Apparel

Association eventually adopted Labouheyre as its own, assuming the expense of its running and maintenance. When the hospital was turned over to the French government in January, 1919, the Women's Apparel Association adopted the expenses at the Foug dispensary run by Mabel Seagrave. The association also donated $5,000 toward the equipment of the gas hospital. See *Women's Oversea Hospitals, U.S.A., of the National American Woman Suffrage Association* (New York: National Woman Suffrage Publishing, 1919), 20.

75. "With the Suffrage Hospitals in the French War Zone," *Woman Citizen*, July 13, 1918.

76. Marcelle T. Bernard, "Nellie O. Barsness," *Journal of the American Medical Women's Association* (April 1953): 151. After serving in Cempuis and Nancy, she moved to the hospital in Reims. See *Women's Oversea Hospitals, U.S.A., of the National American Woman Suffrage Association* (New York: National Woman Suffrage Publishing, 1919). A French medal of valor is in the Nellie Barsness Papers in the Pope County Historical Society of Minnesota, presumably an honor Barsness was awarded by the French government. After the war, Barsness invented the sanitary paper seat cover. See Patent US1396547 — Sanitary Appliance for Closet Seats, Patented November 8,1921. http://google.com/patents/US1396547 (accessed March 29, 2018). See also Johannes R. Allert, "'Dr. Nellie' — A Physician's Experience in the Great War," conference paper. Medical History of World War I Conference, US Army Medical Department — Center of History and Heritage, Ft. Sam Houston, San Antonio, Texas; March 22–25, 2018.

77. The excellent research by Johannes R. Allert helped me confirm this medal. See Allert, "'Dr. Nellie'– A Physician's Experience in the Great War." See also Dr. Nellie Barsness Memoirs, Pope County Historical Society.

78. *Women's Oversea Hospitals U.S.A of the National American Woman Suffrage Association* (New York: National Woman Suffrage Publishing, 1919), 12.

79. More, *Restoring the Balance*, 299n30.

80. As the first director of the new hospital, a position she held until 1939, Lefort was beloved by citizens of Reims. In 1936, a new wing of the hospital was named after her. In 1939, Lefort was awarded an officership in the French Legion of Honor, the highest citizenship award in France. Lefort then returned to the United States, where she died in 1951. See Samuels, "Mary-Louise Lefort," 164.

81. More, *Restoring the Balance*, 123.

82. More, *Restoring the Balance*, 97.

83. Labouheyre was also sometimes misspelled "La Bruyere" in American newspapers. See "Allied Armies, But Not U.S., Use Women Doctors," *Chicago Daily Tribune*, September 23, 1918.

84. There is one conflicting account written by John M. Hyson, Joseph W. A. Whitehome, and John T. Greenwood. They write that the requested dental equipment was denied by the commanding officers, one of whom regretted that he could not make her "Commander-in-Chief and boss of all the dental work" for the district. Cited in Hyson et al., *A History of Dentistry in the US Army to World War II* (Washington, DC: Office of the Surgeon General, 2008), 496; See notes 89–92, which cite correspondence including that from General Scott to Nevin, May 18, 1918, Endorsement No. 703. Box 76. Entry 2361. NARA RG 120.

85. "Women Doctors Cut Army Red Tape to Care for Wounded," *New York Tribune*, July 4, 1918.

86. See L. P. Bethel, ed., "What One Woman Has Done," *Dental Summary* 38 (1918): 990.

87. "Women Doctors Cut Army Red Tape to Care for Wounded," *New York Tribune*, July 4, 1918. Gregory worked in a French military hospital in the Château de Passy with Dr. Percy Turnure, southeast of Paris, for five months. See "Biographies of World War I Veterans: Abel–Isdell," https://www.green-wood.com/2017/biographies-of-world-war-i-veterans-part-one (accessed March 21, 2018).

88. As cited in "Women Scorn Hun Fire," *New York Tribune*, August 25, 1918.

89. "How Women Proved Worth," *New York Times*, September 19, 1918. For a photograph of the women, see "Three Women Physicians Commissioned in French Army," *Washington Post*, October 28, 1918.

90. Edward, cited in Noraleen Duvall Young, "Dr. Mary Lee Edward: A Leading Woman," https://heritage.kappaalphatheta.org/documents/synchronized/ask_an_archivist/2014_Winter.pdf (accessed March 28, 2018). The bombing of June 15 is most likely the event during which her actions were awarded the French Croix de Guerre.

91. *Journal of the American Medical Association* 71, no. 14 (October–December 1918): 1143.

92. "Women to Remain at Hospital Work in France 6 Months," *New York Tribune*, November 25, 1918.

93. Anna Von Sholly, as cited in "Women Doctors Overseas," *New York Tribune*, December 1, 1918.

94. Gertrude Foster Brown, as cited in "American

Women Won French Praise for Hospital Work," *New York Tribune*, February 23, 1919.

95. See *Women's Oversea Hospitals, U.S.A., of the National American Woman Suffrage Association* (New York: National Woman Suffrage Publishing, 1919), 15. Dr. Finley had accepted the cooperation with the American Fund for the French Wounded to supply relief to thirty villages. When in February 1919 an epidemic of typhus called Dr. Finley to Griesheim, Dr. Edward was left in charge in Cambrai.

96. See Young, "Dr. Mary Lee Edward," 30.

97. "Allied Armies, But Not U.S., Use Women Doctors," *Chicago Daily Tribune*, September 23, 1918. Kimberly Jensen discusses "The Campaign for Medical Corps Commission" more fully. See Jensen, *Mobilizing Minerva*, 88–97.

98. Emma Bugbee, "Medals for American War Women—Why Not?" *New York Tribune*, April 13, 1919.

99. Susan B. Anthony and Ida H. Harper, *History of Women's Suffrage Trilogy—Part 2: The Trailblazing Documentation on Women's Enfranchisement in United States, Great Britain & Other Parts of the World*, e-artnow, 2017. However, Kimberly Jensen records that the NAWSA members agreed to give some of the surplus money to American Women's Hospitals "for their continuing work among women and children in the postwar period." See Jensen, *Mobilizing Minerva*, 114.

100. "U.S. Women Doctors Still Busy at Rheims," *New York Tribune*, May 19, 1919.

101. "Fresh News from France of That Nation's Needs," *New York Tribune*, September 21, 1919.

102. "Dr. Irene Morse, Obituary," *Hartford Courant*, June 21, 1933. See "Activities of Women," *Atlanta Constitution*, July 9, 1922.

CATALOGUE 1: RADICAL WOMEN, 1832–1869

1. William Lloyd Garrison began to include a "Ladies' Department" in *The Liberator* early in 1832. See Ira V. Brown, "'Am I Not a Woman and a Sister?': The Anti-Slavery Convention of American Women, 1837–1839," *Pennsylvania History: A Journal of Mid-Atlantic Studies* 50, no. 1 (1983): 1.

2. The Philadelphia Female Anti-Slavery Society was founded by Lucretia C. Mott in 1836. From the beginning, British anti-slavery societies were the model for the American women.

3. T. H., "Address to the Ladies," *The Liberator*, January 7, 1832, 6.

4. T. H., "Address to the Ladies," *The Liberator*, January 7, 1832, 6.

5. For iconology, see Kirk Savage, *Standing Soldiers, Kneeling Slaves: Race, War, and Monument in Nineteenth-Century America* (Princeton, NJ: Princeton University Press, 1997); Donald M. Jacobs, *Courage and Conscience: Black and White Abolitionists in Boston* (Bloomington: Published for the Boston Athenaeum by Indiana University Press, 1993); and James C. Van Horne and Jean Fagan Yellin, eds., *The Abolitionist Sisterhood: Women's Political Culture in Antebellum America* (Ithaca, NY: Cornell University Press, 1994).

6. Cited by Van Horne and Yellin, *Abolitionist Sisterhood*, 212–13.

7. Alison M. Parker, "The Case for Reform Antecedents for the Woman's Rights Movement," in *Votes for Women: The Struggle for Suffrage Revisited*, ed. Jean H. Baker (Oxford: Oxford University Press, 2001), 30.

8. "Minutes of the Anti-Slavery Convention of American Women, June 2, 1837," cited in Dorothy Sterling, ed., *Turning the World Upside Down: The Anti-Slavery Convention of American Women, Held in New York City, May 9–12, 1837* (New York: Feminist Press at the City University of New York, 1987), 27.

9. *Commercial Advertiser*, cited by *The Liberator*, May 25, 1938. Also cited by Brown, "Am I Not a Woman and a Sister?," 1.

10. Brown, "Am I Not a Woman and a Sister?," 6.

11. Charles Wilbanks, *Walking by Faith: The Diary of Angelina Grimké, 1828–1835* (Columbia: University of South Carolina Press, 2003), 59.

12. Sarah Grimké, "Letter XIV: Ministry of Women," in *Letters on the Equality of the Sexes, and the Condition of Woman: Addressed to Mary S. Parker* (Boston: Isaac Knapp, 1838). One instance she refers to is featured in chapter 4, 8–12, "When Christ ascended up on high, he gave gifts unto men." https://archive.org/details/lettersonequalit00grimrich (accessed April 11, 2018).

13. 1 Corinthians 14:3.

14. Grimké, "Letter XIV: Ministry of Women," 103.

15. Sarah Grimké, *Letters on the Equality of the Sexes* (Boston: Isaac Knapp, 1838), 72.

16. Parker, "The Case for Reform Antecedents for the Woman's Rights Movement," in Baker, *Votes for Women*, 30.

17. Brown, "Am I Not A Woman and a Sister?," 2. Quoting *The Liberator*, July 14, 1832.

18. Nancy Lenox was the daughter of Cornelius Lenox, an African American veteran of the American Revolutionary War.

19. "American Slavery," *The Liberator*, May 13, 1859. During an extensive tour abroad, *The Liberator* documented Remond's eloquent appeal in Waterford, Ireland, recording that "her labors may enlist the sympathies and the energies of the British public in the cause of the abolition of slavery."

20. Elizabeth Cady Stanton, Susan B. Anthony, and Matilda Joslyn Gage, eds., *History of Women's Suffrage*, vol. 2 (Rochester, NY: Charles Mann, 1887), 173.

21. Parker, "The Case for Reform Antecedents for the Woman's Rights Movement," in Baker, *Votes for Women*, 33.

22. Harold Francis Pfister, *Facing the Light: Historic American Portrait Daguerreotypes* (Washington, DC: Smithsonian Institution Press, 1978), 270.

23. Nancy A Hewitt, *Radical Friend: Amy Kirby Post and Her Activist Worlds* (Chapel Hill: University of North Carolina Press, 2018), 147–48.

24. Margaret Washington, *Sojourner Truth's America* (Urbana: University of Illinois Press, 2009), 216.

25. Ann D. Gordon, ed., *The Selected Papers of Elizabeth Cady Stanton and Susan B. Anthony* (New Brunswick, NJ: Rutgers University Press, 1997).

26. B. Zorina Khan, "Married Women's Property Laws and Female Commercial Activity: Evidence from United States Patent Records, 1790–1895," *Journal of Economic History* 56, no. 2 (1996): 358.

27. Benjamin Kahan, *Celibacies: American Modernism & Sexual Life* (Durham, NC: Duke University Press, 2013), 13.

28. *Woman in the Nineteenth Century* was originally published as "The Great Lawsuit: Man versus Men, Woman versus Women" in the July 1843 issue of the *Dial*. In 1845 it was expanded and published as *Woman in the Nineteenth Century*.

29. Margaret Fuller, *Woman in the Nineteenth Century* (New York: Greeley and McElrath, 1845), 158.

30. Khan, "Married Women's Property Laws and Female Commercial Activity," 356–88.

31. The engraving also served as the frontispiece for her text, edited by Thomas Wentworth Higginson, in the 1884 edition of *American Men of Letters*. This was a series featuring great American writers of the nineteenth century published in the early 1880s. Margaret Fuller is the only female to be included in the series.

32. Fuller's ideals expressed in *Woman in the Nineteenth Century* are very much in line with those of "second wave feminists"; however, she is rarely cited in their scholarship. For an in-depth analysis of this topic, see Annette Kolodny, "Inventing a Feminist Discourse: Rhetoric and Resistance in Margaret Fuller's Woman in the Nineteenth Century," *New Literary History* 25, no. 2 (Spring 1994): 355–82.

33. Andreá N. Williams, "Frances Watkins (Harper), Harriet Tubman, and the Rhetoric of Single Blessedness," *Meridians: Feminism, Race, Transnationalism* 12, no. 2 (2014): 99–122.

34. Williams, "Frances Watkins (Harper), Harriet Tubman, and the Rhetoric of Single Blessedness," 107.

35. Janell Hobson, "Harriet Tubman: A Legacy of Resistance," *Meridians: Feminism, Race, Transnationalism* 12, no. 2 (2014): 3.

36. Bradford wrote the biography in an effort to help Tubman pay her mortgage. See Sarah H. Bradford, *Harriet: The Moses of Her People*, 9. https://docsouth .unc.edu/neh/harriet/harriet.html#BraHarr9 (accessed August 22, 2018).

37. See the General Affidavit of Harriet Tubman Davis regarding payment for services rendered during the Civil War, ca. 1898, page 1, RG 233, Records of the US House of Representatives.

38. Frances Ellen Watkins married Fenton Harper in 1860, and he died four years after they were married. They had one daughter together. Harper never remarried and instead chose to travel, write, and lecture extensively for the remaining forty-seven years of her life. Tubman was partnered twice; first to John Tubman, a free man, in the late 1840s; second to Nelson Davis in legal marriage in 1869. See Williams, "Frances Watkins (Harper), Harriet Tubman, and the Rhetoric of Single Blessedness," 100.

39. Frances Ellen Watkins married Fenton Harper in 1860.

40. Williams, "Frances Watkins (Harper), Harriet Tubman, and the Rhetoric of Single Blessedness," 109.

41. Frances Ellen Watkins, "The Two Offers," *Anglo-African* (1859). See also Williams, "Frances Watkins (Harper), Harriet Tubman, and the Rhetoric of Single Blessedness," 112–13.

42. Frances Ellen Watkins Harper, "Double Standard," in *Poems*. Cited in Christopher N. Phillips, *The Cambridge Companion to the Literature of the American Renaissance* (New York: Cambridge University Press, 2018), 218.

43. Washington, *Sojourner Truth's America*, 201. It is especially significant that Truth ventured into Ohio,

where the population of black Americans only numbered in the hundreds across the state. Washington writes, "From early statehood, Ohio denied civil and educational rights to blacks, forbade settlement without freedom papers, and required a $500 bond and a white patron." See Washington, *Sojourner Truth's America*, 221–23.

44. Nell Irvin Painter, *Sojourner Truth: A Life, A Symbol* (New York: W. W. Norton, 1996), 126, 285. There has been some debate about whether or not Truth asked, "Ain't I a woman?," which white suffragist Frances Gage first reported in 1863. Most scholars today agree that Truth instead proclaimed, "I *am* a woman!" See Washington, *Sojourner Truth's America*, 229.

45. Washington outlines how Truth sold *Narrative of Sojourner Truth* to help support her lecture circuit. See Washington, *Sojourner Truth's America*, 222–23.

46. Painter, *Sojourner Truth*, 187.

47. Painter points out this possibility, writing, "Had Truth's *cartes-de-visites* served only to wring money from abolitionists, she might have posed in settings or costumes reminiscent of her enslavement." See Painter, *Sojourner Truth*, 187.

48. Blackwell Family Papers, Schlesinger Library, Radcliffe Institute, Harvard University. Papers of the Blackwell family, 1831–1981. https://iiif.lib.harvard .edu/manifests/view/drs:47532020$1i (accessed April 12, 2018).

49. Elizabeth Cady Stanton, *Eighty Years and More: Reminiscences 1815–1897* (New York: T. Fisher Unwin, 1898), 165.

50. Amy Kesselman, "The 'Freedom Suit': Feminism and Dress Reform in the United States, 1848–1875," *Gender and Society* 5, no. 4 (December 1991): 495–510.

51. Washington, *Sojourner Truth's America*, 201.

52. Danny O. Crew, *Suffragist Sheet Music* (Jefferson, NC: McFarland, 2002), 1.

53. Susan B. Anthony, cited by Ida Husted Harper, *The Life and Work of Susan B. Anthony Including Public Addresses, Her Own Letters, and Many from Her Contemporaries during Fifty Years*, vol. 1 (Indianapolis: Hollenbeck Press, 1898), 117.

54. Jane E. Schultz, "The Inhospitable Hospital: Gender and Professionalism in Civil War Medicine," *Signs* 17, no. 2 (Winter 1992): 363–92. Much more scholarship should be written about Dr. Mary Edwards Walker, who does not even have an entry devoted to her biography in the American National Biography.

55. The Medal of Honor was restored to Walker, posthumously, by President Jimmy Carter in 1977.

56. Dr. Mary Edwards Walker, quoted in *Above and Beyond: A History of the Medal of Honor from the Civil War to Vietnam* (Boston: Boston Publishing, 1985), 39–40.

57. Cailin Elise Meyer, "Mary Edwards Walker: The Only Woman Awarded the Medal of Honor," *Military Medicine* 181, no. 5 (2016): 503.

58. Amy Dru Stanley, *The Anti-Slavery Ethic and the Spirit of Commerce: An American History of Human Rights* (Cambridge, MA: Harvard University Press, 2018). See also Amy Dru Stanley, "The Forgotten Emancipation," *New York Times*, March 4, 2015. https://opinionator. blogs.nytimes.com/2015/03/04 /the-forgotten-emancipation/ (accessed July 18, 2018).

59. Ellen Carol DuBois, *Woman Suffrage and Women's Rights* (New York: New York University Press, 1998), 289; and Ellen Carol DuBois, *Feminism and Suffrage: The Emergence of an Independent Women's Movement in America, 1848–1869* (Ithaca, NY: Cornell University Press, 1978), 52. Also cited in Parker, "The Case for Reform Antecedents for the Woman's Rights Movement," 39.

60. Jochen Wierich, "*War Spirit at Home*: Lilly Martin Spencer, Domestic Painting, and Artistic Hierarchy," *Winterthur Portfolio* 37, no. 1 (Spring 2002): 25.

61. Judith Apter Klinghoffer and Lois Elkis, " 'The Petticoat Electors': Women's Suffrage in New Jersey, 1776–1807," *Journal of the Early Republic* 12, no. 2 (Summer 1992): 159–93.

62. "Lady Lobbyists at the White House," *Harper's Weekly* 10, no. 513 (October 27, 1866): 1. See also Mary Elizabeth Massey, *Women in the Civil War* (Lincoln: University of Nebraska Press, 1966), 170.

63. The Fifteenth Amendment, ratified in 1870, was no less damning for women. This amendment stated, "The rights of citizens of the United States to vote shall not be denied or abridged by the United States or by any state on account of race, color, or previous condition of servitude." This ensured that all men had the right to vote no matter their race. However, it did not grant women the right to vote. In other words, the amendment stipulates that voting rights cannot be denied because of race; it does not ensure the vote, but rather, protects from discrimination over race.

64. HWS, 3:384.

65. The immigrants pictured appear to be German, Native American, French, Arab, British, African, Chinese, Italian, Spanish, and Irish. Robert C. Kennedy, "On November 22, 1869, *Harper's Weekly* Featured a Cartoon about Thanksgiving Day,"

New York Times, On This Day. https://archive.nytimes
.com/www.nytimes.com/learning/general/onthisday
/harp/1122.html (accessed April 16, 2018).

CATALOGUE 2: WOMEN ACTIVISTS, 1870–1892

1. Angela G. Ray, "What Hath She Wrought? Woman's
Rights and the Nineteenth-Century Lyceum," *Rhetoric
and Public Affairs* 9, no. 2 (2006): 184.

2. When the AERA disbanded in 1869, suffragists of
AWSA and NWSA, and localized suffrage associations
all used the lyceum as a platform for their
organizations. See Ray, "What Hath She Wrought?"
210.

3. See Laura E. Skandera-Trombley, "'I Am Woman's
Rights': Olivia Langdon Clemens and Her Feminist
Circle," *Mark Twain Journal* 34, no. 2 (Fall 1996): 20.
At the time, Dickinson was paid the same amount per
lecture as Mark Twain and Henry Ward Beecher.

4. Skandera-Trombley, "I Am Woman's Rights," 20.

5. Anna Elizabeth Dickinson's influence extended well
beyond the lecture circuit. On January 16, 1864, she
was invited to speak before the US House of
Representatives—becoming the first woman to do so.
Her lecture to Congress praised African Americans for
their war efforts and admonished Abraham Lincoln's
leniency on the Reconstruction plan. For an in-depth
study of Dickinson's speech to Congress, see
J. Gallman, *America's Joan of Arc: The Life of Anna
Elizabeth Dickinson* (New York: Oxford University
Press, 2006).

6. See Myra MacPherson, *The Scarlet Sisters: Sex,
Suffrage, and Scandal in the Gilded Age* (New York:
Twelve, 2014), 44–45.

7. The two sisters established themselves as "the Lady
Bankers" with a little help from Cornelius Vanderbilt.
See MacPherson, *Scarlet Sisters*, 44–45.

8. Representative John Bingham, cited by MacPherson,
Scarlet Sisters, 64.

9. The Judiciary Committee's minority report in
support of Woodhull was unsurprisingly published in
Woodhull and Claflin's Weekly in 1871 in addition to
Frank Leslie's Illustrated Newspaper and the *Woman's
Journal* the same year.

10. "Pantarchy" was the vision of her editor, Stephen
Pearl Andrews. See Madeleine B. Stern, *The Pantarch:
A Bibliography of Stephen Pearl Andrews* (Austin:
University of Texas Press, 1968), 105.

11. After spending four weeks in New York City's
Ludlow Street Jail on a charge of passing obscenity
through the mail, Woodhull and Claflin moved
to England in 1877. Interestingly, both eventually
repudiated most of their "sex radical" beliefs.
See MacPherson, *Scarlet Sisters*, 256.

12. Meanwhile, the Tiltons, who were part of Beecher's
congregation—he even had presided over their
wedding—were vilified. A subsequent trial over the
case ended with a hung jury. Beecher was cleared of
guilt and remained as pastor of Plymouth Church until
his death on March 8, 1887. Tilton lived out his life in
Paris, in exile, and his wife became an outcast in New
York society, raising their daughter Agnes while in
financial straits. Agnes was greatly influenced by the
aftermaths of the scandal. For Agnes Pelton, see Erika
Doss, "Agnes Pelton's Visionary Modernism," in *Agnes
Pelton: Desert Transcendentalist*, ed. Gilbert Vicario
(Phoenix: Phoenix Art Museum, 2019).

13. The most in-depth biography on Isabella Beecher
Hooker is Barbara A. White, *Beecher Sisters* (New
Haven, CT: Yale University Press, 2014).

14. Ann D. Gordon, *The Trial of Susan B. Anthony*
(Washington, DC: Federal Judicial History Office,
2005), 2. See also Kathi Kern and Linda Levstik,
"Teaching the New Departure: The United States vs.
Susan B. Anthony," *Journal of the Civil War Era* 2, no. 1
(2012): 127.

15. The states were California, Connecticut, Illinois,
Kansas, Maine, Michigan, New Hampshire, New
Jersey, New York, Pennsylvania, and South Carolina.
See Kern and Levstik, "Teaching the New Departure,"
129.

16. See Rosalyn Terborg-Penn, *African American
Women in the Struggle for the Vote, 1850–1920*
(Bloomington: Indiana University Press, 1998), 36–42.
See also Kern and Levstik, "Teaching the New
Departure," 129.

17. Remarks by Susan B. Anthony in the Circuit Court
of the United States for the Northern District of
New York, June 19, 1873. http://ecssba.rutgers.edu
/docs/sbatrial.html (accessed July 18, 2018).

18. "Susan B. Anthony Discussing Her Trial and Unjust
Ruling," Susan B. Anthony to "Young Friend," July 23,
1873. Collection of Chase Livingston.

19. Kenneth Florey, *Woman's Suffrage Memorabilia: An
Illustrated Historical Study* (Jefferson, NC: McFarland,
2013), 17.

20. We assume this based on surviving ballot boxes
from auction records (Heritage Auctions and Live
Auctioneers). Geo. D. Barnard and Co. ballot boxes are

much more abundant and were used throughout the Midwest and western United States—spanning from Indiana to Idaho.

21. Unlike Virginia Woodhull, Virginia Louisa Minor did not plead her case. Her husband, Francis, did. See Angela G. Ray, and Cindy Koenig Richards, "Inventing Citizens, Imagining Gender Justice: The Suffrage Rhetoric Of Virginia And Francis Minor," *Quarterly Journal of Speech* 93 no. 4 (2007): 375–402.

22. Allison Sneider, "Woman Suffrage in Congress: American Expansion and the Politics of Federalism, 1870–1890," in *Votes for Women: The Struggle for Suffrage Revisited*, ed. Jean H. Baker (Oxford: Oxford University Press, 2001), 80.

23. Joseph R. Gusfield, "Social Structure and Moral Reform: A Study of the Woman's Christian Temperance Union," *American Journal of Sociology* 61, no. 3 (1955): 222.

24. In 1858, the WCTU closed all thirty-nine of the saloons in Dixon, Illinois in one week. See Jed Dannenbaum, "The Origins of Temperance Activism and Militancy among American Women," *Journal of Social History* 15, no. 2 (1981): 245.

25. Margaret Hope Bacon, "'One Great Bundle of Humanity': Frances Ellen Watkins Harper (1825–1911)," *Pennsylvania Magazine of History and Biography* 113, no. 1 (1989): 21–43.

26. "Second Decade Celebration," *Revolution*, October 27, 1870, 265. Cited by Lisa Tetrault, *The Myth of Seneca Falls: Memory and the Women's Suffrage Movement, 1848–1898* (Chapel Hill: University of North Carolina Press, 2014), 89.

27. There is no real number for how many *Woman's Holy War* prints were created by Currier and Ives, but a good estimate would be in the thousands. They were sold in packages. For example, "at wholesale, small prints (8 × 12.5 inches) sold for 6 cents apiece, $6 a hundred, and $60 a thousand." See Bryan F. LeBeau, *Currier & Ives: America Imagined* (Washington, DC: Smithsonian Institution Press, 2001), 17.

28. Abigail Scott Duniway quoted in Jennifer Chambers, *Abigail Scott Duniway and Susan B. Anthony in Oregon: Hesitate No Longer* (Charleston, SC: History Press, 2018), 19.

29. In 1885, the Woman Suffrage bill did not pass through the Oregon Senate, which was very difficult for Duniway. She led many failed attempts at lobbying for suffrage in her home state. In 1912, when Oregon finally granted women suffrage, Duniway was in her late seventies and was no longer associated with the state's suffrage organizations. Jean M. Ward and Elaine A. Maveety, *"Yours for Liberty": Selections from Abigail Scott Duniway's Suffrage Newspaper* (Corvallis: Oregon State University Press, 2000), 247.

30. Tetrault, *Myth of Seneca Falls*, 97–98.

31. Tetrault, *Myth of Seneca Falls*, 101.

32. Jane Rhodes, *Mary Ann Shadd Cary: The Black Press and Protest in the Nineteenth Century* (Bloomington: Indiana University Press, 1999), 197.

33. "Today in History: Susan B. Anthony Makes a Statement," *Library of Congress*. https://www.loc.gov /item/today-in-history/march-08/ (accessed July 18, 2018).

34. Signed by President Chester A. Arthur in 1882, the Chinese Exclusion Act prohibited all immigration of Chinese laborers. Intended to last only ten years, it was renewed and later made permanent in 1902 with the Geary Act. It was not until the Magnuson Act of 1943 that Chinese immigrants were allowed in the United States. However, those with Asian ancestry within the United States were not viewed as citizens until the McCarran-Walter Act granted them the right to become citizens in 1952. For a close look at the history of Chinese American immigration and citizenship, see John Robert Soennichsen, *The Chinese Exclusion Act of 1882* (Santa Barbara, CA: Greenwood, 2011).

35. Senator Samuel C. Pomeroy of Kansas first introduced a federal women's suffrage amendment in December 1868, but it was quickly rejected. Nevertheless, it was then that an acquaintance of Susan B. Anthony, Senator Aaron A. Sargent of California, introduced the language that would later come to be used in a federal amendment.

CATALOGUE 3: THE NEW WOMAN, 1893–1912

1. Cited in "Gibson Girl Was Drawn from Business Life," *St. Louis Post-Dispatch*, June 4, 1908, 10.

2. Arthur John, *The Best Years of the Century: Richard Watson Gilder, Scribner's Monthly and Century Magazine, 1870–1909* (Urbana: University of Illinois Press, 1981), 234.

3. Oberlin College, founded in 1833 by abolitionists, accepted African Americans in 1835. Between 1880 and 1890, African Americans composed 5 or 6 percent of the student body. See W. E. Bigglestone, "Oberlin College and the Negro Student, 1865–1940," *Journal of Negro History* 56, no. 3 (1971): 198–219. For more about the history of African Americans and Oberlin

College, see Cally L. Waite, "The Segregation of Black Students at Oberlin College after Reconstruction," *History of Education Quarterly* 41, no. 3 (2001): 344–64; James Oliver Horton, "Black Education at Oberlin College: A Controversial Commitment," *Journal of Negro Education* 54, no. 4 (1985): 477–99; and Roland M. Baumann, *Constructing Black Education at Oberlin College: A Documentary History* (Athens: Ohio University Press, 2014).

4. Rayford W. Logan, *The Betrayal of the Negro from Rutherford B. Hayes to Woodrow Wilson* (1954; reprint, New York: Da Capo Press, 1997), 76.

5. Martha S. Jones, *All Bound Up Together: The Woman Question in African American Public Culture, 1830–1900* (Chapel Hill: University of North Carolina Press, 2007), 175. See also Logan, *The Betrayal of the Negro from Rutherford B. Hayes to Woodrow Wilson*, 76.

6. See Equal Justice Initiative, "Lynching in America: Confronting the Legacy of Racial Terror," https://lynchinginamerica.eji.org/report/ (accessed April 20, 2018). For a study of the lynchings of Latinos, see Ken Gonzales-Day, *Lynching in the West, 1850–1935* (Durham, NC: Duke University Press, 2006).

7. The policy for women schoolteachers to remain unmarried was kept in some states through the 1960s.

8. Women were forced to abandon their professional lives after marriage through the 1960s. See Jessica Contrera, "Stay in School or Get Married? In 1965, the President's Daughter Had to Choose," *Washington Post*, May 20, 2018. https://www.washingtonpost.com /lifestyle/style/stay-in-school-or-get-married-in-1965 -the-presidents-daughter-had-to-choose/2018/05 /20/760c3d86-5acf-11e8-b656-a5f8c2a9295d_story .html?utm_term=.3ec40377bc1c (accessed August 23, 2018).

9. In addition to organizing conferences, Ida Gibbs Hunt served as a translator at London's Pan-African Conference of 1900. See Adele Logan Alexander, *Parallel Worlds: The Remarkable Gibbs-Hunts and the Enduring (In)Significance of Melanin* (Charlottesville: University of Virginia Press, 2012), 183–84.

10. See *Chesapeake, Ohio & Southwestern Railroad Co. v. Wells*, 85 Tenn. 613, 4 S.W. 5 (1887).

11. Ida B. Wells, *Free Speech and Headlight*, May 1892, cited in Shirley Watson Logan, "Ida B. Wells: Lynch Law in All Its Phases," *Voices of Democracy* 2 (2007): 51.

12. Teresa Zackodnik, *Press, Platform, Pulpit: Black Feminist Publics in the Era of Reform* (Knoxville: University of Tennessee Press, 2011), 134.

13. Ida B. Wells, *Southern Horrors: Lynch Law in All Its Phases* (New York: New York Age Print, 1892), 3.

14. See Jones, *All Bound Up Together*, 200. Jones explains that African American women fought for the right to be ordained and won that right during the turn of the century. African American women would not head missionary societies until the late 1890s and early 1900s. See also Jean Gould Bryant, "From the Margins to the Center: Southern Women's Activism, 1820–1970," *Florida Historical Quarterly* 77, no. 4 (1999): 412. A study of Southern white women's missionary societies of the same region is found in Elna C. Green, *Southern Strategies: Southern Women and the Woman Suffrage Question* (Chapel Hill: University of North Carolina Press, 1997), 9–11, 19.

15. Linda Rochell Lane, "The Progressive Era Reform Work of Margaret Murray Washington," NAAAS Conference Proceedings, 2002, 1775.

16. Mary Church Terrell quoted in Hettie V. Williams, *Bury My Heart in a Free Land: Black Women Intellectuals in Modern U.S. History* (Santa Barbara, CA: Praeger, 2018), 74.

17. Rebecca J. Mead, *How the Vote Was Won: Woman Suffrage in the Western United States, 1868–1914* (New York: New York University Press, 2004), 60.

18. J. G. Brown, Lucy Stone, and the National American Woman Suffrage Association Collection, *The History of Equal Suffrage in Colorado — 1898* (Denver: News Job Printing, 1898). https://www.loc.gov/item /ca21000331/.

19. Suffrage rights in Colorado and Idaho were both carried by Populist votes. However, NAWSA adopted a nonpartisanship policy; this led to the defection of some suffragists into the Woman's Party or Congressional Union. Prominent suffragists were affiliated with specific parties: Mott and Stone, republicans; Kate Gordon, Catherine Waugh McCulloch, Democratic; Jane Addams, Progressive.

20. Mead, *How the Vote Was Won*, 64. See also Corrine McConnaughy, *The Woman Suffrage Movement: A Reassessment* (New York: Cambridge University Press, 2004), 3. Although Catt, and others, had underestimated how important and powerful the mining camps were in the West, labor reformers' influence probably helped tip the vote favorably in Colorado. In the East, as Mead points out, similar labor reform energy would not be harnessed until after the Triangle Shirtwaist Fire in March 1911. See Mead, *How the Vote Was Won*, 13.

21. Mead, *How the Vote Was Won*, 68.

22. Women's enfranchisement was written into Wyoming's first state constitution. As a territory, it had granted women full voting rights since 1869, when women comprised only 20 percent of its population. Corrine McConnaughy notes that "Wyoming's experience was likely too unique, and thus hardly instructive for either politicians or activists." See McConnaughy, *Woman Suffrage Movement*, 53.

23. The phrase "secret ballot" is used to describe that a voter has political privacy in an election or referendum. Before the 1890s, voting in the United States was a public ordeal; Americans would vote with their voice (yay or nay), hands (raising hands or signing public documents), or feet (stand on this side to vote for this candidate). See chapter 15 in Jill Lepore, *The Story of America: Essays on Origins* (Princeton, NJ: Princeton University Press, 2014), 240–53.

24. Charlotte Perkins Stetson, *The Yellow Wallpaper* (Boston: Rockwell and Churchill Press, 1892), 2.

25. Charlotte Perkins Stetson, "The Yellow Wallpaper," *New England Magazine* 5, no. 11 (January, 1892): 647–56. See also https://babel.hathitrust.org/cgi/pt?id=njp.32101064987918;view=1up;seq=12 (accessed April 20, 2018).

26. Gilman was the great-niece of the acclaimed Beecher sisters: novelist Harriet Beecher Stowe, the education reformer Catharine Beecher, and the suffragist Isabella Beecher Hooker.

27. Linda Deziah Jennings, *Washington Women's Cook Book* (Seattle: Washington Equal Suffrage Association), 1.

28. Jennings, *Washington Women's Cook Book*, 41.

29. McConnaughy, *Woman Suffrage Movement*, 4.

30. Rochester Regional Library Council, "NYS Suffrage Campaign, 1893–1894," https://rrlc.org/winningthevote/nys-suffrage-1893/ (accessed April 21, 2018).

31. Sylvia D. Hoffert, *Alva Vanderbilt Belmont: Unlikely Champion of Women's Rights* (Bloomington: Indiana University Press, 2010), 72.

32. Joan Marie Johnson, *Funding Feminism: Monied Women, Philanthropy, and the Women's Movement, 1870–1967* (Chapel Hill: University of North Carolina Press, 2017), 68–70. See also Scott G. Schulz, HABS no. DC-821, Sewall-Belmont House and Museum. http://lcweb2.loc.gov/master/pnp/habshaer/dc/dc0900/dc0963/data/dc0963data.pdf (accessed July 19, 2018).

33. In 1902, Miriam Florence Squier Leslie sold her publishing interests. She willed $2 million of her estate for Carrie Chapman Catt; however, only $977,875 of that estate made its way into Catt's hands. For more information, see Joan Marie Johnson, "Following the Money: Wealthy Women, Feminism, and the American Suffrage Movement," *Journal of Women's History* 27, no. 4 (2015): 68.

34. "Frank Leslie's Weekly," http://www.accessible-archives.com/collections/frank-leslies-weekly/ (accessed July 19, 2018).

35. Leslie first became associated with Frank Leslie's Publishing House in the early 1860s, when she volunteered to work as the editor of the company's *Lady's Magazine*, and she also served as one of their writers and managers. In 1880, following her husband's death, she assumed complete control of the publishing house. See Madeline B. Stern, "Mrs. Frank Leslie: New York's Last Bohemian," *New York History* 29, no. 1 (1948): 21–50.

36. Grover Cleveland, "Woman's Mission and Woman's Clubs: By Grover Cleveland, Ex-President of the United States," *Ladies' Home Journal* 22, no. 6 (May 1905): 3–4.

37. Susan B. Anthony quoted in Lynn Sherr, *Failure Is Impossible: Susan B. Anthony in Her Own Words* (New York: Random House, 1995), 143. Anthony also reminded Americans of Cleveland's infidelity and illegitimate child, stating in an interview, "I think that Mr. Cleveland is a very poor one to attempt to point out the proper conduct of the women." See Ann D. Gordon, "Knowing Susan B. Anthony: The Stories We Tell of a Life," in *Susan B. Anthony and the Struggle for Equal Rights*, ed. Christine L. Ridarsky and Mary Huth (Rochester, NY: University of Rochester Press, 2012), 208.

38. Although some argued for maternalism in politics, stating that women would have a "purifying" influence, women were far too diverse to be thought of as one voting bloc. Most politicians knew this.

39. In contrast with the great richness of visual culture in Britain, posters and other visual arts promoting women's suffrage were relatively rare. See "Evelyn Rumsey Cary 'Woman Suffrage' Poster, ca. 1905," http://www.pbs.org/wgbh/roadshow/tg/womansuffrageposter.html (accessed April 22, 2018).

CATALOGUE 4: COMPELLING TACTICS, 1913–1916

1. Holly J. McCammon, "'Out of the Parlors and into the Streets': The Changing Tactical Repertoire of the U.S. Women's Suffrage Movements," *Social Forces* 81, no. 3 (March 2003): 791.

2. Rebecca J. Mead, *How the Vote Was Won: Woman Suffrage in the Western United States, 1868–1914* (New York: New York University Press, 2004), 119. For more on the pageants, see Annelise K. Madsen, "Private Tribute, Public Art: The Masque of the Golden Bowl and the Artistic Beginnings of American Pageantry," in *Pageants and Processions: Images and Idiom as Spectacle*, ed. Herman du Toit (Newcastle upon Tyne: Cambridge Scholars Publishing, 2009); and Sarah J. Moore, "Making a Spectacle of Suffrage: The National Woman Suffrage Pageant, 1913," *Journal of American Culture* 20, no. 1 (June 1997): 94.

3. Katharine H. Adams and Michael L. Keene, *Alice Paul and the American Suffrage Campaign* (Urbana: University of Illinois Press, 2008), 82.

4. Jerry Prout, "Hope, Fear, and Confusion: Coxey's Arrival in Washington," *Washington History* 25 (Summer 2013): 1–2.

5. For descriptions of Boissevain's costume, see "5,000 Women March, Beset by Crowds," *New York Times*, March 4, 1913; and Adams and Keene, *Alice Paul and the American Suffrage Campaign*, 82.

6. Carolyn P. Collette, "Hidden in Plain Sight: Religion and Medievalism in the British Women's Suffrage Movement," *Religion and Literature* 44, no. 3 (Autumn 2012): 170.

7. Ann Marie Nicolosi, "The Most Beautiful Suffragette: Inez Milholland and the Political Currency of Beauty," *Journal of the Gilded Age and Progressive Era* 6, no. 3 (June 2007): 292.

8. Trisha Franzen, *Anna Howard Shaw: The Work of Woman Suffrage* (Urbana: University of Illinois Press, 2014), 57.

9. Marguerite Martyn, "Lives of Bible Women Are Cited as Arguments for Equal Suffrage," *St. Louis Post-Dispatch*, November 23, 1913.

10. See Adams and Keene, *Alice Paul and the American Suffrage Campaign*, 87.

11. See Annelise K. Madsen, "Columbia and Her Foot Soldiers: Civic Art and the Demand for Change at the 1913 Suffrage Pageant-Procession," *Winterthur Portfolio* 48, no. 4 (2014): 303–6.

12. Janice E. Ruth and Evelyn Sinclair, *Women Who Dare: Women of the Suffrage Movement* (San Francisco: Pomegranate Communications, 2006), 32.

13. Adella Hunt Logan quoted in Rosalyn Terborg-Penn, *African American Women in the Struggle for the Vote, 1850–1920* (Bloomington: Indiana University Press, 1998), 60.

14. The pageant, or tableau, was designed by Hazel MacKaye. Her brother, Percy MacKaye, helped write the program. He was the country's premier pageant director; see Madsen, "Columbia and Her Foot Soldiers," 283–310.

15. See Sarah J. Moore, "Making a Spectacle of Suffrage: The National Woman Suffrage Pageant, 1913," *Journal of American Culture* 20, no. 1 (1997): 93–94. Others have identified Hedwig Reicher as Columbia. See Madsen, "Columbia and Her Foot Soldiers," 283–310.

16. The reporter also writes that Auguste Rodin once stated, "Miss Noyes has the most beautiful right arm in the world." Noyes was a muse for sculptors on both sides of the Atlantic. "Progress and the Modern Household," *New York Tribune*, March 2, 1913.

17. Kenneth Florey, *American Woman Suffrage Postcards: A Study and Catalog* (Jefferson, NC: McFarland, 2015), 159.

18. See Moore, "Making a Spectacle of Suffrage," 93–94.

19. Madsen outlines the chaos of the parade. See Madsen, "Columbia and Her Foot Soldiers," 283–310.

20. Florey, *American Woman Suffrage Postcards*, 159.

21. "Suffragists Tell How Police Head Neglected Parade," *St. Louis Post-Dispatch*, March 9, 1913.

22. Cited in Moore, "Making a Spectacle of Suffrage," 101.

23. "Woman's Beauty, Grace, and Art Bewilder the Capital," *Washington Post*, March 4, 1913. Also cited by Adams and Keene, *Alice Paul and the American Suffrage Campaign*, 93.

24. In the 1870s, when Blatch was a student at Vassar College, she founded a political club because she felt her peers "were not well informed on the topics of the interest of the day." Quoted in Ellen Carol DuBois, *Harriot Stanton Blatch and the Winning of Woman Suffrage* (New Haven, CT: Yale University Press, 1999), 29.

25. In 1916, Harriot Stanton Blatch's Women's Political Union merged with the Congressional Union, led by Alice Paul, to become the National Woman's Party. Although there were many high-profile members, the core of its membership comprised factory, laundry, and textile workers. Under Blatch's direction, the organization gave voice to nearly twenty thousand working-class women who revitalized the suffrage movement.

26. "Value of a Pilgrimage: General Rosalie Jones on the Virtues of Suffrage Hike," *New York Tribune*, March 9, 1913.

27. Adams and Keene, *Alice Paul and the American Suffrage Campaign*, 79. For a visual history of the 1913 suffrage procession and pageant, see James Glen Stovall, *Seeing Suffrage: The Washington Suffrage Parade of 1913, Its Pictures, and Its Effect on the American Political Landscape* (Knoxville: University of Tennessee Press, 2013).

28. Mead, *How the Vote Was Won*, 120–21.

29. Labrys are often found in relation to Minoan depictions of mother goddesses. Caterina Mavriyannaki, "La double hache dans le monde Hellénique à l'age du Bronze," *Revue Archéologique*, no. 2 (1983): 216.

30. Egbert C. Jacobson became the director of design for Chicago's Container Corporation of America in 1936. Egbert spoke at many of the same conferences where his wife spoke, addressing Professional Women's Councils. See "Women's Bar Group to Hear Law Professor," *Chicago Daily Tribune*, January 28, 1951, G4.

31. Kenneth Florey, *Women's Suffrage Memorabilia: An Illustrated Historical Study* (Jefferson, NC: McFarland, 2013), 69.

32. Laura R. Prieto, *At Home in the Studio: The Professionalization of Women Artists in America* (Cambridge, MA: Harvard University Press, 2001), 173.

33. Kenneth Florey, *Women's Suffrage Memorabilia: An Illustrated Historical Study* (Jefferson: McFarland, 2013), 109.

34. In fact, early suffragists such as Matilda Joslyn Gage emulated the matriarchal society of the Iroquois in a number of their writings. Sally Roesch Wagner, *The Untold Story of the Iroquois Influence on Early Feminists: Essays* (Aberdeen: Sky Carrier Press, 1996), 12, 39.

35. According to a 2010 report by the US Government Accounting Office, federal attorneys decline to prosecute more than half of violent crimes committed in Indian Country—the majority of which (67 percent) involve sexual abuse. See Cecily Hilleary, "Advocates Seek Justice for Abused Native American Women," February 19, 2018, *Voice of America News*. https://www.voanews.com/a/advocates-seek-justice-abused-native-american-women/4261220.html (accessed August 23, 2018).

36. Adams and Keene, *Alice Paul and the American Suffrage Campaign*, 110.

37. Mary Walton, *A Woman's Crusade: Alice Paul and the Battle for the Ballot* (London: St. Martin's Press, 2010), 113–14.

38. Adams and Keene, *Alice Paul and the American Suffrage Campaign*, 106.

39. Sara Hunter Graham, *Woman Suffrage and the New Democracy* (New Haven, CT: Yale University Press, 1996).

40. "Congresswoman Rankin Real Girl; Likes Nice Gowns and Tidy Hair," *Washington Post* (1877–1922), March 4, 1917.

CATALOGUE 5: MILITANCY IN THE AMERICAN SUFFRAGIST MOVEMENT, 1917–1919

1. Alice Paul, cited by *The Suffragist*, August 18, 1917, 7.

2. Other colleges represented included George Washington University, Goucher College, the University of Pennsylvania, the Washington College of Law, and Western Reserve College. See *The Suffragist*, February 7, 1917, 4. See also Linda G. Ford, *Iron-Jawed Angels: The Suffrage Militancy of the National Woman's Party, 1912–1920* (Lanham, MD: University Press of America, 1991), 126.

3. The amendment was first introduced in 1878, by Susan B. Anthony, as the Sixteenth Amendment. See Ford, *Iron-Jawed Angels*, 135.

4. John Theurer to Woodrow Wilson, June 23, 1917, *Woodrow Wilson Papers*, microfilm, reel 210, Library of Congress; quoted in Ford, *Iron-Jawed Angels*, 148.

5. Anna Howard Shaw to Alice Edith Bisnne Warren, March 9, 1917, *Wilson Papers*, volume 38, p. 399. See also Ford, *Iron-Jawed Angels*, 129.

6. Katharine H. Adams and Michael L. Keene, *Alice Paul and the American Suffrage Campaign* (Urbana: University of Illinois Press, 2008), 166.

7. Alice Paul and Mahatma Gandhi mirrored each other in terms of civil nonviolent disobedience. For an in-depth look at their similarities, see Adams and Keene, *Alice Paul and the American Suffrage Campaign*, 25–30.

8. "Militants in Riot; 13 Held for Trial," *Washington Post*, July 5, 1917.

9. Miyukoff is the anglicized spelling of the Russian Milyukov. Pavel Nikolayevich Milyukov was a Russian academic who saw czarist absolutism as a stumbling block for Russia's progress. Most importantly—Milyukov fought for universal suffrage in Russia.

10. The guards force-fed the women by inserting glass tubes into their nostrils. See Ford, *Iron-Jawed Angels*, 181.

11. Susan Goodier and Karen Pastorello, *Women Will Vote: Winning Suffrage in New York State* (Ithaca, NY: Cornell University Press, 2017), 182.

12. Ford, *Iron-Jawed Angels*, 3.

13. Katherine J. Curtis White, Kyle Crowder, Stewart E. Tolnay, and Robert M. Adelman, "Race, Gender and Marriage: Destination Selection during the Great Migration," *Demography* 42, no. 2 (2005): 216.

14. Emmett J. Scott, *Scott's Official History of the American Negro in the World War* (Chicago: Homewood Press, 1919), 376.

15. Alice Dunbar-Nelson's portrait is found in Scott, *Scott's Official History*, 232.

16. Paul, cited by Adams and Keene, *Alice Paul and the American Suffrage Campaign*, 234.

17. President Woodrow Wilson quoted in Ford, *Iron-Jawed Angels*, 238.

18. The National Woman's Party cited two signers of the Declaration of Independence, Thomas McKain and George Read, in burning an effigy of King George in their community of Dover Green on July 4, 1776. See Stevens, *Jailed for Freedom*, 314.

19. Sixty-three senators voted in favor of the amendment, whereas thirty-three voted against it. Therefore, the amendment lost by one vote.

CATALOGUE 6: THE NINETEENTH AMENDMENT AND ITS LEGACY, 1920 TO TODAY

1. The House of Representatives passed the Nineteenth Amendment by a vote of 304 to 90, and the Senate approved it 56 to 25. See "Tennessee Ratification of 19th Amendment," https://www.archives.gov/education/lessons/woman-suffrage/ratification-tn (accessed July 20, 2018).

2. Carol Lynn Yellin and Janann Sherman, *The Perfect 36: Tennessee Delivers Woman Suffrage*, ed. Ilene Jones-Cornwell (Oak Ridge, TN: Iris Press, 1998), 79.

3. As each state made the decision to ratify, anti-suffragists flooded the scene with what Catt deemed "the most outrageous literature . . . outright lies, innuendoes and near-truths which are more damaging than lies." The "Negro Question," she continued, "will be put forth in ways to arouse the greatest possible prejudice. If there is any exception to the case of Tennessee, it will be the first state to escape this kind of dirty, lying tactics." Carrie Chapman Catt to Catherine Kenny, cited by Yellin and Sherman, *Perfect 36*, 84.

4. Before the proposed amendment was ratified, there were seven remaining states to grant women the right to vote. Nine states had granted suffrage in presidential elections; five had granted presidential and municipal suffrage; two had granted primary suffrage, and fifteen states had given women the right to full suffrage.

5. Catt, cited by Yellin and Sherman, *Perfect 36*, 89.

6. Carrie Chapman Catt and Nettie Rogers Shuler, *Woman Suffrage and Politics: The Inner Story of the Suffrage Movement* (New York: Charles Scribner's Sons, 1926), 284. See also Yellin and Sherman, *Perfect 36*, 89.

7. See Harry T. Burn, cited by Yellin and Sherman, *Perfect 36*, 117; Yellin Sherman, *Perfect 36*, 116.

8. Variations on maternalism continue to characterize the role of motherhood to this day. See Jan Doolittle Wilson, *The Women's Joint Congressional Committee and the Politics of Maternalism, 1920–1930* (Urbana: University of Illinois Press, 2007), 171.

9. "Votes for Women!" *The Suffragist* (September 1920): 193.

10. See Kevin J. Corder and Christina Wolbrecht, *Counting Women's Ballots: Female Voters from Suffrage through the New Deal* (New York: Cambridge University Press, 2016), 19. Corder and Wolbrecht cite the studies of Sarah Alpern and Dale Baum, "Female Ballots: The Impact of the Nineteenth Amendment," *Journal of Interdisciplinary History* 26 (Summer 1985): 43–67; and Maureen Flanagan, "The Predicament of New Rights: Suffrage and Women's Political Power from a Local Perspective," *Social Politics* 2 (Fall 1995): 305–30.

11. Corder and Wolbrecht, *Counting Women's Ballots*, 30.

12. Corder and Wolbrecht, *Counting Women's Ballots*, 10.

13. Tibbles's clothing contrasted greatly against Standing Bear's ceremonial clothing (a vivid red and blue blanket with a grizzly bear claw necklace). See Valerie Sherer Mathes and Richard Lowitt, *The Standing Bear Controversy: Prelude to Indian Reform* (Urbana: University of Illinois Press, 2003), 85.

14. "Letter from Esther P. Hitz to Mrs. Hodgkins," May 23, 1921, "Personal and Business Correspondence (Including National Council of American Indians Material and other related documents)," Box 2, Folder 13, Item 13. National Council of American Indians Records, Special Collections, Harold B. Lee Library, Brigham Young University.

15. These states—states with the highest percentage of Native Americans living on reservations—claimed that Indian tribes and reservations were subject to federal jurisdiction and as such Indians were not citizens of the state and consequently not eligible to vote in local and state elections. In 1948, after much litigation, Native Americans finally were enfranchised within these southwestern states. Diane-Michele Prindeville, "Feminist Nations? A Study of Native American

Women in Southwestern Tribal Politics," *Political Research Quarterly* 57, no. 1 (2004): 102.

16. New York literacy tests at the polls discriminated against over 753,000 Puerto Ricans in 1960. Nan Robertson, "San Juan's Woman Mayor Here to Urge Puerto Ricans to Vote," *New York Times*, October 8, 1960.

17. Rincón de Gautier was the oldest delegate to the Democratic Party nominating convention in 1992. See Eric Pace, "Felisa Rincón de Gautier, 97, Mayor of San Juan," *New York Times*, September 19, 1994.

18. Fannie Lou Hamer, *The Speeches of Fannie Lou Hamer: To Tell It Like It Is*, ed. Maegan Parker Brooks and Davis W. Houck (Jackson: University Press of Mississippi, 2011), 42.

19. L. L. Wall, "The Medical Ethics of Dr. J. Marion Sims: A Fresh Look at the Historical Record," *Journal of Medical Ethics* 32, no. 6 (June 2006): 346–50.

20. See Ann D. Gordon and Bettye Collier-Thomas, eds., *African American Women and the Vote, 1837–1965* (Amherst: University of Massachusetts Press, 1997), 17.

21. Patsy T. Mink, undated handwritten notes for speech given in support of civil rights plank at the Democratic National Convention, Los Angeles, California, July 12, 1960, Container 5, folder 2, Patsy T. Mink Papers, Manuscript Division, Library of Congress.

22. Across the United States, felony disenfranchisement laws vary in severity; however, approximately 5.85 million Americans with felony convictions are disenfranchised. In Iowa, Kentucky, Virginia, and Florida people with felony convictions are permanently disenfranchised. For state-by-state disenfranchisement laws, see "Felony Disenfranchisement Laws (Map)," *ACLU*, 2018, https://www.aclu.org/issues/voting -rights/voter-restoration/felony-disenfranchisement -laws-map. For an in-depth study on how disenfranchisement laws influence elections, see Pamela S. Karlan, "Convictions and Doubts: Retribution, Representation, and the Debate over Felon Disenfranchisement," *Stanford Law Review* 56, no. 5 (2004): 1147–70.

23. Geoff Mulvihill and Maureen Linke, "AP: Women File to Run for US House Seats in Record Numbers," April 6, 2018, https: apnews.com /f41233ffc9ca484ca8a91a59c083f6f9 (accessed May 9, 2018). To see an inclusive list of every woman who ran in state House elections, see Rutgers University's Center for American Women in Politics, "2018: Women Candidates for U.S. Congress and Statewide Elected Executive as of 5/16/2018." http://cawp .rutgers.edu/buzz-2018-potential-women-candidates -us-congress-and-statewide-elected-executive (accessed May 19, 2018). Ella Nilsen, "More than two-thirds of female House candidates won their primary races," *Vox*. https://www.vox.com/2018/5/9/17335660/women -female-candidates-primaries-2018-midterms-indiana -ohio-west-virginia-north-carolina (accessed August 13, 2018).

24. The other two countries without guaranteed paid maternity leave are Oman and Papua New Guinea.

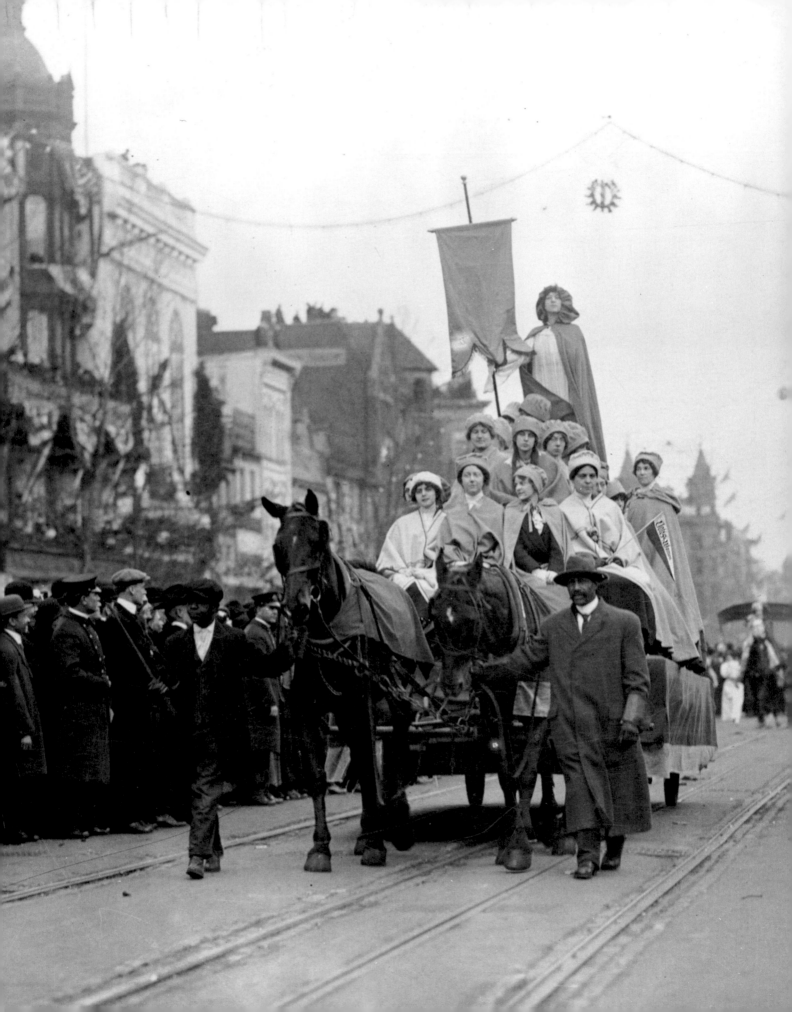

SELECTED BIBLIOGRAPHY

Adams, Katherine H., and Michael L. Keene. *Alice Paul and the American Suffrage Campaign.* Urbana: University of Illinois Press, 2008.

Adams, Katherine H., Michael L. Keene, and Jennifer C. Koella. *Seeing the American Woman, 1880–1920: The Social Impact of the Visual Media Explosion.* Jefferson, NC: McFarland, 2012.

Alexander, Adele Logan. "Adella Hunt Logan and the Tuskegee Woman's Club: Building a Foundation for Suffrage." In *Stepping Out of the Shadows: Alabama Women, 1819–1990,* edited by Mary Martha Thomas. Tuscaloosa: University of Alabama Press, 1995.

———. "Adella Hunt Logan, the Tuskegee Woman's Club, and African Americans in the Suffrage Movement." In *Votes for Women: The Suffrage Movement in Tennessee, the South, and the Nation,* edited by Marjorie Spruill Wheeler. Knoxville: University of Tennessee Press, 1995.

———. *Parallel Worlds: The Remarkable Gibbs-Hunts and the Enduring (In)Significance of Melanin.* Charlottesville: University of Virginia Press, 2012.

———. *Princess of the Hither Isles: Family, Race, and Suffrage in the Jim Crow South.* New Haven, CT: Yale University Press, 2019.

Allgor, Catherine. *Parlor Politics: In Which the Ladies of Washington Help Build a City and a Government.* Charlottesville: University of Virginia Press, 2000.

Andersen, Kristi. *After Suffrage: Women in Partisan and Electoral Politics before the New Deal.* Chicago: University of Chicago Press, 1996.

Andolsen, Barbara Hilkert. *"Daughters of Jefferson, Daughters of Bootblacks": Racism and American Feminism.* Macon, GA: Mercer University Press, 1988.

Anthony, Susan B., Elizabeth Cady Stanton, Matilda Joslyn Gage, and Ida Husted Harper. *History of Woman Suffrage,* Volumes I–VI. Salem, NH: Ayer, 1881–1922.

Baker, Jean H. *Sisters: The Lives of America's Suffragists.* New York: Farrar, Straus and Giroux, 2013.

———. *Votes for Women: The Struggle for Suffrage Revisited.* Oxford: Oxford University Press, 2002.

Banner, Lois W., and Oscar Handlin. *Elizabeth Cady Stanton: A Radical for Woman's Rights.* New York: Addison Wesley Longman, 1980.

Benjamin, Anne Myra Goodman. *A History of the Anti-Suffrage Movement in the United States from 1895 to 1920: Women against Equality.* Lewiston, NY: Edwin Mellen Press, 1991.

Bennion, Sherilyn Cox. *Equal to the Occasion: Women Editors of the Nineteenth-Century West.* Reno: University of Nevada Press, 1990.

Boydston, Jeanne, Mary Kelley, and Anne Throne Margolis. *The Limits of Sisterhood: The Beecher Sisters on Women's Rights and Woman's Sphere.* Chapel Hill: University of North Carolina Press, 1988.

Brown, Ira V. "'Am I Not a Woman and a Sister?' The Anti-Slavery Convention of American Women, 1837–1839." *Pennsylvania History: A Journal of Mid-Atlantic Studies* 50, no. 1 (1983): 1–19.

Brown, J. G., Lucy Stone, and the National American Woman Suffrage Association Collection. *The History of Equal Suffrage in Colorado—1898.* Denver: News Job Printing, 1898.

Brown, Nikki. *Private Politics and Public Voices: Black Women's Activism from World War I to the New Deal.* Bloomington: Indiana University Press, 2006.

Bryant, Jean Gould. "From the Margins to the Center: Southern Women's Activism, 1820–1970." *Florida Historical Quarterly* 77, no. 4 (1999): 405–28.

Buell, Janet W. "Alva Belmont: From Socialite to Feminist." *Historian* 52, no. 2 (February 1990): 219–41.

Camhi, Jane Jerome. *Women against Women: American Anti-Suffragism, 1880–1920.* Brooklyn: Carlson Publishing, 1994.

Carpenter, Cari M. *Selected Writings of Victoria Woodhull: Suffrage, Free Love, and Eugenics.* Lincoln: University of Nebraska Press, 2010.

Cash, Floris Loretta Barnett. *African American Women and Social Action: The Clubwomen and Volunteerism from Jim Crow to the New Deal, 1896–1936.* Westport, CT: Greenwood Press, 2001.

Chambers, Jennifer. *Abigail Scott Duniway and Susan B. Anthony in Oregon: Hesitate No Longer.* Charleston, SC: History Press, 2018.

Clift, Eleanor. *Founding Sisters and the Nineteenth Amendment.* Hoboken, NJ: John Wiley and Sons, 2003.

Cooney, Robert. *Winning the Vote: The Triumph of the American Woman Suffrage Movement.* Santa Cruz, CA: American Graphic Press, 2005.

Corder, J. Kevin, and Christina Wolbrecht. *Counting Women's Ballots: Female Voters from Suffrage through the New Deal.* New York: Cambridge University Press, 2016.

Crew, Danny O. *Suffragist Sheet Music: An Illustrated Catalogue of Published Music Associated with the Women's Rights and Suffrage Movement in America, 1795–1921.* Jefferson, NC: McFarland, 2002.

Dannenbaum, Jed. "The Origins of Temperance Activism and Militancy among American Women." *Journal of Social History* 15, no. 2 (1981): 235–52.

Donnelly, Mabel Collins. *The American Victorian Woman: The Myth and the Reality.* New York: Greenwood Press, 1986.

DuBois, Ellen Carol. *Feminism and Suffrage: The Emergence of an Independent Women's Movement in America, 1848–1869.* Ithaca, NY: Cornell University Press, 1999.

———. *Harriot Stanton Blatch and the Winning of Woman Suffrage.* New Haven, CT: Yale University Press, 1997.

———. *Through Women's Eyes: An American History with Documents.* Boston: Bedford/St. Martin's, 2015.

———. *Woman Suffrage and Women's Rights.* New York: New York University Press, 1998.

Dudden, Faye E. *Fighting Chance: The Struggle over Woman Suffrage and Black Suffrage in Reconstruction America.* New York: Oxford University Press, 2011.

Duniway, Abigail Scott, Jean M. Ward, and Elaine A. Maveety. *"Yours for Liberty": Selections from Abigail Scott Duniway's Suffrage Newspaper.* Corvallis: Oregon State University Press, 2000.

Du Toit, Herman. *Pageants and Processions: Images and Idiom as Spectacle.* Newcastle upon Tyne: Cambridge Scholars Publishing, 2009.

Field, Phyllis F. *The Politics of Race in New York: The Struggle for Black Suffrage in the Civil War Era.* Ithaca, NY: Cornell University Press, 2009.

Finnegan, Margaret Mary. *Selling Suffrage: Consumer Culture and Votes for Women.* New York: Columbia University Press, 1999.

Flexner, Eleanor. *Century of Struggle: The Woman's Rights Movement in the United States.* Cambridge, MA: Belknap Press of Harvard University Press, 1975 (1959).

Florey, Kenneth. *American Woman Suffrage Postcards: A Study and Catalog.* Jefferson, NC: McFarland, 2015.

———. *Women's Suffrage Memorabilia: An Illustrated Historical Study.* Jefferson, NC: McFarland, 2013.

Ford, Linda G. *Iron-Jawed Angels: The Suffrage Militancy of the National Woman's Party, 1912–1920.* Lanham, MD: University Press of America, 1991.

Franzen, Trisha. *Anna Howard Shaw: The Work of Woman Suffrage.* Urbana: University of Illinois Press, 2014.

Fuller, Margaret. *Woman in the Nineteenth Century.* New York: Greeley and McElrath, 1845.

Gallman, J. *America's Joan of Arc: The Life of Anna Elizabeth Dickinson.* New York: Oxford University Press, 2006.

Ginzberg, Lori D. *Elizabeth Cady Stanton: An American Life*. New York: Farrar, Straus and Giroux, 2013.

———. *Untidy Origins: A Story of Woman's Rights in Antebellum New York*. Chapel Hill: University of North Carolina Press, 2005.

Gordon, Ann D., and Bettye Collier-Thomas. *African American Women and the Vote, 1837–1965*. Amherst: University of Massachusetts Press, 1997.

Graham, Sara Hunter. *Woman Suffrage and the New Democracy*. New Haven, CT: Yale University Press, 1996.

———. "Woodrow Wilson, Alice Paul, and the Woman Suffrage Movement." *Political Science Quarterly* 98, no. 4 (1983/84): 665–79.

Green, Elna C. *Southern Strategies: Southern Women and the Woman Suffrage Question*. Chapel Hill: University of North Carolina Press, 1997.

Grimké, Sarah M. *Letters on the Equality of the Sexes, and the Condition of Woman: Addressed to Mary S. Parker*. Boston: Isaac Knapp, 1838.

Guy-Sheftall, Beverly. *Daughters of Sorrow: Attitudes toward Black Women: 1880–1920*. Brooklyn: Carlson, 1990.

Hamer, Fannie Lou. *The Speeches of Fannie Lou Hamer: To Tell It Like It Is*. Edited by Maegan Parker Brooks and Davis W. Houck. Jackson: University Press of Mississippi, 2011.

Hanson, Joyce Ann. *Mary McLeod Bethune and Black Women's Political Activism*. Columbia: University of Missouri Press, 2003.

Hartog, Hendrik. *Man and Wife in America: A History*. Cambridge, MA: Harvard University Press, 2000.

Hendricks, Wanda A. *Gender, Race, and Politics in the Midwest: Black Club Women in Illinois*. Bloomington: Indiana University Press, 1998.

Hewitt, Nancy A. *Radical Friend: Amy Kirby Post and Her Activist Worlds*. Chapel Hill: University of North Carolina Press, 2018.

———. *Women's Activism and Social Change: Rochester, New York, 1822–1872*. Ithaca, NY: Cornell University Press, 1984.

Higginbotham, Evelyn. *Righteous Discontent: The Women's Movement in the Black Baptist Church, 1880–1920*. Cambridge, MA: Harvard University Press, 1993.

Hine, Darlene Clark. *Black Women in White: Racial Conflict and Cooperation in the Nursing Profession, 1890–1950*. Bloomington: Indiana University Press, 1989.

———. *Hine Sight: Black Women and the Re-construction of American History*. Bloomington. Indiana University Press, 1994.

Hine, Darlene Clark, and Kathleen Thompson. *A Shining Thread of Hope: The History of Black Women in America*. New York: Broadway Books, 1999.

Hobson, Janell. "Harriet Tubman: A Legacy of Resistance." *Meridians: Feminism, Race, Transnationalism* 12, no. 2 (2014): 1–8.

Hoffert, Sylvia D. *Alva Vanderbilt Belmont: Unlikely Champion of Women's Rights*. Bloomington: Indiana University Press, 2012.

Horowitz, Helen Lefkowitz. "Victoria Woodhull, Anthony Comstock, and Conflict over Sex in the United States in the 1870s." *Journal of American History* 87, no. 2 (2000): 403–34.

Hunt, Helen LaKelly. *And the Spirit Moved Them: The Lost Radical History of America's First Feminists*. New York: Feminist Press at the City University of New York, 2017.

Irwin, Inez Hayes. *The Story of Alice Paul and the National Woman's Party*. Fairfax, VA: Denlinger's Publishers, 1977.

Isenberg, Nancy. *Sex and Citizenship in Antebellum America*. Chapel Hill: University of North Carolina Press, 1998.

Jablonsky, Thomas J. *The Home, Heaven, and Mother Party: Female Anti-Suffragists in the United States, 1868–1920*. Brooklyn: Carlson Publishing, 1994.

Jacobs, Donald M. *Courage and Conscience: Black and White Abolitionists in Boston*. Bloomington: Indiana University Press, 1993.

Johnson, Joan Marie. "Following the Money: Wealthy Women, Feminism, and the American Suffrage Movement." *Journal of Women's History* 27, no. 4 (2015): 62–87.

Johnston, Johanna. *Mrs. Satan: The Incredible Saga of Victoria C. Woodhull*. New York: Putnam, 1967.

Jones, Jason. "Breathing Life into a Public Woman: Victoria Woodhull's Defense of Woman's Suffrage." *Rhetoric Review* 28, no. 4 (2009): 352–69.

Jones, Martha S. *All Bound Up Together: The Woman Question in African American Public Culture, 1830–1900*. Chapel Hill: University of North Carolina Press, 2007.

Josephson, Hannah Geffen. *Jeannette Rankin: First Lady in Congress, a Biography*. Indianapolis: Bobbs-Merrill Company, 1974.

Kelley, Mary. *Learning to Stand and Speak: Women, Education, and Public Life in America's Republic*. Chapel Hill: University of North Carolina Press, 2012.

Kerber, Linda K. *No Constitutional Right to Be Ladies: Women and the Obligations of Citizenship*. New York: Hill and Wang, 1998.

———. *Women of the Republic: Intellect and Ideology in Revolutionary America*. Chapel Hill: University of North Carolina Press, 1980.

Kern, Kathi, and Linda Levstik. "Teaching the New Departure: The United States vs. Susan B. Anthony." *Journal of the Civil War Era* 2, no. 1 (March 2012): 127–41.

Keyssar, Alexander. *The Right to Vote: The Contested History of Democracy in the United States*. New York: Basic Books, 2009.

Klapper, Melissa R. *Ballots, Babies, and Banners of Peace: American Jewish Women's Activism, 1890–1940*. New York: New York University Press, 2013.

Knight, Louise W. *Citizen Jane Addams and the Struggle for Democracy*. Chicago: University of Chicago Press, 2008.

Kolodny, Annette. "Inventing a Feminist Discourse: Rhetoric and Resistance in Margaret Fuller's Woman in the Nineteenth Century." *New Literary History* 25, no. 2 (Spring 1994): 355–82.

Kraditor, Aileen S. *The Ideas of the Woman Suffrage Movement, 1890–1920*. New York: Columbia University Press, 1965.

Lange, Allison. "Images of Change: Picturing Woman's Rights from American Independence through the Nineteenth Amendment." PhD diss., Brandeis University, 2014.

Lemak, Jennifer A., and Ashley Hopkins-Benton. *Votes for Women: Celebrating New York's Suffrage Centennial*. Albany: State University of New York Press, 2017.

Lerner, Gerda., ed. *Black Women in White America: A Documentary History*. New York: Vintage Books, 1992.

MacConnaughy, Corrine M. *The Woman Suffrage Movement in America: A Reassessment*. Cambridge: Cambridge University Press, 2015.

MacPherson, Myra. *The Scarlet Sisters: Sex, Suffrage, and Scandal in the Gilded Age*. New York: Twelve, 2015.

Madsen, Annelise K. "Columbia and Her Foot Soldiers: Civic Art and the Demand for Change at the 1913 Suffrage Pageant-Procession." *Winterthur Portfolio* 48, no. 4 (Winter 2014): 283–310.

Marilley, Suzanne M. *Woman Suffrage and the Origins of Liberal Feminism in the United States, 1820–1920*. Cambridge, MA: Harvard University Press, 1994.

Massey, Mary Elizabeth. *Women in the Civil War*. Lincoln: University of Nebraska Press, 1966.

McCammon, Holly J. "'Out of the Parlors and into the Streets': The Changing Tactical Repertoire of the U.S. Women's Suffrage Movements." *Social Forces* 81, no. 3 (March 2003): 787–818.

McCool, Daniel, Susan M. Olson, and Jennifer L. Robinson. *Native Vote: American Indians, the Voting Rights Act, and the Right to Vote*. Cambridge: Cambridge University Press, 2007.

McDonald, Laughlin. *American Indians and the Fight for Equal Voting Rights*. Norman: University of Oklahoma Press, 2014.

McKivigan, John R. *Abolitionism and Issues of Race and Gender*. New York: Garland, 1999.

McMillen, Sally G. *Seneca Falls and the Origins of the Women's Rights Movement*. Oxford: Oxford University Press, 2009.

Mead, Rebecca J. *How the Vote Was Won: Woman Suffrage in the Western United States, 1868–1914*. New York: New York University Press, 2004.

Moore, Sarah J. "Making a Spectacle of Suffrage: The National Woman Suffrage Pageant, 1913." *Journal of American Culture* 20, no. 1 (June 2004): 89–103.

Morgan, David. *Suffragists and Democrats: The Politics of Woman Suffrage in America*. East Lansing: Michigan State University Press, 1972.

National American Woman Suffrage Association. *Victory, How Women Won It: A Centennial Symposium, 1840–1940*. New York: H. W. Wilson, 1940.

National Woman Suffrage Association. *Declaration and Protest of the Women of the United States by the National Woman Suffrage Association, July 4th*. Philadelphia, 1876.

Neuman, Johanna. *Gilded Suffragists: The New York Socialites Who Fought for Women's Right to Vote*. New York: New York University Press, 2017.

Nicolosi, Ann Marie. "The Most Beautiful Suffragette: Inez Milholland and the Political Currency of Beauty." *Journal of the Gilded Age and Progressive Era* 6, no. 3 (July 2007): 287–309.

Ortiz, Paul. *Emancipation Betrayed: The Hidden History of Black Organizing and White Violence in Florida from Reconstruction to the Bloody Election of 1920*. Berkeley: University of California Press, 2005.

Painter, Nell Irvin. *Sojourner Truth: A Life, a Symbol*. New York: W. W. Norton, 1996.

Paul, Alice. *Conversations with Alice Paul: Woman Suffrage and the Equal Rights Amendment*. Edited by Amelia Fry. Berkeley: University of California Berkeley, 1976.

Prindeville, Diane-Michele. "Feminist Nations? A Study of Native American Women in Southwestern Tribal Politics." *Political Research Quarterly* 57, no. 1 (March 2004): 101–12.

Ray, Angela G. "What Hath She Wrought? Woman's Rights and the Nineteenth-Century Lyceum." *Rhetoric and Public Affairs* 9, no. 2 (2006): 183–213.

Ray, Angela G., and C. K. Richards. "Inventing Citizens, Imagining Gender Justice: The Suffrage Rhetoric of Virginia and Francis Minor." *Quarterly Journal of Speech* 93, no. 4 (2007): 375–402.

Rhodes, Jane. *Mary Ann Shadd Cary: The Black Press and Protest in the Nineteenth Century*. Bloomington: Indiana University Press, 1999.

Ruth, Janice E., and Evelyn Sinclair. *Women of the Suffrage Movement*. San Francisco: Pomegranate, 2006.

Ryan, Mary P. *Women in Public: Between Banners and Ballots, 1825–1880*. Baltimore: Johns Hopkins University Press, 1990.

Sachs, Emanie N. *"The Terrible Siren:" Victoria Woodhull*. New York: Arno Press, 1972.

Savage, Kirk. *Standing Soldiers, Kneeling Slaves: Race, War, and Monument in Nineteenth-Century America*. Princeton, NJ: Princeton University Press. 1997.

Sernett, Milton C. *Harriet Tubman: Myth, Memory, and History*. Durham, NC: Duke University Press, 2007.

Sheppard, Alice. *Cartooning for Suffrage*. Albuquerque: University of New Mexico Press, 1994.

Sherr, Lynn. *Failure Is Impossible: Susan B. Anthony in Her Own Words*. New York: Random House, 1995.

Showalter, Elaine. *The Civil Wars of Julia Ward Howe: A Biography*. New York: Simon and Schuster, 2017.

Skandera-Trombley, Laura E. "'I Am Woman's Rights': Olivia Langdon Clemens and Her Feminist Circle." *Mark Twain Journal* 34 no. 2 (Fall 1996): 17–21.

Sneider, Allison. *Suffragists in an Imperial Age: U.S. Expansion and the Woman Question, 1870–1929*. New York: Oxford University Press, 2008.

Solomon, Martha. *A Voice of Their Own: The Women Suffrage Press, 1840–1910*. Tuscaloosa: University of Alabama Press, 1991.

Stanton, Elizabeth Cady. *Eighty Years and More: Reminiscences, 1815–1897*. New York: T. Fisher Unwin, 1898.

Sterling, Dorothy. *Turning the World Upside Down: The Anti-Slavery Convention of American Women, Held in New York City, May 9–12, 1837*. New York: Feminist Press at City University of New York, 1987.

Stern, Madeline B. "Mrs. Frank Leslie: New York's Last Bohemian." *New York History* 29, no. 1 (1948): 21–50.

Stevens, Doris. *Jailed for Freedom*. New York: Boni and Liveright Publishers, 1920.

Stillion Southard, Belinda A. *Militant Citizenship: Rhetorical Strategies of the National Woman's Party, 1913–1920*. College Station: Texas A&M University Press, 2011.

Stovall, James Glen. *Seeing Suffrage: The Washington Suffrage Parade of 1913, Its Pictures, and Its Effect on the American Political Landscape*. Knoxville: University of Tennessee Press, 2013.

Streitmatter, Rodger. *Raising Her Voice: African-American Women Journalists Who Changed History*. Lexington: University Press of Kentucky, 1994.

Terborg-Penn, Rosalyn. *African American Women in the Struggle for the Vote, 1850–1920*. Bloomington: Indiana University Press, 1998.

Tetrault, Lisa. "The Incorporation of American Feminism: Suffragists and the Postbellum Lyceum." *Journal of American History* 96, no. 4 (2010): 1027–56.

———. *The Myth of Seneca Falls: Memory and the Women's Suffrage Movement, 1848–1898*. Chapel Hill: University of North Carolina Press, 2014.

Tickner, Lisa. *The Spectacle of Women: Imagery of the Suffrage Campaign, 1907–14*. Chicago: University of Chicago Press, 1988.

Truth, Sojourner, and Margaret Washington, eds. *Narrative of Sojourner Truth*. New York: Vintage Classics, 1993.

Wagner, Sally Roesch. *Sisters in Spirit: The (Haudenosaunee) Iroquois Influence on Early American Feminists*. Summertown, TN: Native Voices, 2001.

Waldman, Michael. *The Fight to Vote*. New York: Simon and Schuster Paperbacks, 2017.

Walton, Mary. *Woman's Crusade: Alice Paul and the Battle for the Ballot*. New York: St. Martin's Griffin, 2015.

Ward, Geoffrey C., Martha Saxton, Ann D. Gordon, and Ellen Carol DuBois. *Not for Ourselves Alone: The Story of Elizabeth Cady Stanton and Susan B. Anthony; An Illustrated History*. New York: Alfred A. Knopf, 2002.

Washington, Margaret. *Sojourner Truth's America*. Urbana: University of Illinois Press, 2011.

Wells, Ida B. *Southern Horrors: Lynch Law in All Its Phases*. New York: New York Age Print, 1892.

Wells-Barnett, Ida B., and Michelle Duster. *Ida: In Her Own Words; The Timeless Writings of Ida B. Wells from 1893*. Chicago: Benjamin Williams, 2008.

Westkaemper, Emily. *Selling Women's History: Packaging Feminism in Twentieth-Century American Popular Culture*. New Brunswick, NJ: Rutgers University Press, 2017.

Wheeler, Marjorie Spruill. *Votes for Women! The Woman Suffrage Movement in Tennessee, the South, and the Nation*. Knoxville: University of Tennessee Press, 1995.

White, Barbara A. *The Beecher Sisters*. New Haven, CT: Yale University Press, 2003.

Wierich, Jochen. "War Spirit at Home: Lilly Martin Spencer, Domestic Painting, and Artistic Hierarchy." *Winterthur Portfolio* 37 no. 1 (Spring 2002): 23–42.

Williams, Andreá N. "Frances Watkins (Harper), Harriet Tubman, and the Rhetoric of Single Blessedness." *Meridians: Feminism, Race, Transnationalism* 12, no. 2 (2014): 99–122.

Williams, Hettie V. *Bury My Heart in a Free Land: Black Women Intellectuals in Modern U.S. History*. Santa Barbara, CA: Praeger, 2018.

Willson, Joseph, and Julie Winch. *The Elite of Our People: Joseph Willson's Sketches of Black Upper-Class Life in Antebellum Philadelphia*. University Park: Pennsylvania State University Press, 2000.

Wilson, Jan Doolittle. *The Women's Joint Congressional Committee and the Politics of Maternalism, 1920–1930*. Urbana: University of Illinois Press, 2007.

Woodhull, Victoria, Paulina W. Davis, and Lucy Stone. *A History of the National Woman's Rights Movement, for Twenty Years: With the Proceedings of the Decade Meeting Held at Apollo Hall, October 20, 1870; With an Appendix Containing the History of the Movement during the Winter of 1871 in the National Capitol*. New York: Journeymen Printers' Co-Operative Association, 1871.

Yellin, Carol Lynn, and Janann Sherman. *The Perfect 36: Tennessee Delivers Woman Suffrage*. Edited by Ilene Jones-Cornwell. Oak Ridge, TN: Iris Press, 1998.

Yellin, Jean Fagan, and John C. Van Horne. *The Abolitionist Sisterhood: Women's Political Culture in Antebellum America*. Ithaca, NY: Cornell University Press, 1994.

Zagarri, Rosemarie. *Revolutionary Backlash: Women and Politics in the Early American Republic*. Philadelphia: University of Pennsylvania Press, 2007.

Zahniser, Jill Diane, and Amelia R. Fry. *Alice Paul: Claiming Power*. New York: Oxford University Press, 2014.

Zitkala-Sa, and Tadeusz Lewandowski. *Zitkala-Sa: Letters, Speeches, and Unpublished Writings, 1898–1929*. Boston: Brill, 2018.

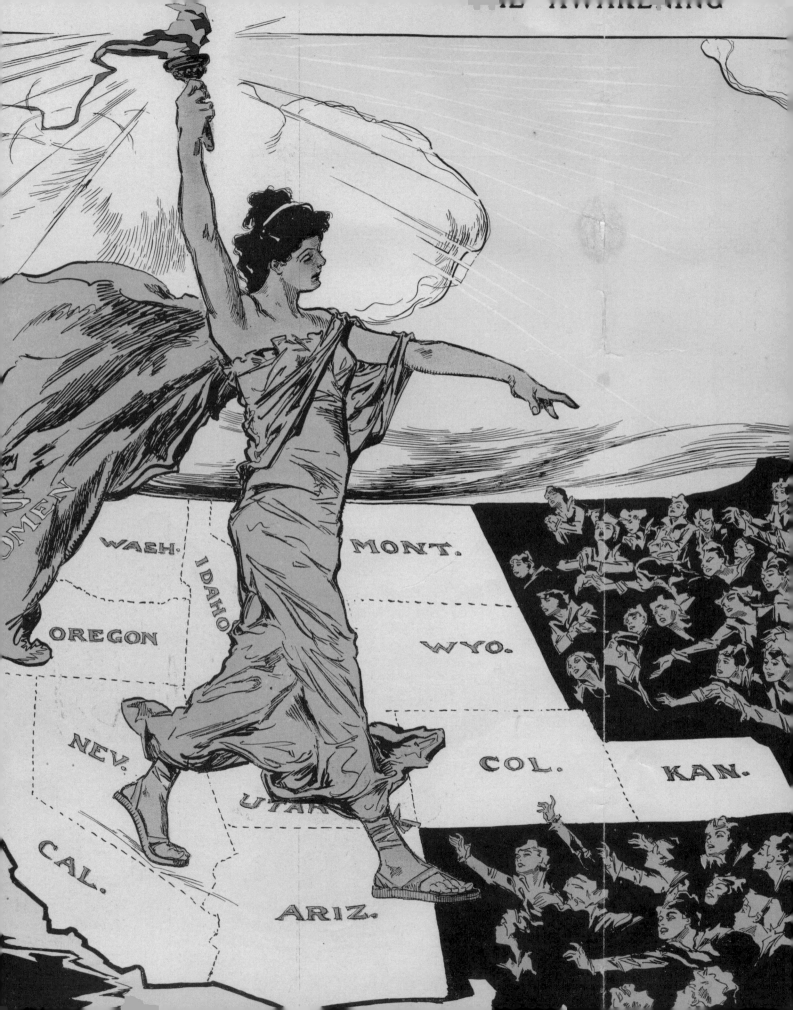

CHRONOLOGY

1832

February: The Female Anti-Slavery Society is founded in Salem, Massachusetts, by and for African American women.

1833

June: Lydia Maria Child publishes *An Appeal in Favor of That Class of Americans Called Africans*, which calls for immediate emancipation and racial equality, and protests colonization in Africa.

September: Oberlin College is founded in Ohio. The school admits African American men beginning in 1835 and women beginning in 1837.

1837

May 9–12: The Anti-Slavery Convention of American Women takes place in New York City and is attended by nearly two hundred women of various backgrounds, representing some twenty female anti-slavery groups. Prominent women in attendance include Lucretia Coffin Mott, Sarah and Angelina Grimké, and Lydia Maria Child.

1840

June 12–23: The World Anti-Slavery Convention is held in London, and American delegate Lucretia Coffin Mott is told she cannot officially participate because she is a woman. While there, Mott begins conversations with Elizabeth Cady Stanton, whose husband was acting as an official delegate at the convention.

1848

July 19–20: The Seneca Falls Convention takes place in Wesleyan Chapel, Seneca Falls, New York. Participants sign the "Declaration of Sentiments and Resolutions." Inspired by the "Declaration of Independence," the document lists ways in which women were repressed in the government, domestic sphere, education, church, and professions.

1849

January: Elizabeth Blackwell becomes the first American woman to receive a physician's license.

The Lily, the first American newspaper by and for women, is published by Amelia Bloomer in New York City.

1850

October 23–24: The First National Woman's Rights Convention is held in Worcester, Massachusetts. Around one thousand people attend, and movement leaders receive national attention.

December: Harriet Tubman is made a conductor of the Underground Railroad.

1852

September 8–10: The Third National Woman's Rights Convention is held in Syracuse, New York. Susan B. Anthony, Matilda Joslyn Gage, and Paulina Wright Davis attend.

1853

February: *The Una* is published by Paulina Wright Davis in Providence, Rhode Island.

1856

February: Sarah Parker Remond is appointed an agent of the American Anti-Slavery Society.

1861

April 12: The Civil War begins. The war disrupts women's suffrage activity, as women in both the North and South put their energy toward "war work." In this capacity, women gain organization and occupational skills that they will later apply to women's suffrage.

1864

January 16: Anna Dickinson becomes the first woman to speak before members of Congress in the United States House of Representatives.

1865

March 4: During his second inaugural address, President Abraham Lincoln proclaims the Enlistment Act, which in order to encourage the enrollment of black soldiers into the Union ranks, emancipates their wives and their children in states loyal to the Union. Nearly one hundred thousand enslaved persons are granted freedom.

May 13: The Civil War officially ends.

December 6: The Thirteenth Amendment frees over two million enslaved African American women.

1866

May 10: The Eleventh National Woman's Rights Convention is held in New York City. The American Equal Rights Association (AERA), an organization for all races and genders dedicated to universal suffrage is founded by Lucretia Coffin Mott, Elizabeth Cady Stanton, Lucy Stone, Susan B. Anthony, Frederick Douglass, and Henry Blackwell.

October 10: Elizabeth Cady Stanton declares herself a candidate for the Eighth Congressional District of New York. (She does not win the race.)

1868

January 8: Elizabeth Cady Stanton, Susan B. Anthony, and Parker Pillsbury launch the weekly newspaper *The Revolution*. Its motto is "Men, their rights and nothing more; women, their rights and nothing less!"

July 28: The Fourteenth Amendment is ratified. As a result, the Constitution uses the word "male" to define "citizens" and "voters."

November: Isabella Beecher Hooker organizes the New England Woman Suffrage Association, and her "Mother's Letters to a Daughter on Woman's Suffrage" appears anonymously in *Putnam's* magazine.

November 19: One hundred seventy-two women, both black and white, attempt to vote in Vineland, New Jersey, by casting their ballots in a separate box during the election. This moment inspires demonstrations across the United States.

December 7: The federal women's suffrage amendment is first introduced in Congress by Senator S. C. Pomeroy of Kansas.

1869

February: Utah Territory approves women's suffrage, and it is ratified in 1870.

March: The federal women's suffrage amendment is introduced as a joint resolution to Congress by Rep. George W. Julian of Indiana.

May 15: Elizabeth Cady Stanton and Susan B. Anthony form the National Woman Suffrage Association (NWSA) in opposition to the Fifteenth Amendment. They hope to achieve women's suffrage through the passage of a congressional amendment in addition to addressing other women's rights issues.

July: Emily Pitts Stevens transforms and retitles a local San Francisco newspaper into the first suffrage newspaper in the West, *The Pioneer*.

November: Conservative activists Lucy Stone, Henry Blackwell, and Julia Ward Howe form the American Woman Suffrage Association (AWSA), which focuses on amending individual state constitutions.

December: Wyoming Territory is the first to grant women suffrage in all elections.

1870

January 8: The first issue of *Women's Journal*—edited by Lucy Stone, Henry Blackwell, and Mary Livermore—is published.

February 3: The Fifteenth Amendment is ratified, granting suffrage without regard to "race, color, or previous condition of servitude."

May: Victoria Woodhull and Tennessee Claflin embark on a brief but spectacular career as Wall Street brokers.

The sisters also found the *Woodhull and Claflin's Weekly*, a women's rights and reform magazine that espouses causes such as a single moral standard for men and women, legalized prostitution, and dress reform.

1871

January 11: Victoria Woodhull addresses the House Judiciary Committee and argues that rights are guaranteed to all citizens—men and women—under the Fourteenth Amendment.

May 5: Abigail Duniway first publishes *New Northwest* in Portland, Oregon. The weekly paper champions women's rights in the Western United States.

June: Nineteen women author a petition to the United States Congress, which *Godey's Lady's Book and Magazine* publishes. This is the first instance of anti-suffrage mobilization.

July: Dressed in men's clothing, some two hundred black women register and vote in Johnson County, North Carolina.

1872

May 10: Despite not having reached the constitutionally mandated age of thirty-five, Victoria Woodhull becomes the first woman to run for president, announcing her campaign in New York City. She cannot fully campaign because she is imprisoned at the Ludlow Street Jail, a federal prison in New York City.

November 5: Susan B. Anthony casts her vote in Rochester, New York. Two weeks later, she is charged with voting illegally and is arrested, along with fifteen other women.

1873

June 17: The trial of Susan B. Anthony takes place in Canandaigua, New York. She is convicted and fined $100, which she refuses to pay.

December 23: The Woman's Christian Temperance Union (WCTU) is founded in Hillsboro, Ohio, by Annie Wittenmyer, with Frances Willard at the helm. By the following year, it is the largest women's organization in the nation.

1875

November: Michigan and Minnesota both grant women "school suffrage," which allows them to vote for school district representation.

1876

July 4: At the World's Fair in Philadelphia, Susan B. Anthony, Matilda Joslyn Gage, and other NWSA leaders disrupt the nation's centennial celebration at Independence Hall by distributing flyers titled, "The Declaration of the Rights of Women of the United States." Mary Ann Shadd Cary writes to NWSA on behalf of ninety-four black women and requests that their names be added as signers of the Declaration. Their names are not included.

1878

January: Mary Ann Shadd Cary speaks at the NWSA convention in Rochester, New York, where she applies the principles of the Fourteenth and Fifteenth Amendments to women as well as to men.

January 10: Using words similar to what Elizabeth Cady Stanton had written, Senator Aaron A. Sargent of California introduces a joint resolution that eventually becomes the Nineteenth Amendment: "The right of citizens of the United States to vote shall not be denied or abridged by the United States or by any State on account of sex."

December: A petition for women's suffrage is presented to the House and Senate, and all thirty-three signatures on the document are from African American residents of the Uniontown neighborhood in Washington, DC.

1879

March 3: Belva Ann Lockwood becomes the first woman admitted to practice law before the Supreme Court of the United States.

1880

February: Mary Ann Shadd Cary organizes the Colored Women's Progressive Franchise Association in Washington, DC, as an auxiliary of the predominantly white NWSA.

1881

October: The WCTU, led by Frances Willard, endorses the women's suffrage movement.

1882

May 6: Signed by President Chester A. Arthur, the Chinese Exclusion Act prohibits all immigration of Chinese laborers for ten years.

1883

November: Frances Ellen Watkins Harper begins her term as Superintendent of Work among the Colored People, an auxiliary of the WCTU.

November 26: Sojourner Truth dies.

1884

September: Belva Ann Lockwood becomes the first woman candidate to be nominated by a major party (the National Equal Rights Party) to run for president.

1887

January 25: The federal suffrage amendment is defeated in the Senate.

April: Women in Kansas are granted municipal suffrage.

1890

May: The National American Woman Suffrage Association (NAWSA) is created by merging the National Woman Suffrage Association (NWSA) and the American Woman Suffrage Association (AWSA).

July 10: Wyoming is admitted to the Union as a state and becomes the first state to grant women full suffrage.

1891

December: The American Federation of Labor, with its membership of approximately 265,000 people, announces its support for a women's suffrage amendment.

1892

January: Josephine St. Pierre Ruffin founds the Woman's Era Club in Boston.

October: After the murder of three black businessmen in Memphis, Tennessee, Ida B. Wells launches her nationwide anti-lynching campaign. She publishes *Southern Horrors: Lynch Law in All Its Phases*.

December: The Colored Women's League is established in Washington, DC.

1893

October 18: Lucy Stone dies.

November 7: The Colorado Woman's Suffrage Referendum of 1893 is passed, giving Colorado women the right to vote.

1894

November: Clara Cressingham, Carrie C. Holly, and Frances S. Klock become the first women to serve in state legislature after being elected to the Colorado House of Representatives.

1895

May: The Massachusetts Association Opposed to the Further Extension of Suffrage to Women is launched. It is the first time anti-suffragists institutionalize their cause.

November: The first volume of *The Woman's Bible* is published by Elizabeth Cady Stanton. After its publication, NAWSA distances itself from Stanton because many conservative suffragists consider her to be too radical. Stanton publishes a second volume in 1898.

1896

January: Utah becomes a state, and women's suffrage is restored through the state's constitution. Women's suffrage in Utah territory had been revoked by Congress in 1887 through the Edmonds-Tucker Act, in an effort to eliminate polygamy.

July: The National Federation of Afro-American Women and the National League of Colored Women merge to form the National Association of Colored Women (NACW). The organization's first president is Mary Church Terrell, and she is joined by Ida B. Wells-Barnett, Margaret Murray Washington, Fanny Jackson Coppin, Frances Ellen Watkins Harper, Charlotte Forten Grimké, and Harriet Tubman.

November: Idaho approves women's suffrage through referendum.

1900

February: Carrie Chapman Catt becomes president of National American Woman Suffrage Association (NAWSA).

1902

October 2: Elizabeth Cady Stanton dies.

1904

June 4: The International Alliance of Women (IAW) is founded in Berlin, Germany, to promote women's suffrage and gender equality worldwide. Suffragists from the United States in attendance include Carrie Chapman Catt and Susan B. Anthony.

October: Mary McLeod Bethune founds the Daytona Educational and Industrial Training School for Negro Girls, later known as Bethune-Cookman College.

1906

March 13: Susan B. Anthony dies.

June 29: The Naturalization Act of 1906, signed into law by President Theodore Roosevelt, requires immigrants to learn English to become naturalized citizens while vaguely limiting those eligible for citizenship by ethnicity and nationality through the terms "white" and "of African descent."

1907

April: Harriot Stanton Blatch founds the Equality League of Self-Supporting Women (later named the Women's Political Union).

1910

April: Ida B. Wells-Barnett founds her first suffrage club, the Women's Second Ward Republican Club in Chicago.

May: The first suffrage parade, organized by the Women's Political Union, takes place in New York City. The procession marches down Fifth Avenue.

November: Washington State grants suffrage rights to women through referendum.

1911

March 25: A fire at Triangle Shirtwaist factory, in New York, kills around one hundred people, predominately women and teenage girls. The tragedy sparks the largest female strike to date and spurs workplace safety protective legislation.

November: The National Association Opposed to Woman Suffrage (NAOWS) is established by Josephine Jewell Dodge at her home on Park Avenue in New York City.

In California, women receive suffrage via referendum after an elaborate campaign. They win 3,587 votes—an average of one vote in every precinct in the state.

1912

January: Kansas adopts a constitutional amendment for women's suffrage.

July: Margaret Murray Washington, the newly elected president of the NACW, founds the periodical *National Association Notes*, later known as *National Notes*.

October: Oregon adopts a constitutional amendment for women's suffrage.

November: Arizona adopts a constitutional amendment after referendum petitions for women's party.

December: Alice Paul is appointed chairman of the National American Woman Suffrage Association's Congressional Committee at a NAWSA convention.

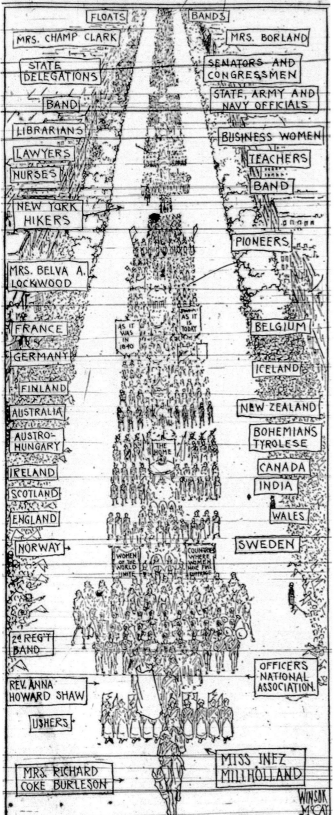

How Thousands of Women Parade To-day at Capital.

SUFFRAGE MARCH LINE

January 30: Ida B. Wells-Barnett founds the Alpha Suffrage Club of Chicago. This is credited as being the first African American suffrage club.

March 3: One day before President Woodrow Wilson's inauguration, Alice Paul organizes approximately eight thousand suffragists for a parade in Washington, DC. While the event is successful in garnering media attention, some of the participants are mobbed by abusive crowds.

March 10: Harriet Tubman dies.

March 21: In the territory of Alaska, a bill approved by the governor extends the elective franchise to women.

April: Alice Paul and Lucy Burns found the Congressional Union, later known as the National Woman's Party (NWP), which, as an auxiliary of NAWSA, works toward securing a federal amendment for women's suffrage.

May: At the opening ceremony of the Flying Carnival of the Aeronautical Society, in Staten Island, New York, Rosalie Jones flies over crowds and "bombs" them with suffrage flyers.

May 10: A suffrage parade featuring close to ten thousand participants marches along Fifth Avenue in New York City. The parade is the largest one to date and is watched by hundreds of thousands of people.

June 26: Illinois grants women presidential suffrage.

November: The Southern States Woman Suffrage Conference is formed in an effort to lobby state legislatures for the enfranchisement of white women.

November 15: The first issue of *The Suffragist* is published.

1914

June: The National Federation of Women's Clubs endorses the suffrage campaign at their biennial convention.

September 18: Mrs. Frank Leslie dies, bequeathing

almost $2 million to Carrie Chapman Catt for "the furtherance of the cause of women's suffrage."

November: Montana and Nevada both adopt constitutional amendments for women's suffrage.

December 8: At President Wilson's formal address to Congress, five suffragists unfurl a banner that reads "Mr. President, What Will You Do for Woman Suffrage."

1915

June 5–7: The National Woman's Party is officially formed at a convention of women voters organized by the Congressional Union (CU) at Blackstone Theatre in Chicago. Its goal is to remain independent of existing political parties and immediate action on the federal woman suffrage amendment.

September: Mabel Vernon and Sara Bard Field gather more than half a million signatures for petition during their transcontinental tour.

December: Carrie Chapman Catt is chosen as the head of NAWSA for a second time and serves as the organization's president through the Nineteenth Amendment's enactment in 1920.

1916

April–May: "The suffrage special," comprising twenty-three CU members, departs from Washington, DC, on a five-week train tour of the Western United States to gather support for a federal woman suffrage amendment.

August: NAWSA endorses the "Winning Plan," the campaign of its president, Carrie Chapman Catt, who seeks to push the amendment through Congress so that it can be ratified by their respective legislatures.

November 7: Jeannette Rankin of Montana becomes the first woman to be elected to the House of Representatives and Congress.

December 2: Suffragists fly over President Wilson's yacht to drop suffrage amendment petitions near Midland Beach (Staten Island, New York).

1917

January 10: NWP begins picketing the White House. Some of their banners read, "Mr. President, What Will You Do for Woman Suffrage" and others read, "How Long Must Women Wait for Liberty." Women agree to take turns holding banners so that the signs can be continuously displayed, regardless of the weather; the pickets earn the nickname "Silent Sentinels."

October: While imprisoned at Occoquan Workhouse, Lucy Burns circulates a petition that demands better conditions for her and the other suffragists. Every woman who signs the request is transferred to the district jail and placed in solitary confinement.

October 20: Alice Paul is arrested and sentenced to an unprecedented seven months in Occoquan Workhouse.

November: After a failed attempt in 1915, New York adopts a constitutional amendment for women's suffrage in all elections. The following states secure presidential suffrage for women: North Dakota, Nebraska, Ohio, Indiana, Rhode Island, Maine, Missouri, Iowa, Minnesota, Wisconsin, and Tennessee.

November 5: Alice Paul and Rose Winslow begin a hunger strike. After a week, they are subjected to force-feeding three times per day for three weeks. Paul is separated from other prisoners and taken to a psychiatric ward.

November 15: Imprisoned suffragists at Occoquan Workhouse endure the "Night of Terror," where guards drag, carry, push, and beat them into their cells. The next day, sixteen women go on a hunger strike.

1918

January 9: For the first time, President Wilson publicly supports the federal woman suffrage amendment.

January 10: The suffrage amendment receives two-thirds of the votes in the House, but it fails to pass in the Senate.

March 4: A US federal appeals court declares that the arrest and detainment of all White House suffrage pickets was unconstitutional.

September 30: President Wilson addresses the Senate and argues for the passage of a federal woman suffrage amendment as a war measure.

1919

January 1: NWP watchfire demonstrations begin outside the White House. Picket leaders Edith Ainge, Hazel Hunkins, Alice Paul, and Julia Emory are arrested, but they are soon released.

June 4: The Senate passes the Nineteenth Amendment, 56 to 25. It is then sent to the states for ratification, initiating intense lobbying campaigns to obtain ratification by the then required thirty-six state legislatures.

1920

February 14: The League of Women Voters is founded in Chicago.

August 18: Tennessee becomes the thirty-sixth state to ratify the Nineteenth Amendment.

August 26: The Nineteenth Amendment is signed into law.

1922

November 13: The Supreme Court case *Ozawa v. United States* rules that people of Japanese heritage are ineligible to become naturalized citizens and therefore are unable to vote.

1923

February: The Supreme Court rules in *United States v. Bhagat Singh Thind* that Indo-Aryan people are not classified as "white" or of "African descent" and are thus racially ineligible for naturalized citizenship under the Naturalization Act of 1906. Thus, they are unable to vote.

July: Alice Paul proposes the Equal Rights Amendment (ERA) to Congress at the seventy-fifth anniversary of the Seneca Falls Convention, boldly proclaiming that "men and women shall have equal rights throughout the United States and every place subject to its jurisdiction."

1924

June 2: President Calvin Coolidge signs the Indian Citizenship Act, which grants all Native Americans US citizenship and promises them the right to vote.

1926

November: While attempting to register to vote in Birmingham, Alabama, a group of African American women are beaten by election officials.

1943

December 17: Chinese immigrants living in the United States are given the right to citizenship and the right to vote by the Magnuson Act, also known as the Chinese Exclusion Repeal Act.

1946

July 2: The Luce-Celler Act is signed into law, allowing Filipino Americans and South Asian Americans to naturalize and become US citizens.

1948

June: Miguel Trujillo Sr., a Native American and former marine, sues New Mexico for not allowing him to vote. He wins, and New Mexico and Arizona are subsequently required to allow all Native Americans to vote.

1952

June 27: The McCarran-Walter Act grants all immigrants of Asian ancestry the right to become citizens and ultimately the right to vote.

1962

August: Fannie Lou Hamer and seventeen others go to the courthouse in Indianola, Mississippi, to register to vote. They face voter discrimination and are told they must take a literacy test, which they all fail.

1964

June: Freedom Summer, a volunteer campaign, attempts to register as many African American voters as possible in Mississippi.

August: At the Democratic National Convention, Fannie Lou Hamer gains national attention when she speaks as a delegate of the Mississippi Freedom Democratic Party (MFDP) and describes the horrors African Americans face when registering to vote in the South.

1965

January 3: Patsy Takemoto Mink becomes the first woman of color elected to Congress and represents Hawaii in the House for nearly twenty-six years.

March: In an effort to demonstrate their desire to vote and to draw attention to voter discrimination, African Americans in Alabama organize three 54-mile nonviolent protest marches from Selma to Montgomery. The final march includes over twenty-five thousand people.

August 6: The Voting Rights Act (VRA) is signed into law by President Lyndon B. Johnson, thereby forbidding states from imposing discriminatory restrictions on voters.

1966

June 6: James Meredith begins his solitary March Against Fear to encourage African Americans to vote. On the second day of his 220-mile march from Memphis, Tennessee, to Jackson, Mississippi, he is shot and hospitalized. Some fifteen thousand people finish his march to Jackson, inspiring many to register to vote.

1968

June 18: Shirley Chisholm becomes the first black woman elected to Congress, representing New York.

1972

March 22: After being reintroduced to Congress every year for forty-nine years, the Equal Rights Amendment is finally adopted by both sides of Congress and sent to the states for ratification. (As of 2018, the ERA has been ratified by thirty-seven of thirty-eight states needed.)

June 23: Title IX, co-authored by Senator Birch Bayh and Congresswoman Patsy Takemoto Mink, is signed into law by President Richard Nixon.

2000

October: A federal court decides that although residents of US territories are citizens, they cannot vote in presidential elections. The ruling affects residents of Puerto Rico, Guam, American Samoa, Northern Mariana Islands, and the US Virgin Islands.

2013

June: The Supreme Court validates a law requiring that politicians in states with a history of voter discrimination against minorities obtain federal permission before changing voting rules.

2018

November: A record-breaking total of 126 women are elected to the 116th Congress during the midterm elections. One hundred and two women are elected to serve in the House of Representatives, including 43 women of color. Twenty-four women are elected to serve in the Senate, including 4 women of color.

WOMAN SUFFRAGE PARTY

THE SUFFRAGIST

VOTES FOR

ACKNOWLEDGMENTS

Organizing this exhibition and producing this catalogue have been deeply enriching experiences. The success of *Votes for Women* came about as the result of a brilliant team of individuals. At the National Portrait Gallery, Rhys Conlon, head of publications, is a fantastic colleague and collaborative editor who exercised great care and thought in shaping this book. Grateful thanks and immeasurable appreciation must be accorded to the 2018–2019 research assistant, Nicole Ashley Vance, who offered meticulous and thorough help, especially in unearthing some of the missing information for the essays and in her excellent work on assembling the video projection of the Silent Sentinels. I cannot heap enough praise on the 2016–2017 History Department intern, Grace Marra, whose memory never failed when recalling innumerable objects and biographies as the exhibition evolved. Madi Shenk, also an intern, aided our endeavor during the summer of 2017 with great insight and enthusiasm, helping track down innumerable bibliographic sources. In the Publications Department, we were extremely fortunate to have Anne-Soléne Bayan and Sarah McGavran assist with editing.

Exhibition program specialist Allison Keilman's keen eye for detail kept the entire team organized, especially as the show evolved through many iterations. She, along with image rights specialist Erin Beasley and the museum's photographer Mark Gulezian, worked tirelessly to ensure that the book's illustrations live up to the power of the objects. Claire Kelly, head of exhibitions, was a pleasure to work with, and the exhibition benefited greatly from her sharp focus and experience. Alex Cooper, head of exhibit technology, makes technology seem easy—no small feat. Program assistant Jackie Petito anchors the History Department, and I am so glad for her steady, thoughtful help. I am also grateful to David C. Ward, senior historian emeritus, for helping me work through the earliest iterations of this project.

Other Portrait Gallery colleagues demonstrated kindness, enthusiasm, and support throughout this project, helping to make this a meaningful experience as

well as an important exhibition. Deep thanks to Peter Crellin, Raymond Cunningham, Tibor Waldner, Michael Baltzer, Caroline Wooden, and Rachael Huszar—the design and production team that created such a deep and rich visual presentation of historic American women radicals. For their important Audience Engagement programs, thank you to Rebecca Kasemeyer, Deb Sisum, Kaia Black, Beth Evans, Vanessa Jones, Elisabeth Kilday, Shirlee Lampkin, Geraldine Provost Lyons, Jewell Robinson, and Briana Zavadil White—all who amplify and empower the public by effectively engaging them with women's history. Sincere thanks as well to Concetta Duncan and Emily Haight of communications, and to Rachel Niehoff and Lindsay Gabryszak, who lead the museum's outstanding advancement team. The exhibition includes many loans, and I am so grateful to the registrarial department, especially John McMahon, Melissa Front, Marissa Olivas, Jennifer Wodzianski, Wayne Long, and Dale Hunt. Thank you to my fellow curators for their thoughtful engagement with this exhibition: Brandon Brame Fortune, Ann Shumard, Leslie Ureña, Robyn Asleson, Dorothy Moss, Taína Caragol, and Jim Barber.

Finally, I am especially grateful to Portrait Gallery director Kim Sajet, as she demonstrates an exemplary devotion to why portraiture matters in American women's identity and history. Thanks to the work of this incredible team, we are able to honor the American suffrage movement with the most significant exhibition on its history to date, as well as a beautiful book.

It was a privilege to partner with Princeton University Press, and I wish to recognize their phenomenal staff for all of their hard work on this publication, particularly: Michelle Komie, Terri O'Prey, Steve Sears, and Pamela Weidman. I am grateful for the sharp eyes of copyeditor Dawn Hall, and I thank designer Roy Brooks of Fold Four, Inc. for his incredible design.

Some of the most important ways in which I learned about this complex topic was by talking with those most passionate about suffrage. Ronnie Lapinsky Sax and Ann Lewis both graciously welcomed me into their homes to see their collections and spent time discussing with me some of the more significant moments of the movement. A research trip to the West Coast to visit the collections of Michael Kahn, Robert Cooney, and Chase Livingston opened my eyes to objects I had not previously known. As I was finding objects and learning about their nuanced meanings, Kenneth Florey also was an unfailing source of insight. Jane Kamensky, director of the Schlesinger Library, was enthusiastically supportive of the exhibition from its inception and made available the prodigious resources of her institution. Jennifer Krafchik, executive director of the Belmont-Paul Women's Equality National Monument, also has been an ally and colleague for this exhibition since its beginning phase. Janice E. Ruth at the Library of Congress generously helped me to navigate the papers of the National American Woman Suffrage. Regarding the suffrage efforts of her grandmother Adella Hunt Logan, Adele Alexander was delightfully engaging and shared much of her expertise. I also wish to thank Dr. Rosalyn Terborg-Penn, the late professor emeritus at Morgan State University and a co-founder of the Association of Black Women Historians. Her book *African American Women in the Struggle for the Vote, 1850–1920* offers tremendous insight into this critical period in American

history and documents the significant contributions of African American women to the struggles for political empowerment of all women. The scholars who contributed essays to this book—Lisa Tetrault, Martha S. Jones, and Susan Goodier—are experts whose exemplary thinking in the field of women's history continues to push boundaries and ask the most important questions.

I endeavored to make this exhibition an inclusive, teachable, and visually interesting story of the nation, and as such, I requested to borrow objects from people and institutions across the nation. I am thankful to the following lenders: Adele Logan Alexander; Boston Public Library; Bryn Mawr College Library; Robert P. J. Cooney Jr.; Cornell University, the PJ Mode Collection of Persuasive Cartography; Dr. Danny O. Crew; Emory University, Stuart A. Rose Manuscript, Archives, and Rare Book Library; Virginia and Gary Gerst; the Gilder Lehrman Institute of American History; Harriet Beecher Stowe Center; Harvard University, Fine Arts Library; Howard University, Moorland-Spingarn Research Center; Michael and Susan Kahn; Ann Lewis and Mike Sponder; Library of Congress; Chase Livingston; Maryland Historical Society, H. Furlong Baldwin Library; Museum of the City of New York; National Museum of African American History and Culture, Smithsonian Institution; National Museum of American History, Smithsonian Institution; National Susan B. Anthony Museum and House; National Woman's Party, Washington, DC; Newark Museum; Oberlin College Archives; Peabody Essex Museum; Rochester Public Library; Ronnie Lapinsky Sax; Schlesinger Library, Radcliffe College; Seneca Falls Historical Society Museum; State Archives of Florida; U.S. House of Representatives; University of Delaware Library; University of Michigan, William L. Clements Library; University of Oregon Libraries; University of Pennsylvania, Kislak Center for Special Collections, Rare Books and Manuscripts; Wells Fargo & Company; White House Historical Association; Wolfsonian—Florida International University Museum; and Xavier University of Louisiana. Thanks also to Laura Wathen Greiner.

As the co-coordinating curator of the American Women's History Initiative at the Smithsonian, I have had the privilege to learn from some of the best cultural leaders in the world, led by Provost John Davis and director of the Smithsonian American Art Museum, Stephanie Stebich. For their sisterhood and immeasurable talent, I thank the other co-coordinating curator, Dorothy Moss; senior program officer of digital strategy, Effie Kapsalis; assistant secretary of communications and external affairs, Julissa Marenco; program coordinator, Jenn Schneider; senior program officer for history and culture, Michelle Delaney; and director of operations, Stacy Cavanaugh. The American Women's History Initiative focuses on Her Story at the Smithsonian through our collections and our exhibitions, and I am so proud that this exhibition is part of such an important endeavor.

INDEX

Note: Page numbers in italic type indicate illustrations.

CREDITS

We would like to thank all those who gave their kind permission to reproduce material. Individual works of art appearing herein may be protected by copyright in the United States of America or elsewhere, and may not be reproduced in any form without the permission of the rights holders. In reproducing the images contained in this publication, the Museum obtained the permission of the rights holders whenever possible. In those instances where the Museum could not locate the rights holders, notwithstanding good-faith efforts, it requests that any contact information concerning such rights holders be forwarded so that they may be contacted for future editions.

Unless otherwise noted, measurements indicate the image size for photographs, plate size for daguerreotypes, stretcher size for paintings, and sheet size for works on paper.

COPYRIGHT NOTICES

© Antonio Martorell: p. 227, cat. 130.
© The Family of Charmian Reading: p. 229, cat. 131.
© The Regents of the University of California, The Bancroft Library, University of California, Berkeley: p. 195, cat. 98.

PHOTOGRAPHIC CREDITS

Courtesy of Adele Logan Alexander, PhD: p. 179, cat. 82.
Associated Press / William J. Smith: p. 28, fig. 1.
Barnard Special Archives and Special Collections: p. 67, fig. 11.
Berenice Bryant Lowe Papers, Bentley Historical Library, University of Michigan: p. 35, fig. 5.
Boston Public Library, Rare Books and Manuscripts: p. 90, cat. 1.
Bryn Mawr College Library, Special Collections: p. 222, cat. 124.
Courtesy of Robert P. J. Cooney Jr.: p. 114, cat. 24; p. 122, cat. 30; p. 151, cat. 57; p. 159, cat. 65; p. 160, cat. 66; p. 182, cats. 85–86; p. 185, cat. 89; p. 194, cat. 97; p. 220, cat. 122.
Cornell University—The PJ Mode Collection of Persuasive Cartography: pp. 188–89, cat. 91.
Courtesy of Dr. Danny O. Crew: p. 109, cat. 19.
Drexel University College of Medicine; Legacy Center Archives, Philadelphia: p. 83, fig. 13.
Emory University, Stuart A. Rose Manuscript, Archives, and Rare Book Library: p. 103, cat. 13.
Fenimore Art Museum, Cooperstown, New York, Photographic Collection: p. 50, fig. 2.
Courtesy of Virginia and Gary Gerst, photographs by Nathan Keay: p. 152, cat. 58.
Gilder Lehrman Institute of American History: p. 93, cat. 5.
Courtesy of Laura Wathen Greiner: p. 172–73, cat. 76.
Harvard University; Arthur and Elizabeth Schlesinger Library on the History of Women in America, Radcliffe Institute for Advanced Study: p. 9, fig. 8; p. 62, fig. 8; p. 107, cat. 16; p. 110, cat. 20; p. 149, cat. 54; p. 153, cat. 59; p. 187, cat. 90; p. 191, cat. 93.

CREDITS

We would like to thank all those who gave their kind permission to reproduce material. Individual works of art appearing herein may be protected by copyright in the United States of America or elsewhere, and may not be reproduced in any form without the permission of the rights holders. In reproducing the images contained in this publication, the Museum obtained the permission of the rights holders whenever possible. In those instances where the Museum could not locate the rights holders, notwithstanding good-faith efforts, it requests that any contact information concerning such rights holders be forwarded so that they may be contacted for future editions.

Unless otherwise noted, measurements indicate the image size for photographs, plate size for daguerreotypes, stretcher size for paintings, and sheet size for works on paper.

COPYRIGHT NOTICES

© Antonio Martorell: p. 227, cat. 130.
© The Family of Charmian Reading: p. 229, cat. 131.
© The Regents of the University of California, The Bancroft Library, University of California, Berkeley: p. 195, cat. 98.

PHOTOGRAPHIC CREDITS

Courtesy of Adele Logan Alexander, PhD: p. 179, cat. 82.
Associated Press / William J. Smith: p. 28, fig. 1.
Barnard Special Archives and Special Collections: p. 67, fig. 11.
Berenice Bryant Lowe Papers, Bentley Historical Library, University of Michigan: p. 35, fig. 5.
Boston Public Library, Rare Books and Manuscripts: p. 90, cat. 1.
Bryn Mawr College Library, Special Collections: p. 222, cat. 124.
Courtesy of Robert P. J. Cooney Jr.: p. 114, cat. 24; p. 122, cat. 30; p. 151, cat. 57; p. 159, cat. 65; p. 160, cat. 66; p. 182, cats. 85–86; p. 185, cat. 89; p. 194, cat. 97; p. 220, cat. 122.
Cornell University—The PJ Mode Collection of Persuasive Cartography: pp. 188–89, cat. 91.
Courtesy of Dr. Danny O. Crew: p. 109, cat. 19.
Drexel University College of Medicine; Legacy Center Archives, Philadelphia: p. 83, fig. 13.
Emory University, Stuart A. Rose Manuscript, Archives, and Rare Book Library: p. 103, cat. 13.
Fenimore Art Museum, Cooperstown, New York, Photographic Collection: p. 50, fig. 2.
Courtesy of Virginia and Gary Gerst, photographs by Nathan Keay: p. 152, cat. 58.
Gilder Lehrman Institute of American History: p. 93, cat. 5.
Courtesy of Laura Wathen Greiner: p. 172–73, cat. 76.
Harvard University; Arthur and Elizabeth Schlesinger Library on the History of Women in America, Radcliffe Institute for Advanced Study: p. 9, fig. 8; p. 62, fig. 8; p. 107, cat. 16; p. 110, cat. 20; p. 149, cat. 54; p. 153, cat. 59; p. 187, cat. 90; p. 191, cat. 93.

Harvard University; Courtesy of Special Collections, Fine Arts Library: p. 120, cat. 28.

Courtesy of Michael and Susan Kahn; image courtesy of Division of Political History, National Museum of American History, Smithsonian Institution: p. 136, cat. 44.

Courtesy of Kate Clarke Lemay: p. 130, cat. 38.

Courtesy of Ann Lewis and Mike Sponder: p. 93, cat. 4; p. 134, cat. 41; p. 150, cat. 56; p. 155, cat. 62; p. 163, cat. 69; p. 164, cat. 77; p. 203, cat. 104; p. 213, cat. 117; p. 216 (detail), p. 222, cat. 125; p. 224, cat. 126.

Library Company of Philadelphia: p. 14, fig. 12; p. 40, fig. 7.

Library of Congress: p. xii; p. 7, figs. 5–6; p. 12, fig. 10; p. 15, fig. 13; p. 16, fig. 14; p. 37, fig. 6; p. 42, fig. 8; p. 44, fig. 9; p. 48, fig. 1; p. 61, fig. 7; p. 65, fig. 10; p. 68, fig. 1; p. 73, fig. 3; p. 76, fig. 6; p. 127, cat. 35; p. 140, cat. 45; p. 161, cat. 67; p. 171, cat. 75; pp. 178, 260 (detail), cat. 80; pp. 178, 274, cat. 81; p. 181, cat. 84; p. 197, cat. 100; p. 206, cat. 108; p. 215, cat. 119; pp. ii, 219, cat. 121.

Courtesy of Chase Livingston, photographs by Don Ross: pp. 88 (detail), 110, cat. 21; p. 126, cat. 33; p. 126, cat. 34; p. 162, cat. 68; p. 184, cat. 88.

Maryland Historical Society, H. Furlong Baldwin Library: p. 202, cat. 103.

Metropolitan Museum of Art: p. 10, fig. 9; p. 59, fig. 5.

Moorland-Spingarn Research Center, Howard University: p. 143, cat. 49.

Museum of the City of New York: p. 131, cat. 39.

National Archives at College Park, Maryland: p. 70, fig. 2; p. 75, fig. 5.

National Museum of African American History and Culture, Smithsonian Institution: p. 91, cat. 2.; p. 146, cat. 52.

National Museum of American History, Smithsonian Institution: p. 175, cat. 78; pp. v (detail), 204, cat. 105; p. 207, cat. 110; p. 211, cat. 115.

© National Portrait Gallery, London: p. 4, fig. 2.

National Susan B. Anthony Museum and House: p. 107, cat. 17.

National Woman's Party: p. 156, cat. 63; p. 171, cat. 73; p. 171, cat. 74; p. 183, cat. 87; p. 196, cat. 99; p. 198, cat. 101; p. 205, cat. 106; p. 205, cat. 107; p. 207, cat. 109; op. 200 (detail), 208, cat. 111; p. 209, cat. 112; p. 209, cat. 113; p. 210, cat. 114; p. 221, cat. 123.

Newark Museum: p. 112, cat. 22.

New York Public Library, The Miriam and Ira D. Wallach Division of Art, Prints and Photographs, Photography Collection: p. 19, fig. 15.

Oberlin College Archives: p. 142, cats. 46–48.

© 2018 Peabody Essex Museum. Photographed by Kathy Tarantola: p. 95, cat. 6.

Rochester Public Library: p. 96, cat. 8.

Schomburg Center for Research in Black Culture, Art, and Artifacts Division,

New York Public Library: p. 30, fig. 2.

Courtesy of Ronnie Lapinsky Sax: p. 128, cat. 36; p. 135, cat. 43; p. 154, cat. 61; p. 169, cat. 72; pp. 166 (detail), 180, cat. 83; p. 191, cat. 92; p. 192, cat. 94; p. 193, cats. 95–96; p. 212, cat. 116; p. 218, cat. 120; p. 225, cat. 127.

Seneca Falls Historical Society: p. 97, cat. 9; p. 108, cat. 18.

State Archives of Florida: p. 147, cat. 53.

Harriet Beecher Stowe Center, Hartford, CT: p. 124, cat. 32.

University of California, Riverside, Special Collections and University Archives: p. 26, fig. 16.

University of Delaware Library, Special Collections: p. 214, cat. 118.

University of Michigan, William L. Clements Library: p. 92, cat. 3; p. 35, fig. 5.

University of North Carolina at Greensboro, Martha Blakeney Hodges Special Collections and University Archives: p. 74, fig. 4; p. 81, figs. 10–11; p. 82, fig. 12; pp. 85–87, figs. 14–16.

University of Northern Iowa, Cedar Falls; Catherine H. Palczewski Suffrage Postcard Archive : p. 60, fig. 6.

University of Oregon Libraries: p. 132, cat. 40.

University of Pennsylvania; Kislak Center for Special Collections, Rare Books and Manuscripts: p. 153, cat. 60.

University of Washington Libraries, Special Collections, Seattle: pp. 77–78, figs. 7–8; p. 81, fig. 9.

University of Wisconsin-Madison; Department of Special Collections, Memorial Library: p. 32, fig. 3.

U.S. House of Representatives: p. 230, cat. 132.

Wells Fargo and Company: p. 158, cat. 64.

Western Connecticut State Archives: p. 62, fig. 9.

White House Historical Association: p. 113, cat. 23.

Wolfsonian–Florida International University, Miami Beach, Florida; The Wolfson Mitchell Jr. Collection. Photo: Silvia Ros: p. 164, cat. 70.

Woman's Medical College of Pennsylvania Photograph Collection, Drexel University Libraries, Philadelphia: p. 83, fig. 13.

Xavier University of Louisiana: p. 145, cat. 51.

Copyright © 2019 Smithsonian Institution

Requests for permission to reproduce material from this work should be sent to Permissions, Princeton University Press

Published by Princeton University Press, 41 William Street, Princeton, New Jersey 08540

In the United Kingdom: Princeton University Press, 6 Oxford Street, Woodstock, Oxfordshire OX20 1TR

press.princeton.edu

Cover illustrations: (front) *Votes for Women* (detail), by Bertha Margaret Boyé, 1911. The Arthur and Elizabeth Schlesinger Library on the History of Women in America, Radcliffe Institute for Advanced Study, Harvard University. (back) *Mary McLeod Bethune* (detail), by William Ludlow Coursen, 1910-1911. State Archives of Florida, Collection M 95-2.

All Rights Reserved

ISBN 978-0-691-19117-1

LCCN 2018955219

British Library Cataloging-in-Publication Data is available

Published to accompany the exhibition *Votes for Women: A Portrait of Persistence* at the National Portrait Gallery, Smithsonian Institution, Washington, D.C. (March 1, 2019– January 5, 2020)

npg.si.edu

Designed by Roy Brooks, Fold Four, Inc.

This book has been composed in Bauer Bodoni, Gill Sans, and Janson

Printed on acid-free paper. ∞

Printed in Canada

10 9 8 7 6 5 4 3 2 1

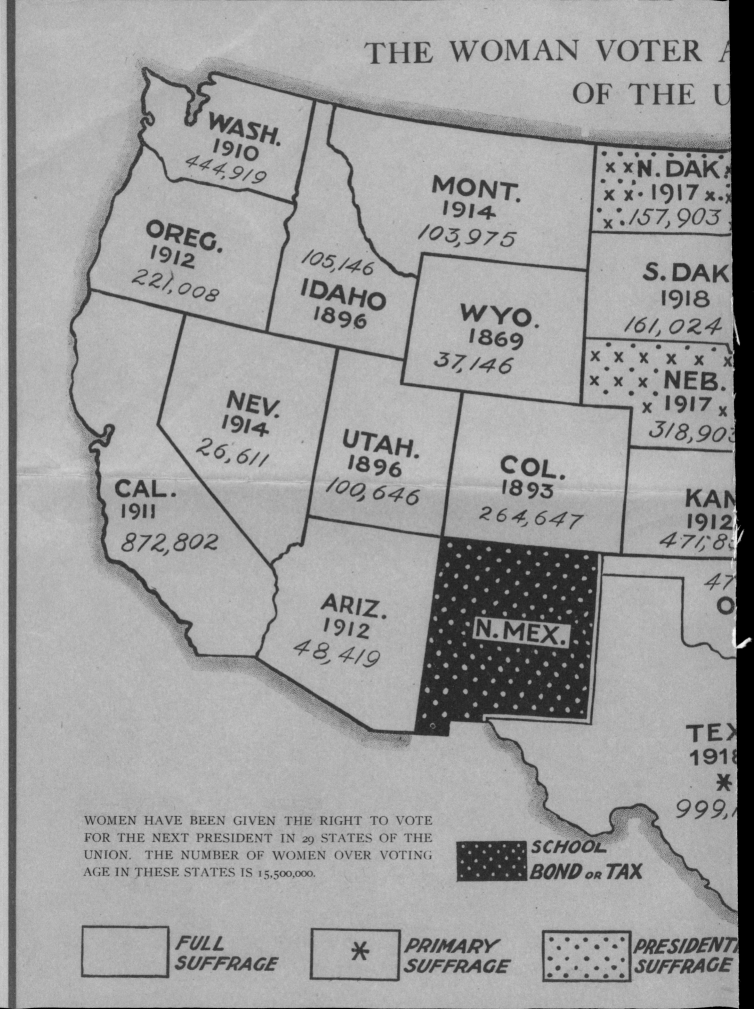

WASH.
1910
444,919

OREG.
1912
221,008

105,146
IDAHO
1896

MONT.
1914
103,975

WYO.
1869
37,146

× × N. DAK
× × · 1917 × ·
× · 157,903

S. DAK
1918
161,024

× × × × × ×
× × × **NEB.**
× 1917 ×
318,903

NEV.
1914
26,611

UTAH.
1896
100,646

COL.
1893
264,647

CAL.
1911
872,802

KAN
1912
471,8

47
O

ARIZ.
1912
48,419

N.MEX.

TEX
1918
*
999,

WOMEN HAVE BEEN GIVEN THE RIGHT TO VOTE
FOR THE NEXT PRESIDENT IN 29 STATES OF THE
UNION. THE NUMBER OF WOMEN OVER VOTING
AGE IN THESE STATES IS 15,500,000.

SCHOOL
BOND OR TAX

☐ **FULL SUFFRAGE**

★ **PRIMARY SUFFRAGE**

⋮⋮⋮ **PRESIDENT SUFFRAGE**